Medieval History and Archaeology

General Editors

JOHN BLAIR HELENA HAMEROW

MEDIEVAL HISTORY AND ARCHAEOLOGY

General Editors

John Blair Helena Hamerow

The volumes in this series bring together archaeological, historical, and visual methods to offer new approaches to aspects of medieval society, economy, and material culture. The series seeks to present and interpret archaeological evidence in ways readily accessible to historians, while providing a historical perspective and context for the material culture of the period.

RECENTLY PUBLISHED IN THIS SERIES

RURAL SETTLEMENTS AND SOCIETY IN ANGLO-SAXON ENGLAND
Helena Hamerow

PARKS IN MEDIEVAL ENGLAND
S. A. Mileson

ANGLO-SAXON DEVIANT BURIAL CUSTOMS
Andrew Reynolds

BEYOND THE MEDIEVAL VILLAGE
The Diversification of Landscape Character in Southern Britain
Stephen Rippon

WATERWAYS AND CANAL-BUILDING IN MEDIEVAL ENGLAND
Edited by John Blair

FOOD IN MEDIEVAL ENGLAND
Diet and Nutrition
Edited by C. M. Woolgar, D. Serjeantson, and T. Waldron

GOLD AND GILT, POTS AND PINS
Possessions and People in Medieval Britain
David A. Hinton

THE ICONOGRAPHY OF EARLY ANGLO-SAXON COINAGE
Sixth to Eighth Centuries
Anna Gannon

EARLY MEDIEVAL SETTLEMENTS
The Archaeology of Rural Communities in North-West Europe 400–900
Helena Hamerow

VIKING IDENTITIES

Scandinavian Jewellery in England

JANE F. KERSHAW

OXFORD

UNIVERSITY PRESS

OXFORD

UNIVERSITY PRESS

Great Clarendon Street, Oxford, OX2 6DP,
United Kingdom

Oxford University Press is a department of the University of Oxford.
It furthers the University's objective of excellence in research, scholarship,
and education by publishing worldwide. Oxford is a registered trade mark of
Oxford University Press in the UK and in certain other countries

First Edition published in 2013

Published in the United States of America by Oxford University Press
198 Madison Avenue, New York, NY 10016, United States of America

British Library Cataloguing in Publication Data
Data available

Library of Congress Cataloging in Publication Data
Data available

ISBN 978–0–19–963952–6

For my parents, Christine and David Kershaw

Preface and Acknowledgements

I first became interested in Scandinavian metalwork from England when searching the records of the Portable Antiquities Scheme (PAS). Many of the early medieval dress items found in the eastern counties were described as possessing Scandinavian characteristics and I soon became convinced that, if brought together and placed in its proper cultural context, this material had great potential for shaping understanding of the Viking-Age settlements. The number of Scandinavian-style brooches and pendants now recorded from England is far greater than I originally anticipated, at just over five hundred artefacts. They are presented here, as a group, for the first time. This book describes these objects and explores a number of themes related to their contemporary use, including their date, distribution, and function in costume. Its emphasis, however, is an interpretation of the significance of the artefacts in a broader, historical context. I argue that these finds provide valuable new evidence for Scandinavian cultural influence and activity in England, including settlement. As items worn by women, they also generate a fresh perspective on the Danelaw, exposing the presence of a population group which has, until now, been largely invisible.

This study stems from recently completed PhD research, funded by the Arts and Humanities Research Council (AHRC). My doctoral thesis was supervised with great care and enthusiasm by Helena Hamerow and then rigorously examined by Lesley Abrams and James Graham-Campbell. I am extremely grateful to all three for their time, constructive criticism, and their continued encouragement and guidance. The research was completed during my tenure of the Randall MacIver Studentship in Archaeology at The Queen's College, Oxford. At Queen's, I am indebted to John Blair, who first sparked my interest in archaeology as an undergraduate, and who has remained a source of wisdom and encouragement ever since. I would also like to thank the two anonymous reviewers for their time, advice, and support. Any remaining errors are mine alone.

During the course of this research I have benefited immensely from discussions with a number of scholars, both in England and Scandinavia. My thanks go to Helen Geake, Caroline Paterson, Tim Pestell, Birgit Maixner, Anne Pedersen, Birgitta Hårdh, Ingmar Jansson, Heidemarie Eilbracht, and John Naylor. Thanks in particular to Kevin Leahy for his valuable input into a number of aspects of Viking-Age metalwork, as well as access to his finds archive.

Fieldwork in England was greatly facilitated by a number of Portable Antiquities Scheme staff, including Steve Ashby, Nellie Bales, Rachel Atherton, Wendy Scott, Faye Minter, Adam Daubney, Lisa Staves, Liz Wilson, and Rob Collins. Particular thanks go to Alice Cattermole and Heather Hamilton for patiently guiding me through the workings of the Norfolk Historic Environment

Records (HER) at Gressenhall and Andrew Rogerson, for sharing with me his knowledge of Norfolk's sites and finds. Thanks also to Colin Pendleton and Mike Hemblade for providing assistance in the Suffolk and Lincolnshire HERs, and to Rose Nicholson for her help in North Lincolnshire Museum. For help with maps, I am indebted to Nigel James of the Bodleian Library.

My research trips to Scandinavia have been among the most enjoyable aspects of this research. I was warmly welcomed to Schleswig by Volker Hilberg, to Copenhagen by Maria Baastrup, to Moesgård by Jens Jeppesen, to Bornholm by Finn Ole Nielsen, and to Stockholm by Lotta Fernstål. Thank you to all for your hospitality.

Finally, I would like to thank Nick, my sister and parents for their continuing support. My parents, David and Christine Kershaw, have been a source of endless encouragement throughout my academic career and this book would not have been possible without them.

Contents

List of Figures

List of Colour Plates

List of Maps

List of Tables

List of Abbreviations

a) General

ADS	Archaeological Data Service
HER	Historic Environment Record
PAS	Portable Antiquities Scheme (www.finds.org.uk)
SMR	Sites and Monuments Record
XRF	X-ray fluorescence

b) Museums

ÅM	Ålands Museum
BGM	Bergen Museum
BHM	Bornholms Museum
BM	British Museum
LUHM	Lunds Universitets Historiska Museum
NCM	Norwich Castle Museum
NLM	North Lincolnshire Museum
NMK	Nationalmuseet København (Copenhagen)
MOL	Museum of London
ROM	Roskilde Museum
SHM	Stockholm Historiska Museet
SM	Sigtuna Museum
UO	Universitetets Oldsaksamling, Oslo
UUM	Uppsala Universitets Museum för Nordiska Fornsaker
VNTNU	Vitenskapsmuseet, Norges Teknisk-Naturvitenskapelige Universitet, Trondheim
WMH	Wikinger Museum Haithabu, Schleswig

1

Scandinavian-style jewellery in England: approaches and sources

Introduction

The nature, scale, and location of the Scandinavian settlement of England have long exercised students of the Viking Age. A few lines from the *Anglo-Saxon Chronicle*, the primary written source for the settlement, provide a skeletal history. Following raids on Britain's coastline in the late eighth century, Viking armies returned in the mid-ninth century, this time conquering the Anglo-Saxon kingdoms of East Anglia, Northumbria, and Mercia and settling in a region of northern and eastern England, which later became known as the Danelaw. Here, the *Chronicle* famously records, the Viking armies 'shared out the land...and proceeded to plough and to support themselves' (Whitelock 1979, 199–201).

Danish rule in northern and eastern England was officially recognized in a late ninth-century treaty between King Alfred of Wessex and the Viking leader Guthrum. Scandinavian political independence was not long-lived, however, and by AD 920, Edward the Elder has successfully captured Danish territories south of the Humber, with York finally falling to the Anglo-Saxons in 954. The nature of Danelaw society under Viking rule remains largely enigmatic. Scholarly opinion is split on the impact of the Scandinavian settlers and their contribution to English society, a reflection both of the paucity of contemporary written sources and of the diverse and often contradictory evidence afforded by linguistic, archaeological, and historical data (for reviews, see Trafford 2000; Hadley 1997; 2006, 2–9). Many fundamental questions about the Scandinavian settlement remain unanswered and, on the basis of current evidence, seem unanswerable: Which areas of England saw the greatest Scandinavian settlement? How many settlers were there? How Scandinavian were new Danelaw communities? Were all the settlers men?

In comparison with place-name and documentary evidence, traditional archaeological approaches have contributed relatively little to our understanding of this dynamic period. Burials and rural settlements identified as Scandinavian are few in number. So-called 'Viking' burials, for instance, have been

found at fewer than thirty sites in England, despite excavation of increasing numbers of ninth- to eleventh-century cemeteries (Richards 2002; Redmond 2007). Moreover, their study is beset by problems of interpretation, as archaeologists struggle to define what, if anything, can be considered 'diagnostically Scandinavian' in terms of burial rite, settlement layout, and building type (Richards 2001; 2002; Halsall 2000). Monumental stone sculptures found in northern England and the north-east Midlands offer more potential, both for elucidating the Scandinavian funerary record and for revealing regional identities among elite groups (Sidebottom 2000; Stocker 2000). However, the restricted geographical and social context in which stone sculpture was produced constrains its overall value as an archaeological source.

Over the last twenty-five years this picture has changed dramatically as new archaeological evidence has come to light. Since the onset of metal-detecting activity in the 1970s and 1980s, there has been nothing short of an explosion of new finds of Late Anglo-Saxon and Viking-Age metalwork found in areas of historically documented Scandinavian settlement. Among the recent discoveries are a range of items displaying Scandinavian influence, including objects which may have functioned as amulets, such as Thor's hammers and Valkyrie pendants, silver bullion and coins minted by Viking kings, and male dress items, equestrian fittings, and weapons decorated in Scandinavian art styles. As recent works have demonstrated, these offer enormous potential for exploring the religious, political, and cultural affiliations of the Scandinavian settlers and their rulers (for instance, Williams 2007; Blackburn 2001, 137–8).

Particularly prominent among the new material is female jewellery—brooches as well as pendants—in Scandinavian and Anglo-Scandinavian forms and styles. These finds add an entirely new dimension to the limited existing archaeological evidence for Scandinavian activity in England. They make possible a substantial reassessment of the nature, scale, and location of the Scandinavian settlement and reveal, for the first time, the female contribution to Viking society in the Danelaw.

The aim of the book is to harness this new material to cast fresh light on Scandinavian settlement and cultural identity in England. Assimilating data from antiquarian sources, archaeological excavation and, in particular, recent metal-detecting, the book discusses a corpus of just over five hundred brooches and pendants, dated from the late ninth to eleventh centuries. It considers the likely origins of Scandinavian-style jewellery, its wearers, and the reasons why it is found in relative abundance in some areas of England. In contrast to previous claims of high levels of cultural assimilation between the Anglo-Saxon and Scandinavian populations, the book argues that Scandinavian-looking jewellery was worn by substantial numbers of women to articulate a distinct cultural identity. It suggests, further, that the find-spots of jewellery point towards fairly dense Scandinavian settlement in areas of England not commonly associated with Viking activity.

In considering a group of material which displays clear Scandinavian influence in its form and decoration, including many items likely to have been imported from the Scandinavian homelands, this study naturally contributes to the long-running and often polarized debate about the scale and impact of the Scandinavian settlement (for a historiography, see Trafford 2000; Hadley 2006, 2–6). Arguably, it provides the clearest archaeological evidence yet for dense Scandinavian settlement across many areas of eastern England, and for the familial nature of much of that settlement. Since recent academic thinking has tended to downplay the potential for archaeology to reveal a tangible Viking presence (Hadley and Richards 2000), this finding may prove controversial. It is hoped it will at least reignite discussion of the character and extent of Scandinavian settlement, recently described by one writer as 'stranded in a state of deadlock' (Trafford 2000, 21). In addition to furthering this well-established debate, the book seeks to engage with recent scholarship on identity formation, cultural exchange, and the use of political power within Scandinavian England (Hadley and Richards 2000; Graham-Campbell et al. 2001; Hadley 2002). Working on the understanding that highly visible personal dress items have much to reveal about an individual's personal identity, as well as their broader affiliations with particular political or ethnic groups, the book uses female dress items to investigate the construction of cultural identities and, in turn, Anglo-Danish relations. It suggests that 'appearing Scandinavian' via the adoption of Scandinavian-style jewellery was in some way desirable, perhaps even politically or socially advantageous, in the territories of independent Danish rule in the late ninth and tenth centuries.

Scope and structure

The jewellery discussed in this book mainly dates to the later part of what is commonly described as the First Viking Age in England, *c.* 865–954, with a small number of items dating to the later tenth and eleventh century and thus coinciding with the Second Viking Age, *c.* 980–1066. The geographical scope of the study is England; objects found elsewhere in the British Isles and Ireland are discussed only briefly in cases where they may shed light on English discoveries. Although the study surveyed material on a national scale, the majority of items come from the area of northern and eastern England once known as the Danelaw. The term *Dena lagu*, 'the law of the Danes' or Danelaw is, strictly speaking, a historical legal definition of a region governed by Danish, rather than West Saxon or Mercian, law. However, it is also used by historians to describe the area of Scandinavian conquest and settlement as defined in the Treaty of Wedmore between King Alfred and Guthrum, conventionally dated to 886–90 but possibly concluded earlier (for a discussion, see Abrams 2001; Dumville 1992, 19–20). Here, the Danelaw is a geographical term, which embraces the modern-day counties of Yorkshire, Nottinghamshire, Derbyshire,

Leicestershire, Lincolnshire, Northamptonshire, Cambridgeshire, Bedford-shire, Norfolk, Suffolk, Essex, Hertfordshire, and Buckinghamshire (see Map 1.1). It is, however, acknowledged that the geographic limits of the Danelaw are likely to have shifted over time, in the wake of continuing political and military campaigns (Dumville 1992, 19).

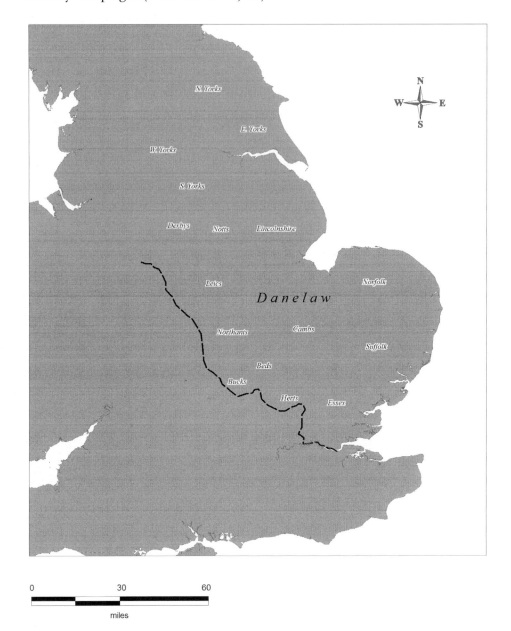

Map 1.1 The location of the Danelaw. The boundary refers to that defined in the treaty between Alfred and Guthrum *c.* 886–90

The terms 'Scandinavian' and 'Anglo-Scandinavian' are used extensively in this study to describe objects found in England, and should be clearly defined from the start. 'Scandinavian' objects are identical in appearance to objects found in the Scandinavian homelands; they carry pure Scandinavian ornament and bear the hallmarks of Scandinavian manufacture. By contrast, 'Anglo-Scandinavian' objects reveal a blend of Scandinavian and Anglo-Saxon forms and styles; they may, for instance, combine an Anglo-Saxon brooch form with a Scandinavian motif. When used to describe brooches and pendants, 'Scandinavian' and 'Anglo-Scandinavian' are employed as cultural, rather than ethnic or geographic, terms. They describe the cultural origin and context of an artefact, rather than the ethnic identity of its wearer or its place of manufacture. Thus, Scandinavian items found in England may have been produced locally by craftsmen working in a Scandinavian tradition, or have been imported, via trade or migration. The term 'Scandinavian-style jewellery' is used throughout, when discussing both groups of jewellery together.

This study is concerned with ornamental female dress items, namely brooches and pendants. For convenience, these artefacts are described as jewellery, although they do not contain jewels or precious stones. The jewellery items discussed are mainly composed of base metals: copper- and lead-alloys, although a small group of items are solid silver. No artefacts are made of gold, although gilding is observed throughout the corpus. It is important to note that, in addition to performing the function of jewellery in the strict sense of adornment, these dress items often had a practical function, securing shoulder straps, for instance, or holding together two layers of clothing. Since this study is concerned with ornamental dress fittings, it excludes items with potentially amuletic significance, such as Thor's hammers and Valkyrie pendants (the corpus of which is also steadily expanding). Due to their Hiberno-Norse cultural origins and use in male dress, large silver penannular brooches of the type found in hoards in northern England have also been excluded.

The brooches and pendants discussed here were found and recorded in England before December 2008. The material collection process took over a year and was designed to be as wide-ranging and thorough as possible. It began with a survey of published literature, through which artefacts recorded in excavation reports, museum catalogues, and archaeological journals were identified. Comprehensive searches were then carried out to identify relevant metal items recorded on the online Portable Antiquities Scheme (PAS) database (www.finds.org.uk) to which full research access was granted. The results of this preliminary data collection directed the focus of fieldwork, involving the identification and collation of unpublished artefact records from three main sources: regional and national museums, county archaeological units and, most significantly, county Historic Environment Records (HERs), previously called Sites and Monuments Records (SMRs). The survey did not take account of publicized finds on other hobby websites (such as the UK detector finds website) or

of items for sale in the antiquities market, unless the item had also been recorded by the PAS or relevant HER.

This volume is organized as follows: Chapters 1 to 3 examine the material evidence at the heart of this study. Chapter 1 starts with a consideration of the history and archaeological sources of Scandinavian-style jewellery in England. Chapter 2 presents a methodology for the identification of Scandinavian-style jewellery, before the jewellery itself is presented and discussed in relation to its Scandinavian background in Chapter 3. Given the substantial size of the current corpus, this, largely technical, chapter is considerably longer than others. Following on, Chapters 4 to 7 examine the significance of Scandinavian-style dress items. Chapter 4 considers the date range of the jewellery, and the length of time for which it remained in use; it also reviews the evidence for its manufacture in England. Chapter 5 investigates the gender and likely ethnicity of brooch wearers through an examination of brooch style, shape, and pin-fittings. Important and unexpected trends in the distribution of the jewellery are discussed in Chapter 6, which aims to provide a fresh perspective on the geography of Scandinavian settlement in England. The final chapter (Chapter 7) generates an overarching synthesis of jewellery use in England aimed at revealing how brooches were harnessed to negotiate cultural identity and difference in the late ninth and tenth centuries. Through an evaluation of changing brooch styles, it proposes answers to the questions: who wore Scandinavian jewellery, and why?

Before such questions can be approached, it is necessary to establish a framework for assessing the contribution of Scandinavian jewellery to the archaeological record. With this in mind, this chapter now turns to explore briefly the research agendas within which studies of Scandinavian-style jewellery have been conducted in the past. It then moves on to consider the theoretical approaches underpinning the interpretations made in later chapters. The remainder of the chapter reviews the archaeological sources of Scandinavian-style jewellery, providing a critical assessment of the benefits and pitfalls of studying material largely derived from metal-detecting.

Past approaches to Scandinavian jewellery

To date, over five hundred items of Scandinavian-style jewellery are known to have been found in England. This represents a remarkable twenty-five-fold increase in the number of items recorded a generation ago from antiquarian (pre-1900) sources and archaeological excavation (Roesdahl et al. 1981). Indeed, such was the paucity of Scandinavian-style metalwork that one scholar, writing in 1990, claimed: 'Nor are there any other signs of a Danish culture in the rural Danelaw; stray finds of metalwork are infrequent and as likely to be found in English as in Danelaw England' (Hinton 1990, 71). Perhaps because of this, the recent and rapid growth in finds of such metalwork has yet to

attract the academic attention it deserves. While some integrated and theoretically-informed approaches to Scandinavian metalwork are beginning to emerge (Thomas 2000b; Paterson 2002), academic treatment of Scandinavian and Anglo-Scandinavian brooches remains limited in scope, with many relevant, recent finds remaining unpublished and largely inaccessible to researchers.

The earliest record of Scandinavian-style jewellery from England dates to 1705 when a disc brooch with Ringerike-style elements from the Isle of Ely, Cambridgeshire, was first published (the Scandinavian art styles of Borre, Jellinge, Mammen, Ringerike, and Urnes are discussed in Chapter 2) (Hickes 1705; Backhouse et al. 1984, no. 105). A small number of antiquarian discoveries of Scandinavian dress items have been published, mainly as short notes devoted to stylistic descriptions of the relevant pieces. Examples include a Borre-style trefoil brooch found near Pickering in North Yorkshire and several pairs of oval brooches retrieved from burials excavated in the nineteenth century, for instance, from Santon Downham, Norfolk, and Claughton Hall, Lancashire (Fairholt 1847; Longstaff 1848; Greenwell 1870; Smith 1906; Kirk 1927). Despite their early date, these accounts established parallels between finds from England and material in the Scandinavian homelands, providing an accurate date and cultural attribution for most items (for instance, Kirk 1927, 528).

A catalogue of Viking-Age artefacts from England, based on data collected in 1925, collated the small number of stray and burial jewellery items known at the time, providing a useful snapshot of contemporary knowledge (Bjørn and Shetelig 1940). Only with the onset of urban excavations in the 1970s and 1980s, in locations such as Lincoln, York, Beverley, and Norwich, were further brooches unearthed. Notwithstanding important, independent, dating evidence for select items retrieved from datable contexts (for instance, at York: Mainman and Rogers 2000, 2571–2), these excavations largely failed to assess the significance of the new jewellery finds. For the most part, subsequent archaeological reports provided only brief physical descriptions of each item and its context, and did not consider its wider implications (examples being: Adams 1980, 6, fig. 9; Armstrong et al. 1991, 155, fig. 117, 707; Margeson and Williams 1985, 29, nos. 1–2).

Despite early interest in the cultural origins of a distinct group of Borre-style disc brooches, first recognized in the 1950s (Evison 1957; Wilson 1956; 1964, 48–9), a broader research agenda for Scandinavian and Anglo-Scandinavian metalwork only began to emerge in the late 1970s. In several short studies, scholars such as Sue Margeson and James Graham-Campbell commented on the character and insular distribution of identifiable brooch series (Graham-Campbell 1976; 1983; Margeson 1982). These works placed the jewellery in its proper Scandinavian or Anglo-Scandinavian context, drawing attention to known Scandinavian parallels and highlighting the range of Scandinavian brooch forms and styles current in England. The correct identification of the cultural background of

Scandinavian and Anglo-Scandinavian finds remains a priority in current academia, as demonstrated by the continuing debate over the origins of the Borre-derived disc brooches mentioned above (Wilson 1976, 504–6; Jansson 1984b, 63–4; Richardson 1993, 28–34; Leahy and Paterson 2001, 197).

Academic interest in Scandinavian and Anglo-Scandinavian brooches and pendants was further bolstered in the 1970s and 1980s by the inclusion of select items in reviews of Viking-Age art. In this context they were used to illustrate the development of individual art styles, particularly in relation to distinct, Anglicized versions of Scandinavian motifs (Wilson and Klindt-Jensen 1966; Wilson 1976; 1984; Fuglesang 1980; Graham-Campbell 1987b). For instance, the disc brooch from the Isle of Ely, Cambridgeshire, notable for combining Scandinavian Ringerike and Anglo-Saxon Winchester-style ornament, appeared in Signe Horn Fuglesang's review of the Ringerike style, forming a small part of her comprehensive evaluation of the style as it appeared on metalwork from England (1980, 47–51, cat. no. 50). There remains considerable art-historical interest in Scandinavian and Anglo-Scandinavian metalwork, as illustrated by the incorporation of two brooches in a recent review of the so-called 'English Urnes' style (Owen 2001).

Taking advantage of a much expanded insular corpus of Borre-style items, including both excavated and metal-detector material, Caroline Richardson (now Paterson) provided an overview of the appearance of the Borre style in the British Isles in an important, though currently unpublished, Master's thesis (1993). Her work drew attention to Scandinavian parallels for several brooch series found in the Danelaw and highlighted the explicitly Scandinavian nature of many English-provenanced items. In addition, Richardson established criteria against which artefacts could be assessed for their cultural origins, drawing attention to differences in Anglo-Saxon and Scandinavian brooch morphology and pin-attachment styles. Although couched in an art-historical framework and limited to a review of artefacts in just one Scandinavian style, Richardson's approaches and findings provided a hugely valuable resource for the present study.

Since the 1990s, the number of Scandinavian and Anglo-Scandinavian metal dress fittings has increased further still. A number of scholars have addressed the quantity, character, and distribution of the expanding corpus, including brooches and pendants, as a means of exploring Scandinavian activity in England (Margeson 1996; 1997; Leahy and Paterson 2001). Of prime importance in this context is the work of the late Sue Margeson, former Keeper of Archaeology at Norwich Castle Museum, who was first to draw attention to the Scandinavian character of metal-detector finds from Norfolk (Margeson 1982). On the basis of the close affinity of significant quantities of local metalwork with Scandinavian brooch and pendant types, as well as its low quality and widespread, rural distribution, Margeson argued for a substantial, peasant Scandinavian settlement in the county (Margeson 1996, 55; 1997). Similar approaches to the study of Scandinavian metalwork were adopted in a review

of Scandinavian metalwork from Lincolnshire (Leahy and Paterson 2001). While this work confirmed many of the findings reached by Margeson, the authors noted an altogether different distribution pattern, raising the possibility that Scandinavian and Anglo-Scandinavian metalwork was used differently in different areas of the Danelaw (Leahy and Paterson 2001, 189).

These articles illustrated the potential for exploiting Scandinavian and Anglo-Scandinavian jewellery for information about the nature and scale of Scandinavian activity in England. However, most archaeologists would now be reluctant to equate Scandinavian metalwork with an ethnic Scandinavian presence. Indeed, stimulated by anthropological studies of material culture, more recent studies of Scandinavian dress items have moved away from such themes. They focus instead on ways in which metalwork forms and styles may be studied to elucidate processes of cultural assimilation in Anglo-Scandinavian communities (Thomas 2000b; Paterson 2002; Hadley 2002, 66; 2006, 120–7). These have, for instance, drawn attention to the selective use of Scandinavian brooch types in Late Anglo-Saxon England, suggesting that object forms which were not easily assimilated with native female dress, such as oval brooches, were abandoned by Scandinavian settlers in an attempt to integrate with the existing, Anglo-Saxon fashions (Thomas 2000b, 252; Paterson 2002).

In integrating Scandinavian metalwork into theoretically informed studies of material culture, these recent studies are of great interest to the current work. But they are limited in scope, drawing mainly on readily available, published material, in Early Viking-Age styles only (Thomas 2000b, 239). Given the low publication rate of new finds of metalwork—just a scattering of finds are published in annual finds reports in the journal *Medieval Archaeology*—this is a limiting factor on any research into this topic. In discussing a more comprehensive and up-to-date body of data, incorporating hundreds of unpublished finds, this book aims to provide fresh insights into the significance of Scandinavian metalwork in England. Consequently, some of its findings cast doubt on the conclusions of these most recent works.

Interpreting ornamental metalwork

In order to unlock meaning in ornamental metalwork, it is vital to understand how artefact style and form can be used to elucidate aspects of cultural and social identity. Accordingly, this study adopts recent theoretical approaches to material culture, which emphasize the active role of artefacts in both embodying and shaping the identities of their users and wearers (Chilton 1999, 1; Shanks and Tilley 1992, 149). Originating largely in the fields of ethnography and visual anthropology, this approach sees material culture as not simply reflecting human behaviour, or the presence of distinct, ethnic groups, but constituting an active means through which people negotiate social identities and

relationships (Gell 1998, 6). Crucially, the form, decoration, and distribution of artefacts can be studied to reveal social and cultural values. Through their diverse styles and appearances, artefacts act as a non-verbal means of communication and serve to reflect certain affiliations, such as age, culture, gender, and ethnic, social, and political allegiances (Wobst 1977). In this sense, artefact style may be analogous with language, and may be 'read', as text. As the archaeologist Tania Dickinson has written:

material culture (broadly artefacts) has meaning because it is part of human thinking about the world; such thinking depends on categorisation, and artefacts, like language, are a means of categorisation, incorporating rules (grammar) and context (vocabulary). (1991, 39–40)

This understanding is especially pertinent for a consideration of Scandinavian-style jewellery, which exhibits a broad repertoire of art styles. However, it is important to note that style does not simply refer to the decorative motifs applied to an artefact, but may encompass the shape of an item, its material composition, method of manufacture, and use (Hodder 1982, 56; Wobst 1999, 122–6). The selective use of a certain type of brooch and the way in which it was worn may, therefore, be just as relevant in signalling a message as its shape and decorative content. Moreover, style may be actively manipulated to achieve certain ends; it can encourage change or conserve the status quo (Hodder 1982, 56, 161; Wobst 1999, 120). Changes in style over time, which may result in the evolution of object forms and motifs as well as the creation of new types of artefact, are, then, socially meaningful and may reflect and reinforce shifting social relationships and values. This understanding is highly significant for our understanding of Scandinavian-style jewellery, select examples of which can be demonstrated to have evolved from their original Scandinavian forms under Anglo-Saxon influence.

Recently it has been doubted whether small, portable, and personal items such as brooches could have been actively employed by contemporaries to assert aspects of personal and group identity (Hadley 2006, 121). I would argue to the contrary that dress and dress items, along with other forms of bodily adornment, represent widely used mediums for conveying social information. Indeed, as highly visible and decoratively diverse objects selected by individuals and worn in everyday dress, brooches and pendants are likely to have been popular mediums for the expression of social and cultural identity. Consequently, they have much to reveal about gendered and cultural identities in late ninth- and tenth-century England.

Sources and archaeological approaches

Establishing the identity and motivations of the wearers of Scandinavian-style jewellery is not straightforward. Since only a very few items have been recovered from burials using modern archaeological methods, opportunities to

expose the gender, social status, and cultural or ethnic background of jewellery wearers are extremely limited. One, rare glimpse of an individual behind the jewellery is provided by the recent discovery of a probable female burial at Adwick-le-Street, South Yorkshire (see Colour Plate 2). Here, excavation revealed the presence of a woman whose dress incorporated Scandinavian oval brooches, in addition to an iron knife, a key or latch-lifter, and a decorated bronze bowl (Speed and Walton Rogers 2004). Notably, isotope analysis of two teeth from the skeleton indicated that the deceased woman had grown up either in north-east Scotland or, more likely, Norway, providing a neat example of a likely ethnically Scandinavian woman preserving her distinct Scandinavian dress and appearance in England (Speed and Walton Rogers 2004, 61–3).

Such burials, with accompanying isotopic evidence, are unfortunately rare, however. The vast majority of the Scandinavian-style jewellery recovered in England—450 items, around 89 per cent of the total corpus—represent single finds, discovered via metal detecting. Far fewer items are known from antiquarian sources (chance finds or finds made during excavation prior to 1900) and modern archaeological excavation, which might reveal furnished burials: twenty (around 4 per cent) and fourteen (just under 3 per cent) respectively. Only eight objects belong to a fourth, minor category: chance finds spotted during gardening, building, or agricultural work. The find contexts of a few remaining items are unknown (see Figure 1.1). It is clear, then, that metal

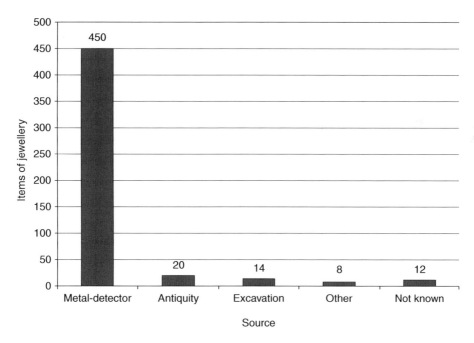

Fig. 1.1 Sources of Scandinavian-style jewellery in England.

detecting is by far the most prominent source of Scandinavian-style jewellery from England. Indeed, this study would not be possible without the contribution of detector material.

As metal detecting as well as archaeological investigation continues, the corpus of Scandinavian-style jewellery from England will undoubtedly increase. How confident can we be that the current dataset is representative of the Scandinavian-style jewellery originally in circulation? Put another way, are future discoveries likely to substantially alter the main trends and distributions presented here? Artefacts discovered since the end of 2008, when this study stopped recording relevant material, will of course expand the dataset, introduce new object categories, and further populate the distribution map. As with all modern, metal-detector-based databases the aim is not to generate a complete corpus, but a representative one. In one or two cases, it is indeed anticipated that, due to local difficulties in gaining access to metal-detector finds, future discoveries will fill in currently blank areas. These anticipated additions are considered in Chapter 6. Overall, however, I believe that the current corpus of artefacts can be judged to be a representative sample of the items originally in circulation. By the end of 2008, the total number of recorded brooches and pendants from England was just over five hundred, making it possible to document all items found nationally before that date. Seven core categories of jewellery and over forty subcategories were recorded; these encompass all the main Viking-Age brooch types documented within Scandinavia and even include several 'new' and rare artefact types which occur in single instances. This is, in sum, a substantial, heterogeneous and, as we shall see, a geographically widespread corpus, with scope for assimilating future discoveries.

More broadly, the reliance of the current corpus of Scandinavian-style jewellery on metal detecting brings both benefits and pitfalls. Since amateur metal detecting typically takes place in isolation, without controlled excavation, most metal finds lack archaeological contexts, making it difficult to say anything meaningful about the type of sites from which they derive (but see Chapter 6) (Pestell and Ulmschneider 2003, 3). Moreover, most metal-detector items are taken from the ploughsoil and are therefore unstratified. Consequently, dating artefacts on anything other than stylistic grounds is problematic. However, metal-detector finds also benefit the archaeological record, ensuring the survival of artefacts which, in heavily cultivated areas such as East Anglia and Lincolnshire, would otherwise be destroyed by modern agricultural processes (Leahy 2003a, 138). As chance finds, they also help to balance out bias towards traditional areas of archaeological focus, such as burials, settlements, and hoards (Thomas 2000b, 238). The prominence of metal detecting as a source of Scandinavian-style jewellery nonetheless requires careful critique of the factors involved in the survival, recovery, and recording of metal-detector material, all of which have the potential to impact on the findings of this study. This follows below, while a more detailed consideration of the factors

influencing the recovery of detector finds within specific regions can be found in Chapter 6.

Metal-detecting activity and recovery

Before considering the specific biases on archaeological data introduced by metal-detector material, it is worth noting that the survival of Viking-Age metalwork down to the present day will be influenced by a range of archaeological and environmental factors, regardless of the method of recovery. Such factors include the extent of modern cultivation and soil erosion, in addition to the size, shape, and material composition of the item; all factors which can make some types of object more prone to loss, as well as survival in the topsoil, than others. The mechanics of loss and deposition may also affect the numbers and types of objects that survive. We would, for instance, expect a bias towards lower-quality items in a sample of artefacts which, as largely single finds, have been casually lost or discarded. This is particularly pertinent for rural locales, where, due to terrain and long distances covered on foot, artefacts may have been more difficult to retrieve than in towns. In areas of concentrated populations, such as towns and nucleated settlements, lost metalwork is also more likely to have been seen and recovered by local inhabitants than in areas of dispersed, rural settlement. Prevailing settlement models will, then, influence the permanent loss rate of small items of metalwork such as jewellery.

The pre-eminence of metal detecting as a source of Scandinavian-style jewellery introduces a number of specific constraints on the distribution and character of the jewellery corpus. Perhaps most obviously, the geographical distribution of finds will be profoundly affected by locations of metal-detecting activity. Whilst detecting predominantly takes place on flat, low-lying agricultural land, within the limits of the plough zone, there are many factors that may influence the location of detecting within this zone (Naylor and Richards 2005). Detecting is naturally constrained by modern and topographical features, including built-up urban environments, 'danger zones' such as military practice areas, lakes, forests, and coastlines. In a recent survey of nationwide patterns of metal detecting, metal-detector finds reported to the PAS were plotted against 'perceived constraints on data recovery'. The survey revealed that finds from urban areas accounted for less than 5 per cent of all PAS records, while those from lakes, forests, and 'danger zones' collectively contributed just over 1 per cent (Richards et al. 2009, 2.4.1, fig. 9). Since detectorists may only detect on land with permission from the landowner, access to searchable land may be restricted where such permission may be difficult to obtain, for instance, where landownership is fragmented with multiple owners or tenant farmers (Chester-Kadwell 2009, 85).

Conversely, ease of access to agricultural lands encourages activity, with detectorists choosing to detect on local low-lying agricultural land adjacent to

main roads or immediately outside town centres. Indeed, in some areas of England, the distribution of detector finds is neatly correlated with that of modern A-roads (Richards et al. 2009, 2.4.2.1). Detectorists are often attracted to 'productive sites', as well as particular landscape features which yield a high volume of material, such as Roman roads and prehistoric trackways. The western Yorkshire Wolds, with a substantial number of deserted medieval villages, act as a magnet for detectorists, who travel from outside the region to detect there (Richards et al. 2009, 2.4.2.1). While some 'productive' areas are likely to have been foci for contemporary settlement and activity, concentrations of detecting on such sites may inflate their apparent richness. That such sites may be revisited on multiple occasions, while other, less productive sites, are not further searched after initial survey, may further skew artefact distribution patterns.

The personal interests and agendas of detectorists may also impact on the material they choose to locate and recover (Chester-Kadwell 2009, 67). Arguably, detectorists are more likely to recognize, and therefore retain, well-preserved objects with distinctive shapes and recognizable decorative features than heavily worn or corroded items without discernible surface decoration, a practice which is, however, likely to benefit the recovery of Scandinavian brooches with their distinctive trefoil, equal-armed, lozenge, and domed disc shapes. The model of metal detector used and the skill of the detectorist may also shape the success of a detecting session (Gregory and Rogerson 1984, 180). In particular, the depth to which a machine is able to pick up signals from metal objects will affect the extent of ploughzone surveyed (Pestell 2005, 171 note 22). Environmental variables, such as fluctuating weather, soil, crop, and tillage conditions, also have the potential to affect the ability of the detector to recover metal from the ploughsoil. The presence of crop stubble in a field may, for instance, prevent the detector from achieving suitable height from which to receive accurate signals (Gregory and Rogerson 1984, 181–2). To balance out these inconsistencies, detectorists may return to the same site over the course of several years (Chester-Kadwell 2005, 75–6).

The reporting of metal-detector finds

One question at the heart of this study is: what percentage of the overall number of jewellery items recovered by metal-detecting is represented by reported finds? The answer depends on levels of finds reporting, which are notoriously difficult to quantify. While metal-detecting organizations and advisory bodies encourage detectorists to report their finds, there is no legal requirement to do so, unless the discovered artefact is classified as Treasure according to the 1996 Treasure Act.[1]

[1] An object may be classed as Treasure if it contains more than 10 per cent precious metal, that is, gold or silver, and if it is at least 300 years old when found. Items found together with items of Treasure are also classified as such. *Treasure Act 1996.*

Until recently, there was no consistent framework for finds recording. While finders could offer their discoveries for reporting to local museums, a survey carried out in 1995 to assess the contribution of metal detecting to the archaeological record concluded that reporting levels directly reflected the level of local 'goodwill' that existed between archaeologists and the detecting community (Dobinson and Denison 1995, 8–9, 11). Levels of finds reporting were skewed in favour of areas with a long history of successful liaison with detectorists, namely Norfolk, Suffolk, and Lincolnshire. Levels could, however, be negligible in regions without a tradition of finds recording, such as Cambridgeshire and Essex (Dobinson and Denison 1995, 19–21, table 10). This was reflected not only in the huge variation in the numbers of items handled annually by regional museums, but also in the differing levels of data recorded by county Sites and Monuments Records (SMRs), now called Historic Environment Records (HERs) (Dobinson and Denison 1995, 21–2, 25, table 12).

Since 2003, the activities of the nation-wide PAS have, however, lessened regional biases in finds recording (for a history and description of the activities of the PAS, see Richards and Naylor 2010). To the extent to which the Scheme works to improve national levels of finds recording through effective liaison and brings into the public domain archaeological material which would otherwise be inaccessible to researchers, it has clearly been of tremendous benefit to this survey. The PAS has undoubtedly helped to introduce finds recording in areas without pre-existing systems in place, in regions such as North Yorkshire. Here, just three items of Scandinavian jewellery were recorded prior to the Scheme's establishment; as of December 2008, the Scheme's website recorded 14 objects. However, there remains a significant disparity between the current estimate of the number of metal detectorists regularly operating in England and Wales, 13,000–30,000, and the number of detectorists who report their finds to the PAS (Trevor Austin, National Council for Metal Detecting, pers. comm.). Between 2003 and 2009, the average number of finders (metal detectorists and others) offering their discoveries for recording each year was just 3,631.

While not all detectorists will find archaeological objects relevant to the PAS, estimates of the number of archaeological artefacts recovered each year compared to the number of artefacts reported present a similar picture of substantial and widespread under-reporting. It has been estimated that up to 400,000 finds of pre-1600 date are found *each year* through metal detecting (Dobinson and Denison 1995, 8). However, the PAS recorded its 400,000th find only in August 2009. Nonetheless, the yearly average number of artefacts found during metal-detecting and reported by the PAS has increased steadily from the start of the Scheme (the apparent downturn in the year 2007–8 reflects the fact that, in 2007, Norfolk added over 11,000 older HER records to the PAS, superficially inflating figures for that year) (see Figure 1.2). In 2010, over 77,000 objects were reported as metal-detector finds outside of controlled excavation (*PAS Annual Report* 2009-10, 4).

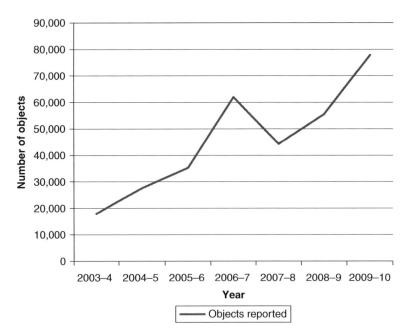

Fig. 1.2 Number of objects found each year via metal detecting and reported to the PAS (Source: Portable Antiquities Scheme).

Despite the establishment of a national scheme for recording archaeological finds made by the public, there remain considerable regional discrepancies in levels of finds reporting; a reflection both of variable PAS success rates across different counties and genuine regional differences in levels of detecting activity. In Norfolk, Suffolk, and Lincolnshire, curators have successfully liaised with detectorists over several decades. Consequently, levels of finds recording to the PAS are among the highest nationally (*PAS Annual Report* 2004–5, table 3a; 2005–6, table 3c; see also Table 6.1). Levels of finds reporting in Norfolk are likely to be even higher than PAS records suggest, since Norfolk primarily records material on the HER, and only secondarily logs finds with the PAS. Perhaps unsurprisingly, these counties have yielded the greatest amount of Scandinavian-style jewellery. In other areas of the country, it has taken longer for the PAS to establish relationships with detectorists. In 2004–5, the PAS in South and West Yorkshire was in regular contact with just half of all local clubs (six of twelve), although this figure improved (to eight of eleven local clubs) the following year (*PAS Annual Report* 2004–5, table 7b; 2005–6, table 7b). In Cambridgeshire in 2005–6, only 42 metal detectorists offered their finds for reporting, compared to 188 and 165 in the adjacent counties of Norfolk and Suffolk (*PAS Annual Report* 2005–6, table 7a). However, this may partly reflect the decision of Cambridgeshire detectorists to detect in Norfolk and Suffolk, where sites are generally more productive.

Even in the counties of Norfolk, Suffolk, and Lincolnshire, levels of finds reporting remain difficult to quantify. Anecdotal evidence suggests that, in

some areas, the figure could be low. In conversation with the author, one Norfolk detectorist, based near Norwich, estimated that just 25 per cent of local detectorists reported their finds to the relevant bodies, a figure which is not, however, accepted by the county archaeologist for Norfolk, Andrew Rogerson (pers. comm.). In Lincolnshire, certain sites, including Riby Cross Roads and Kirmington, are known to have been targeted by metal detectorists not reporting their finds, but county-wide levels of reporting are simply not known (Ulmschneider 2000a, 13).

Geographical biases in levels of metal-detecting activity and reporting will undoubtedly influence the relative regional distributions of Scandinavian-style jewellery, as indeed with other categories of metal-detector finds. But too narrow a focus on levels of finds reporting risks obscuring the broader point that the number of brooches and pendants recovered by detecting can only be the lower limit of the total number of items that could possibly be found, and this lower limit can still be very informative. Under all circumstances, the current corpus of Scandinavian and Anglo-Scandinavian items, while vast, is likely to comprise just a small fraction of the number of objects originally in circulation. Nevertheless, in order to establish meaningful distributions in Scandinavian jewellery it is necessary to place metal-detector finds in context. When analysing the distribution of material in Chapter 6, this book compares the find-spots of Scandinavian finds against known regional constraints on metal-detecting. In addition, reported finds of Scandinavian-style brooches and pendants are compared against those of contemporary Anglo-Saxon artefacts, including metalwork, pottery, and coins, in addition to multi-period finds, to determine whether an 'absence' of Scandinavian metalwork is genuine, or a reflection of broader artefact patterning.

The quality of metal-detector data

One of the main challenges in studying metal-detector finds is the restricted access to items discovered by individuals and held privately. Of just over five hundred items of jewellery, it has only been possible to study sixty-seven (13 per cent) in person, with the remaining objects identified either through images, written descriptions, or a combination of both. The identification and classification of artefacts is therefore heavily reliant on images and written accounts produced by others, which can vary in quality and detail. This has clear implications for the ability of this study to identify and classify relevant artefacts, and to assess more subtle features which may be revealed only through close, first-hand study, such as design irregularities, object wear, and surface treatment. These problems are, however, somewhat mitigated by the high degree of standardization in style and form exhibited by most pieces of jewellery, with many items belonging to, or imitating, mass-produced brooch or pendant series.

Information regarding Scandinavian-style jewellery, as with metal-detector finds more generally, derives from three main sources: the PAS, museum

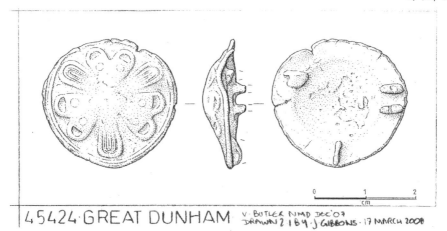

45424

45424·GREAT DUNHAM V. BUTLER NMD DEC'07
DRAWN 2 I B 4 · J GIBBONS · 17 MARCH 2008

MS/LS cast copper alloy convex disc brooch. Quite worn, although some traces of gilding are still visible. Borre-style decoration comprises three cat-like animal heads facing into the centre of the brooch separated by the lobes of a trefoil. On the reverse are the remains of a pin-lug and catch-plate set at right-angles to the outside edge of the brooch, and the remains of a loop for a pendant. All fastenings on the reverse are damaged. The presence of a third fastening on the reverse of the brooch was believed by Sue Margeson (*The Vikings in Norfolk*, 1997, p. 21) to be "a sure sign of Scandinavian origin", and other similar examples are known from the county (e.g. Heckingham 22663). No trace of a pin remains.

These brooches are relatively common in East Anglia, with over 20 known from Norfolk alone. Brooches of this type are also widespread in Scandinavia, with a particular concentration at Birka (near Stockholm, Sweden).

Maximum diameter: 28mm.
Weight: 7.31g.

DIGIT
DRAW

Fig. 1.3 Recent Norfolk HER entry for a Borre-style brooch. Brooch drawn by Jason Gibbons © Norfolk County Council.

archives, and county HERs. The practice of recording metal-detector finds varies considerably from county to county, a factor which introduces regional inconsistencies in recording conventions. In Norfolk, for instance, single finds have been recorded on the county HER since the 1970s, resulting in a particularly rich dataset of Scandinavian-style jewellery. However, the quality of data available between and within each source can vary significantly, depending on the date of the object record, local recording conventions as well as the knowledge, time, and resources of the find recorder. Thus, whereas early HER data, from the 1970s or early 1980s, usually contains only a cursory object description, such as '9th century bronze trefoil brooch' (Norfolk HER 16959), more recent HER descriptions are much more detailed, typically comprising fifty to one hundred and fifty words and containing Polaroid or digital images occasionally in addition to professional finds drawings (see Fig. 1.3).

The precision with which a find-spot is recorded varies considerably across sources. HER and PAS data typically include high-resolution find-spot locations, most often to an eight-figure grid reference, enabling artefacts to be recorded within a 10-metre square. The same precision does not apply to museum records, however. In order to encourage detectorists to report material, museums have, in the past, made low demands on detectorists for this data (Dobinson and Denison 1995, 27–8). This is reflected in the data for Scandinavian and Anglo-Scandinavian brooches and pendants: of fifty-three metal-detector objects recorded in the first instance by a museum, just 18 per cent were assigned a grid reference, of which only 8.7 per cent possessed an eight-figure grid reference.[2] Both the source of Scandinavian-style jewellery and its subsequent method of recording play a role in determining the kind of data available for Viking-Age brooches and pendants in England.

Conclusions

Twenty-five years ago, just a handful of Scandinavian-style jewellery items had been found in England. Today, the corpus of jewellery is vast, and continues to expand on a monthly basis. As I hope to have demonstrated in this chapter, the recent and rapid surge in Viking-Age jewellery finds provides a unique opportunity to examine the personal and group identities and cultural allegiances of the inhabitants of the ninth- and tenth-century Danelaw. In certain cases, jewellery may also tell us about the nature, impact, and location of the Viking settlement. The following chapters are devoted to an exploration of this new material—its appearance, cultural background, role in costume, and distribution within England. They aim to bring this currently elusive material fully into the public domain, starting, in the following chapter, with a guide to the identification of Scandinavian-style jewellery.

[2] Since this information is potentially sensitive, only four-figure grid references have been provided in the online catalogue.

2

Identifying Scandinavian and Anglo-Scandinavian jewellery

Introduction

Scandinavian-style jewellery is not the only category of metalwork to have increased in quantity in recent years. The surge in metal detecting has also brought to light fresh evidence for contemporary metalwork in Anglo-Saxon, Irish, and Continental styles. The first step in any study of Scandinavian-style jewellery is, then, to identify it amid the vast amount of metal-detector material now dated to the Late Anglo-Saxon or Viking-Age period. Accordingly, the aim of this chapter is to answer the question: how can we distinguish Scandinavian and Anglo-Scandinavian styles of jewellery, both from indigenous Anglo-Saxon accessories, and from each other?

Separating Scandinavian-style jewellery from other styles of contemporary metalwork is not straightforward. Trends in Scandinavian and Western European (including Anglo-Saxon) jewellery could overlap considerably, with particular fashions in brooch shape and motif, for instance, being adopted in both regions. Small disc brooches were worn by women in both England and Scandinavia, while designs incorporating backwards-looking animals, isolated animal masks, and plant motifs were produced by craftsmen on both sides of the North Sea. Distinguishing Scandinavian jewellery (identical to jewellery from Scandinavia) from Anglo-Scandinavian jewellery (with a mix of cultural forms and styles) presents an additional challenge, yet is essential for measuring the influence of Scandinavian dress styles on female fashion in England. Which features of Anglo-Saxon jewellery were adopted by Anglo-Scandinavian jewellery, and which were not? To what extent were Anglo-Scandinavian brooches English and to what extent Scandinavian?

Despite the many shared features of Anglo-Saxon and Scandinavian jewellery, Scandinavian and Western European metalworking traditions remained distinct, with craftsmen producing ornamental dress fittings in different shapes and sizes, employing different forms of attachment mechanism, creating distinctive decorative content, and even using different metal alloys for some object types. Together, these variables provide criteria against which brooches

Table 2.1 Features distinguishing Scandinavian from Anglo-Saxon jewellery

Features	Scandinavian Brooches	Anglo-Saxon Brooches
Brooch type	Oval, equal-armed, trefoil, lozenge and convex-disc brooches and pendants	Flat disc brooches
Pin fittings	Double, H-shaped pin lug and hooked catchplate at right angle to brooch rim	Single, transverse pin-lug and C-shaped catchplate, aligned with the brooch rim
Attachment loop	Often present, positioned at a right angle to the pin-lug and catchplate	Never present
Artistic content	Borre (including Terslev), Jellinge, Ringerike, and Urnes styles, and plant ornament	Trewhiddle and Winchester styles; other geometric and animal motifs
Metal composition	Frequent use of brass	Brass not typically used
Embellishment	Tinning on brooch reverse	No tinning on reverse

and pendants may be assessed for their Scandinavian or Anglo-Scandinavian traits independently of their provenance. This chapter discusses each of these features in turn, with the aim of presenting a comprehensive classification scheme for Scandinavian and Anglo-Scandinavian jewellery. The scheme set out below, and summarized in Table 2.1, is based on the author's own analysis of material held in museums in Sweden, Denmark, Germany, and England, as well as information contained in published artefact typologies and other studies (Jansson 1984a; 1984b; Callmer 1989; Maixner 2005; Richardson 1993). It is hoped that it will provide a practical resource for curators and finds professionals, and will facilitate the correct identification of future discoveries of metalwork.

Brooch size and shape

One of the most visually recognizable features which distinguished Scandinavian from Anglo-Saxon jewellery in the ninth and tenth centuries is brooch shape and size. Scandinavian brooches of Viking-Age date encompass a range of distinct forms, including disc, trefoil, lozenge, equal-armed, and oval shapes. These diverse brooch types served multiple functions in Scandinavian female costume, with oval brooches acting as shoulder clasps for the straps of an apron-type dress, and the remaining brooch types being used to fasten an outer

garment or inner shift (Jansson 1985, 11). In addition to brooches, pendants were popular dress accessories in Norway and Sweden, where they were strung on necklaces or attached to festoons of beads suspended between pairs of oval brooches (Callmer 1989).

This diversity of brooch form is not matched in contemporary Anglo-Saxon England. Here, disc brooches were the norm, with large disc brooches typical of ninth-century dress styles and smaller items becoming popular during the later ninth and tenth centuries (Owen-Crocker 2004, 207–8). Unfinished brooches from the Cheapside hoard, London, deposited around the year AD 1000, provide evidence for a type of lead-alloy disc brooch worn in Late Anglo-Saxon England, examples of which have been recorded in significant quantities in Norfolk, Lincolnshire, and Yorkshire, among other locations (Clark 1989, 22; Wilson 1964, 35–6; Reynolds 1994; Tweedle 2004, 452; for instance, PAS 'Find-ID' NLM 255; NLM 4364; NLM 4905; NLM 436).

Unlike in Scandinavia, pendants were not part of female dress in England, having fallen out of fashion after their floruit in the sixth and seventh centuries (Paterson 2002, 270). The author knows of no Anglo-Saxon pendants of con-temporaneous date. There is indeed very little evidence for the wearing of neck-laces by Late Anglo-Saxon women, whose use of headdresses, often depicted in manuscripts as extending down to the shoulders, is likely to have concealed the neck area (Owen-Crocker 2004, 219–24, with figs.). A sculpture from Sutton upon Derwent, East Yorkshire, depicts the Madonna wearing what has been described as 'a collar or necklace of five pear-shaped elements', and may hint at a fashion for necklaces in northern England in the late tenth or eleventh century (Lang 1991, 220, pl. 868; Owen-Crocker 2004, 229). But it seems likely that such a fashion, if indeed it did exist, was influenced by Scandinavian trends popularized in the northern Danelaw. Where diverse brooch forms and pendants occur in England, it is most likely that they represent a 'foreign' fash-ion element, distinct from the corpus of indigenous Anglo-Saxon jewellery.

The disc brooch is less easy to attribute, since it was common to both Scan-dinavia and England during this period (Jansson 1984a; 1984b; 1984c; Owen-Crocker 2004, 207–8). For this brooch type, we must rely on morphological features, particularly the artefact's profile, to determine its cultural origins. Within Scandinavia, disc brooches are characteristically domed, with a hollow back for the accommodation of the bunched pleated fabric of the inner shift (see Fig. 2.1) (Hägg 1983, 344; Jansson 1984b, 59; Richardson 1993, 20). Brooch convexity could be more or less pronounced; dimensions recorded for small convex disc brooches found at Birka, Sweden, reveal profiles ranging from 3 to 11 mm in height (Jansson 1984b, 59–60). By contrast, late ninth- and tenth-century Anglo-Saxon disc brooches, in common with Western Euro-pean types, are uniformly flat, although raised features such as bosses could be incorporated into the overall design (see Figs. 2.2; 2.13) (Richardson 1993, 20). The flat form of Anglo-Saxon brooches may reflect the unpleated form of

Fig. 2.1 Scandinavian disc brooch: form and fittings
a) Double, H-shaped pin-lug, at a right angle to brooch edge.
b) Hooked catchplate, at a right angle to brooch edge.
c) Attachment loop, at a right angle to pin-lug and catchplate.

Fig. 2.2 Anglo-Saxon disc brooch: form and fittings
a) Single, perforated pin-lug, aligned with brooch edge.
b) C-shaped catchplate, aligned with brooch edge.

native shifts and marks a clear point of difference from Scandinavian disc brooches.

Pin-fittings

One of the most distinctive features of Viking-Age brooches of Scandinavian origin is the form and arrangement of the pin-lug and catchplate on the reverse of the

brooch. Scandinavian oval, equal-armed, lozenge, trefoil, and disc-shaped brooches typically possess a double, H-shaped pin-lug, consisting of two rounded plates, positioned at a right angle to the brooch rim. A transverse bar fixed between the two pin lugs secures the pin and provides its axis (Fig. 2.1a). The fastening mechanism for the pin consists of a simple hooked lobe, also positioned at a right angle to the brooch rim (Fig. 2.1b) (Jansson 1984b, 58; Richardson 1993, 20). Evidence from unfinished brooches, including three joined Borre-style disc brooches from Smiss, Gotland, indicates that catchplates were cast as straight lobes and were bent after casting to achieve their hooked profile (Zachrisson 1962, 213, fig. 9). Pin-fittings on Scandinavian brooches were usually cast integrally with the brooch plate, the cavities for the fittings having been carved into damp clay moulds or created with the help of wax pegs (Brinch Madsen 1984).

By contrast, it appears to have been customary for Anglo-Saxon brooches of the same date to possess a single perforated pin-lug, around which the pin-head was looped. Rather than being positioned at a right angle to the brooch rim, the fitting is aligned with it (see Fig. 2.2a). On Anglo-Saxon brooches, the pin is usually held by a catchplate lobe with a C-shaped profile, also aligned vertically with the brooch edge (see Fig. 2.2b) (Wilson 1964, fig. 22; Jansson 1984b, 58; Richardson 1993, 20; Geake 2004, 244). Anne Pedersen has suggested that the positioning of fittings in line with the brooch rim may have been a space-saving device, well suited to the small disc brooches fashionable in Late Anglo-Saxon England (pers. comm.). The pin-fittings on Anglo-Saxon brooches were cast integrally, the patterns for the features being pressed into the clay mould before each casting (Leahy 2003b, 141).

By the later tenth and eleventh centuries, conventions determining the form of pin-lugs and catchplates appear to have weakened, with the double pin-lug falling out of use in Scandinavia. Eleventh-century Scandinavian brooches, including some bird-shaped brooches, instead adopt a single, perforated pin-lug of the form already well established in Western Europe, an adoption perhaps related to the brooches' smaller size (Bertelsen 1992, 254; Pedersen 2001, 29). By contrast, a number of brooches of tenth- and eleventh-century date produced in England, including enamelled brooches and large lead-alloy disc brooches, use a double H-shaped pin-lug and hooked catchplate (Buckton 1986; 1989). In the case of the enamelled brooches, these are constructed of gilded copper-alloy strips soldered on to the reverse of the brooch, and thus take a very different form to the H-shaped lugs characteristic of earlier Scandinavian brooches (Buckton 1986; 1989). In a reversal of the Scandinavian situation, such a change may have been motivated by the heavier construction or larger size of these later Anglo-Saxon brooches.

One further element which can be used to distinguish Scandinavian from Anglo-Saxon brooches is the presence on most, although not all, Scandinavian brooches of an attachment loop or 'eye', positioned at a right angle to the pin-lug and catchplate (Fig. 2.1c) (Jansson 1984b, 58). Attachment loops usually

constitute cast metal loops, although on some equal-armed and trefoil brooches the feature can be replaced by a simple perforation through the metal surface of the brooch (Aagård 1984, 96; Hårdh 1984, 86). The origin, function, and significance of the loop is discussed fully in Chapter 5. Here, it is important to note that while attachment loops are common on brooches in Scandinavia from the Viking Age onwards, they do not appear on contemporary indigenous brooches from England, or indeed from the Continent. When they are encountered on brooches found in insular settings, 'eyes' therefore represent a distinctly Scandinavian brooch element.

Decorative content

Classifying a piece of jewellery as Scandinavian or Anglo-Saxon on the basis of its stylistic content can be difficult. Several artistic compositions were familiar to both Anglo-Saxon and Scandinavian traditions. Both areas, for instance, possessed a backwards-turned animal motif, interlacing plant ornament, and isolated animal masks—the latter motif comprising a *leitmotif* common to Anglo-Saxon, Scandinavian, and Carolingian art (Richardson 1993, 62). Nevertheless, these shared stylistic components derived from different indigenous traditions and retained distinct characteristics, accentuated by the mass production of motifs on ornamental metalwork. Consequently, Scandinavian styles can be distinguished from contemporary, Anglo-Saxon ornament. The formal design elements of both Anglo-Saxon and Scandinavian art styles have been discussed in detail elsewhere (Wilson and Klindt-Jensen 1966; Wilson 1995; 2008b; Fuglesang 1980; 1981; 1982; Kershaw 2010; 2011). Here, it is useful to review the appearance of the main art styles as they appeared on metal dress-fittings.

Scandinavian Style E and the Oseberg style

Style E is the name given to a group of animal motifs which appear in Scandinavian art from the late eighth to late ninth century (Wilson 2008b, 323). The three main motifs which characterize the style are well represented on a collection of bronze bridle-mounts from Broa, on the Swedish island of Gotland. These include a broken animal, with a swelling, subtriangular body, stylized head and hips, and lappets (pigtail-like extensions) formed of open loops, and a more compact creature, with a long head lappet and a neck and hips which take the form of heart-shaped openings, and interlace with limbs or lappets (see Fig. 2.3 a–b) (Wilson 1995, 38–42, fig. 12–13). It is, however, the Style E gripping-beast which is mainly encountered on the metalwork under discussion here, in particular, on oval brooches. The beast is slim, with a full face, mask-like head and two large body parts connected by a thin line. It lacks symmetry, its four legs extending to grip the frames of the composition, as well as neighbouring creatures, in an almost random manner (Fig. 2.3c) (Wilson 1995, 46–8, fig. 21–2; Fuglesang 1982, 130).

Fig. 2.3 Style E animal motifs as seen on bridle-mounts from Broa, Gotland © Eva Wilson.

Perhaps most famously, Style E creatures appear on carved wooden objects— including on a ship, carriage, sledges and sledge poles, and animal head posts— found in a burial at Oseberg, Norway, in 1904. The distinct appearance of Style E motifs in select Oseberg media has led some scholars to adopt the term 'Ose-berg style' for a chronologically late phase of Style E, characterized by the use of graded relief planes, the equal distribution of evenly-sized creatures, and the suppression of open loops in favour of squat zoomorphic shapes (Fuglesang 1982, 143; Fuglesang and Wilson 2006, 83 note 3, but see Wilson 2001, 140). Although applied principally to the Oseberg woodcarvings, this distinction also seems to characterize the development of animal motifs on oval and equal-armed brooches during the ninth century, and is thus adopted here (Fuglesang 1982, 143–5, figs. 14–15). Within Scandinavia and England, these brooch types feature lively, compact gripping-beasts, divided into compartments by evenly distributed fretwork and executed in three dimensions (Jansson 1985, 229).

The Scandinavian Borre style

The Borre style, named after the ornament decorating a group of belt mounts discovered in a ship burial in Borre, Norway, dominates assemblages of late ninth- and tenth-century metalwork from Scandinavia (Maixner 2004, 88–94). In orna-

mental metalwork it is characterized by two main motifs, the first of which is a symmetrical gripping-beast with a pretzel-shaped body and a mask-like, triangular face (Wilson 1995, 89). The body of the Borre animal is formed of a bowed band passing between two hips, from which legs emerge to grip or interlace with the body or with the frame surrounding the beast, as seen on the openwork pendants from the Vårby hoard, Sweden, and their parallels (see Fig. 2.4; see too front cover). The beast occurs in full on these objects, but isolated elements, including masks or gripping paws, are recurrent motifs on dress items, including brooches and pendants (Wilson 1995, 89–90; Jansson 1984b, fig. 8:2 II A).

Also diagnostic of Borre-style metalwork is a symmetrical ring-chain motif: a double-contoured ribbon plait composed of a chain of interlacing circles overlain by lozenges and separated by transverse bands (see Fig. 2.5) (Wilson 1995, 89). The Scandinavian ring-chain is not to be confused with a related insular version, sometimes called the 'vertebral ring-chain', which appears as a rib of truncated triangles flanked by side loops, for instance, on sculpture from North Yorkshire, Northumbria, the Isle of Man, and Cumbria, including on the Gosforth Cross (Bailey 1980, 54–5, 217–18, figs. 23, 60a, b, e). While commonly encountered on strap-ends and belt mounts, the Scandinavian ring-chain is not usually the main decorative component on female jewellery, except when it forms part of the Terslev repertoire.

Terslev forms a subcategory of the Borre style and takes its name from the ornament which features on brooches from a silver hoard discovered in Terslev,

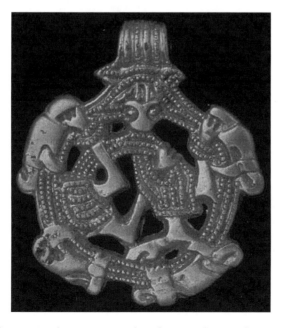

Fig. 2.4 Borre-style gripping-beast on a pendant from Vårby, Sweden © National Historical Museum Stockholm.

Fig. 2.5 Borre-style ring-chain, carried on mounts from Borre, Norway © Eva Wilson.

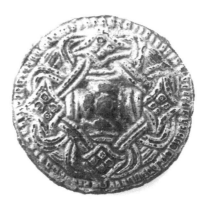

Fig. 2.6 Terslev ornament on a disc brooch from Hedeby, Schleswig-Holstein © author.

Denmark (Skovmand 1942). It comprises three or four symmetrically placed volutes which, when bound by a closed ring, create a ring-knot related to the Borre ring-chain (see Fig. 2.6) (Paterson 2002, 270). The Terslev repertoire encapsulates a diverse range of complex knot ornament based on this basic pattern, recently classified by Sunhild Kleingärtner (Kleingärtner 2004, 273–9; 2007). Within Scandinavia, it occurs principally on brooches and pendants, including both high-quality gold and silver jewellery in filigree and granulation and simpler, cast copper-alloy items (Kleingärtner 2007).

The Scandinavian Jellinge style

The Jellinge style is named after the animal ornament depicted around the side of a silver cup from the North Mound at Jelling, Denmark (see Fig. 2.7)

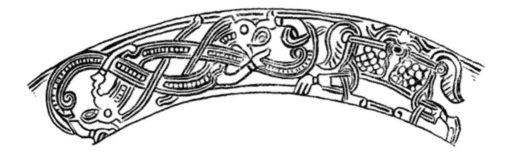

Fig. 2.7 Jellinge-style ornament around the side of the silver cup from Jelling, Denmark © Eva Wilson.

(Wilson 1995, 115). Its characteristic motif is a profiled animal with a double-contoured, S-shaped billeted body, spiral hips, and legs ending in clawed feet. The animal's head usually has an interlacing neck or ear lappet, a lentoid-shaped eye, and an open jaw with a bulbous upper lip. The Jellinge style is not especially common on metalwork in its pure form, and is more often seen in combination with the Borre style, with which it was contemporaneous (Wilson 1995, 117; Wilson and Klindt-Jensen 1966, 97–9). The two styles merge on, among other items, a series of composite openwork disc brooches with a single, profiled Jellinge animal in a layout reminiscent of the Borre-style gripping-beast (Graham-Campbell 1976; Jansson 1984b, fig. 8.2, I A1, I A2). In independent and combined forms the Jellinge style adorns pendants, as well as large disc, oval, and trefoil brooches. In a recurring motif, the Jellinge animal appears in a single backward-looking pose, with an extended tongue passing behind its paw (Callmer 1989, figs. 3.6–8, 3.20–1).

Vegetal styles

Vegetal motifs, adopted in Scandinavia from Western European sources and subsequently modified, also form part of the artistic repertoire of late ninth- and tenth-century metalwork from Scandinavia, albeit on a much smaller scale than contemporary animal art styles. These motifs take one of two forms: vine-scroll ornament, descended from Northumbrian and/or Continental traditions, or, more commonly, naturalistic vegetal motifs descended from Carolingian acanthus (see Figs. 2.8 and 2.9). Both forms of plant ornament appear in original and stylized versions on jewellery within Scandinavia, occurring with particular frequency on trefoil brooches, as well as disc brooches executed in filigree (Maixner 2005, 32–3; Fuglesang 1982, 154). Of particular relevance to the jewellery discussed in this book is the highly schematic, geometric rendering of acanthus patterns on small trefoil brooches, on which the acanthus is reduced to a central stem and transverse branches in what may be described as a fir-tree pattern (Maixner 2005, pl. 7, Group G).

Fig. 2.8 Trefoil brooch with acanthus ornament, Täveslås, Småland, Sweden (after Maixner 2005, pl. 1, P 1.1).

Fig. 2.9 Trefoil brooch with stylized scroll ornament, Norret, Småland, Sweden (after Maixner 2005, pl. 4, P 4.9).

The Scandinavian Mammen style

The Late Viking-Age art styles of Mammen, Ringerike, and Urnes mark the end of the stylized animal motifs characteristic of earlier Scandinavian styles and bring to the fore a suite of semi-naturalistic animal and plant motifs. Within Scandinavia, these styles are most often encountered on a monumental scale: on runic stones, for instance, or in church architecture. They are less commonly encountered in the medium of metal and, with the exception of the Urnes style, are rarely encountered on dress accessories. The Mammen style, characterized by semi-naturalistic lions, birds, and snakes enveloped in loosely

Fig. 2.10 Mammen ornament on a memorial stone from Tullstorp, Skåne (after Moltke 1985, 259, fig. 1).

interlacing tendrils and scroll (see Fig. 2.10) is securely identified on just one cast disc brooch type within Scandinavia (Fuglesang 1991, 85–6, cat. no. 32; 2001, 159–67). This carries an asymmetrical bird with tendril-like wings, an interweaving head lappet and prominent angles in the legs and elbows (Fuglesang 1991, cat. no. 32). Despite Mammen's limited occurrence on metalwork within Scandinavia, it is encountered in a novel form on two Anglo-Scandinavian brooches from England.

The Scandinavian Ringerike style

The Ringerike style, named after a district in Norway with a number of carved stones decorated with tendril and animal motifs, has a rather ragged, if balanced composition. It is composed of three main motifs: a quadruped, descended from the semi-naturalistic Mammen beast; a snake, which often encircles the decorative plane; and long, drawn-out, fleshy tendrils, often with tightly-scrolled ends, which envelop both creatures (Fuglesang 1980). In common with the Mammen style, Ringerike is typically encountered on stone carving and is less frequently a feature of metalwork (see Fig. 2.11). However, it does occur on circular brooches made of sheet metal with engraved or punched decoration (Wilson and Klindt-Jensen 1966, 139–42). A classic Ringerike animal with elongated tendrils is encountered on a round silver brooch from the large Swedish hoard at Äspinge, Skåne (Graham-Campbell 1980, no. 144). A small number of openwork brooches depicting birds with lobed beaks and tail feathers have also been assigned to the Ringerike style, although in their looping interlaced bodies, they also bear Urnes-style traits (Pedersen 2001, 20–2; Wilson and Klindt-Jensen 1966, 140).

Fig. 2.11 Ringerike ornament on a carved stone from St Paul's churchyard, London (after Wilson 1995, pl. 166).

The Scandinavian Urnes style

The Urnes style is identified with the elegant woodcarvings on Urnes stave-church in Sogn, Norway. These feature fluid, biting quadrupeds encased in thin, looping snakes with foliate tails and fuller, biting snake-like creatures with one fore and one back leg. The large quadruped, with its gently swollen body, maintains the spiral hips and lip-lappets of previous animals, but differs from its predecessors in its elongated form, tapering legs and feet, and hooked lower jaw (see Fig. 2.12) (Wilson and Klindt-Jensen 1966, 147). With the exception of the spiral hips, similar features are encountered on the snake-like bipeds. Urnes compositions incorporate wide and thin line-widths to form fluent, balanced looping patterns, often in the form of a figure-of-eight (Fuglesang 2001, 172–3; Wilson 2008b, 334). The unbroken lines characteristic of the style are well served by a plain background, and it is perhaps for this reason that one of the most frequent applications of the style in metalwork is to brooches executed in openwork (Owen 2001, 204). Openwork brooches with

Fig. 2.12 Drawing of the Urnes decoration carved on the gable of Urnes Church, Norway © Eva Wilson.

sinuous animals interlacing with thin snakes and enveloped in diagnostic Urnes-style loops are known in significant quantities from southern Scandinavia, although Urnes elements also occur on some bird-shaped and filigree disc brooches (Bertelsen 1992; Fuglesang 2001, 176; Wilson 1995, 211, fig. 191).

Anglo-Saxon art styles

The styles which adorn indigenous Late Anglo-Saxon disc brooches are difficult to classify in the traditional sense. A small number of ninth-century disc brooches carry ornament in the Anglo-Saxon Trewhiddle style. This is a lively, animated art style distinguished by the use of niello inlay against a silver background and the nicking of individual motifs, as well as by the division of the ornamental surface into multiple, small fields (Wilson 1964, 21–35; 1984, 95–105). Trewhiddle-style animals in semi-naturalistic, profiled form appear on several famous Late Anglo-Saxon products, including the Strickland, Fuller, Pentney, and Beeston Tor brooches, on which they adopt a number of different standing or crouching poses to make best use of available space (Wilson 1964, nos. 2, 3, 152, 153; Webster and Backhouse 1991, no. 187). These items are all high-status pieces. Perhaps due to its period of currency—the ninth century—the style is not common on cast copper-alloy brooches, which appear to have been produced on a serial scale only from the later ninth and tenth centuries. The later, tenth- and eleventh-century Winchester Style, composed of foliate motifs derived from the Carolingian acanthus, occasionally inhabited with

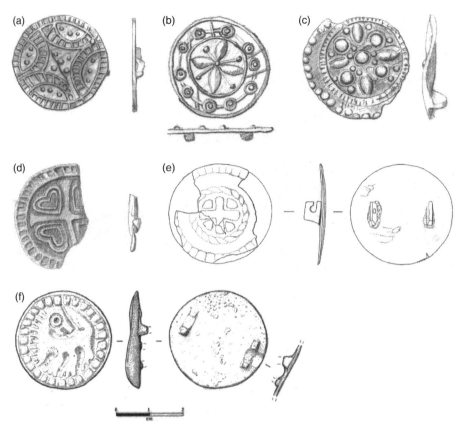

Fig. 2.13 Late Anglo-Saxon brooches: a) Barton-on-Humber, Lincolnshire, b) Horncastle, Lincolnshire, c) Ketsby, Lincolnshire, d) Swinhope, Lincolnshire, e) Thetford, Norfolk, f) Marham, Norfolk; a–d © Kevin Leahy; e–f © Norfolk County Council.

birds or beasts, is another Anglo-Saxon style. Yet while encountered on metal-work, including strap-ends, it is rare in the medium of female dress (Kershaw 2008).

Some styles carried on Late Anglo-Saxon brooches are paralleled in other Western European traditions. These include geometric motifs, such as the raised bosses, chevrons, and lentoid shapes which appear on Anglo-Saxon brooches from York and elsewhere (see Fig. 2.13a) (Roesdahl et al. 1981, YD6, YD9, YD10, YD15, YD16). Foliate motifs, including vine scroll and palmette features, along with cross-shapes and nummular designs, further decorate Anglo-Saxon brooches of this date (MacGregor 1978, 42, fig. 24, nos. 6 and 7; Leahy 2006). A recurring feature of such brooches is their use of heavy, and often beaded, borders, perhaps intended to imitate granulation (see Fig. 2.13c) (for instance, Tweddle 2004, 452–3, fig. 111; Roesdahl et al. 1981, YD7). Overall, animal ornament is less commonly applied to Anglo-Saxon than Scandinavian brooches. One notable exception is a regional motif of a backwards-

turned quadruped with a ragged mane and ring-dot eye, which adorns small disc brooches found mainly in East Anglia (see Fig. 2.13f) (Smedley and Owles 1965).

Embellishment techniques

A further means of establishing the provenance of a brooch lies in techniques of surface plating and embellishment. There is little discernible difference between Scandinavian and Anglo-Saxon artefacts in the practice and frequency of most forms of surface embellishment, such as gilding or the use of niello inlay, although the latter is more frequently encountered in Anglo-Saxon metalwork in the ninth century (Wilson and Klindt-Jensen 1966, 117). However, the coating of the reverse of a brooch in tin, a practice which protected the brooch against wear as well as the wearer's clothing against staining, is a treatment which marks out Scandinavian artefacts of this date (see Colour Plate 1) (Gramtorp and Henriksen 2000). The practice appears to be widespread in Scandinavia from the mid-sixth to twelfth centuries, and is documented on a range of trefoil, lozenge, and disc brooches from Hedeby, Uppåkra, and Birka (for instance, Hedeby: WMH 2004/10374, 2003/2633, 2003/2407, 2003/3311, 2004/9650; Uppåkra: LUHM137, LUHM106; Birka: brooches from graves 631, 649, 791). By contrast, tinning is not encountered on any brooches of Anglo-Saxon manufacture known to the author.

Metal composition

The criteria for distinguishing Scandinavian from Anglo-Saxon jewellery discussed so far rely entirely on assessing physical traits, discernible by eye, and are thus dependent on the perception and knowledge of the examiner. An arguably more powerful taxonomic tool for classifying different types of jewellery lies in the use of X-ray fluorescence (XRF) analysis to establish the metal content of Scandinavian and Anglo-Saxon artefacts. Several recent studies, discussed below, suggest that different metal alloys were available in Scandinavian and Anglo-Saxon workshops in the later ninth and tenth centuries, making it possible, in some instances, to establish distinct alloy profiles for Scandinavian and Anglo-Saxon products. By correlating the metal-alloy composition of a Scandinavian-style brooch or pendant with those known to have been in use in different geographical areas, it may, in principle, be possible to identify the item's location of manufacture.

In practice, this process is hampered by the small scale on which the metallurgical analysis of Scandinavian and Anglo-Saxon brooches has so far been carried out. In addition, the few studies to date suggest that a wide variety of alloy compositions were in use in early medieval England (Oddy 1983; Mortimer 1988; 1992; Mortimer et al. 1986; Bayley 1992; Blades 1995). While most Anglo-Saxon copper-alloy objects have been shown to be bronzes (copper

+ tin), gunmetals (copper + tin + zinc) and, less frequently, brasses (copper + zinc) are also in evidence (Bayley et al. 2008, fig. 65). This motley combination of alloys would appear to reflect the common reuse of Roman scrap or recycled metal (Mortimer 1988, 228; Craddock 1989, 170).

However, recent studies carried out on Viking-Age material from sites in the British Isles suggest the possibility of separate Scandinavian and insular metal-alloy traditions during the Late Anglo-Saxon and Viking Age. XRF tests carried out on grave goods from 'pagan Norse' graves in Scotland revealed culturally Scandinavian artefacts to be high-zinc brass, but found insular objects to consist of bronzes (Eremin et al. 1998; Paterson 2001). In this instance, the Scandinavian artefacts included several oval brooches, plus a large trefoil and equal-armed brooch, with moderate- to high-zinc contents. This raises the possibility that large Scandinavian brooches were typically fabricated from brass, rather than bronze as is commonly suggested (for instance, Jansson 1985, 13).

Other, independent analyses similarly suggest that Scandinavian dress items were commonly made of brass. Brasses have been identified in Viking-period Gotlandic brooches, as well as in a selection of metal items from Hedeby (Arrhenius 1989; Bayley 1992, 809–10). A small number of oval and equal-armed brooches, together with non-dress items such as metal vessels, have similarly been revealed to be brass, some with high-zinc contents (20–30 per cent) indicative of a fresh source of metal (Oldeberg 1966, 57–8; Trotzig 1991). Within insular contexts, culturally Scandinavian objects have also been shown to be brass, including two oval brooches from the female burial at Adwick-le-Street, South Yorkshire and sword hilts from Scar and Eigg, in the Orkneys and Hebrides respectively (Speed and Walton Rogers 2004, 73; Eremin et al. 1998). XRF tests conducted by the writer on three small Scandinavian brooches from Lake Tissø, Denmark, revealed one lozenge brooch to be leaded brass, and a small trefoil and disc brooch to be quaternary metals with low-zinc contents (see Appendix B, Table 1). This result points to variability in the metal-alloy compositions of small brooch types and, possibly, the use of different metal-alloys for small and large brooch types.

Brass was certainly available in ninth- and tenth-century Scandinavia. It has, for instance, been found in relatively 'pure' forms in large bar ingots at Hedeby and in bars on Gotland, Sweden, and in Ribe, Denmark (Sindbæk 2003). At present, its source is unclear. Brass objects are known to have been imported to Scandinavia via Eastern trade routes (Eremin et al. 1998). However, the presence of relatively pure brass bars at the southern Scandinavian sites of Hedeby and Ribe, tentatively dated on the basis of their dimension and shape to the late eighth or early ninth century, may indicate an alternative source, closer to home (Sindbæk 2003, 57–9). One possible brass source is the Limborg and upper Maas region of Germany, where Roman brass mines reopened, following a hiatus, around this date.

In this context, it is notable that a preference for brass over other copper-alloy compositions has been documented in artefacts and scrap metal preserved at insular sites with a known Scandinavian presence, including Dublin, York, and Lincoln (Fanning 1994, 122; Bayley 1992, 807–10; 2009; Bayley and Budd 2008). The presence of brasses at these sites contrasts with the dominance of bronze observed at other contemporary insular sites without Scandinavian contact, as well as in contemporary Celtic metalwork (Blades 1995, 157; Fairbrother 1990; Craddock et al. 2001, 121). It also represents a complete change from the sites' pre-Viking periods, suggesting a new development, perhaps brought about by the introduction of Scandinavian metalworking practices (Bayley 1992, 810; 2009).[1]

XRF analysis has also been carried out on several Anglo-Scandinavian objects, some from culturally Scandinavian contexts, including a group of trefoil-shaped mounts from locations in Yorkshire and Lincolnshire and strap-fittings from 'pagan Norse' graves in Scotland (Richardson 1997; Eremin 1996; Eremin et al. 1998). These were shown to consist of low-zinc brass, a result attributed to the recycling of Scandinavian brass artefacts on sites in the British Isles (Eremin et al. 1998). Five pins of a type known to have been produced on Norse sites in Britain, including Dublin, have also been shown to be brass, with variable levels of zinc, suggestive of the use of recycled metals (Eremin et al. 1998). In sum, while not all Scandinavian jewellery employed brass, the use of brass does appear to distinguish Scandinavian from insular metalworking and appears to have been typical for large brooch types (oval, equal-armed, and large trefoil brooches).

This finding prompted the author to conduct new XRF tests on a selection of twenty-two brooches from the collections of the North Lincolnshire and Norwich Castle Museums. These brooches were all found in English soil and had been identified by the author as either Scandinavian or Anglo-Scandinavian on the basis of physical traits. The results of this analysis, discussed in full in the Appendix, revealed that of nine items from England classified by the author as Scandinavian, four could be classed as brasses: two large trefoil brooches and a small disc and lozenge brooch (see Appendix B, Table 2). Although the zinc levels present in these four brooches were below the maximum 30 per cent, they were nonetheless considerable, at around 9–12 per cent (Eremin et al. 1998). It should be noted, however, that the XRF methods used

[1] The Northumbrian coins known as stycas are another medium which made regular use of brass from around the mid-ninth century. The significant quantities of brass observed in later issues have encouraged the view that brass was newly available in the ninth century, either from a local or imported source (Gilmore and Metcalf 1980). Since brass appears to have otherwise been infrequent in insular contexts, it seems possible that the uptake of brass in stycas was influenced by a Scandinavian fashion for brass, as recently suggested by Justine Bayley (Bayley et al. 2008, 50). However, the chronology of the styca coinage is not well understood, making its relationship to Scandinavian activity in the area unclear. Further work is needed to establish the proper chronological relationship between the introduction of brass into the coinage and the Viking presence in Northumbria.

had a limited penetration depth, and therefore captured the surface metal rather than the bulk of the alloy. Since many of the objects were visibly corroded and zinc levels relative to copper can decrease significantly with corrosion, it is likely that the XRF results under-represent the zinc content of the core metal (Eremin et al. 1998). To judge from their metal content alone, these items would appear to have been produced according to Scandinavian methods.

With one exception, the remaining Scandinavian items, all small brooches, consisted of copper alloys, some with appreciable quantities of lead. Since bronzes are observed in both insular and Scandinavian artefacts, it is difficult to reach any conclusions about their provenance of manufacture. That said, the analysis of thirteen Anglo-Scandinavian brooches indicated the preferential use of lead-alloys among these items, a pattern not paralleled among the Scandinavian artefacts (see Appendix B, Table 3). Lead was frequently used to produce brooches in Late Anglo-Saxon England, but is rarely the dominant metal in Scandinavian jewellery (Leahy 2007, 179, fig. 80). Its employment in select Anglo-Scandinavian brooches suggests their production in line with Anglo-Saxon methods of manufacture.

This is further suggested by the low quantities of zinc recorded for these items. Appreciable quantities of zinc, which might indicate the recycling of Scandinavian metals, were observed in just two of thirteen Anglo-Scandinavian objects: a small trefoil and Jellinge-style disc brooch (Appendix B, Table 3). Significantly, both of these items also reveal strong Scandinavian influence in their object form and pin-fitting arrangements and, in one case, can be shown to have been produced using the same model as brooches found in Scandinavia (see Chapter 3). In all other instances, zinc contents were low, ranging from 0.89 per cent in a lead-alloy trefoil brooch to 4.30 per cent in a Borre-style disc brooch, and could not be used to identify the presence of Scandinavian metals. The levels of zinc recorded in three brooches from the same Anglo-Scandinavian brooch series (labelled in this book the 'East Anglian Series') were especially low, suggesting that they were produced independently of Scandinavian metalworking techniques. In short, the results indicate variation in the metal content of Anglo-Scandinavian products: this is, in turn, likely to reflect different contexts of production for such artefacts, and different stages in their adoption and assimilation in England.

Anglo-Scandinavian jewellery

The previous discussion focused on ways of identifying a distinctly Scandinavian element among the corpus of Late Anglo-Saxon metalwork from England. This chapter also seeks to distinguish jewellery of Scandinavian origin from that which displays a mixture of Anglo-Saxon and Scandinavian attributes. Indeed, it is the interplay between these two jewellery categories which has the

most to reveal about cultural contact within the Danelaw. What features, then, mark out Anglo-Scandinavian products?

Anglo-Scandinavian brooches display a mix of features drawn from Anglo-Saxon and Scandinavian traditions. As a suite of characteristics, they are never encountered on conventional Scandinavian or Anglo-Saxon brooches and, in this way, Anglo-Scandinavian products introduce new brooch forms. However, the features adopted by Anglo-Scandinavian brooches are inconsistent: an Anglo-Scandinavian brooch may combine an Anglo-Saxon brooch form (a flat disc brooch) with a Scandinavian motif, or possess a Scandinavian brooch form along with Anglo-Saxon-type pin-fittings. Given this diversity, the degree to which an Anglo-Scandinavian product reveals Anglo-Saxon influence, or preserves Scandinavian features, will vary from brooch to brooch. The significant feature of Anglo-Scandinavian brooches is that, in borrowing from the set of Scandinavian and Anglo-Saxon brooch traits outlined above, they always generate new brooch types, unique to the Danelaw.

Despite variation in the appearance of Anglo-Scandinavian brooches, it is possible to identify a number of recurring traits, which are widespread throughout the corpus. For instance, many Anglo-Scandinavian brooches preserve Scandinavian decoration yet adopt one or both types of Anglo-Saxon pin-fitting, enabling them to be attached to clothing in the traditional, Anglo-Saxon manner. Most often, they pair an Anglo-Saxon pin-lug with a Scandinavian-style hooked catchplate, a fusion of forms which reflects influence from both traditions, but which is unparalleled outside of the Danelaw (see Fig. 2.14). A further, recurring feature of Anglo-Scandinavian products is the absence of an attachment loop or 'eye', even on brooches which preserve Scandinavian features in most other respects. These different combinations of brooch forms and

Fig. 2.14 Anglo-Scandinavian disc brooch: form and fittings
a) Single, transverse pin-lug of Anglo-Saxon type
b) Hooked catchplate, at a right angle to the brooch rim, of Scandinavian form.

styles are likely to reflect different stages in cultural accommodation and exchange. They are explored fully in Chapter 7.

It is, of course, possible that Scandinavian brooches were simply copied by Anglo-Saxon craftsmen in England, leaving no visible signs of difference either in their decoration or pin arrangement. It is well documented that, in Scandinavia, existing brooches and pendants could be used as models for new moulds (Jansson 1981; Maixner 2004, 55) (see Chapter 4). Since jewellery production could therefore take place wherever existing ornaments were in use, a Scandinavian brooch could be produced in England simply with the aid of an existing artefact. Because the process would only require the reproduction of ornament originally designed by others, the craftsman would not need to be trained in Scandinavian art styles or craft techniques. One consequence of this is that it may not be possible to distinguish imported items from those produced in England using Scandinavian prototypes (Jansson 1981, 6). This is especially true of small brooches with simple decoration, such as geometric trefoil brooches, since these would have been much easier to reproduce by Anglo-Saxon craftsmen than larger items with complex geometric or animal ornament.

The extent of the practice of producing exact replicas of Scandinavian brooches within the Danelaw is questionable, however. The widespread employment of one or two insular-type pin-fittings on Anglo-Scandinavian brooches suggests that craftsmen retained the pin-lug arrangements with which they were familiar, rather than substituting them for a foreign form and adding the feature of the third loop which was redundant in Anglo-Saxon dress (Chapter 5). This is, to some extent, to be expected. While brooch forms and ornament could be copied by using existing brooches as models, the pattern for the pin-fittings would be created anew for each mould, with the craftsman carving cavities for the fittings into the clay mould prior to each new casting. Given this widespread practice, across different brooch groups, it seems unlikely that Anglo-Saxon craftsmen routinely reproduced the Scandinavian form of pin-fitting, with which they were unfamiliar. As we shall see, the widespread distribution and broad typological range of Scandinavian brooches in England is also inconsistent with their serial manufacture within Danelaw workshops.

Conclusion

This chapter presented a methodology for the classification of Scandinavian and Anglo-Scandinavian brooches, highlighting five criteria which distinguish Scandinavian from Anglo-Saxon products. These criteria are summarized in Table 2.1. Most differences, in brooch form, pin-lug arrangement, decorative content, and surface treatment, are easy to identify by eye and provide a clear, user-friendly guide to classification. More detailed analysis of the metal content

of the jewellery item also has the potential to act as a powerful taxonomic tool, as suggested by the results of XRF tests on Scandinavian-style brooches from England. Taken together, these qualities mark out Scandinavian brooches in the Anglo-Saxon archaeological record, while also highlighting a list of traits which may be adopted by Anglo-Scandinavian products. They form the basis for the identification of the brooches and pendants found in England, to which we can now turn.

3

Scandinavian-style jewellery from England: origins, styles, and parallels

Introduction

As demonstrated in the preceding chapter, the form, decoration, and pin-fittings of a dress item offer vital clues as to its cultural background and the contexts in which it was produced and worn. This chapter considers those dress accessories that, through their salient physical features, have been identified as Scandinavian or Anglo-Scandinavian, and provides a synthesis of their appearance and circulation in England. As of December 2008, five hundred and four Viking-Age female brooches and pendants displaying Scandinavian influence of one form or another had been found in England and reported. They are discussed here, as a group, for the first time.

The overarching goal of this chapter is simply to identify, describe, and locate the artefacts, and to examine their cultural origins with reference to counterparts from Scandinavia. Analysis of the jewellery, including its wider social and cultural significance and geographic distribution, is reserved for later chapters. This chapter outlines the main brooch and pendant groups and links them with existing Scandinavian artefact typologies where possible. Particularly notable pieces, such as a fine silver openwork pendant with a Borre-style gripping-beast, from Little Snoring, Norfolk (cat. no. 448) or an elaborate trefoil brooch with combined Borre- and Jellinge-style decoration from Alford, Lincolnshire (cat. no. 414), are occasionally treated in more detail. In total, this chapter identifies seven core groups of Scandinavian jewellery in the Scandinavian art styles of Borre, Jellinge, Mammen, Ringerike, and Urnes, in addition to a number of other brooch and pendant types found in small numbers. As is clear from Table 3.1, this jewellery is extremely diverse, encapsulating many of the different artefact types and subtypes encountered in the Scandinavian homelands.

The jewellery is discussed below according to type, in broad chronological order. Rather than offering a new classification of brooch and pendant types, the book adopts and extends existing typologies, occasionally renaming them when necessary (see Table 3.1). Since a significant number of dress items are fragmented or corroded, it was important to select simple typologies, based on

Table 3.1 Scandinavian brooch and pendant types found in England

Artefact type	Variants	References
Lozenge brooches	Types I, II, II A	Richardson 1993
Convex disc brooches		
Borre style	II A (A1 and A2), II C, II D	Jansson 1984b
Terslev	Types I, II, III, IV, V, VI, VII, VIII	Kleingärtner 2007
Jellinge style	Types I A1, I B2, I C, I D, I E	Jansson 1984b
Trefoil brooches	Types P 2.4; P 4.2; P 7.12; P 5.1; G 1.3; E 1.3; E 1.2; E 2.1; F 3.1; Z 1.5; Z 2.3; Z 2.4	Maixner 2005
Oval brooches	Types Berdal; P 37; P 51	Petersen 1928; Jansson 1985
Equal-armed brooches	Types III A; III F; IV C	Aagård 1984
Pendants	Borre style: Type Norelund	Callmer 1989
	Terslev style: Types II, VII	Kleingärtner 2007
	Jellinge style: Type A3	Callmer 1989
Ringerike- and Urnes-style brooches	Openwork animal brooches Bird-shaped brooches	Bertelsen 1994 Pedersen 2001

basic visual differences. It is hoped that this approach distinguishes material in a way that would have been meaningful to the original jewellery wearers, and enables scholars and finds professionals to identify and compare future discoveries with ease. In the discussion that follows, particular consideration is given to whether the jewellery in question is Scandinavian or Anglo-Scandinavian, an important distinction which will play a fundamental role in later analysis. This identification is highlighted in summary tables which follow each section; these tables also provide a typological breakdown of the jewellery, generating a quick, yet detailed, guide to the object classifications represented by the English corpus. The following discussions are supported by the online catalogue maintained by the Archaeological Data Service (ADS), where select object images may also be accessed (see website details on p. xix), as well as by typological finds lists of material from Scandinavia, compiled by the author, contained in Appendix A.

Lozenge brooches

The openwork lozenge brooch, with a raised central rosette and four arms terminating in moulded Borre-style animal heads, is a ninth-century Scandinavian brooch type which is found with some frequency in the eastern counties of England (see Fig. 3.1) (Arwidsson 1989, 70). Within Scandinavia, it is found mainly, although not exclusively, in the area of Viking-Age Denmark (modern-day Denmark, Skåne, and Schleswig) (see Map 3.1). The core motif depicted on

Fig. 3.1 Scandinavian lozenge brooch, Birka, Sweden © National Historical Museum Stockholm.

lozenge-shaped brooches, a quadrangular layout of four outward-facing animal heads, was popular and far-reaching; in both Scandinavia and the Scandinavian settlements, it occurred on a variety of Viking-Age artefact types, including oval, disc, and rectangular brooches, pendants, and mounts (Jansson 1985, fig. 23; Leahy and Paterson 2001, 194; Kleingärtner 2007, pl. 16b; Hilberg 2009, 95). The quadrangular arrangement of outward-facing Borre-style animal heads was particularly prominent on contemporary horse harness mounts, several of which have been recovered from Hedeby and its surrounding areas (Müller-Wille 1977, fig. 3, 2–3; 1987, 40–2, pls. 76, 77.1, 102.1–102.4).

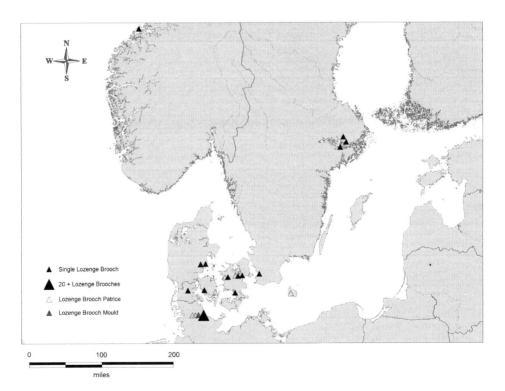

Map 3.1 Lozenge brooches in Scandinavia

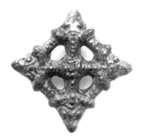 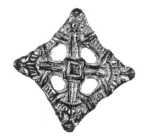

Fig. 3.2 Lozenge brooch Types I (a) and II (b).

Apart from one lozenge-brooch find from Norway, and three from the Upp-land area of Sweden, the brooch group is represented exclusively by finds from the area of Viking-Age Denmark: modern-day Denmark, Skåne and Schleswig (Map 3.1) (see Appendix A, Finds Lists 1–2 for an up-to-date list of all known lozenge brooches found in Scandinavia). Lozenge brooches are particularly well represented at Hedeby, where systematic metal-detector surveys since 2003 have lead to the recovery of 21 specimens, in addition to two patrices (Hilberg 2009, 95, fig. 11). These recent finds, together with items previously recorded from within the ramparts at Hedeby—two lozenge brooches and a brooch mould—suggest the prominence of Hedeby as a location for the serial production of the brooch type (Capelle 1968a, pls. 9.2, 9.3, 10.2). The manu-facture of such items appears to have been widespread, however. Patrices for lozenge-brooch moulds have been recovered from Lake Tissø and Lejre on Zealand, Gudme on Fyn, and Dalshøj on Bornholm (Map 3.1; Appendix A, Finds List 3).

As yet, there is no established typology for the lozenge-brooch series, a reflection of the young age of the existing corpus. However, in 1993, Caroline Paterson (née Richardson) suggested that the brooch group could be divided into two main variants, distinguished by cast beading or paired ridges along the four intersecting arms (Richardson 1993, 18; Leahy and Paterson 2001, 194). Although the corpus of lozenge brooches found in Scandinavia has increased significantly since Paterson's analysis, her division of the type into two variants remains applicable. As Paterson did not formally classify the series, the variants are named here in line with the numerical system adopted for most other brooch types: Types I (beaded) and II (ridged) (see Fig. 3.2).

Type I

Of thirty-two lozenge brooches recorded from England, twenty-seven items possess sufficient information to be classified by type (see Table 3.2 and Map 3.2). Of these, thirteen may be classified as Type I, distinguished by cast pellets along the four intersecting arms (see Fig. 3.3) (cat. nos. 1–13). Most of these brooches are Scandinavian in origin. Twelve of the thirteen specimens carry

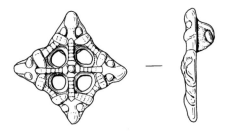

Fig. 3.3 Type I lozenge brooch, Wenham Parva, Suffolk © Suffolk County Council.

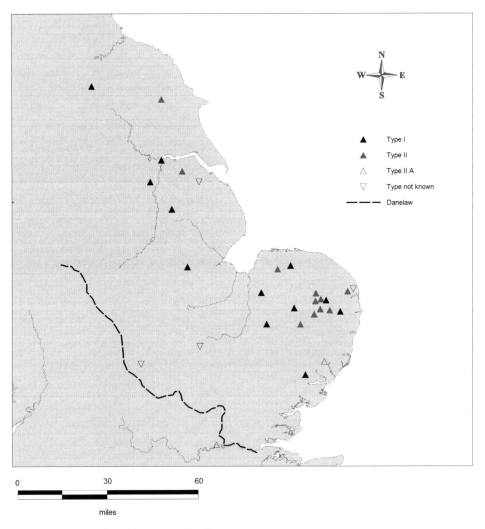

Map 3.2 Lozenge brooches in England

Scandinavian-type attachment fittings, including, on two brooches, a loop for the suspension of chains or pendants (cat. nos. 3, 9). In addition to these items, one further brooch, from Stoke Holy Cross, Norfolk, is distinguished by its use of an Anglo-Saxon, rather than Scandinavian, pin-lug form (cat. no. 10). Notably, this fitting is paired with a catchplate of typical Scandinavian type, a common pairing of attachment features paralleled on a number of other Anglo-Scandinavian products.

Type II

In England, lozenge brooches of Type II, distinguished by paired ridges along the four intersecting arms, are represented by thirteen finds (cat. nos. 14–26). In five instances, these finds can be identified on stylistic and morphological grounds as Scandinavian (cat. nos. 14–16, 19, 26). This is revealed by their Scandinavian pin-type fittings which include, on three brooches, an attachment loop (cat. nos. 14–15, 19). On these items, in addition to a fourth brooch (cat. no. 16), the central rosette is underlain by a circular plate, a feature also encountered on select Scandinavian lozenge brooches of this type (see Fig. 3.4). A further Scandinavian treatment—tinning on the reverse of the brooch—is seen on the remaining item from Thorpe Bassett, Yorkshire (cat. no. 26).

Type II lozenge brooches also appear in England as an independent Anglo-Scandinavian series. Eight objects, identifiable as lozenge brooches by their distinctive openwork lozenge-shaped form, differ in their decorative treatment from their Scandinavian counterparts (see Fig. 3.5) (cat. nos. 17–18, 20–5). On these brooches, the four terminals retain key zoomorphic features, including the ears, eyes, and truncated nose of a Borre-style animal. However, they are flat, rather than moulded as was traditional in Scandinavia. The paired ridges along the arms may be similarly characterized, while the raised central rosette is reduced to a slight circular depression.

These items possess a single, perforated pin-lug, positioned in line with the brooch edge, confirming their manufacture in an insular setting. Yet in six of seven instances in which the catchplate survives, the Anglo-Saxon pin-lug

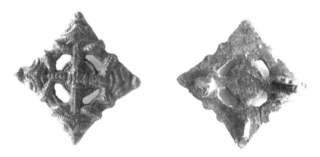

Fig. 3.4 Type II lozenge brooch, Elsham, Lincolnshire © Kevin Leahy.

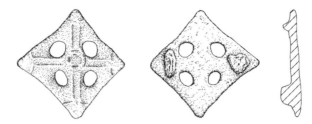

Fig. 3.5 Anglo-Scandinavian Type II lozenge brooch, Ketteringham, Norfolk © author.

appears together with a catchplate of typical Scandinavian, hooked form (cat. nos. 17–18, 20, 22, 24–5). Only one brooch, from North Lopham, Norfolk, carries a C-shaped catchplate aligned with the brooch edge in the true Anglo-Saxon fashion (cat. no. 21). The combination of different attachment types suggests multiple stages in the adoption and alteration of lozenge brooches by craftsmen trained in Anglo-Saxon traditions, with the North Lopham brooch representing the final, most Anglicized version.

These eight brooches form a homogenous group in terms of size, form, and decorative content, suggesting that they were the products of a single work-shop, as their restricted distribution around Norwich would similarly suggest (Map 3.2, compare with Map 4.1). Moreover, to judge from available images, they would appear to greater or lesser extents to share a common design fault: the elongation of the terminal bearing the single pin-lug, resulting in a dis-torted, asymmetrical lozenge shape (see digital catalogue). This asymmetry, together with their geographical concentration, suggests that the series derived from a common model.

Type II A
The lozenge brooches discussed so far fit neatly within the classification scheme established on the basis of brooches from Scandinavia. Two further finds from England introduce a new lozenge type to the repertoire of known variants, which we may coin Type II A (cat. nos. 27–8). Both brooches, from Hasketon in Suffolk and Queenhithe (Bull Wharf) in London, depict paired ridges on their arms in the classic Scandinavian style. However, their terminals carry a schematic rendering of the Borre-style animal head, in which the ears are reduced to ribbed bands, and the nose has been lost altogether (see Fig. 3.6). Due to their 'devolved' appearance, it has been suggested that these brooches are Anglo-Scandinavian (Leahy and Paterson 2001, 195). However, both brooches possess Scandinavian pin-fittings and the Suffolk brooch is gilded on the front and tinned on the reverse, a reoccurring feature of brooches found in Scandinavia. Although schematic Borre-style animal heads are not a feature of the lozenge brooches hitherto found in Scandinavia, similar motifs are known in Scandinavian art and appear, for instance, on Scandinavian trefoil brooches,

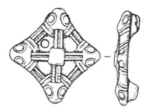

Fig. 3.6 Type II A lozenge brooch, Hasketon, Suffolk © Suffolk County Council.

as well as on the Type II A2 disc brooch described below. The lozenge brooches from Hasketon and London are, then, likely to represent a Scandinavian lozenge-brooch variant not yet known from Scandinavia.

Table 3.2 Summary of lozenge brooches from England

	Type I	Type II	Type II A	Unclassifiable	**Total**
Scandinavian	12	5	2	0	19
Anglo-Scandinavian	1	8	0	0	9
Unclassifiable	0	0	0	4	4
					32

Borre-style disc brooches Type II

The small convex disc brooch, measuring between 24 and 34 mm in diameter, is the most common Scandinavian jewellery item found in England. In Scandinavia it is associated with a range of Scandinavian, as well as Western European-inspired zoomorphic, interlace, and foliate motifs, some, but not all, of which were included in Jansson's 1984 classification of the artefact type based on fifty-six brooches recovered from graves at Birka (Jansson 1984b). One of the most popular motifs to adorn the convex disc brooch comprises three inward-looking Borre-style animal heads separated by the lobes of a double-contoured trefoil: Jansson's Type II A (Jansson 1984b, fig. 8:2; previously classified by Petersen as his Type P 128; Petersen 1928, fig. 128). In this composition, the classic *en-face* Borre animal masks have beady eyes and large, rounded ears and snouts. A contoured band, carried under the animal masks and over the lobes of the trefoil feature, encircles the motif creating a closed ring characteristic of the Borre style (see Fig. 3.7) (Jansson 1984b, 62).

The motif of symmetrically arranged, inward-facing Borre-style animal heads features on a range of Scandinavian Viking-Age brooch types, including trefoil brooches, on which the animal heads occur at the junction of three lobes, similarly positioned around a central trefoil feature (see, for instance,

Fig. 3.7 Disc brooch Type II A (drawn by Anders Eide, after Jansson 1984b, fig. 8:2).

Maixner 2005, pl. 3, P 4.1, pl. 11, F 4.1). The motif is also a feature of large disc brooches, measuring over 45 mm in diameter, the best example of which is an openwork brooch from Bjølstad in Oppland, Norway (Fuglesang 1982, fig. 22). On this brooch, the animal heads are attached to classic Borre-style gripping bodies and divided by a prominent central trefoil, integrated with further zoomorphic ornament. It seems likely that the motif as it appeared on small disc brooches represents a simplified version of such elaborate gripping-beast ornament, without animal bodies.

Until recently, disc brooches of this type were thought to have a mainly eastern Scandinavian provenance, with a concentration of finds at Birka and in the wider Uppland region of Sweden (Jansson 1984b, 62). Miscast and unfinished items from Smiss, on Gotland, and Birka confirm the manufacture of the type in eastern Sweden (Zachrisson 1962, fig. 9; Jansson 1984b, fig. 8:3). Yet more recent discoveries made by metal detectorists indicate that Type II A brooches were also well known in southern Scandinavia. These more recent find-spots, collated here for the first time, indicate a widespread Scandinavian distribution for the brooch group, with concentrations at Uppåkra and Hedeby, as well as at Birka (see Map 3.3; Appendix A, Finds List 5).

Within Scandinavia, the Type II motif shows a number of variant forms which differ from the Type II A by laying greater emphasis on the geometric rather than zoomorphic ornament (Jansson 1984b, fig. 8:2 II B–D). Type II C depicts four outward-facing animal heads and a complex Borre-style ring-knot pattern in a symmetrical quadrangular layout; an up-to-date finds list indicates a mainly Swedish distribution, although two examples are known from southern Scandinavia (see Fig. 3.8, Map 3.4; Appendix A, Finds List 7). A further variant design, carried on brooches classified as Type II D, depicts three small, outward-facing, long-necked animal heads stemming from a concentric circle. Lines of cast beading flank the small masks and form a border around the inner edge of the brooch (Jansson 1984b, fig. 8:2, II D) (see also Fig. 3.9). Within Scandinavia, this variant is recorded mainly in the south, from locations including Lake Tissø and Vorbasse, as well as Hedeby (Map 3.4; Appendix A, Finds List 8).

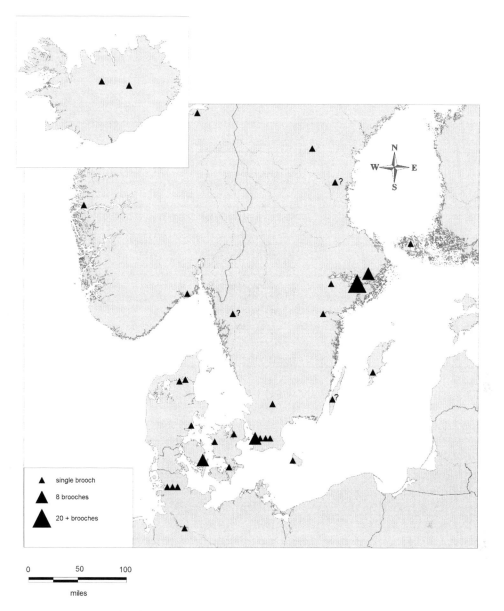

Map 3.3 Type II A disc brooches in Scandinavia

Type II A

In England, the Type II series is well represented, with a total of fifty-three brooches recorded to date, including the variants II A, C, and D (see Table 3.3 and Map 3.5). Type II A disc brooches are represented by forty-four finds, found predominantly in Norfolk, but also in Suffolk, Lincolnshire, and York-shire (cat. nos. 33–76). Of these, sixteen can be classified as Scandinavian on

Fig. 3.8 Disc brooch Type II C (drawn by Anders Eide, after Jansson 1984b, fig. 8:2).

Fig. 3.9 Disc brooch Type II D (drawn by Anders Eide, after Jansson 1984b, fig. 8:2).

the basis of their stylistic and morphological traits. All possess an H-shaped double pin-lug, hooked catchplate and, with one exception (cat. no. 66), an attachment loop for a chain or pendant (see Colour Plate 3).

The ornamental scheme depicted on these brooches is identical to that seen on Scandinavian examples and encompasses a derivative stylized motif also seen in Scandinavia, here coined Type II A1 (cat. no. 67). This is not the only subtype recorded in England. Two further brooches, from Laxfield in Suffolk and Malton, North Yorkshire, also carry a variant of the classic Type II A motif, not included in Jansson's typology of the Birka disc brooches (cat. nos. 75–6). In this composition, the ears of the animal masks are missing and the trefoil lobes have distinctive, flared ends. The motif is distinguished by the heavy use of pellets, which fill the trefoil lobes and form an inner border (Fig. 3.10). This variant, which we may coin Type II A2, is rare even within Scandinavia (see Appendix A, Finds List 6). The objects from England, both of which may be identified as Scandinavian on the basis of their attachment fittings, have just two parallels, from Uppåkra, Skåne, and Gudme, Fyn (LUHM 3100–36592; Thrane 1987, fig. 44c, 4:592). They provide proof that brooch types which were rare in Scandinavia did, nonetheless, circulate in England.

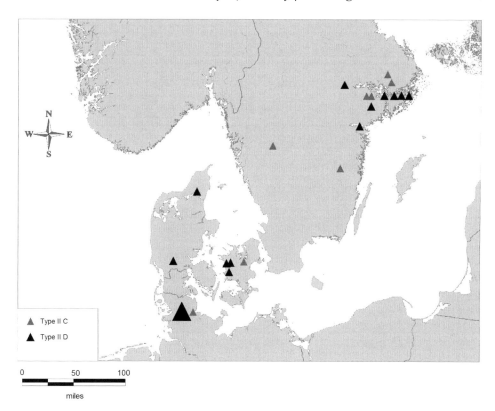

Map 3.4 Disc brooches Types II C and D in Scandinavia

In addition to these, Scandinavian items, there is evidence that Type II A brooches were produced locally. Twenty-five brooches can be identified as Anglo-Scandinavian. These brooches look identical to Scandinavian products, and retain the convex shape characteristic of Scandinavian brooches. However, they have a different pin-lug form which follows Anglo-Saxon, rather than Scandinavian, convention (a single, transverse pin-lug). In contrast to the Scandinavian Type II A brooches from England, none of the Anglo-Scandinavian items carries an attachment loop, providing further confirmation of their insular origins.

Significantly, the decoration carried on Anglo-Scandinavian brooches is consistently in low relief, and lacks embellishment on the raised border and trefoil lobes encountered on Scandinavian items (see Fig. 3.11). With wear, the decoration on some brooches is barely detectable, a problem not typically encountered on Scandinavian items (for instance, cat. nos. 41, 54, 59–60, 62). These Anglo-Scandinavian brooches are also smaller on average than their Scandinavian counterparts, with a less pronounced convexity or height. This is difficult to quantify exactly as the convexity, or height, of a brooch is not regularly measured by finds recorders, but evidence from eight Scandinavian and seven

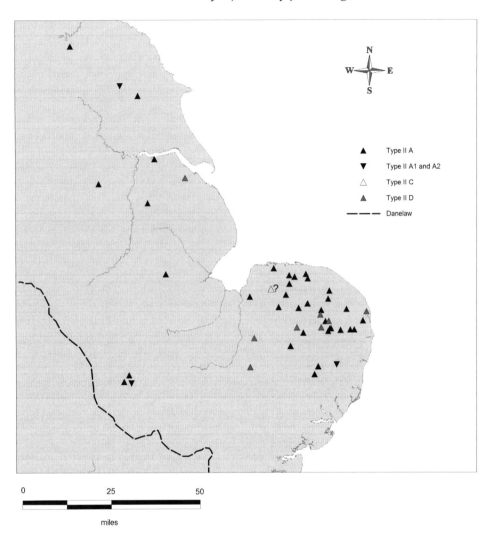

Map 3.5 Type II disc brooches in England

Anglo-Scandinavian brooches suggests an average height of 4.5–5.0 mm for Anglo-Scandinavian items, compared with 5.4–8.0 mm for Scandinavian products, a measurement in keeping with measurements recorded in Scandinavia (Maixner 2004, cat. nos. 57–9, 61–3, 67, 72–80, 82, 84–7). These features may suggest that Anglo-Scandinavian brooches were produced using existing brooches, Scandinavian or, over time, Anglo-Scandinavian specimens, as models. This would account for the consistency in ornamental content but degradation in ornament quality within the Anglo-Scandinavian series.

Fig. 3.10 Disc brooch Type II A2, Laxfield, Suffolk © Suffolk County Council.

Fig. 3.11 Anglo-Scandinavian Type II A disc brooch, Shotesham, Norfolk © Norfolk County Council.

Types II C and D

Just one brooch from England can be assigned to the group II C, a Scandinavian brooch, said to come from East Anglia (cat. no. 77). Eight examples of the disc brooch Type II D are recorded from England, all stylistically identical to their Scandinavian counterparts. The Scandinavian origin of four brooches is confirmed by their pin-lug arrangement, which includes a double, H-shaped pin-lug and hooked catchplate, positioned at a right angle to the brooch rim, together with an attachment loop (see Fig. 3.12) (cat. nos. 78, 81–2, 85). However, the remaining four brooches possess an Anglo-Saxon pin-lug form (cat. nos. 79, 80, 83–4). On these items the attachment loop is absent. Although they would have looked Scandinavian when worn, their fittings suggest that they were, in fact, produced locally.

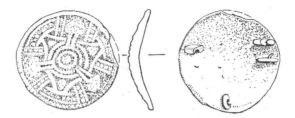

Fig. 3.12 Type II D disc brooch, Keswick, Norfolk, drawn by K. J. Penn © Norfolk County Council.

Table 3.3 Summary of Type II disc brooches from England

	Type II A	Type II A1	Type II A2	Type II C	Type II D	Total
Scandinavian	15	1	2	1	4	23
Anglo-Scandinavian	25	0	0	0	4	29
Unclassifiable	1	0	0	0	0	1
						53

Borre-style disc brooches: the 'East Anglian Series'

The Anglo-Scandinavian brooches discussed thus far may be described as local, somewhat Anglicized, versions of distinctly Scandinavian brooch types (the lozenge and convex disc brooch), produced as one-off designs or small series, probably in the workshops of the Danelaw. An altogether different phenomenon is represented by a group of flat disc brooches, with an interlacing motif derived from the Scandinavian Borre style. These brooches carry a central sunken roundel surrounded by a concave-sided lozenge, the four corners of which extend to form double-stranded, loosely knotted interlace (see Fig. 3.13). A variant of this design appears on a brooch from Birka, classified by Jansson as Type III E, but the distinct group of brooches from England is named here the 'East Anglian Series', due to its geographic distribution within East Anglia (see Map 3.7). Not only are brooches in the series uniformly flat and shallow cast, they also carry a single perforated pin-lug aligned with the rim of the brooch, traits which indicate their manufacture within an insular setting. In combining an Anglo-Saxon brooch form with a Scandinavian art style, these brooches are, then, true cultural hybrids, reflecting a fusion of Scandinavian and Anglo-Saxon styles.

Perhaps because of this mix of cultural influences, there has been much debate about the stylistic and cultural origins of these brooches since they were first recognized as a distinct group in the 1950s. Although there is now widespread consensus that the brooches were produced in workshops in England, contention remains over whether the brooches reflect insular or Scandinavian influence in their interlacing tendrils (Shetelig 1940–54, 69; Wilson 1956; 1964, 48–9; 1976, 506; Evison 1957; Jansson 1984b, 63–4; Leahy and Paterson 2001,

Fig. 3.13 East Anglian Series disc brooch, Harling, Norfolk, drawn by T. Jenkins © Norfolk County Council.

197). While David Wilson has laid emphasis on the zoomorphic character of the tendrils, suggesting that they could have developed from the looping bodies of Borre-style gripping-beasts, Ingmar Jansson and Caroline Paterson (née Richardson) have rejected the attribution of the motif to the Borre style, the latter arguing that the interlace does not form closed knots typical of the Scandinavian style (Wilson 1976, 504–6; Jansson 1984b, 63–4; Richardson 1993, 33).

The solution to this dispute is best sought with reference to the first artefact of this type to come to light: a disc, bereft of attachment fittings, from Oxshott Wood, Surrey (cat. no. 320) (see Fig. 3.14a). This disc is stylistically distinct from the mass-produced East Anglian Series brooches in that it displays hatched arms emanating from behind the concave-sided lozenge and includes four pellets interspersed within its knotting tendrils, features not present on the flat brooches found in England (Wilson 1956). As noted by Paterson, a Scandinavian parallel for the Oxshott Wood disc, of comparable dimensions, has recently been recovered in the form of a pendant from Kalmergården, Store Fuglede, Denmark (see Fig. 3.14b) (Paterson 2002, 274). This parallel suggests that the Oxshott Wood disc also once functioned as a pendant.

The motif carried by the Oxshott Wood and Kalmergården items is directly rooted in Scandinavian artistic traditions, suggesting that the Oxshott Wood disc was imported from Scandinavia. As first noted by Evison, the design shares a number of stylistic traits with Vendel-period disc brooches from Bornholm decorated with Style II animal ornament (Fig. 3.15) (Evison 1957, 222). These traits include a central sunken roundel, surrounded by a concave-sided lozenge, four arms flowing in a clockwork direction, and four pellets, which, on the disc brooches from Bornholm, represent the eyes of the Style II animals (Evison 1969, pl. 11, 85; Leahy and Paterson 2001, 197).

The Oxshott Wood and Kalmergården pendants cannot be precisely dated, yet it seems likely that they pre-date and provide the inspiration for the Anglo-Scandinavian brooches (the 'East Anglian Series'). This suggestion is supported by the author's documentation within Scandinavia of eight convex disc brooches (Scandinavian artefact types) with an identical motif to that carried on some East Anglian Series brooches (Appendix A, Finds List 9) (Map 3.6). These items, recorded mainly from Denmark, carry a central circle with a raised border, surrounded by a concave-sided lozenge, which loosely knots into the familiar tendril motif, executed in either high or low relief (see Fig. 3.16). A variant of this type, with a trefoil feature in place of

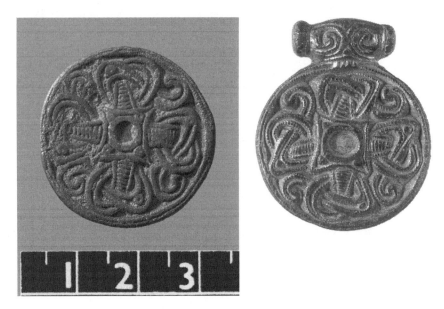

Fig. 3.14 a) Disc, Oxshott Wood, Surrey © the Trustees of the British Museum; b) pendant, Kalmergården, Store Fuglede © National Museum of Denmark.

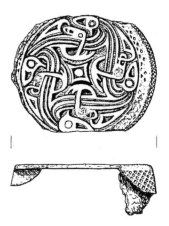

Fig. 3.15 Vendel-period disc brooch with Style II animal ornament, Bækkegård, Bornholm (after Jørgensen 1990, pl. 9.8).

the central roundel, is known from grave 968 at Birka and constitutes Jansson's disc brooch Type III E (Jansson 1984b, fig. 8:2, Type III E). Two Scandinavian brooches—the item from Birka and a Danish find from Syvsig—are dated to the late ninth or first half of the tenth century on account of associated finds, suggesting that the Scandinavian series did indeed pre-date the Anglo-Scandinavian variant produced in England (Rieck 1982, 8; Arbman 1940–43, 394–6).

The brooches found in Scandinavia are subtly domed, with Scandinavian-type double pin-lugs, hooked catchplates, and attachment loops, indicating their manufacture in a Scandinavian setting. Indeed, there is concrete evidence for the

Fig. 3.16 Convex disc brooch with Borre-style interlace, Lake Tissø, Denmark © National Museum of Denmark.

Map 3.6 Borre-style interlace brooches in Scandinavia

manufacture of this brooch type within Scandinavia. A bronze model with an almost identical motif, on which the interlacing tendrils flow in an anti-clockwise, rather than clockwise, direction, was recently recovered from Lake Tissø, where two of the seven Danish finds, and the pendant, were also found (see Fig. 3.17). Supplementing this evidence, we might also draw attention to the repeated use within Scandinavia of the motif of a central circle surrounded by a concave-sided lozenge, occasionally embellished with corner pellets, for instance, on

Fig. 3.17 Model for the manufacture of Scandinavian Borre-style interlace brooches, Lake Tissø, Denmark © National Museum of Denmark.

select lozenge brooches from Hedeby (for example, WMH 2004/10374). While the East Anglian Series disc brooches are undoubtedly Anglo-Scandinavian products, their Scandinavian background and context cannot now be ignored.

One final remark on the cultural and stylistic origins of this disc brooch series must be made in reference to one further Danelaw item: a gilt copper-alloy pendant recovered from Akenham, Suffolk (cat. no. 321) (see Fig. 3.18). This pendant does not belong to the East Anglian Series, but shares with the Oxshott Wood and Kalmergården pendants the composition of three pellets within double-stranded interlace. It is therefore likely to be related to it. Like the Borre-derived interlace motif, the design on the Akenham pendant finds parallels among the Vendel-period Gotlandic brooches. It is securely paralleled by a number of pendants and brooches from Denmark, from where it is likely to have been imported (Appendix A, Finds List 12) (Nerman 1969, pl. 11, 85).

In England the East Anglian Series is remarkably prolific, the motif achieving a level of popularity unmatched in the Scandinavian homelands. With two hundred and thirty-four finds to date, East Anglian Series disc brooches comprise 47 per cent of the total corpus of Scandinavian-style jewellery from England (cat. nos. 86–319). The series reveals a high degree of stylistic homogeneity. Although no moulds for the brooches survive, it is clear that they were mass produced to a standard design. Among the brooches recorded to date there are just two main variant motifs, distinguished by the relationship of the concave-

Fig. 3.18 Pendant with zoomorphic interlace motif, Akenham, Suffolk © Suffolk County Council.

sided lozenge to the central sunken roundel (Richardson 1993, 29). We may coin these variants Types I and II (see Fig. 3.19a–b and Table 3.4).

On Type I brooches the central roundel appears as a simple, shallow depression within the raised lozenge-shaped field (Richardson 1993) (Fig. 3.19a). On Type II brooches, it is distinguished by an accentuated sunken roundel, surrounded by a raised border. This border effectively truncates the surrounding concave-sided lozenge, creating triangular spaces within its four corners (Fig. 3.19b). Of one hundred and fifty-five brooches from England with sufficient information to be classified by Type, ninety-one brooches belong to Type I, while sixty-four are identified as Type II. However, eighty brooches remain typologically unidentifiable, making it difficult to reach conclusions about the relative ratios in circulation. The distribution of the two brooch groups is equivalent, with both groups concentrated in Norfolk and, to a lesser extent, Lincolnshire (see Map 3.7).

When the interlacing tendril motif occurs in Scandinavia, it consists of an accentuated, bordered roundel set within a truncated surrounding lozenge, and is clearly identified with the second motif group. The one exception is a brooch from Birka, grave 968, with a triangular feature in place of the usual roundel (Jansson 1984b, fig. 8:2, Type III E). Brooches with the Type II motif found in England would appear, then, to be closer to their Scandinavian counterparts than brooches belonging to Type I. This is significant, for it suggests that the Type I motif represents a simplified version of the original, Scandinavian design, with less ornamental detail in the central panel.

In addition to these two main groups, two brooches within the series display a slightly altered version of the motif. One brooch, from Norwich Castle Bailey, is unusually large for the series, measuring 32mm in diameter. It is distinguished not only by its size, but also by an elaborate incised border plated in white metal—probably tin (cat. no. 219) (see Fig. 3.20). A second Norwich specimen, revealed during the same excavations, lacks the ornate border, but is set apart by the loose, unfurling arrangement of its interlacing tendrils (cat. no. 220) (Fig. 3.21) (Richardson 1993, 31–2). A similar tendril pattern occurs on a second brooch from Postwick, just to the east of Norwich, and suggests that this variant type may have constituted a small series (cat. no. 226). These three

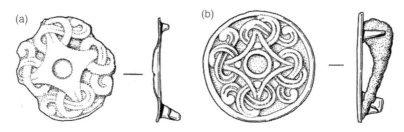

Fig. 3.19 East Anglian Series brooch Types I (a) and II (b), Little Thurlow and Braiseworth, Suffolk © Suffolk County Council.

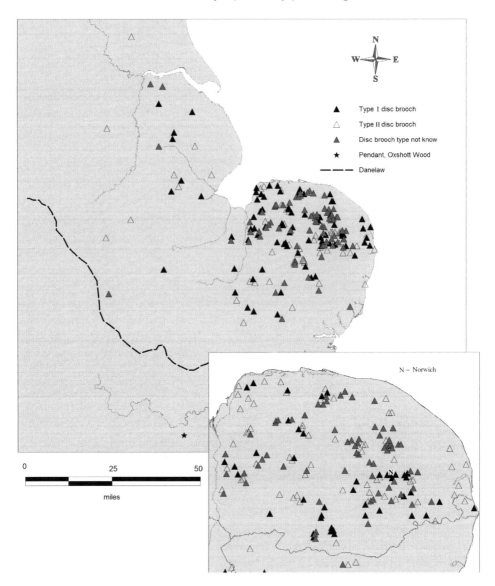

Map 3.7 East Anglian Series disc brooches in England

items, all of which belong to Type II, represent the only evidence for stylistic diversity within series. They point to Norwich as a likely centre for the production of the brooch series, as first suggested by Richardson (1993, 31–2).

Although stylistically homogenous, East Anglian Series disc brooches vary in quality as well as size. Alongside a few finely executed brooches with crisp decoration (for instance, cat. nos. 91, 189, 219), the East Anglian Series encompasses a large number of degraded specimens, with only faint traces of their original surface decoration (for instance, cat. nos. 86, 97, 110, 190). The broad qualitative range exhibited by the series will, to a large extent, reflect different

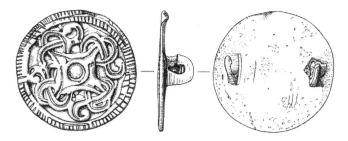

Fig. 3.20 East Anglian Series brooch with incised border, Norwich Castle Bailey, Norfolk, drawn by R. Hajdul © Norfolk County Council.

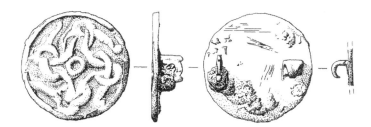

Fig. 3.21 East Anglian Series brooch with unfurling tendrils, Norwich Castle Bailey, Norfolk, drawn by R. Hajdul © Norfolk County Council.

states of preservation and degrees of wear: One hundred and thirty-six brooches in the series were classified by the author as 'worn' or 'very worn', suggesting the lengthy circulation of the series, or perhaps the widespread use of low-quality alloys. However, genuine qualitative differences are indicated by the selective use of surface treatments such as gilding or tinning. Such treatment, usually applied to the raised interlace, distinguishes ten brooches within the series, including the elaborate example from Norwich Castle (cat. nos. 95, 107, 150, 155, 189, 219, 230, 270, 277, 293). Many other items are so worn that traces of white metal or gilding are unlikely to survive.

One final feature which deserves attention is the form of the pin-fittings. Almost all brooches within the East Anglian Series carry the standard Anglo-Saxon pin-lug: a single pierced lug vertically aligned with the brooch rim. However, one brooch, from Wetheringsett-cum-Brockford, Suffolk, appears to buck this trend: it possesses a double, H-shaped pin-lug of typical Scandinavian form (cat. no. 312) (see Fig. 3.22). Moreover, it appears from the drawing of this brooch that the one surviving pin-lug is, in fact, unfinished, since it is not perforated, although the outline of a perforation is visible and it may have simply been filled with corrosion or dirt. While it is difficult to reach any conclusions about this item, unfortunately unavailable for study, the potentially unfinished Scandinavian pin-lug may point to local manufacture. The use of a Scandinavian pin-lug form is unusual in Anglo-Scandinavian brooches, and would suggest that this item was directly modelled on a Scandinavian brooch. As such, it offers further evidence for the Scandinavian background of this disc brooch series.

Fig. 3.22 East Anglian Series brooch with atypical double pin-lug, potentially unfinished, Wetheringsett-cum-Brockford, Suffolk © Suffolk County Council.

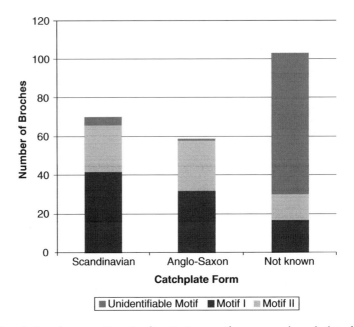

Fig. 3.23 Correlations between East Anglian Series motif groups and catchplate forms.

The Wetheringsett brooch is not the only item to display Scandinavian influence in the form of its attachment fittings. Of one hundred and thirty-two brooches whose pin-fitting arrangements are recorded, sixty-one pair an insular-type pin-lug with an insular-type catchplate, consisting of a single perforated lug aligned with the brooch rim, and seventy brooches adopt the more typical Anglo-Scandinavian pin arrangement of an insular, single pin-lug paired with a Scandinavian, hooked catchplate. The existence of two pin-fastening arrangements suggests different stages in the 'Anglicization' of this brooch series, with Scandinavian influence initially preserved in some catchplate forms and gradually evolving into Anglo-Saxon attachment types. Although a similar process has been suggested for the evolution of the tendril motif, there does not appear to be a correlation between the two motif groups and the two forms of pin-fitting arrangement: brooches with the classic, Type II motif may carry a complete insular pin-fitting arrangement, while brooches with the Anglicized

version of the motif (Type I) may carry a Scandinavian-type catchplate (see Fig. 3.23). This would appear to suggest a broadly contemporary period of use of both motif groups.

Table 3.4 Summary of East Anglian Series brooches and related pendants from England

	Disc Brooch	Pendant	Total
Scandinavian	0	2	2
Anglo-Scandinavian	234	0	234
			236

Terslev and other geometric Borre-style disc brooches and pendants

In both Scandinavia and England a range of other geometric Borre-style motifs also adorn disc brooches and pendants. A recurring trend within this group is the use of three or four symmetrically placed volutes, positioned back-to-back in a square or lozenge arrangement (Friis Johansen 1912). When bound by a closed square or ring, the volutes create a ring-knot pattern related to the Scandinavian Borre style (Paterson 2002, 270). Such motifs are often dubbed 'Terslev', after the discovery of such ornament in a silver hoard from Terslev, Denmark. Related geometric designs, which lack closed rings, can be distinguished from true Terslev compositions. Both Terslev and non-Terslev designs have been subject to interrelated classifications by Ingmar Jansson and Sunhild Kleingärtner (Jansson 1984b, fig. 8:2 III A–E; Kleingärtner 2004; 2007). For simplification, these classifications have been merged and renamed here using a straightforward numerical system (Types I–VIII).

In their most elaborate form, geometric Borre-style motifs appear in Scandinavia on highly-ornate silver, and occasionally gold, disc-shaped pendants and brooches in applied filigree (twisted wire) and granulation. The geographical distribution of these high-status artefacts, of which over sixty examples are known, points to their use in the area of Viking-Age Denmark, as well as in eastern Scandinavia, where bronze patrices used in the production of such objects are similarly concentrated (Eilbracht 1999, 237, map 8; Armbruster 2004, 113–14, fig. 7). In addition to appearing on jewellery in precious metal, geometric motifs also adorned simpler, cast base-metal brooches and pendants, sometimes referred to as 'imitation' jewellery. Over eighty such cast objects are known from Scandinavia, mainly from the area of Viking-Age Denmark and eastern Sweden (see Kleingärtner 2007, 311–14, maps 3–5, 7–11 for distributions).

There can be no doubt that these cast brooches and pendants were intended to emulate the high-quality decoration depicted on precious metal jewellery. Techniques such as gilding, transverse nicking, and the use of double-strand designs are typical features of cast brooches, and were intended to imitate the

use of twisted filigree wire. Similarly, cast pellets were employed to copy the structure of granulation. Although in Scandinavia the repertoire of geometric designs executed in filigree and granulation is more diverse than that exhibited on cast jewellery, the same decorative schemes were applied to both groups of objects, making it possible to trace the transfer of separate designs from silver brooches and pendants, to simpler cast copper- and lead-alloy objects. The repertoire of geometric designs is extremely diverse, both within Scandinavia and England (Kleingärtner 2007). Indeed, the designs encountered on jewellery in England extend the existing repertoire by introducing new, Scandinavian motifs, currently unrecorded within Scandinavia (see Table 3.5). The diversity of styles encountered on jewellery in England is impossible to treat in detail here, but interested readers will find full classifications as well as object images on the ADS database.

Silver brooches and pendants

To date, all geometric Borre-style jewellery found in England can be described as 'imitations', since none is executed in filigree and granulation (although there is evidence for the production of other forms of filigree and granulation jewellery in northern England, see Chapter 4). However, four items are cast silver and can be distinguished from the remaining corpus of copper- and lead-alloy jewellery (cat. nos. 322–4) (see also Map 3.8). A convex disc with niello inlay and a silver content established by XRF of around 50 per cent is recorded from Castlefield, Manchester (cat. no. 322). Although it cannot technically be classed as a brooch, since it lacks any form of attachment fittings for a pin on the reverse, its size and domed shape strongly suggest that it originally functioned as one (Graham-Campbell 1983, fig. 6; Richardson 1993, 167). It displays ornament consisting of four circular fields, each with three or four pellets, which enclose a lozenge-shaped central space. The circular fields are bound by a closed ring, around which form side loops, embellished with nicks, at the intersection of each field to generate four volutes (see Fig. 3.24).

The ornament on the Manchester disc does not have exact Scandinavian parallels, but the arrangement of four circular fields is a familiar Terslev

Fig. 3.24 Silver Terslev-ornamented disc, Manchester.

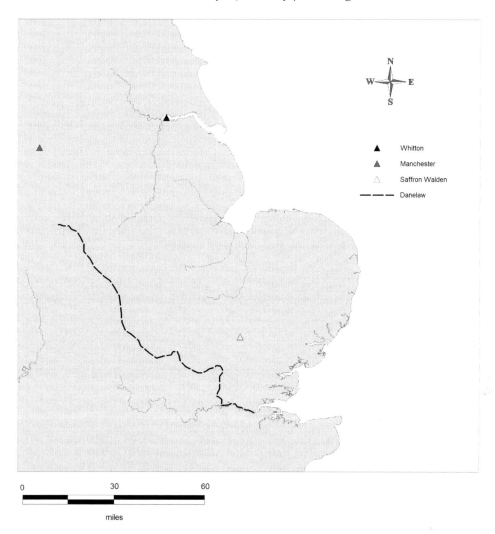

Map 3.8 Silver Terslev-ornamented brooches and pendants in England

component. Four circular fields feature on an elaborate silver disc brooch from
Hornelund, near Ribe, and on a pendant from Øster Mose, Viborg, on which
three of the fields are bound by overlying arms in a similar fashion to the Man-
chester disc (see Fig. 3.25) (Kleingärtner 2007, pl. 20e, fig. 29; Eilbracht 1999,
pl. 7, 96). The arrangement of the four volutes, the closed ring and the presence
of pellets in place of granulation are also characteristic of the classic Terslev
style, to which the Manchester disc clearly belongs. If, as is likely, the disc
originally functioned as a brooch, it can be ascribed a Scandinavian origin,
since its domed form is atypical of brooches of Anglo-Saxon origin.

Fig. 3.25 Scandinavian filigree pendant, Øster Mose, Denmark (after Eilbracht 1999, pl. 7, 96).

A second silver disc brooch, from Whitton, Lincolnshire, is cast in very deep relief in an attempt to imitate the relief decoration of filigree and granulation brooches (cat. no. 323). Its ornament, incised with notches in imitation of filigree, comprises a central triangle and three volutes, bound by a double-contoured bow-sided triangle. Within the triangle, a band bunches at intervals between each volute (see Colour Plate 4). The Whitton brooch does not have an exact Scandinavian counterpart, but its central triangle, bow-sided frame and tri-volute pattern relate it to an established composition carried on artefacts from eastern Scandinavia and Russia, as well as on patrices from Hjørring and Lake Tissø, Denmark (Kleingärtner's Type 'Dreipass', here coined Type VIII, see Fig. 3.40) (Kleingärtner 2007, 64–5, map 11). The bunching of the inner band finds parallels in the design of applied gold-filigree wires on a finely worked silver pendant from the hoard from Vester Vedsted, Ribe (see Fig. 3.26) (Eilbracht 1999, cat. no. 95). Despite the lack of an exact Scandinavian counterpart, there can be little doubt that the Whitton brooch is Scandinavian in origin, as its convex form, double pin-lug and attachment loop indicate.

Two gilt silver pendants recovered from an inhumation from Saffron Walden, Essex, are perhaps the best known Terslev-ornamented jewellery items from England and have generated considerable academic interest since their recovery in 1876 (cat. no. 324) (see Colour Plate 5). The pendants' designs are so similar as to suggest production from the same model. They comprise a core motif of four volutes bound by an inner circle and linked by a square frame, features which relate it to a composition well known on filigree and granulation products from southern Scandinavia, coined here Type II (Kleingärtner's 'Haupptyp 2' (See Fig. 3.29)) (Kleingärtner, however, assigns it to her 'Typ 3'; 2007, 63). In addition, and in contrast to the true Type II motif, the ornament consists of a central sunken annulet contained within an inner bow-sided central square, to which it is bound by four 'arms'. At each corner the outer square frame is joined to the pendant edge by a triquetra knot; these knots alternate with trilobate features and their attendant pellets to form part of an elaborate border scheme. A notable feature of the pendants is the paired animal feet, which extend from each volute and turn outwards (Paterson 2002, 272).

Fig. 3.26 Silver pendant, Vester Vedsted, Ribe, Denmark (after Eilbracht 1999, pl. 7, 95).

Caroline Paterson's recent discussion of these pendants established on the basis of their design irregularities that they are most likely to have been produced in the British Isles, as originally suggested by David Wilson (Richardson 1993, 28; Paterson 2002, 272; Wilson 1976, 507). For instance, the elaborate border scheme is atypical of Scandinavian pendants, although it does find parallels on a Scandinavian belt slide from Wharram Percy, Yorkshire (Paterson 2002, 272; see Fig. 5.8). Despite the fact that these items are likely to have been manufactured in England, they exhibit strong Scandinavian influence in their overall design. There are, for instance, clear Scandinavian parallels for the appearance and positioning of the animal feet and triquetra knots, as on a silver disc brooch from Erikstorp, Sweden (Kleingärtner 2007, fig. 15, 1b).

Further evidence for strong Scandinavian influence over the pendants rests in their volute design, composed of three equally-sized bands with diagonal hatching in imitation of filigree. As noted by Eilbracht, such imitation work would have required the use of a Scandinavian filigree model (1999, 144–5). On jewellery found in Scandinavia, the use of three filigree wires is typical, but rather than conforming to equal sizes as on the Saffron Walden pendants, the three wires usually comprise a central thick wire, flanked by two thinner wires. This pattern indicates that the design of the Saffron Walden pendants is likely to have been altered (Eilbracht 1999, 145).

A further important element of the Saffron Walden pendants concerns the ornament contained within their barrel-shaped suspension loops. This decoration is said by Paterson to comprise pairs of stylized feet, which she notes is unique, as the suspension area is usually adorned with spirals, knots, or *en-face* animal heads (2002, 272). However, the feet are curved inwards, with a scroll-like appearance; combined with the extended volute neck, from which the feet

emanate, and the elongated central field which divides them, they generate a schematic bird mask. In such a composition, the scrolled feet make up the bird's eyes, the extended volute its neck, and the central panel its nose.

This composition finds parallels among the gold bird-shaped pendants, with elaborate bird-head suspension loops, from the Hiddensee hoard, Rügen (Armbruster and Eilbracht 2006; Kleingärtner 2007, 83–7). Such pendants were produced in Viking-Age Denmark, as well as in the northern Danelaw, as attested by the recovery of a bird-shaped bronze die, used in the manufacture of filigree and granulation pendants, from Swinhope, Lincolnshire, and a lead patrix for the production of moulds for similar dies, from York (Naylor et al. 2009, 337; Roesdahl et al. 1981, YMW 13). Objects such as these suggest the availability of bird-shaped pendants in the Danelaw and raise the possibility that finished objects provided the inspiration for the Saffron Walden detail.

Copper and lead-alloy brooches and pendants (Type I)

More common in England are simpler disc brooches and pendants in base metals: copper- and lead-alloys. Twenty-eight examples are currently recorded, including two pendants (cat. nos. 325–53) (see Map 3.9). A motif labelled here as Type I (Kleingärtner's 'Grundtyp 1'), comprising four volutes bound by a square frame and a central field divided into quadrants, was produced on a serial scale at Hedeby (see Fig. 3.27) (Kleingärtner 2007, fig. 8, cat. nos I.19–I.24, map 7). In England, the design is carried on five disc brooches, a figure which almost doubles the total number of Type I brooches on record (cat. nos. 325–9). Stylistically, these items are identical to their counterparts across the North Sea, with two brooches from Norfolk displaying pellets in the centre of their volutes, a feature encountered on select disc brooches of this type found in Scandinavia (cat. nos. 327, 329) (see Fig. 3.28). In addition, all objects bear Scandinavian-type pin-fittings, including, in four instances, an attachment loop. This, together with their convex form, identifies the group as Scandinavian in origin.

Fig. 3.27 Terslev Type I motif (drawing by Holger Dieterich, after Kleingärtner 2007, fig. 8).

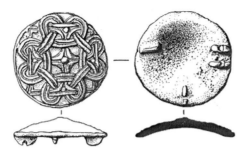

Fig. 3.28 Disc brooch from Thurlton, Norfolk, with the Terslev Type I motif, drawn by Sue White © Norfolk County Council.

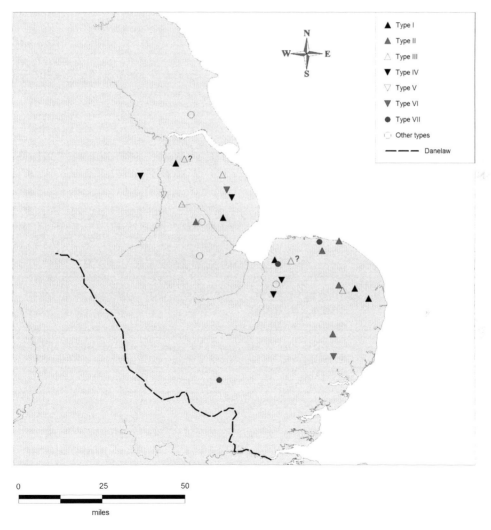

Map 3.9 Copper- and lead-alloy Terslev-ornamented brooches and pendants in England

Type II

The Type II motif (Kleingärtner's 'Haupttyp 2') comprises a central lozenge sur-rounded by four volutes, each overlain by a solid triangular 'arm' (see Fig. 3.29) (Kleingärtner 2007, 61–2, fig. 9). In England, the design appears on a pendant from Kirkby Green, Lincolnshire (cat. no. 330) (see Fig. 3.30). Two pendants, from Postgården and Lake Tissø, Denmark, provide exact Scandinavian counter-parts to the Kirkby Green item, which can be assigned to the same, small, pendant series (Arkæologiske udravninger i Danmark 1990, 188; Jørgensen and Pedersen 1996, fig. 8). These two objects are the only Type II cast objects recorded within Scandinavia, making it all the more notable that the design occurs on three further brooches from England, all identified as Anglo-Scandinavian products due to their flat form and pin-fitting arrangement (cat. nos. 331–2, 334). One brooch, from Braiseworth, Suffolk (cat. no. 334) carries a bold design which resembles the outline patterns of bronze patrices used in the production of relief-decorated disc-shaped jewellery (Capelle and Vierck 1975, figs. 1–2). These parallels suggest the intriguing possibility that the Braiseworth brooch was produced by a craftsman who had seen such a patrix and copied the outline pattern across to the brooch.

Type III

A closely related motif, which differs in that the four volutes are bound by an inner circle, rather than a square frame, is carried on brooches of Type III (Kleingärtner's 'Typ 3') (Fig. 3.31) (Kleingärtner 2007, 62–3, fig. 10). Within Scandinavia, this composition is carried exclusively on filigree and granulation objects, making four Anglo-Scandinavian brooches from England with related designs unique (cat. nos. 335–8). The motif carried on a lead-alloy brooch, said to come from Lincoln, offers a good example of the Type III design, which dif-fers slightly in that its volutes are joined to the brooch rim by pellet-filled 'arms' (cat. no. 335). This feature appears on other Terslev compositions, for instance, on pendants of Type VI (Kleingärtner's Type 'Stora Ryk'), an example of which is also recorded from England (cat. no. 344). In common with other Terslev imitations, the Lincoln brooch uses cast pellets to emulate granulation, although its flat form ultimately suggests that it is an Anglo-Scandinavian product.

A further example of a Type III variant is an unusually large (42 mm in diameter) unprovenanced lead brooch, now in the British Museum (cat. no. 338). This item has four volutes bound by an irregular closed ring, which has additional triangular extensions (Paterson 2002, 270–1) (see Fig. 3.32). The volutes enclose a central lozenge field, infilled with cast pellets; unusually, these also occur within the border and interlace. These features find parallels on a disc brooch from Birka (Jansson's Type III B), but the brooch's design irregu-larities and its heavy use of pellets within the interlace mark it out as a hybrid product, its large size presumably reflecting the ninth-century Anglo-Saxon tra-dition for large disc brooches.

Fig. 3.29 Terslev Type II motif (drawing by Holger Dieterich, after Kleingärnter 2007, fig. 9).

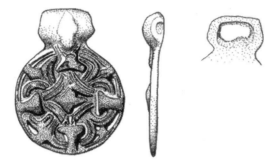

Fig. 3.30 Pendant from Kirkby Green, Lincolnshire, with the Terslev Type II motif © Kevin Leahy.

Type IV

A further motif, termed here Type IV (Kleingärtner's 'Typ 4'), consists of four volutes linked by a square frame and overlain by pellet-filled lozenges (see Fig. 3.33) (Kleingärtner 2007, 63–4, fig. 11). It appears to have been popular within Scandinavia, where thirty-three brooches with the motif have been recorded to date (Kleingärtner 2007, cat. nos. I.28–51, I.53–63). In Scandinavia, Type IV

Fig. 3.31 Terslev Type III motif (drawing by Holger Dieterich, after Kleingärtner 2007, fig. 10).

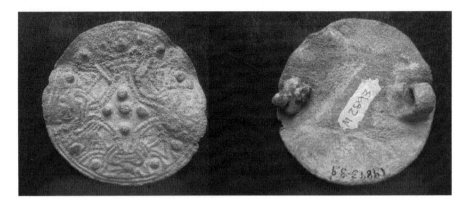

Fig. 3.32 Lead-alloy disc brooch with a variant of the Terslev Type III motif © the Trustees of the British Museum.

compositions include either a central rosette or lozenge and both features are represented in the English corpus (cat. nos. 339–42). Uncharacteristically, the flat surface of these brooches is also a feature of Scandinavian brooches of this type, an inheritance, perhaps, from the original association of this motif with flat pendants in Scandinavia (Richardson 1993, 51).

In England, this group of objects (none of which could be reproduced here) is relatively diverse, which may imply that many more objects than the four on record here originally circulated in England. Only one item, from Ketsby, Linconshire, can be assigned to a Scandinavian origin on the basis of its style and attachment fittings (cat. no. 339). The other three items all possess somewhat different pin-fitting arrangements. For instance, a brooch from Bawtry, Yorkshire, displays the common Anglo-Scandinavian arrangement of a single transverse pin-lug and hooked catchplate (cat. no. 342), while an item from Wereham, Norfolk, possesses, unusually, a Scandinavian-type pin-lug and an insular catchplate (cat. no. 341) (Richardson 1993, 24–5). The design of these Anglo-Scandinavian brooches is close in style to the composition carried on Scandinavian brooches of the type, with the exception of some irregularities in the volute pattern of the Bawtry brooch.

Type V

Several other geometric Borre-style compositions recorded in England are known, including those classified by Kleingärtner as types 'Local Variant Birka', 'Stora Ryk', and 'Uppåkra' (Jansson's Type III C), here relabelled Types V, VI, and VII respectively. Type V (see Fig. 3.34) has just one representative from England, a lead-alloy Anglo-Scandinavian disc brooch from Torksey, Lincolnshire, with four unevenly-spaced Terslev-type volutes (cat. no. 343) (Fig. 3.35).

Fig. 3.33 Terslev Type IV motif (drawing by Holger Dieterich, after Kleingärtner 2007, fig. 11).

The volutes are bound by an irregular square frame, which passes under the centre of each volute, unlike in the main Type V composition, in which it lies over their centres. At just under 36 mm in diameter, this brooch is unusually large; this feature, together with the brooch's flat form and design irregularities, points to its Anglo-Scandinavian origins. Within Scandinavia, Type V motifs are encountered only on jewellery executed in filigree and granulation. The lack of Scandinavian cast variants of the type make the Torksey brooch unique, and may suggest that it was modelled on a Scandinavian filigree prototype which circulated in England.

Type VI

A pendant from Tathwell Louth, Lincolnshire, bears a motif related to, but distinct from, the true Terslev style, consisting of a central concave-sided trefoil with splayed 'arms' and three volutes, here coined Type VI (see Fig. 3.36) (cat. no. 344). It belongs to a pendant series otherwise found exclusively in southern Sweden and Denmark (Callmer 1989, 23, fig. 3:30, Type 'Stora Ryk'). In England, a variant of the motif, with no known Scandinavian counterparts, appears on a disc brooch from Hemingstone in Suffolk (cat. no. 345) (Geake 2004, fig. 3d). This brooch displays a similar arrangement of volutes, which interlace with the three solid arms that emerge from the brooch rim (see Fig. 3.37). However, the central concave-sided triangle has been replaced by a central sunken annulet, set within

Fig. 3.34 Terslev Type V motif (drawing by Holger Dieterich, after Kleingärtner 2007, fig. 12).

Fig. 3.35 Disc brooch from Torksey, Lincolnshire, with a variant of the Terslev Type V motif © Kevin Leahy.

a ringed circle. Only remnants of the splayed arms of the triangle are present, in three truncated rectangular lobes, which extend to the brooch rim in between each volute (Geake 2004). The replacement of the triangle by a sunken annulet is of interest given the appearance of a similar feature on two pendants from Saffron Walden and the mass-produced East Anglian disc brooch series, and hints at a fusion of Anglo-Saxon and Scandinavian designs. This is confirmed by

Fig. 3.36 Terslev Type VI motif (drawing by Holger Dieterich, after Kleingärnter 2007, fig. 6).

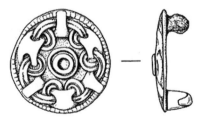

Fig. 3.37 Disc brooch from Hemingstone, Suffolk, with a variant of the Terslev Type VI motif © Suffolk County Council.

the brooch's slightly convex form and its use of both insular and Scandinavian-type pin-fittings. The exclusive appearance of the Type VI motif on pendants in Scandinavia strengthens the likelihood that the Hemingstone brooch is a product of Anglo-Scandinavian interaction, probably produced in a Danelaw workshop.

Type VII

An unprovenanced brooch from the North Lincolnshire region carries a motif of two symmetrical inward-facing volutes, bound by a square frame (cat. no. 347). This motif identifies the brooch with the composition Type VII, which is again related to, rather than representative of, Terslev (see Fig. 3.38) (Kleingärtner's Type 'Uppåkra': 2007, 55–7, fig. 4; Capelle 1999, 222, fig. 2). The domed shape of the North Lincolnshire brooch and its Scandinavian-type pin-fitting suggest its Scandinavian origin. In England, the motif also occurs on three further brooches, one example of which, from Bygrave, Hertfordshire, represents a rare, non-Danelaw, find (cat. nos. 346, 348–9) (see Fig. 3.39).

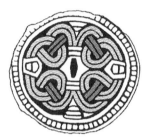

Fig. 3.38 Terslev Type VII motif (drawing by Holger Dieterich, Kleingärnter 2007, fig. 4).

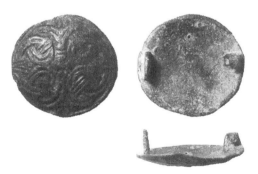

Fig. 3.39 Disc brooch from Bygrave, Hertfordshire, with a variant of the Terslev Type VII motif © Portable Antiquities Scheme.

Other geometric compositions

Two lead-alloy items—a disc from Beverley, Humberside, and a brooch from Pointon, Lincolnshire—represent local variants of Scandinavian Terslev compositions (cat. nos. 350, 353). Both objects carry ornament consisting of three Terslev-type volutes, linked by a triangular frame. Although the composition of three volutes is established in the Terslev repertoire, for instance, in the Type VIII variant (see Fig. 3.40), the Danelaw items depict simplified and somewhat clumsy compositions (Kleingärtner 2007, 64–5, fig. 13). The relationship between a volute and the frame on the Pointon brooch is misunderstood, resulting in the appearance of a pair of side-loops, while the central field is an uneven lozenge shape. The pin-fittings on the reverse of this brooch originally consisted of Scandinavian H-shaped lugs, but at a later stage the lugs have been folded over to create a pin-fitting more in keeping with Anglo-Saxon traditions. It appears that a craftsman working in an insular workshop has made a concerted effort to copy a Scandinavian prototype, with limited success.

The Beverley disc also betrays Anglo-Scandinavian origins, this time in its under-developed volutes and in the discontinuity of its triangular frame. It is best considered a simplified version of the Terslev style (Richardson 1993, 80–1). Interestingly, its ring-knot pattern finds parallels on local sculpture, in the tri-volute interlace motif inscribed on a cross head from St Mary Castlegate in York, on fragments now in the Yorkshire Museum (Armstrong et al. 1991, 155; Wenham 1987, 158, fig. 38, b and c). It may also be paralleled on the Whitton brooch, an indication, perhaps, of the regional currency of the tri-volute motif. The Beverley disc does not retain evidence of pin-fittings and its find context suggests its use as scrap metal. It has a perforated centre, possibly indicating reuse as a mount.

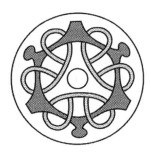

Fig. 3.40 Terslev Type VIII motif (drawing by Holger Dieterich, after Kleingärnter 2007, fig. 13).

Table 3.5 Summary of geometric Borre style brooches and pendants from England

	I	II	III	IV	V	VI	VII	Other	**Total**
Scandinavian	5	2	0	1	0	1	1	4	**14**
Anglo-Scandinavian	0	3	4	3	1	1	3	4	**19**
									33

Trefoil brooches

Trefoil brooches were one of the most characteristic items of female dress in Viking-period Scandinavia. They took their form from Carolingian trefoil-shaped baldric mounts, imported from Carolingian Europe to the Scandinavian homelands as items of trade or loot in the ninth century (Graham-Campbell 1980, no. 328; Wamers 1985, pl. 39). Within Scandinavia, these mounts were widely copied as brooches and worn by women; their elaborate Carolingian plant ornament gradually being replaced by stylized foliates, as well as zoomorphic and interlace motifs characteristic of Scandinavian art (Petersen 1928, 93).

Viking-Age trefoil brooches are widely distributed within Scandinavia. They appear in particularly high numbers in the area of Viking-Age Denmark, where imported Carolingian mounts are similarly concentrated (Maixner 2005, 11–16, fig. 1). Numerous trefoil brooch mould fragments have been recovered at Hedeby, indicating the manufacture of a variety of trefoil types at the site (Maixner 2005, 64–82). The distribution of trefoil brooches within Scandinavia varies according to style. For instance, large trefoils decorated with Borre-style zoomorphic ornament are mainly found in Norway. They are less common in Denmark, where smaller brooches with simple, geometric ornament are the most common trefoil type (Maixner 2005, figs. 11 and 12). As the following discussion suggests, trefoil brooches found in England are predominantly paralleled by finds from southern Scandinavia. They encompass a wide range of different types, recently classified by Birgit Maixner, whose typology is adopted here (2005).

To date, seventy-three trefoil brooches have been found on English soil (cat. nos. 354–427). These items exhibit a broad repertoire of geometric, interlace, foliate, and zoomorphic motifs, reflecting an artistic diversity similarly characteristic of trefoil brooches found in Scandinavia. In addition, they introduce 'new' varieties, not currently recorded within Scandinavia (see Table 3.6). Together with their heterogeneity, trefoil brooches from England are characterized by poor preservation and fragmentary survival, their lobes being particularly vulnerable to breakage. The incomplete form of many surviving trefoils prevents analysis of their attachment fittings and other culturally diagnostic features, rendering cultural attributions impossible in many cases.

Trefoil brooches with plant ornament (Type P)

Large trefoil brooches with plant ornament are a southern Scandinavian brooch type with a distribution in England, particularly Norfolk (Maixner 2005, fig. 12, maps 1–9, for up-to-date Scandinavian distribution maps) (see also Map 3.10). Within Scandinavia, plant ornament on trefoil brooches takes one of two forms: naturalistic acanthus in imitation of Carolingian foliates, occasionally combined with Borre-style animal motifs, and a more stylized vine-scroll, which also has Western European prototypes. Both forms are also present in England (cat. nos. 354–60).

The best known of these is an antiquarian find from Lakenheath Warren in Suffolk (cat. no. 356) (see Fig. 3.41). This brooch has a concave-sided triangle in the central field, the three corners of which are marked by inward-facing animal masks characteristic of the Borre style, with beady eyes and rounded ears and snouts: a common feature of Scandinavian trefoils with zoomorphic or plant motifs. The decoration in each lobe consists of three tiers of scroll, bound both at the stem and to each other, with paired volutes curling in alternate directions. The Lakenheath Warren brooch, with a typical Scandinavian form of pin-lug, catchplate, and attachment loop, represents a rare Scandinavian trefoil type. It has counterparts in just two Scandinavian trefoils, of Type P 4.2, recently recovered at Lake Tissø in Denmark (Maixner 2005, cat. nos. 57–8). Given its Scandinavian features and the rare occurrence of Type P 4.2s in Scandinavia, the Lakenheath brooch was most probably produced in Scandinavia, and imported to England. The same is probably true of a second Type P 4.2 trefoil from England, from Taverham in Norfolk (cat. no. 355), which survives only as a single lobe.

Stylized vine scrolls appear on two further trefoil brooch fragments, both consisting of the tips of broken lobes: from Bawburgh and Thurlton in Norfolk (cat. nos. 354, 360). The Bawburgh fragment carries a horizontal bar, flanked by two attendant loops. Two outer stems terminate in volute spirals while two inner stems, bound by another bar, emanate tendrils. It is paralleled by just one Scandinavian trefoil brooch, from Vindblæs, Denmark (Maixner 2005, cat. no. 27, pl. 2). This counterpart designates the Bawburgh fragment a Type P 2.4 trefoil of probable Scandinavian origin, although, given that no attachment fitting survives, its cultural origins cannot be established for certain. The decoration on the Thurlton piece consists of a line of four pellets, above which are two closed scrolls with central pellets, and a drop-pendant (Hattatt 2000, 380, fig. 125, no. 1422). It does not fit clearly within Maixner's typology, and introduces a further Type P subtype, as yet unknown in the Scandinavian homelands.

A large trefoil brooch from Colton, Norfolk, carries acanthus motifs, rather than scroll (cat. no. 357) (see Fig. 3.42). Dense foliage springs from four symmetrically-positioned acanthus plants, bound at the stem, to fill each lobe, a design which finds close parallels with Type P 5.1 brooches from eastern and southern

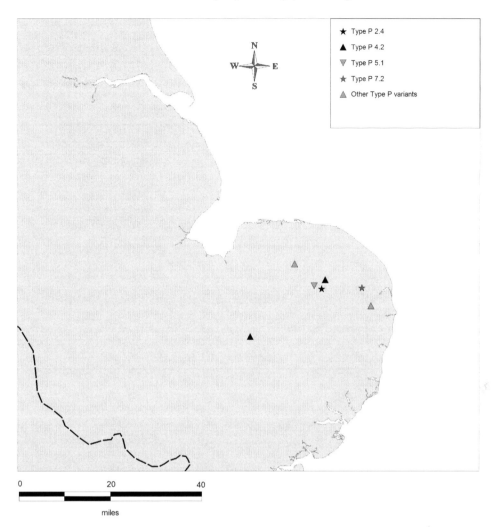

Map 3.10 Type P trefoil brooches in England

Sweden, areas of Norway and modern-day Denmark (Maixner 2005, map 5). Like some trefoil brooches with acanthus ornament found in Scandinavia, the Colton brooch also carries Borre-style elements, most notably in the outward-facing animal-heads at the tip of each lobe, but also in the overlying bands which restrain the plant ornament and bind the foliates to the brooch edge. Two further trefoil brooch fragments from England also carry acanthus ornament (cat. nos. 358–9). One item, which survives only as a single lobe, displays a central oval field and radiating acanthus ornament (cat. no. 358). This design is characteristic of group P 7.12 brooches, represented in Scandinavia by just one brooch from Kirke Hyllinge, Denmark (Maixner 2005, cat. no. 172).

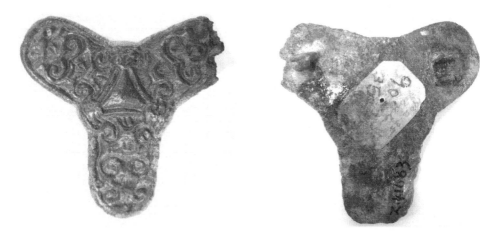

Fig. 3.41 Naturalistic plant-ornamented trefoil brooch, Lakenheath Warren, Suffolk © Suffolk County Council.

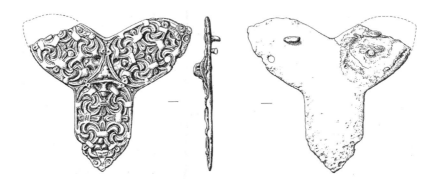

Fig. 3.42 Scroll-ornamented trefoil brooch, Colton, Norfolk, drawn by Sue White © Norfolk County Council.

Trefoil brooches with geometric decoration (Type G)

The most common trefoil brooch type from England is a small trefoil with a central triangular field and lobes decorated with stylized acanthus ornament set within a double-contoured border: Maixner's Type G 1.3 (Maixner 2005, pl. 7, G 1.3) (see Fig. 3.43). When found in England, this group of trefoils is frequently assumed to represent a 'second-generation', Anglo-Scandinavian product—the crude appearance of the schematic acanthus ornament suggesting the devolution of brooch ornament from more ornate Scandinavian designs (for instance, Ashwin and Davison 2005, 56). In fact, these trefoils are the most common sub-type recorded from southern Scandinavia: forty-four examples are currently known, mainly from the area of Viking-Age Denmark (Maixner 2005, cat. nos. 192–235, map 13) (see also Map 3.11). In England, forty-three examples are recorded, a figure which almost doubles the size of the former

corpus (see Map 3.12). Unfortunately, the fragmentary condition of many examples from England makes them difficult to classify as Scandinavian or Anglo-Scandinavian. Many items lack the pin-fittings necessary for such diagnosis, for instance, or are missing one or more lobes. In the latter case, this makes it difficult to test for the presence of a distinct morphological trait of G 1.3s from Scandinavia, namely the misalignment between the trefoil lobe which carries the catchplate and the central triangular plate (Maixner 2005, 123).

It is nonetheless possible to observe a few interesting trends among a subset of twenty-two trefoil brooches from England which survive in more or less complete forms. A group of six Type G 1.3 trefoils, coined here Type G 1.3 A, share the design irregularity observed on Scandinavian examples of the mis-aligned lobe (cat. nos. 361–3, 369, 384, 397). The central panels of these brooches are decorated with stamped ring-dots, a type of decoration which is not normally employed by Anglo-Saxon metalworkers in the ninth and tenth centuries, but which is found on a subset of trefoil brooches of this type within Scandinavia (Maixner's subgroup G 1.3 Ia) (Maixner 2005, 123–4) (see Colour Plate 6). Of the five brooches which retain evidence for attach-ment fittings, all carry an H-shaped lug positioned at the junction of two trefoil arms, mirroring the form and position of the pin-lug found on Scandi-navian geometric trefoils. In each case, however, this Scandinavian lug is twinned with an Anglo-Saxon type C-shaped catchplate. The use of an Anglo-Saxon catchplate indicates that these brooches were, in fact, produced in workshops in England, despite the fact that, to viewers, they would have looked wholly Scandinavian.

Since these brooches replicate the design flaws of Scandinavian trefoils, it seems probable that they were manufactured using an existing Scandinavian trefoil brooch as a model for new clay moulds. This implies that Scandinavian trefoils were available to, and used by, craftsmen working in workshops in the Danelaw. Two further Type G 1.3 brooches from England are contenders for

Fig. 3.43 Geometric trefoil brooch, Hedeby, Schleswig-Holstein (Type G 1.3) © author.

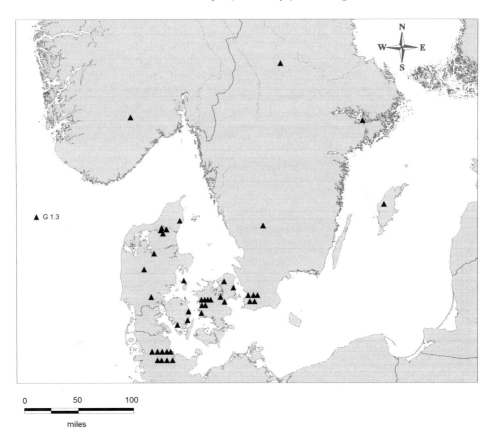

Map 3.11 Type G 1.3 trefoil brooches in Scandinavia

Scandinavian brooches on the grounds of their distinctive lobe shapes and surface ornament (cat. nos. 388, 393). One brooch, from Paston, Norfolk, carries a Scandinavian double H-shaped pin-lug, positioned at the junction of two lobes, while its surface ornament is distinguished from other G 1.3s by a triquetra knot which appears in its central panel (cat. no. 388). This decorative motif identifies the fragment with Scandinavian trefoils of Maixner's group G 1.3 1b, examples of which are recorded from Denmark (Maixner 2005, cat. nos. 206, 210, 212–13, 215, 222, 224–5, 228, 230). The partial survival of the Paston piece means that it cannot be ruled out as an Anglo-Scandinavian copy, but its status as a Scandinavian product seems likely: it is the only example of its type recorded in England, suggesting that the variant was not serially copied in workshops in the Danelaw.

Despite evidence for the presence in England of Scandinavian Type G trefoil brooches, available evidence suggests that Anglo-Scandinavian examples outnumbered their Scandinavian counterparts. A further group of twelve

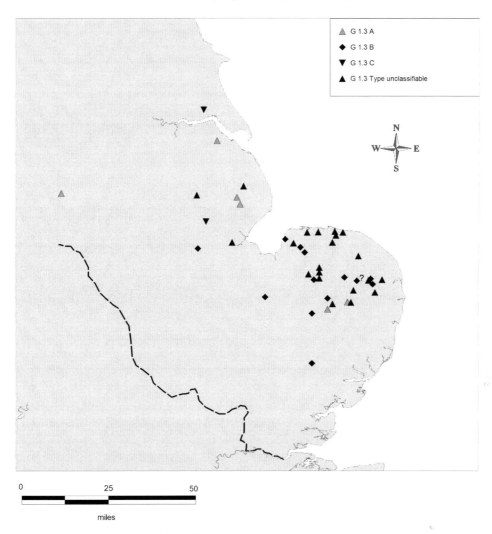

Map 3.12 Type G 1.3 trefoil brooches in England

brooches, which we may term Type G 1.3 B, have correctly-aligned lobes and an Anglo-Saxon pin-lug, but, unusually, a Scandinavian-type catchplate (cat. nos. 365, 373, 380–1, 387, 389, 392, 395–6, 399, 401, 403). Unlike the brooches described above, there does not appear to have been an established pattern to the positioning of the pin attachments: the pin-lug could occur at the junction of two lobes (for instance, cat. nos. 380–1), or in the centre of one lobe with the catchplate aligned opposite (for instance, cat. no. 395). This group lacks the stamped ring-dot ornament carried on Scandinavian trefoils. Combined, these traits suggest that this group of trefoils circulated as a separate, local series.

Two further geometric trefoils from England belong to a third subgroup, Type G 1.3 C (cat. nos. 366, 404). They display a combination of features from the two main types, including stamped-ring dots and an Anglo-Saxon type of pin-lug positioned at the junction of two trefoil lobes. Their distinguishing feature is the low relief of their ornament and their thin form. They would appear to have been produced using existing brooches, most probably G 1.3 As, as models. Their Anglo-Saxon pin-lugs set them apart from group A brooches, however, confirming their separate production.

Trefoil brooches with Borre-style interlace (Type E)

In England, four trefoil brooches are ornamented with Borre-style interlace, a form of decoration mainly encountered on trefoil brooches from Denmark (cat. nos. 405–8) (Maixner 2005, fig. 12, maps 14–18) (see also Map 3.13). One Scandinavian example, with a double pin-lug, catchplate, and an attachment loop, comes from Hindringham, Norfolk (cat. no. 407) (see Fig. 3.44). It displays a central concave-sided trefoil with a raised boss and decorative pellets. This feature truncates the double-contoured bands of Borre-style ring-knot which fill each lobe, creating an oval field filled with pellets. This scheme assigns the brooch to the rare Scandinavian Type E 1.3, known only from Kaupang, Norway, and Skåne, Sweden (Maixner 2005, cat. nos. 313–4). A second, fragmentary trefoil from Aylesby, Lincolnshire, is decorated with Borre-style ring-chain characteristic of trefoils of Type E 2.1 (cat. no. 408). Scandinavian counterparts are known from Uppåkra, Lake Tissø, and Lejre, among other locations (Maixner 2005, cat. nos. 332–41).

A related motif, distinguished by the appearance of a bifurcating rib of truncated triangles in the central field, occurs on another Scandinavian trefoil brooch from Maltby, South Yorkshire (cat. no. 406). This brooch belongs to the populous Scandinavian trefoil Type E 1.2, with a predominantly Danish distribution (Maixner 2005, cat. nos. 284–306). The presence in England of a Scandinavian Type E 1.2 trefoil is of note since a further brooch, from Carlton Colville, Suffolk, displays schematic ornament related to the variant (cat. no. 405) (Margeson 1982, 109, fig. 4b). Despite the poor quality of the design on this item, the brooch possesses a typical Scandinavian arrangement of attachment fittings, including the remains of an attachment loop for a chain. The item is therefore likely to have been produced in an Anglo-Scandinavian context, perhaps using a Scandinavian Type E 1.2 brooch as a model.

Trefoil brooches with zoomorphic and interlace ornament (Type F)

Two trefoil brooches found in English soil combine geometric and zoomorphic motifs characteristic of the Borre style and can thus be assigned to Maixner's Type F (cat. nos. 409–10) (Map 3.13). Within Scandinavia trefoils of this type

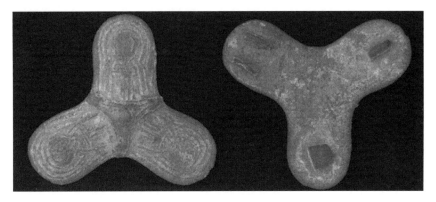

Fig. 3.44 Type E trefoil brooch, Hindringham, Norfolk, photo by Norwich Castle Museum © Norfolk County Council.

are geographically widespread, yet relatively rare, comprising just 7 per cent of all recorded finds (Maixner 2005, figs. 10 and 12). One example from England comes from Bures Hamlet in Essex (cat. no. 410) (see Fig. 3.45). It has a raised triquetra knot in the central field, from behind which three animal feet extend to grip the side of the brooch, at the junction of each lobe. The trefoil lobes are filled with contoured Borre-style ring-knot which terminates in confronting volute-spirals. This brooch belongs to Maixner's Type F 3.1, a series otherwise found exclusively in eastern Sweden (Maixner 2005, pl. 10, F 3.1; Hårdh 1984, 89, fig.10:1, 2). Notably, it shares with the Swedish brooches an unusual pin-lug arrangement in which the pin was fastened to the right, a feature which affirms its eastern Scandinavian origin (Maixner 2005, map 22, fig. 26, D2). A second brooch, a silver item with rivets indicating repair in antiquity, comes from Thetford, Norfolk (cat. no. 409). It has distinctive, pointed trefoil lobes, filled with double-contoured interlace and animal masks typical of the Borre style. Both the shape of the brooch and its double pin-lug, suggest its Scandinavian origin, although no exact Scandinavian counterpart presents itself.

Trefoil brooches with Borre-style zoomorphic ornament (Type Z)

Within Scandinavia, trefoil brooches with pure zoomorphic ornament, Maixner's Type Z, are encountered in Norway as well as Denmark (Maixner 2005, figs. 11–12). Here, at Hedeby, numerous mould fragments attest the serial manufacture of numerous variant types (Maixner 2005, cat. B. LII–LXVI). With their complex Borre-style ornament and large trefoil shapes, these brooches represent an overtly Scandinavian fashion—all four examples from England are likely to have been imported from the Scandinavian homelands (cat. nos. 411–14) (Map 3.13). An antiquarian find from Pickering belongs to Maixner's Type Z 1.5 (cat. no. 412). It depicts three Borre-style animal heads

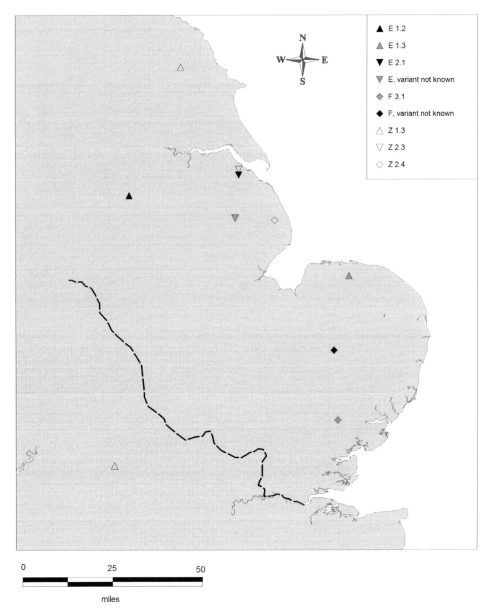

Map 3.13 Type E, F, and Z trefoil brooches in England

which flank the sides of a central triangular feature and turn outwards, towards the trefoil lobes. The lobes themselves are filled with the looping, hatched body of the gripping-beast, whose feet grip the edges of the brooch, as well as itself. The Scandinavian origin of this brooch is attested in the tinning on the reverse of the brooch, as well as in its fastening mechanisms, which include a loop with the remains of an iron chain. A second example of the same brooch type comes,

Fig. 3.45 Type F trefoil brooch, Bures Hamlet, Essex © Suffolk County Council.

unexpectedly, from Bampton, Oxfordshire (cat. no. 411). It too was originally gilded and retains a double, H-shaped lug for a pin.

A further brooch, found in Stallingborough, Lincolnshire, but now lost, has gripping-beast ornament which assigns it to the brooch group Z 2.3, a western Scandinavian brooch type known only from Norway and Iceland (Maixner 2005, cat. nos. 479–81) (see also Fig. 3.46) (cat. no. 413). It has a number of distinctive features, including a rare, U-shaped pin-lug form (Leahy and Paterson 2001, 194). This type of lug is found mainly on trefoil brooches from Norway, confirming the western Scandinavian origins of the piece (Maixner 2005, 53, pl. 53, 7 and 9). Notably, the brooch also possesses a central, trilobate stud which obscures some of the Borre-style decoration. The stud is likely to represent a secondary addition to the brooch, and may be of Carolingian inspiration; similar studs appear on a trefoil brooch with vine-scroll ornament

Fig. 3.46 Type Z trefoil brooch, Stallingborough, Lincolnshire © Kevin Leahy.

from Mosanes, as well as on a Carolingian mount from Hoen, both in Norway (Wilson and Klindt-Jensen 1966, pl. xxxii, f–g; Leahy and Paterson 2001, 194).

Just one trefoil brooch found in England displays combined Borre- and Jellinge-style zoomorphic decoration. This item, from Alford, Lincolnshire, carries interlace representing an animal as viewed from above, with an outward-facing animal mask, pelleted neck, and a double-contoured, looping body with spiral hips and clawed feet (cat. no. 414). While the animal mask and the balanced composition of the motif are characteristic of the Borre style, the double con-toured body, spiral hips, and clawed feet are typical Jellinge-style traits. These features assign the brooch to the transitional Borre/Jellinge trefoil brooch type Z 2.4 (Maixner 2005, map 25).

Devolved trefoil brooch types (Type D)

The final group of trefoil brooches found in England display highly debased versions of designs carried on Scandinavian trefoils (cat. nos. 415–21) (Map 3.14). These brooches, most of which survive only as single lobes without evidence for

Fig. 3.47 Type D (I) trefoil brooch fragment, Bloxholme, Lincolnshire © Kevin Leahy.

Fig. 3.48 Trefoil brooch fragment with overlying 'arms', Lake Tissø, Denmark (after Maixner 2005, pl. 37, 7).

Fig. 3.49 Type D (II) trefoil brooch fragment, Kirmington, Lincolnshire © Kevin Leahy.

pin-fittings, may be broadly classified as devolved types. They are of probable Anglo-Scandinavian manufacture, although some of their stylistic features are paralleled in Scandinavia. Three trefoils bear such similar decoration and dimensions as to suggest production from the same model (subtype I) (cat. nos. 415–16, 421). They display a triple-contoured border, bound on the sides and terminal end of each lobe with a solid, overlying arm (see Fig. 3.47). Within the heavy border, incised, slightly curved lines and further ring-dots generate a highly stylized pattern, reminiscent of acanthus motifs. The debased ornament on these brooches identifies them as Anglo-Scandinavian products, but the overlying arms may have been directly inspired by Scandinavian decoration. Similar arms occur on the sides of a geometric trefoil lobe from Lake Tissø, Denmark, classified by Maixner as Type G 1.4 (see Fig. 3.48) (Maixner 2005, cat. no. 247, pl. 37, 7).

Three further trefoils are distinguished by their thin and elongated lobe forms, unparalleled in Scandinavia (Type II) (cat. nos. 417–18, 420). They are decorated with a simple engraved border with incised horizontal notching running along the inner edge of the lobe and stamped ring-dots, possibly deriving from acanthus motifs (see Fig. 3.49). Although the debased appearance of such foliate decoration is not encountered on trefoils from Scandinavia, ring-and-dot ornament is a feature of some acanthus ornamented trefoils, perhaps indicating an original source for this subtype (Maixner 2005, 123–4, pls. 35, 25, and 27–8). One further lobe fragment, from Norfolk, bears a triple-contoured border enclosing what appears to be a rib of joined triangles (cat. no. 419) (Type III). A possible source of information for this item is the Borre-style ring-knot ornament carried on trefoil brooches of Type E 2.1, comprising a central rib of truncated triangles. An example of this brooch type comes from Aylesby, Lincolnshire (cat. no. 408).

Table 3.6 Summary of trefoil brooches from England

	Type P	Type G	Type E	Type F	Type Z	Type D	Unclassifiable	Total
Scandinavian	7	2	3	2	4	0	0	**18**
Anglo-Scandinavian	0	20	1	0	0	7	1	**29**
Unclassifiable	0	21	0	0	0	0	5	**26**
								73

Equal-armed Brooches

Viking-Age equal-armed brooches consist of two, usually flat, concave-sided arms of equal size, and a short, central arched plate with a hollow boss or crown (Aagård 1984, 95) (see Fig. 3.50). Evidence from burials in Scandinavia suggests that they were worn horizontally on the chest, where they

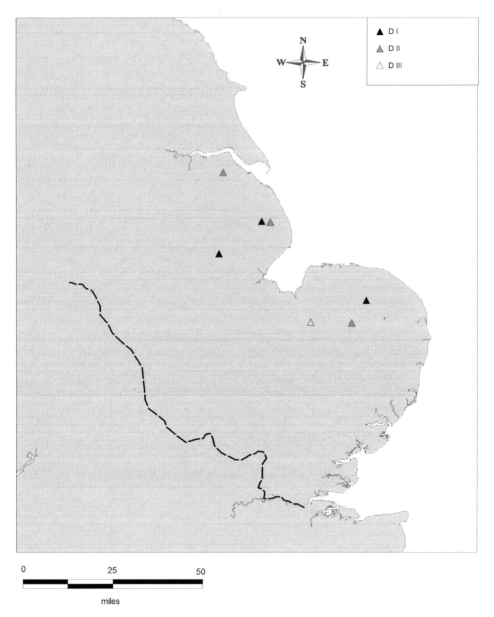

Map 3.14 Type D trefoil brooches in England

secured an outer garment (Aagård 1984, 96). In the Viking Period, they are a diagnostically Scandinavian brooch type, distinct both in shape and decorative content from other equal-armed brooches with similar constructions, such as ninth-century Continental 'Ansate' brooches (Thörle 2001).

In their decoration and form, Scandinavian equal-armed brooches are extremely diverse, a factor which undoubtedly reflects their long period of use.

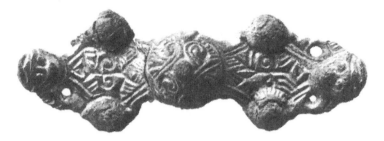

Fig. 3.50 Equal-armed brooch Type III A, Birka, Sweden (after Aagård 1984, fig 11.1).

In Scandinavia, equal-armed brooches were worn in significant numbers from the second half of the eighth century until the tenth century, during which they appear to have fallen out of use (Callmer 1999, 201–2). They carry a range of decorative schemes, incorporating projecting bosses, free-standing animals, and elaborate relief-cast zoomorphic decoration. A common decorative element comprises seemingly irregular grooves and ridges along the arms, features best understood as devolved or debased representations of Scandinavian animal ornament.

The geographical distribution of equal-armed brooches within Scandinavia is uneven. Although a handful of brooches is known from Norway, equal-armed brooches are usually characterized as an eastern Scandinavian brooch type, concentrated in the Lake Mälar area of Sweden, Småland and on the island of Öland (Petersen 1928; Aagård 1984, 96; Callmer 1999, 203). There are indications, however, that the type was more common in the area of Skåne and Bornholm in Viking-Age Denmark than has hitherto been appreciated (Hedeager Krag 1995; Callmer 1999, 202). Recent metal-detector surveys at Uppåkra, Skåne, have revealed fragments belonging to twenty-six or twenty-seven equal-armed brooches, while four brooches are now known from the adjacent southern Swedish province of Blekinge (Callmer 1999, 201–2). Two mould fragments for equal-armed brooches were uncovered at Ribe, suggesting production there on a limited scale (Brinch Madsen 1984, 78; Petersen 1928, figs. 64–6). Despite these examples, equal-armed brooches remain rare finds from southern areas of Viking-Age Denmark: extensive metal-detector surveys from Hedeby have uncovered just one, small equal-armed brooch, which brings the total number of specimens from the site to three (WMH 2004/11233; Arents 1992, 123). In this sense, they are atypical of Scandinavian-style jewellery from England, which is most often paralleled by finds from southern Scandinavia.

Perhaps because of their diverse geographical and stylistic profiles, equal-armed brooches of Viking-Age date found in Scandinavia have not yet been comprehensively studied. Five published works offer classifications, but all are

Map 3.15 Equal-armed brooches in England

limited by their exclusive focus on material from a particular region or site or by their inaccessibility in the UK (Petersen 1928; Kivikoski 1938; Aagård 1984; Callmer 1999; Riebau 1999). The typology suggested by Aagård for equal-armed brooches from Birka offers the best visual and chronological guide for classifying equal-armed brooches found in England, and is thus adopted here (Aagård 1984).

To date, five equal-armed brooches or fragments thereof have been recorded in England, from locations across the eastern counties (cat. nos. 428–32) (see also Map 3.15). This total is considerably less than the number of recorded examples of other types of Scandinavian jewellery, an observation considered in more detail in Chapter 7. Apart from one fragmentary, undiagnostic piece (cat. no. 432) all equal-armed brooches from England can be classified as Scandinavian on account of their H-shaped pin-lugs and hooked catch-

plates, as well as their diagnostically Scandinavian shapes and ornament (see Table 3.7).

Type III

Two brooches, a fragmentary example from Harworth and Bircotes, Nottinghamshire (see Colour Plate 7) and a complete find from Lakenheath, Suffolk (cat. nos. 428–9) belong to the same mass-produced Scandinavian class: Aagård's Type III A, represented by eight finds from Birka, in addition to artefacts from Norway, Finland, and other areas of eastern Scandinavia (Petersen 1928, 86, figs. 71–2; Kivikoski 1938, 11–12; Aagård 1984, 101, 104–5, fig. 11:1 III A:1). These brooches are distinguished by the presence at the end of each arm of an *en-face* animal mask flanked by two outstretched legs or arms; these join the head at the ear generating two round holes at each terminal. However, the ornament on the Lakenheath brooch is a devolved version of that carried on the brooch from Harworth, with both the animal mask and legs or arms being reduced to grooved ridges. It would seem that the Lakenheath brooch was produced later on in the Type III A series than its Nottinghamshire counterpart.

An openwork crown found in Collingham, West Yorkshire, is all that survives of a third equal-armed brooch from the Danelaw (cat. no. 430). Although the main body of the brooch is absent, the crown's openwork form and distinct decoration, including four raised bosses positioned around a central knop, assign it to the equal-armed brooch Type III F:1, a type which typically carries Borre-style animal ornament, including *en-face* masks, on its arms (Aagård 1984, fig. 11.2 III F:1). Brooches of this type are known from Norway as well as Sweden; two examples come from Birka, where a mould fragment possibly used in the production of the type has also been recovered (Petersen 1928, figs. 67, 69; Aagård 1984, 102, 104; Callmer 1999, fig. 26; Arrhenius 1973, 106, 110, fig. 44b).

Type IV

A further equal-armed brooch, from South Kyme in Lincolnshire, consists of a central crown embellished with a projecting central knop, and two arms incorporating *en-face* animal masks at their terminals. These features relate the South Kyme brooch to Aagård's Type IV C:1, although on Aagård's type specimen, the zoomorphic element is much reduced (Leahy and Paterson 2001, 193; Aagård 1984, 102, fig. 11.2 IV C:1). This is a rare variant within Scandinavia: just three examples are recorded from Birka, although a significant number of closely related examples are known from mainland Finland (Aagård 1984, 102; Kivikoski 1938, 20–5, figs. 14-16). Despite its rarity, the type was evidently transported to England.

Table 3.7 Summary of equal-armed brooches from England

	III A	III F	IV C	Unclassifiable	Total
Scandinavian	2	1	1	0	**4**
Anglo-Scandinavian	0	0	0	0	**0**
Unclassifiable	0	0	0	1	**1**
					5

Oval brooches

Oval brooches comprise one of the largest and most distinctive components of Viking-Age female dress (Graham-Campbell 1980, 27–30). Due to their domed shape and vertical, recessed pin, they could only be worn to fasten the shoulder straps of a Scandinavian-type tunic dress, worn over a shift. For this reason, oval brooches may be described as diagnostically Scandinavian, representative of Scandinavian 'national' dress, to adopt James Graham-Campbell's terminology (2001a, 33). When found in the archaeological record, they therefore provide a secure indication of Scandinavian appearance and cultural affiliation.

Oval brooches carry elaborate zoomorphic ornament, drawn mainly from the Scandinavian Oseberg and Borre styles. Most items found in Scandinavia belong to highly standardized, serially-produced types, dominated in the late eighth and ninth century by the single-shelled Type P 37, and in the late ninth and tenth century by the double-shelled Type P 51 (Jansson 1981, 2–3; Petersen 1928, figs. 37 and 51). These types were first distinguished by Jan Petersen, and form the core of Ingmar Jansson's more recent, updated typology, based on material from Birka, Sweden (Petersen 1928, figs. 1–55; Jansson 1984a; 1985). Underpinning Jansson's typology was his discovery that the decoration on oval brooches degenerated over time through the mechanical copying of existing brooches (Jansson 1985). This scale of degeneration, which also helps to preserve old art styles beyond their period of fashion, enables brooches to be placed early or late on in particular series.

Oval brooches are the most common Viking-Age brooch form, with over 4,000 examples to date (Jansson 1985, 12). They are found not just in the Scandinavian homelands, but also in Scandinavia's overseas settlements, including Russia, Iceland, Ireland, and Scotland (Jansson 1981, fig. 1; 1985, 12). Yet although frequently seen as a 'standard feature' of Viking-Age female dress (for instance, Speed and Walton Rogers 2004, 86) the geographical distribution of oval brooches in fact reveals stark regional differences. During the tenth century, oval brooches were far less common in the area of Viking-Age Denmark, particularly in the south-west, than in Sweden or Norway (Eisenschmidt 2004, 112–13, figs. 16 and 21; Hedeager Krag 1995, 65–9). As of 1994, just three hundred and thirty-one oval brooches were recorded from the area of Viking-Age Denmark, excluding the southern, modern-day Swedish provinces of Bohuslän and Halland, and Schleswig (Hedeager Krag 1995,

65–9). This count reaches three hundred and eighty-seven if the brooches from Schleswig, including Hedeby, are included, but remains low compared to the one and a half thousand brooches known from both Sweden and Norway in 1985 (Eisenschmidt 2004, fig. 16; Arents 1992, 88; Jansson 1981, fig. 1; 1985, 12). This regional variation within the Scandinavian homelands has significant consequences for the interpretation of fifteen oval brooch finds from England (cat. nos. 433–42; see Table 3.8 and Chapter 7).

Berdal brooches

In England, as in Scandinavia, the earliest brooch belonging to this group is the so-called Berdal type, decorated with a median band and symmetrically-arranged crouched or gripping-beasts, executed in relief (Petersen 1928, 12; Jansson 1985, 24–5). Although infrequent finds in northern Scandinavia, Berdal brooches are common in Viking-Age Denmark, where, at Ribe, there is evidence for their production on a serial scale (Feveile and Jensen 2000, 179, fig. 6; Brinch Madsen 1984, 37–74). In England a fragmentary Berdal brooch is associated with Viking-Age graves recently uncovered near Cumwhitton, Cumbria (cat. no. 433) (see Map 3.16). Reassembled, the fragments form a number of side, end, and corner panels, delineated by broad bands of fretwork and decorated by stylized, gripping or biting animals with triangular faces. These features, particularly the distinctive pattern of fretwork, assign the brooch to the Berdal subtype, P 23/24, termed 'Type Bj 550' by Jansson (Petersen 1928, figs. 23–4; Jansson 1985, 31–2). It has counterparts from Norway, as well as Hedeby and Småland in Viking-Age Denmark (Petersen 1928, 19–21, fig. 23; Jansson 1985, 32).

P 37

The single-shelled P 37 oval brooch is decorated with bands of fretwork, which create panels filled with gripping quadrupeds, occasionally disturbed by human masks and roundels (Jansson 1985, 46–7, figs. 39 and 40). The type is found throughout Scandinavia and represents the most common ninth- and tenth-century oval brooch type in Denmark (Hedeager Krag 1995, 65–9). In England, two matching P 37 oval brooches were excavated in 2001 from a probable female inhumation at Adwick-le-Street, near Doncaster (cat. no. 434) (see Colour Plate 2) (Speed and Walton Rogers 2004). They carry bands of fretwork arranged in two diamond shapes, and ornament derived from gripping quadrupeds with *en-face* masks. However, the quality of the ornament carried on the brooches varies: on one item, a Type P 37:3, the animal ornament is recognizable, whereas on the other it is highly debased. This debasement suggests the second brooch was produced late on in the P 37 series and assigns it to the subtype P 37:12 (Speed and Walton Rogers 2004, 65–9).

Map 3.16 Oval brooches and brooch fragments in England

P 51

The P 51 oval brooch series is the most common late ninth-/tenth-century oval brooch series in Scandinavia, representing 40 per cent of all oval brooches recorded from Norway, 65 per cent of oval brooches from Iceland and 60 per cent from Scandinavian Russia, but only 10 per cent from Hedeby in the south (Jansson 1981, fig. 1). It is characterized by openwork zoomorphic ornament, attributed by Jansson, somewhat controversially, to the Oseberg style, as well as diamond-patterned fretwork and nine decorative bosses (Jansson 1985, 197–200, figs. 54–5; Fuglesang 1986, 237).

In England, all three antiquarian oval brooch discoveries belong to this type: a pair from Claughton Hall belong to the subtype P 51 B1, a matching pair of oval brooches from Santon Downham, Norfolk, with decoration characteristic of the variant P 51 A1, and a pair from Bedale, Yorkshire, with

Fig. 3.51 Oval brooch fragments, Wormegay, Norfolk, drawn by A. Holness © Norfolk County Council.

animal compositions diagnostic of the variant P 51 F (cat. nos. 436–7, 439). The P 51 series is also represented by two oval brooches recently discovered within a small cemetery near Cumwhitton in Cumbria (cat. no. 435). The decorative detail along the ridge of these brooches includes a prominent mask flanked by gripping legs or arms with spiral joints (Jansson's Type Rb1/2) and, on the side, paired bird-like creatures with interlocking necks (Jansson's Type Sa1) (Jansson 1985, fig. 54). Such detail assigns the brooches to the Type P 51 B, specifically the variant B4.

Several oval brooch fragments recovered by recent metal-detecting add to the tally of Type P 51 oval brooches from England. Two gilded fragments form the openwork side and end panels of a Scandinavian oval brooch from Wormegay, Norfolk (cat. no. 438) (see Fig. 3.51). The decoration of transverse bands, an inward-curling spiral and ribbed ornament carried on the side panel represents the feet, hips, legs, and wing-like appendages of an ascending beast; the end panel depicts scrolls for animal hips or shoulders (Jansson 1985, fig. 54 Sa1/2, Ha, Rb1). This treatment, together with the form of the bosses, which are distinctive in containing two, rather than four, perforations, assigns the brooch to Jansson's Type 51, variant B3.

Two further oval brooch fragments are recorded from Mautby and Mile-ham, Norfolk (cat. nos. 441–2). These come from the openwork outer shells of two separate oval brooches. Both pieces consist of a boss surrounded by the partial remains of a side panel; they are heavily worn, and preserve only faint traces of decoration, making typological identification impossible. However, as components of openwork shells of oval brooches, both fragments clearly derive from double-, rather than single-shelled, types, and they are most likely to belong to the P 51 series.

The final oval brooch fragment, from Kilnwick near Beswick in Yorkshire (cat. no. 440) can be assigned to the variant P 51 E on account of the form of the openwork bosses and its animal ornament (Jansson 1985, fig. 54 Sc; fig. 56 Ka). Notably, it is attached to a lead mass and appears to have been used as decoration for a weight, presumably after it fell out of use as a dress-fitting. The use of ornamental metalwork to decorate lead weights was an established Scandinavian practice and has been documented in other Scan-dinavian contexts in the British Isles, for instance, at Kiloran Bay on Colon-say where weights decorated with Anglo-Saxon and Irish metalwork are known from a culturally Scandinavian male burial (Graham-Campbell and Batey 1998, 119–20, fig. 7.4). At Little Dunagoil on Bute in the Firth of Clyde, the openwork boss of an oval brooch was used to decorate a lead weight in the same manner as the Kilnwick fragment (Graham-Campbell and Batey 1998, 98).

Table 3.8 Summary of oval brooches from England

	Berdal	P 37	P 51	Unclassifiable	Total
Scandinavian	1	2	10	2	**15**
Anglo-Scandinavian	0	0	0	0	**0**
					15

Other early Viking-Age Scandinavian-style jewellery

In addition to these established brooch or pendant types, a handful of Scan-dinavian-style dress items from England represent rare or one-off designs (see Table 3.9 and Map 3.17). A group of rectangular lead-alloy brooches, all from the Thetford area, Norfolk, carry contorted Borre/Jellinge-derived ani-mals arranged around a central lozenge (cat. nos. 443–6) (Fig. 3.52). The ornament of the brooches consists of a pair of stylized beasts with head lap-pets, loosely knotting ribbed bodies, which extend diagonally across the cen-tral lozenge, and clawed feet, which can grip their bodies. The ornament undoubtedly roots the beasts in a Scandinavian tradition: their pretzel shape relates to the Borre style, while their prominent ribbing and the looping form of their upper bodies are drawn from the Jellinge repertoire. At the same

time, the brooches' distinctive rectangular shape is likely to ultimately derive from Carolingian rectangular brooches, so-called *Rechteckfibeln*, examples of which are independently recorded in England (for instance, PAS 'Find-ID' LIN-5FCA0; PAS-D45A87) (Frick 1992/3, 279–87). These items are, then, true cultural hybrids; they uniquely combine Scandinavian and Carolingian ornamental and brooch styles to create a new brooch type exclusive to the Danelaw.

Among the more unusual items of Scandinavian-style jewellery from England is a silver openwork pendant from Little Snoring, Norfolk, one of just two Scandinavian jewellery items from England classified as Treasure (cat. no. 448) (Fig. 3.53). This depicts a Borre-style beast with a triangular, *en-face* head, an arched, ribbon-shaped body and paws, which grip its body as well as the circular pendant frame (Paterson 2002, 267). Identical pendants are found in eastern Scandinavia, including in the Vårby hoard, Sweden (see front cover) (Callmer 1989, fig. 3:33). Examples are also known from the south, including from Lake Tissø and Hedeby, where a mould for the pendant type has also been recovered (Callmer 1989, 24; Paterson 2002, 268). The example from Little Snoring is one of two known variants of this pendant type (Callmer's Type Norelund); distinguished by its prominent ears, it is the more elaborate of the two and the type to which most Scandinavian finds belong (Callmer 1989, 24).

A second pendant, in the form of a coiled snake, comes from Overstone, Northamptonshire (cat. no. 449). This item is assigned to the Borre style on account of the snake's *en-face* head, which features two, beady eyes and a snout similar to those encountered on lozenge brooches (Richardson 1993, 42–3). However, its coiled form finds parallels in the spiral snake which appears on the Oseberg ship, suggesting earlier roots (Fuglesang and Wilson 2006, 85, pl. 38E). The Overstone pendant is similar to Scandinavian coiled snake pendants known from Nordfjord, Norway, Eketorp, Sweden, and an unprovenanced location in Denmark (Gustafson 1906, 123, fig. 522; Petersen 1928, 141, figs. 162–3; Richardson 1993, 42–3). A similar pendant in gold, with a longer, outstretched neck, is also known from the Hoen hoard, Norway (Fuglesang and Wilson 2006, pl. 4). On these Scandinavian examples, the snake coils in an anti-clockwise rather

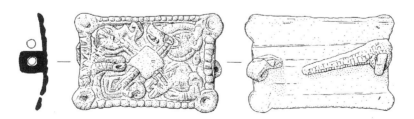

Fig. 3.52 Rectangular brooch with Borre/Jellinge-style ornament, Thetford, Norfolk, drawn by Steven Ashley © Norfolk County Council.

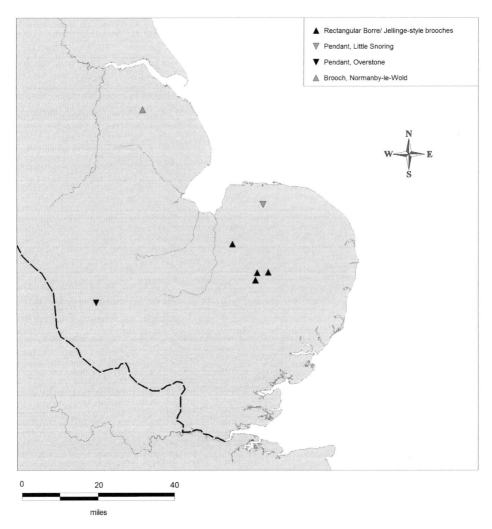

Map 3.17 Rectangular and other Borre-style brooches and pendants in England

than clockwise direction as on the Overstone pendant: the Overstone pendant is, therefore, a mirror image of its Scandinavian counterparts. It seems likely to have been made from a cast taken from an existing Scandinavian brooch, either in Scandinavia or within the Danelaw, as originally suggested by Richardson (1993, 43).

The final item to be discussed here is a Borre-style brooch from Normanby-le-Wold, Lincolnshire (cat. no. 447). This brooch has a wide, flat rim and a pronounced convex profile. Both the rim and main body of the brooch carry a double-stranded interlace scheme related to the Borre style, composed of an

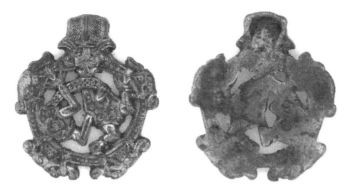

Fig. 3.53 Silver pendant with Borre-style gripping-beast, Little Snoring, Norfolk © Norfolk County Council.

outer band, overlain by four tapering 'arms', and an inner interlace pattern. Brooches of the same construction and with similar interlace schemes are known from Vað and Gautlönd, Iceland, suggesting a northern Scandinavian origin for this Lincolnshire brooch (Petersen 1928, 122, figs. 123 and 126 a–b). However, wide-rimmed, convex disc brooches with geometric ornament are also recorded from Finland (Kivikoski 1973, pl. 75, 670) and both the Icelandic brooches were found with attached chatelaine chains and decorative plaques, a fashion similarly encountered in the Baltic (Kivikoski 1973, pls. 87–91). An eastern Scandinavian source may, then, be more likely.

Table 3.9 Summary of other Borre-style brooches and pendants from England

	Plate Brooches	Other brooches	Other pendants	Total
Scandinavian	0	2	1	3
Anglo-Scandinavian	4	0	0	4
Unclassifiable	0	0	1	1
				8

Jellinge-style brooches and pendants

Type I

The ornamental dress items discussed so far carry ornament in, or related to, the Scandinavian Borre style. In England, as in Scandinavia, the Jellinge style also adorned brooches and pendants. Jellinge-style artefacts have not been subject to the same thorough typological study as Borre-style objects, but recent discoveries indicate that the style appeared on women's dress accessories in a range of compositions, typically incorporating ribbon, S-shaped beasts, often in a back-

wards-facing position. Five Scandinavian Jellinge-style motifs can now be identified on jewellery in England, and can be assimilated into Jansson's typology of small Scandinavian disc brooches with zoomorphic ornament (Type I) (Jansson 1984b). While some items are candidates for imports, others demonstrate that the Jellinge style was adopted into the repertoire of Anglo-Saxon craftsmen and reproduced, in slightly altered form, on Anglo-Scandinavian jewellery (see Table 3.10).

Type I A1

One of the first Jellinge-style brooch types to be recognized in England was Jansson's Type I A1 (Jansson 1984b, fig. 8:2 I A1). These are double-plated disc brooches, with a convex outer shell secured to a solid-cast, flat base plate with a central iron rivet. The outer shell carries openwork ornament consisting of a profiled, ribbon-shaped beast, with an elongated neck, a round eye, and an extended ear lappet which loops around the animal's neck and terminates at its nose. The double-contoured, billeted body of the beast loops in an arc below the head and gives way to a spiral hip, rear and front legs, and a tail, features which interlace with the looping body (see Fig. 3.54) (Jansson 1984b, 60). Although these features root the beast firmly in the Jellinge style, the arched form of the animal's body is descended from the Borre-style gripping-beast; it is therefore to a composite Borre/Jellinge phase that brooches in this series can be assigned (Graham-Campbell 1976, 448; Wilson 1995, 117).

In 1984, Jansson recorded three Type I A1 brooches then known from Scandinavia: from Birka, Folkesta in Södermanland (Sweden), and Hedeby. A further,

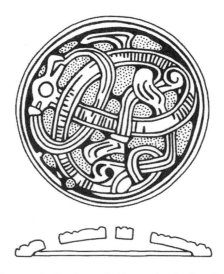

Fig. 3.54 Type I A1 Jellinge-style disc brooch (drawn by Anders Eide, after Jansson 1984b, fig. 8.2).

unprovenanced find, now in Uppsala University Museum, probably also came from Sweden (Jansson 1984b, 60). This distribution encouraged the view that the brooch type had eastern Scandinavian origins (Graham-Campbell 1976, 449). However, more recent find-spots generated by new discoveries recorded by the author suggest a much broader distribution with a concentration of finds in southern Scandinavia (see Map 3.18). These recent discoveries include three further finds from Hedeby, six finds from modern-day Denmark, and single examples from northern Germany and Iceland (Appendix A, Finds List 13). This southern Scandinavian focus is also a feature of brooches with the same decoration, which are solid cast, rather than double-plated (Jansson's Type I A2, no examples of which are currently recorded in England) (Skaarup 1976, 35:1; 35.1; Brøndsted 1936, fig. 20; Laux 1995; Muhl 2006).

In the British Isles, one of the earliest examples of this brooch type was excavated from a mid-eleventh-century context (originally erroneously published as tenth century) from the 1962/3 High Street excavations in Dublin (Ó Ríordáin 1971, 73 and 79, fig. 21c; Graham-Campbell and Lloyd-Morgan 1994, 66). James Graham-Campbell compared this item, which had been secondarily fitted with a pin and reused as a decorative pin-head, with two further finds: one from Chester and a further find from 'the area of the Wash', the former of which was noted as having particularly close similarities to the brooch from Dublin (Graham-Campbell 1976, 448) (see Fig. 3.55). Due to a common design fault, the result of which was the misalignment of the animal's neck on either side of the arcing body, Graham-Campbell argued that all three brooches derived from a common model (1976, 448).

Our understanding of this brooch series and its distribution in England has advanced significantly in recent years as a result of new finds from both England and Scandinavia. Since 1985, nine further brooches have been recorded in England, bringing the current tally to eleven (cat. nos. 450–60) (see also Map 3.19). Just one of the recent finds, from St Mark's Station, Lincoln, shares with the established insular corpus the feature of the misaligned neck (cat. no. 452). This item is therefore likely to derive from the same model as brooches from the Wash, Chester, and Dublin. In addition to this group, it is possible to identify a separate, second set of brooches which are also distinguished by their treatment of the animal neck. On three brooches the animal's upper neck is truncated by the arc formed by its looping body, and is thus distinct from the elongated necks seen on other Type I A1 brooches from England (cat. nos. 456–8). Similar truncated necks are also present on two Type I A1 brooches from Scandinavia, from Hedeby, Schleswig-Holstein, and Lolland, Denmark, suggesting that the English and Scandinavian provenanced brooches were produced from the same master (Appendix A, Finds List 13).

Of the eleven brooches currently recorded from England, seven are complete, with the base plate intact. All these items display a typical Scandinavian

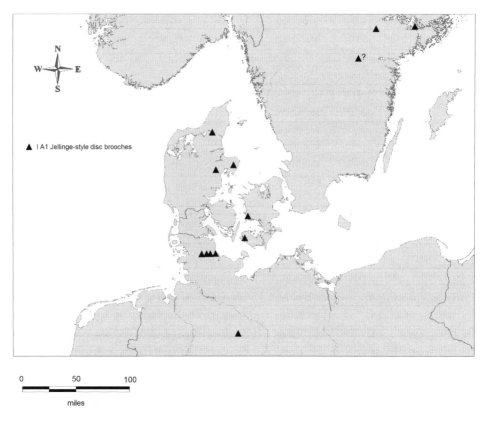

Map 3.18 Type I A1 Jellinge-style disc brooches in Scandinavia

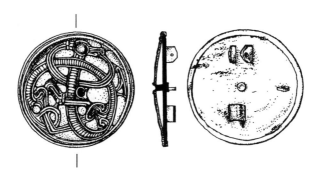

Fig. 3.55 Type I A1 Jellinge-style disc brooch, Chester © Cheshire West and Chester Council.

arrangement of fastening mechanisms, including an attachment loop or 'eye'. The remaining four examples constitute only the openwork outer shells, without base plates. Although these items were not intended to function independently as brooches, two items have fittings for a pin and appear to have been used in exactly that way (cat. nos. 450, 456) (see also Fig. 3.56). The surviving fittings

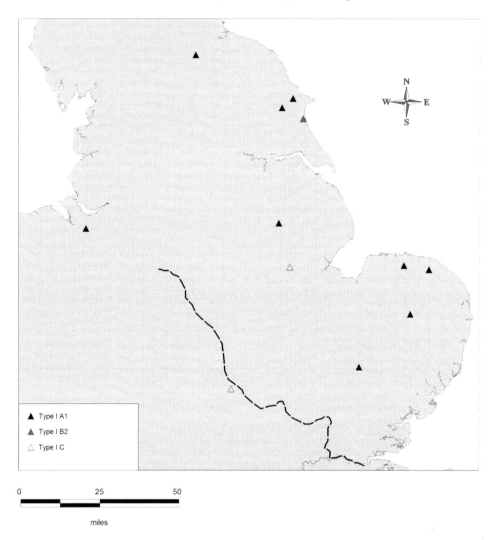

Map 3.19 Type I A1, I B2, and I C Jellinge-style disc brooches in England

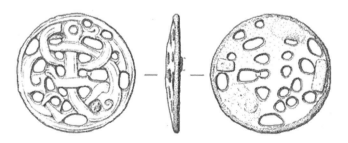

Fig. 3.56 Top plate of Type I A1 Jellinge-style disc brooch, Hindringham, Norfolk, drawn by Jason Gibbons © Norfolk County Council.

Fig. 3.57 Type I B2 Jellinge-style disc brooch, Nørholm skole, Ålborg, Denmark © National Museum of Denmark.

are of an undiagnostic form, but nonetheless give clear indications of brooch reuse. In so doing, they provide interesting parallels for the disc brooch from Dublin, reused as a pin-head.

Type I B2

Jansson's Type I B disc brooch carries a profiled quadruped, with legs and lappets ending in scrolled terminals (1984b, fig. 8:2 I B). No examples have yet been found in England, but the type is related to another, rare Scandinavian brooch group (hitherto unclassified), represented by just three brooches from Denmark and one from Norway (see Map 3.20) (Appendix A, Finds List 14). These brooches carry a profiled, right-facing animal with a large round eye and an open, upward-turned mouth; the lower jaw emerges from the animal's long, billeted neck. A head lappet interlaces with the animal's double contoured, billeted body, which bows to the left and forms an arch, running behind the animal's neck. The body leads, via a spiral hip, to two legs, bent at the knee and each with two-toed feet (see Fig. 3.57). In view of its similarities to Jansson's Type I B disc brooch, we may coin this brooch Type I B2.

Despite the fact that this brooch type is rare in Scandinavia, it is represented by a find from Skipsea in the East Riding of Yorkshire (cat. no. 462). The motif on the Skipsea brooch consists of a right-facing animal with an interlacing head lappet, long neck and an arching billeted body, with two legs, bent at the knees. It is identical to animals carried on brooches of this type within Scandinavia and its domed shape and pin-lug arrangement, including an attachment loop, help to confirm its Scandinavian origins.

Type I C

Another motif with Jellinge-style traits which occurs on disc brooches in Scandinavia, as well as in England, comprises a left-facing animal, with a prominent eye, bulbous upper jaw and long neck. An extensive head lappet weaves through the animal's double-contoured body; this interlaces in a figure-of-eight pattern and wraps around one of the animal's splayed lower legs. The splayed legs are bent at the knee, giving the animal a bird-like

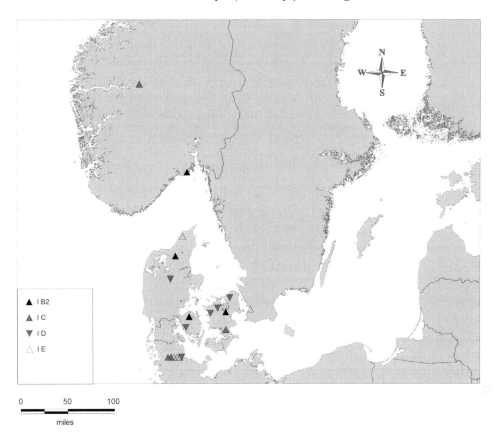

Map 3.20 Type I B2, I C, I D, and I E Jellinge-style disc brooches in Scandinavia

appearance; a grooved border encircles the composition (see Fig. 3.58) (Capelle 1968a, fig. 4.3). In Scandinavia, this composition appears in open-work and solid-cast form: four brooches are known to the author, including three from Viking-Age Denmark where it is likely the series was produced (Map 3.20) (Appendix A, Finds List 15). This brooch may be appended to

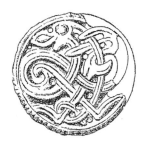

Fig. 3.58 Type I C Jellinge-style disc brooch, Sogndal, Sogn og Fjordane, Norway (after Shetelig 1920, fig. 313).

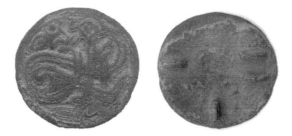

Fig. 3.59 Type I C Jellinge-style disc brooch, Brackley, Northamptonshire © Portable Antiquities Scheme.

Jansson's established typology for small disc brooches with zoomorphic ornament, to become his Type I C.

Two solid-cast brooches from England can be assigned to the same small brooch group (cat. nos. 462–3) (Map 3.19). The motif on a brooch from Brackley, Northamptonshire, encapsulates a left-facing creature with a prominent, round eye and bulbous, foliate-shaped upper lip. Its extended head lappet loops around its left leg, interlacing on the way with a wing-like feature, which extends in one area across the animal's neck (see Fig. 3.59). These details, together with the animal's figure-of-eight form and splayed, bent legs suggest a Scandinavian origin for the piece, which is confirmed by the dished form of the brooch and its Scandinavian-type pin-fittings.

A brooch from Walcott, Lincolnshire, is an Anglo-Scandinavian version of the same motif. Its double contoured, left-facing animal is stylistically very close to Scandinavian prototypes; the brooch even replicates the grooved border of Scandinavian brooches. It is, however, flat and has an unusual arrangement of fastening mechanism, including a looped pin-lug (now broken), formed by the joining of two plates positioned at a right angle to the brooch rim, together with a hooked catchplate. The brooch appears to follow closely a Scandinavian model, but its flat form ultimately distinguishes it as an Anglo-Scandinavian product.

Pendant Type A3 and brooch Type I D

In Scandinavia, one of the most distinctive expressions frequently assigned to the Jellinge style is the motif of a backwards-turned animal with an S-shaped billeted body of even width, a ribbed neck and a round eye. In this composition, the animal is depicted in profile; its extended tongue passes over its body and behind its rear legs (see Fig. 3.60) (Fuglesang 1991, 100).

In Scandinavia, the backwards-turned beast motif occurs in a number of slightly different forms on pendants of Callmer's Type A3, found predominantly from eastern Sweden, and, to a lesser extent, Norway (Callmer 1989, 38–40, figs. 3:6–3:8, 3:20, 3:21, 3:31, 3:32, 3:34). In addition, it is now clear that the motif also appeared on convex disc brooches, a finding at odds with Paterson's assessment that the association of the motif with brooches was an

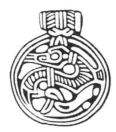

Fig. 3.60 Jellinge-style backwards-turned beast, as carried on pendants of Callmer's Type A3 (drawing after Callmer 1989, fig. 3.8).

Fig. 3.61 Type I D Jellinge-style disc brooch, Hedeby, Schleswig-Holstein © author.

insular phenomenon (see Fig. 3.61) (Paterson 2002, 273). I have documented the motif, in a number of variant forms, on six disc brooches from the area of Viking-Age Denmark (Appendix A, Finds List 16) (Map 3.20). Extending Jansson's typology for small brooches with zoomorphic ornament, these may be coined Type I D.

In England, the Jellinge-style backwards-turned animal appears on a group of nineteen disc brooches and a single pendant (cat. nos. 464–83) (see also Table 3.11 and Map 3.21). The appearance of the motif is not consistent, but occurs in three distinct expressions. While the first two manifestations of the composition are paralleled on artefacts from Scandinavia, the third represents a debased version of the design, formulated in an Anglo-Scandinavian milieu.

The first expression appears just once, on a pendant from Cawston in Norfolk (cat. no. 464) (see Fig. 3.62). This object, with a broken suspension loop, is identified by its upright, backward-turned creature with Scandinavian pendants of a type classified by Callmer as group A3 (Callmer 1989, fig. 3:7). Within Scandinavia, animals on pendants of this type appear in a number of slightly different formats (Callmer 1989, figs. 3:6–8, 3:20–1). The animal on the Cawston pendant appears in a rounded form (like Callmer's A3 subtype, Type Tuna) (Callmer 1989, 23, 38–9, fig. 3:31). The pendant, a probable import, provides the most westerly and southerly example of this pendant group to date (Callmer 1989, 38–40).

In southern Scandinavia, the same motif also appears on convex disc brooches of a type coined above Type I D. On these brooches, the animal again takes variant forms, and can be elongated, with angular features, or more rounded.

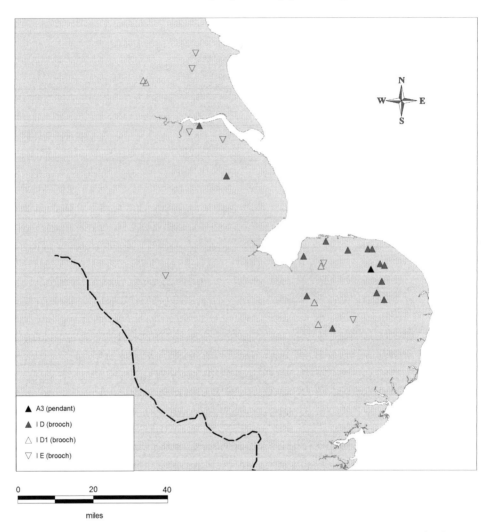

Map 3.21 Type A3 pendants and I D and I E Jellinge-style disc brooches in England

In England, this motif occurs on fourteen Type I D convex disc brooches; in each case the composition can be identified with the rounded version of the motif (see Fig. 3.63) (cat. nos. 465–78). On these items, the beast has a round eye, an open jaw with a bulbous upper lip, together with a ribbed neck and a billeted, profiled body, although some brooches are so worn that the billeting does not survive.

These brooches have a convex form and typical Scandinavian-type pin-lugs and catchplates. Together with their stylistic affinities with disc brooches from Scandinavia, these features would appear to suggest their Scandinavian origin. However, in only two instances do the brooches possess an attachment loop, despite the fact that all six examples from Scandinavia carry this feature (cat.

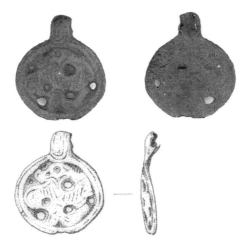

Fig. 3.62 Type A3 pendant, Cawston, Norfolk, drawn by Jason Gibbons © Norfolk County Council.

nos. 473, 478) (Fig. 3.63). Since the attachment loop is not integral to all small Scandinavian disc brooches, its absence on these brooches need not indicate an insular place of manufacture. Nonetheless, its restricted occurrence on the finds from England is anomalous with material from Scandinavia, possibly indicating that the series was produced in England under strong Scandinavian influence.

The third manifestation of the backwards-turned beast composition occurs on a group of five disc brooches, all Anglo-Scandinavian products (cat. nos. 479–83). These brooches display a debased version of the Jellinge-style beast, with a heavy, lumbering body, a bulbous upper lip, and a pronounced round eye (Paterson 2002, 273). On all but one disc brooch, the animal motif is contained within a double or triple beaded border, a common design element on Late Anglo-Saxon disc brooches. They are lead-, rather than copper-alloys, and their profile is flat rather than domed. Since they are distinct from the main Type I D group, they may be classified here Type I D1 (see Fig. 3.64).

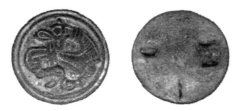

Fig. 3.63 Type I D Jellinge-style disc brooch, Colney, Norfolk © Norfolk County Council.

Fig. 3.64 Type I D1 Jellinge-style disc brooch, York © York Museums Trust (Yorkshire Museum).

Surviving attachment fittings on these items adopt the common Anglo-Scandinavian pairing of an Anglo-Saxon pin-lug and Scandinavian-type catchplate. In addition, a brooch from Gooderstone, Norfolk, also carries an additional lug in the location of an attachment loop (cat. no. 479) (see Fig. 3.65). However, rather than being set perpendicularly to the brooch rim in the traditional manner, this lug is aligned vertically with it. Moreover, it appears to be unfinished: it is not perforated and therefore defunct as an attachment loop. Given that the brooch was fitted with an iron pin, which survives partially intact, it is likely to have been worn and used. The preservation of an incomplete loop would thus appear to suggest that this element was abandoned during production, having been miscopied or miscast, perhaps by a craftsman unfamiliar with such a feature. This possible scenario raises interesting questions about the use of the attachment loop, and its significance as a feature of Scandinavian metalwork, discussed further in Chapter 5.

Type I E
The final Jellinge-style motif to appear on jewellery in both Scandinavia and England belongs to a composite Borre-/Jelling-style phase. It comprises two

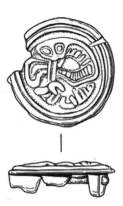

Fig. 3.65 Type I D1 Jellinge-style disc brooch, Gooderstone, Norfolk © Norfolk County Council.

opposed S-shaped beasts, positioned around a central boss. Each animal has a round eye, ear lappet, and pelleted body with a spiral shoulder, characteristics which assign it to the Scandinavian Jellinge style. However, the animal bites its own tail and grips its own neck with its front paw while its back paw grips its partner's rear leg: elements which feature in the Borre style. In Scandinavia, this motif is carried on pendants of Callmer's Type Fiskeby, recorded mainly in the Uppland area of Sweden and the Swedish Baltic (Callmer 1989, 39, figs. 3:22 and 3:32)(see Fig. 3.66). The motif also occurs in Scandinavia on a series of convex disc brooches, here termed Type I E, to again extend Jansson's typology (Appendix A, Finds List 17). Unlike the pendants, brooches with the motif are concentrated in the area of southern Scandinavia, all finds coming from Viking-Age Denmark (Map 3.20).

In England, the motif of opposed S-shaped Borre/Jellinge-style beasts is represented on seven disc brooches (cat. nos. 484–90) (Map 3.21). Like their Scandinavian counterparts, these objects have a subtle convex shape and a typical Scandinavian arrangement of attachment fittings, including an attachment loop (see Fig. 3.67). They display identical ornament to that found on the Scandinavian pendant and brooch series, putting their Scandinavian origins beyond doubt.

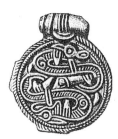

Fig. 3.66 Type Fiskeby Jellinge-style pendant, Fiskeby, Sweden (after Lundström 1965, pl. 22.9).

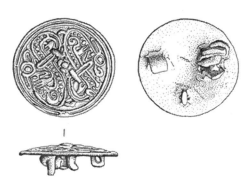

Fig. 3.67 Type I E Jellinge-style disc brooch, Quidenham, Norfolk, drawn by Sue White © Norfolk County Council.

Table 3.10 Summary of Jellinge-style brooches and pendants from England

	I A1	I B2	I C	I D / A3	I E	Total
Scandinavian	11	1	1	3	7	**23**
Anglo-Scandinavian	0	0	1	17	0	**18**
						41

Mammen-style brooches

Two rectangular brooches from England are highly unusual in combining Scandinavian and Continental cultural influences. The brooches, from West Stow Heath, Suffolk, and Bergh Apton, Norfolk, have slightly different measurements and are not mould-identical (cat. nos. 491–2) (see Map 3.22). Their ornamental scheme, set within a raised border, is nevertheless very similar. Uniquely for Scandinavian-style ornamental metalwork in England, the brooches depict a Mammen-style bird, and not a Jellinge-style creature as previously suggested (Hinton 1974, cat. no. 35; 2008, 67). The bird has an arched neck and a forward-bent head with a round eye and open jaw, together with a double-contoured head lappet; this arches downwards to interlace with its body and wings before terminating in an open-ended tendril. The wings, represented by a pair of double tendrils, extend diagonally downwards to the bottom left corner and pass behind a similarly constructed tail, extending diagonally upwards. The bird's raised leg, with bent foot, is also visible (see Fig. 3.68).

This treatment, particularly the movement and open-ended tendril terminal of the head lappet and the use of tendril ornament to depict the bird's wings and tail, identify the bird with the Mammen style (Fuglesang 1991, 84, 100). Related, compact birds are carried on the Bamberg casket and on two horse collars from Søllested, Fyn, while a more stylized version appears on the axe head from Mammen itself (Fuglesang 1991, fig. 24c; Wilson and Klindt-Jensen 1966, pls. LII and LIVb). Yet whereas the brooch motif is influenced by Scandinavian art styles, its rectangular shape is not Scandinavian in origin. The brooch shape would instead appear to relate to rectan-

Fig. 3.68 Mammen-style brooch, West-Stow, Suffolk © Ashmolean Museum, University of Oxford.

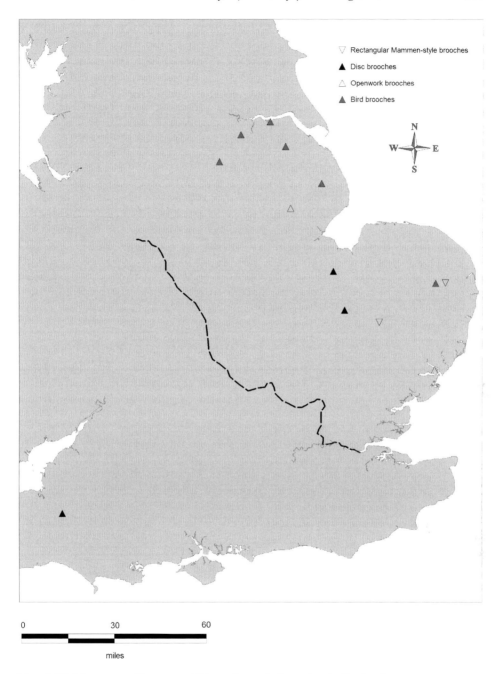

Map 3.22 Mammen-, Urnes-, and Ringerike-style brooches in England

gular and square brooches found predominantly in northern Germany and the Netherlands: so-called *Rechteckfibeln* of the type already discussed in relation to the group of Borre-style plate brooches from the Thetford area (Wamers 1994, 586–8; Frick 1992/3, 279–86, maps 6 and 7). Square-shaped brooches are dated on the Continent to the tenth century, a date which accords with the appearance of the Mammen style in Scandinavia (Wamers 2000, fig. 175).

Urnes- and Ringerike-style brooches

Scandinavian-style jewellery of later tenth-, eleventh-, and early twelfth-century dates is also known from England, albeit in far fewer numbers than earlier examples (Map 3.22). Despite its small size, the corpus of Ringerike- and Urnes-style brooches from England is diverse, encompassing both Scandinavian and Anglo-Scandinavian items in a range of disc, openwork, and bird-shaped forms.

Disc brooches

Ornate silver and gold convex disc brooches decorated in the Ringerike and Urnes styles occur in Scandinavia in hoards from Gotland and Öland, among other locations (Wilson 1995, 208–12). However, three disc brooches from England with late Scandinavian artistic affinities are distinct in both their form and decorative detail—all may be classed as Anglo-Scandinavian products. The Ringerike style occurs independently on just one brooch from England: a large, hammered sheet silver disc brooch discovered in a coin hoard (deposited *c.* 1070) from Sutton, Isle of Ely (cat. no. 493).[1] The surface ornament on this brooch is framed by four, interlacing circles; Ringerike-style snakes and quadrupeds appear in its four main fields, with spiral hips, lentoid eyes, and lobed upturned mouths (see Fig. 3.69). The style is also visible in the accompanying trilobate features, as well as in the curled tendrils in the surrounding lentoid panels. Much of the subsidiary linear ornament appears to have lost its original meaning, however, and offers only a highly abstracted version of Ringerike.

While the ornament of the brooch is inherited from the Scandinavian Ringerike style, its flat disc form signals its Anglo-Saxon manufacture; indeed, the brooch may be considered a late descendant of the large, silver Anglo-Saxon disc brooches characteristic of the ninth century (Backhouse et al. 1984, no. 105). This is confirmed by the division of the ornamental surface into multiple fields by four circles, a treatment similarly encountered on a brooch from the

[1] A second, large silver disc brooch with Ringerike-style ornament was recovered in 2010, from Bredfield, near Woodbridge, Suffolk (James Graham-Campbell, pers. comm.).

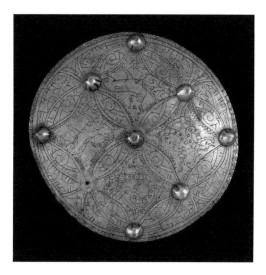

Fig. 3.69 Anglo-Scandinavian disc brooch with Ringerike-derived ornament, Sutton, Isle of Ely © the Trustees of the British Museum.

ninth-century Beeston Tor hoard (Wilson 1964, no. 3). The brooch's Anglo-Saxon manufacture is further supported by the Old English inscription on its reverse, which in translation reads: 'Ædwen owns me, may the Lord own her. May the Lord curse him who takes me from her, unless she gives me of her own free will' (Backhouse et al. 1984, no. 105).

Two further, openwork disc-shaped brooches are recorded from England, from Pitney, Somerset, and Wisbech, Cambridgeshire (cat. nos. 496–7). These items carry a distinctly anglicized version of the Urnes style, coined by Olwyn Owen the 'English Urnes' style (2001). The splendid brooch from Pitney, gilded on both the front and back, carries within a scalloped frame the motif of a coiled, sinuous beast in combat with a snake. The beast has a large, almond-shaped eye, upturned ear, scrolled upper-lip lappet, and open jaws, with which the beast bites its own body. Its body, composed of plain and beaded bands, forms a heart-shaped loop with a prominent spiral hip. It then forms a back leg which bifurcates into tendril-like extensions, one of which interlaces with the main body of the animal and terminates in a foliate trefoil. A coiled snake, seen from above, bites the animal at the neck; its body loops in an uneven figure-of-eight pattern before ending in two scrolls (Backhouse et al. 1984, no. 110; Wilson 1964, no. 60; Graham-Campbell 1980, no. 147).

Scandinavian influence on the Pitney brooch is seen in its sinuous creature, particularly the animal's head, extended neck, and looping body, which recall the snake-like beast encountered on Scandinavian openwork Urnes-style brooches. However, the even body width and biting pose of the dominant creature is not characteristic of such artefacts, although the biting element may

have instead descended from other Urnes-style combat motifs, such as those in the wood carvings from Urnes church itself (although, on these, the snake-like creatures bite standing quadrupeds, rather than themselves) (Graham-Campbell 1980, no. 147). Other elements betray Anglo-Saxon taste, such as the scalloped border and the use of beading on the animal's body, the latter feature of which is also displayed on the Urnes-style carvings from Norwich Cathedral (Owen 2001, 217; Green 1967). The heart-shaped pattern formed by the animal's looping body also identifies the Pitney animal with a distinct, English strand of the Urnes style, as, in the true Urnes style, figure-of-eight schemes are more common.

The Wisbech disc, although of much cruder workmanship than the Pitney brooch, bears a similar composition to it, in which the prominent biting snake is replaced by an inanimate tendril-tail (Wilson and Klindt-Jensen 1966, 154) (see Fig. 3.70). The animal's head, abutting a plain circular frame, has a lentoid eye, protruding ear, open jaws, and upturned upper lip. Its coiled body is formed of a double-contoured band, of even width apart from a slight swelling at the spiral hip. The animal's foreleg grips the main body, while its hind leg grips the brooch border. A tapered and bifurcating tail emerges from the body to interlace in wide loops with the animal (Graham-Campbell 1980, no. 148). Although no pin-fittings survive, its original use as a brooch is suggested by its disc shape, and by its similarity in design content with the Pitney brooch.

The ornament carried on the Wisbech brooch contains a number of features identified with the 'English Urnes' style (Owen 2001). These include the spiral form of the animal's body and its homogenous width. The absence of a combative motif separates the Wisbech brooch from the Scandinavian Urnes style; in particular, Owen has identified the use of inanimate tendrils springing from the body of the animal as an English Urnes trait, distinct from the independent thread-like snakes encountered in biting poses in Scandinavian expressions of the style (Owen 2001, 215). Scandinavian features are, however, discernible in

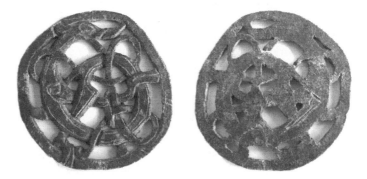

Fig 3.70 Openwork Urnes-style disc brooch, Wisbech, Cambridgeshire © Wisbech and Fenland Museum.

the treatment of the Wisbech animal's head: in its large eye, ear, and upper lip-lappet. These composite influences, together with the poor quality of the disc, indicate its production in an Anglo-Scandinavian context.

Openwork animal brooches

Within Scandinavia, one of the most common expressions of the Urnes style is in the form of an openwork animal brooch, characterized by a dominant serpentine creature entwined in interlacing tendrils (Bertelsen 1994). Urnes-style brooches of this type display a rich diversity of forms and can, on occasion, incorporate Mammen- and Ringerike-style elements (Bertelsen 1994, 347). Most items, however, incorporate features diagnostic of the Urnes style, including smooth tapering lines, broad and narrow band widths, and multi-loop schemes (see Fig. 3.71). By the mid-1990s, over one hundred openwork brooches in the Urnes style had been recorded in Scandinavia; a figure which has increased further still in recent years due to the influx of finds registered through metal-detecting (Bertelsen 1994, 347; Roesdahl 2007, 26, note 46). The brooch type is concentrated in southern Scandinavia, especially northern Jutland (Bertelsen 1994, 347, fig. 3). A specialized workshop for the manufacture of openwork Urnes-style brooches, indicated by the presence of numerous moulds, unfinished brooches, and complete specimens has also been excavated in Lund, southern Sweden (Bergman and Billberg 1976, 206–10).

Evidence for the circulation in England of Scandinavian openwork Urnes-style brooches comes from an unlikely source: a late eighth-/early ninth-century manuscript of a Bible from St Augustine's, Canterbury, BL Ms. Royal I. E.vi (Owen 2001, 208–9, pl. 11.3). Abutting a rectangular frame accompanying an Evangelist miniature—a later addition to the manuscript—is an unfinished sketch of a beast in the classic Urnes style, along with the inscription, in the same hand, '*P ego*' (Owen 2001). The beast, a snake-like creature with open jaws, an upturned ear, an arched neck, pronounced hip, and extended foreleg,

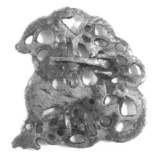

Fig. 3.71 Openwork animal brooch in the Urnes style, Hedeby, Schleswig-Holstein © author.

Fig. 3.72 Animal-shaped brooch in the Urnes style, Shotley, Suffolk © Suffolk County Council.

is so similar in design to animals executed on openwork brooches as to suggest direct copying from a metal prototype. Indeed, Owen has suggested that 'the enigmatic "*P*" (whoever the scribe was) most probably had an Urnes-style openwork animal brooch actually in front of him' (Owen 2001, 209).

Until recently, there was little in the archaeological record that could be cited in support of such conclusions. This position has recently changed, with the discovery of two openwork Urnes-style brooches (cat. nos. 494–5). One, from Walcott, Lincolnshire, depicts a profiled ribbon-shaped animal enveloped in interlacing tendrils and snakes. The animal's head is down-turned with a large, almond-shaped eye, open jaws, and a bulbous upper lip. Its main body forms a fluent S-shape, with fore and hind legs that bifurcate into tendril offshoots and appear to form the body of a snake. The interlace scheme on the Walcott brooch invites comparisons with a complete brooch from Tröllaskógur, southern Iceland (Graham-Campbell 1980, no. 151). This counterpart, together with the diagnostic animal and snake combat motif, assign the Walcott brooch to the classic Scandinavian Urnes style and identify it as a probable import. The pin-attachments on the reverse of the brooch include a double pin-lug, catchplate, and a 'suspension' loop and likewise indicate a Scandinavian origin.

A similar attribution can also be made for a second openwork Urnes-style brooch, unfortunately in a very poor state of preservation, from Shotley, Suffolk (see Fig. 3.72). This item has a slightly chunkier appearance, with a serpentine creature executed around small perforations. Such a treatment would seem to indicate the poorer quality of the piece, since the holes appear to have been drilled after casting, rather than cast integrally as was traditional (Anne Pedersen, pers. comm.). However, the thicker lines of the beast may also reflect the influence of the Ringerike style. The fittings on the reverse of the item include a Scandinavian-type double pin-lug and catchplate, and would appear to confirm the Scandinavian source of the piece.

Bird brooches

Late Viking-Age artistic elements also appear on bird-shaped brooches, a type recently surveyed by Anne Pedersen (2001). Bird brooches derive principally

from southern Scandinavia and come in a variety of different forms, including birds with defined Urnes- or Ringerike-style features, occasionally in an openwork form which relates them to the openwork animal brooches discussed above (Perderson 2001, fig. 15; Graham-Campbell 1980, no. 150). Semi-realistic birds, with defined feathers, a curved beak, and legs with clawed feet, also appear as brooches, as do stylized, simpler bird types, on which the detail is restricted to the fan-shaped tails (see Fig. 3.73) (Pedersen 2001). The geographical distribution of the seventy-five bird brooches currently known from Scandinavia points to their production in Denmark, perhaps in north Jutland where there is a particular concentration of finds (Pedersen 2001, 29, fig. 15). However, an unfinished semi-realistic bird brooch from Hedeby, without attachment fittings and a lead model for related brooches from Lund, suggests that production may have been widespread (Fig. 3.73; Pedersen 2001, 29, fig. 6f.).

Both the Urnes/Ringerike bird types and the semi-realistic forms are represented by brooches from England: seven are currently recorded, almost double the number known ten years ago (cat. nos. 498–504) (see Table 3.11 and Map 3.22) (Pedersen 2001, cat. nos. 76–9). These items are distinct from a group of earlier Anglo-Saxon brooches, which also adopt various bird-shaped forms (Pederson 2001, 32–4). One Scandinavian bird brooch from England comes from Stoke Holy Cross, Norfolk (cat. no. 500) (see Fig. 3.74). This bird has a round eye, a beak with a tendril-like extension, and a fan-shaped tail, defined, like its wing and shoulder, by engraved lines. Its shoulder is represented by a spiral: a Ringerike-style trait. However, the extended beak and closed mouth is traditionally attributed to the Urnes style, as depicted, for instance, on a bird brooch fragment from Falster, Denmark (Pederson 2001, fig. 5). A very similar brooch is known from South Ormsby, Lincolnshire (cat. no. 499). Interestingly, there are no exact Scandinavian parallels for these two brooches, although a similar bird motif does appear on a coin of Magnus the Good (1042–47) from Lund (Pederson 2001, 31, fig. 18). Ringerike- and Urnes-style elements are deployed in other ways on bird brooches from Scandinavia, and make a Scandinavian origin for these two items highly likely.

Fig. 3.73 Semi-realistic bird brooch, possibly unfinished, Hedeby, Schleswig-Holstein © author.

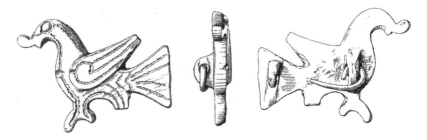

Fig. 3.74 Bird brooch with Ringerike-style elements, Stoke Holy Cross, Norfolk, drawn by Sue White © Norfolk County Council.

Two further bird-shape ornaments, both from Nottinghamshire, take a semi-realistic form (cat. nos. 501–2). An item from Harworth, bereft of attachment fittings, is formed of a profiled, right-facing bird, with a fan-shaped tail and engraved lines marking its feathers and tails. This brooch lacks specific Scandinavian artistic features, but its form and naturalistic treatment is paralleled among a group of Scandinavian bird brooches noted by Pedersen for their feathers and body details (Pedersen 2001, 32, fig. 6). A second item, also without attachment fittings, depicts a left-facing creature, with an oval eye and what appears to be a small head crest; engraving marks out its tail and wing while its feet are joined at the base, creating a circular opening underneath the body (cat. no. 501). The bird's curved tail is a distinctive trait, and is rare in Scandinavian contexts, although a similar tail appears on the bird depicted on the Magnus the Good coin from Lund (Pedersen 2001, fig. 18).

Two final bird brooches are discussed here in a Scandinavian context on the strength of the inclusion of one item in Pedersen's 2001 survey (cat. nos. 503–4) (2001, cat. no. 78). There are, however, no direct Scandinavian parallels for the treatment of these items, and they may represent Anglo-Scandinavian products. These two brooches depict a bird with a rounded body, ornamented with lines of ring-dots, and feet which form three circular openings underneath the body; one bird has a lowered head and curved neck, missing on the other example.

Table 3.11 Summary of Late Viking-Age brooches from England

	Mammen-style brooches	Ringerike-style brooches	Urnes-style brooches (disc)	Urnes-style brooches (openwork)	Urnes-style brooches (bird)	Total
Scandinavian	0	0	0	2	5	7
Anglo-Scandinavian	2	1	2	0	0	5
Unclassifiable	0	0	0	0	2	2
						14

The ring-dot ornament is unique to these two items, although the curved form of the extant bird's neck relates it to known Scandinavian examples.

Anglo-Saxon jewellery in Scandinavia[2]

The evidence presented in this chapter suggests strong cultural connections between southern Scandinavia and England in the late ninth and early tenth centuries, with an array of Danish-style jewellery being imported to England or produced there. In order to understand the processes by which artefact forms and styles were transferred from Scandinavia to the Danelaw, it is worth exploring evidence for the reverse process: the circulation of contemporary Anglo-Saxon jewellery within the Scandinavian homelands. Here, the concern is not with eighth- or early ninth-century insular metalwork imported to Scandinavian as 'loot' and secondarily converted into brooches (for which, see Wamers 1985; 1998). Rather, it is with later ninth- and tenth-century dress items of everyday use which are likely to have arrived in Scandinavia via trade or cultural contact with the Danelaw. In a model in which we suppose Scandinavian dress styles to have been introduced to England through trade and cultural exchange we may expect Anglo-Saxon styles to have been similarly adopted in Denmark.

It is clear that insular dress fashions were, on occasion, transmitted to Scandinavia. From the mid-ninth century, penannular brooches of Irish origin were adopted in Scandinavia, the uptake occurring via Hiberno-Norse communities in Dublin, first in Norway and then in Sweden (Graham-Campbell 1987a; Wamers 1998, 38). The transfer of this article of male dress is of particular importance, since it signalled the introduction within Scandinavia of a new dress component modelled on insular customs: the cloak, with which penannular brooches were worn (Wamers 1998, 38). As recently argued by Zanette Glørstad, the adoption of the cloak and associated metalwork by high-ranking males in Norway is likely to have been a conscious move designed to foster connections with the Irish Sea, the source of economic wealth, and political authority for Norway's ruling elite (2010).

The adoption of penannular brooches in male dress in Norway and Sweden highlights the potential for insular metalwork to make a profound impact on Scandinavian dress customs. However, since they evolved from Irish, rather than Anglo-Saxon, traditions, their uptake in Scandinavia cannot be taken as evidence for trade or cultural contact with the Danelaw per se.[3] Moreover, within Scandinavia, penannular brooches are largely confined to Norway and Sweden, whereas it is in Denmark that we may expect to find evidence for cultural exchange with the Danelaw.

[2] I am grateful to James Graham-Campbell for his advice on this section.

[3] Since penannular brooches, as well as ringed·pins, are also found in England, it is possible that some items reached Scandinavia via the Danelaw, as suggested by Fanning (1994, 35–6).

The number of specifically Anglo-Saxon dress items of ninth- and tenth-century date found in Scandinavia is small. A gold Anglo-Saxon finger-ring of ninth-century date, which had been fitted with a gold loop to facilitate reuse as bullion, or as a pendant, was contained in the Hoen hoard, Norway, but this item is likely to have been loot brought back to Scandinavia following Viking raids on England (Graham-Campbell 1999, 55; Fuglesang and Wilson 2006, 119–21). Other silver dress items of English origin contained in Scandinavian hoards may have also been treated as bullion. A fragmentary silver strap-end from Krogen, Norway, appears to have formed part of a small hoard deposited in the second half of the ninth century and seems likely to have functioned as bullion or scrap silver rather than as a dress accessory (Thomas 2000a, 175–6). The same applies to two broken and cut Late Anglo-Saxon silver disc brooches found in mixed (coin and ornament) hoards from Sturkö and Igelösa, Sweden, and a third complete brooch of the same type from a further silver hoard, from Kungsholmen, Stockholm (Wamers 1985, cat. nos. 112, 150–1, 153).

A handful of bronze and silver hooked tags of Late Anglo-Saxon manufacture, found in different contexts in Scandinavia, are likely to have been used in dress as originally intended (Graham-Campbell 1980, no. 311; Pedersen 2004, 46; Weber 1987, 106, fig. 4; Arbman 1940–43, pl. 91, 6). An English origin can also be assigned to a number of strap-ends with a Scandinavian provenance, including a late eighth- or early ninth-century silver strap-end with two interlacing animals from a grave in Østebø, Norway, a strap-end in the Trewhiddle style from Gamle Viding, near Ribe, Denmark, and a bronze item from the 'Black Earth' at Birka (Wamers 1985, cat. no. 79, pl. 29, 7; Thomas 2000a, 198; Jensen 1990, 34, fig. 13; James Graham-Campbell, pers. comm.).

A tenth-century bronze strap-end of Anglo-Saxon tongue-shaped form, is known from Aggersborg, Denmark (Graham-Campbell 1980, no. 187). However, this item carries Scandinavian-influenced interlace and is best classed as an Anglo-Scandinavian, rather than Anglo-Saxon, product (Graham-Campbell 1980, no. 187; Pedersen 2004, 46). Interestingly, this item is not the only strap-end to demonstrate a degree of stylistic transfer from England to Scandinavia. A distinct insular version of the Borre-style ring-chain, characterized by a central mid-rib of truncated, concave-sided triangles, appears on a strap-end from Sundvor, Rogaland, Norway (Wilson and Klindt Jensen 1966, fig. 49). This so-called 'vertebral ring-chain' motif is common on sculpture in north-west England and the Isle of Man, but is rare in Scandinavia, making its appearance on a strap-end from Norway all the more notable. It would seem that the commonality of strap-ends to both Anglo-Saxon and Scandinavian dress facilitated the adoption and adaptation of this artefact type and its stylistic content across cultures (Thomas 2000b, 252).

Within Scandinavia the best evidence for Anglo-Saxon metalwork comes from Hedeby. Here, as elsewhere in Scandinavia, there is evidence for the appropriation and reuse of looted metalwork in Scandinavian dress, as in grave 60,

where a silver Anglo-Saxon circular pin-head was refashioned as a third brooch and worn in between a pair of oval brooches in the traditional Scandinavian manner (Hilberg 2009, 98, fig. 17). Perhaps more interestingly, the site has also yielded simple, lower quality dress accessories which may have arrived via trade or as costume items on visitors. The current tally includes two bronze hooked tags and over fifteen bronze strap-ends, including Trewhiddle-style, 'multi-headed' and 'ribbed' types, all of ninth- or early tenth-century date (for a selection, see Hilberg 2009, 97–8, figs. 15, 16, and 18). As Hilberg notes, Anglo-Saxon Trewhiddle-style strap-ends have also recently been recovered from Truso, Poland, as well as Rjurikovo Gorodišče, the predecessor of Novgorod (Hilberg 2009, 98). Like Hedeby, these sites served as market centres. The light scatter of Anglo-Saxon metalwork at such sites may suggest that relatively common dress items like strap-ends were transported by ninth-century traders from England moving around the Baltic Sea, although, as noted above, the uptake of Anglo-Saxon strap-ends within the Scandinavian homelands is also likely to have been helped by local familiarity with the artefact type.

The small number of Anglo-Saxon dress accessories encountered in Scandinavia presents a striking contrast with the large number and diffuse distribution of Scandinavian and Anglo-Scandinavian dress items within England. It is similarly at odds with the substantial number of brooches of Carolingian and Ottonian origin now documented in Denmark (Baastrup 2009). English coins of ninth- and early tenth-century date are similarly scarce within southern Scandinavia, only occurring in hoards in significant numbers from the late tenth century (Pedersen 2004, 44). Archaeological evidence for contacts between Denmark and England increases substantially in the eleventh century. Finds in southern Scandinavia of English coinage, pottery, and decorative items of this date, most notably at Lund and Viborg Søndersø, point to a transfer of material culture forms from west to east, a process no doubt facilitated by the rule in England of a Danish King (Cinthio 1999; Roesdahl 2007; Pedersen 2004; Iversen et al. 2005). While cultural connections between Denmark and England in the eleventh century are likely to be far more complex than revealed by small finds alone, this material throws into sharp relief the paucity of evidence for two-way cultural exchange in the late ninth and early tenth centuries. In terms of female dress items, there is very little indication in the archaeological record for a true exchange of cultural forms and motifs. This, in turn, suggests a close link between the onset of Scandinavian settlement in England in the late ninth century and the dress items at the heart of this study.

Conclusions

This chapter presented evidence for over five hundred Scandinavian and Anglo-Scandinavian brooches and pendants from England. In so doing, it demon-

strated the wide availability of Scandinavian-style dress fittings in the later ninth- and tenth-century Danelaw. As the summary of recorded jewellery types presented in Table 3.1 made clear, the insular repertoire is extremely diverse. Not only does it encompass many of the small disc, trefoil, and lozenge brooches encountered in Scandinavia, including rare and hitherto unrecorded types, it also includes the large trefoil, oval, and equal-armed brooches earlier thought to have been discarded by early settlers (Thomas 2000b, 252). This diversity is highly significant and has huge potential to inform our understanding of how and by whom Scandinavian dress fashions were introduced in England (Chapter 7). Significantly, typological variety is a feature of both Scandinavian and Anglo-Scandinavian products, demonstrating a vibrant local demand for jewellery which looked Scandinavian, but which adopted a pin-fitting form familiar to Anglo-Saxon women. This theme is explored further in Chapter 5.

Turning to Scandinavian parallels for the dress items from England, two trends emerge. The first is that the material from England finds parallels across the Scandinavian world, encompassing artefacts otherwise found predominantly in Norway, Iceland, eastern Sweden, and the Baltic, as well as in Denmark. The broad geographic spectrum of this material highlights regional differences in artefact styles within Scandinavia, and hints at the potentially diverse cultural origins of Scandinavian migrants to the Danelaw. The second trend is that, despite evidence for eastern and western Scandinavian jewellery styles in the Danelaw, most material from England finds its closest counterparts in southern Scandinavia: at sites such as Hedeby, Lake Tissø, and Uppåkra, in the area of Viking-Age Denmark. It is important to note that this pattern may, to some extent, reflect concentrations of metal-detecting within modern-day Denmark and Skåne: this has given rise to an expanding corpus of finds from the south which privileges artefact types most easily found via detecting, such as small disc, lozenge, and trefoil brooches. Nonetheless, it remains true that only a small number of the dress items discussed here have representatives among the stray finds and excavated material from Norway and Sweden, including recent excavations at Kaupang (Hårdh 2011). Indeed, jewellery types largely confined to these areas, such as pendants and large disc brooches, are rare or absent in England. The stylistic parallels for female dress accessories, while in one sense widespread, thus point to Viking-Age Denmark as the area of Scandinavia with the tightest ties to the Danelaw.

4

The production and lifespan of Scandinavian-style jewellery

Introduction

By the late ninth and tenth centuries, female dress accessories in Scandinavian styles were common currency in some regions of the Danelaw. In the preceding chapters, these brooches and pendants were identified, described, and linked with their counterparts across the North Sea. The goal of the ensuing chapters is to uncover the reasons why such artefacts are found, in high numbers, across northern and eastern England. Who wore these dress items and what did they symbolize? To what extent can they be correlated with a female Scandinavian presence? In order to answer these questions it is vital to consider the origin and use of the artefacts: their locations of manufacture as well as the length of time for which they were worn.

Establishing the source of Scandinavian-style dress items from England is crucial for revealing both the identities of its wearers and its role in shaping Anglo-Scandinavian culture, but presents a number of methodological challenges. As small items of portable metalwork, brooches and pendants may be sold, traded, bequeathed, borrowed, inherited, lost, or stolen. The life histories of individual items of jewellery are unknowable, and are likely to be diverse. A brooch may have arrived in England on the clothing of a female migrant, for instance, or have been imported as a market good and sold in a Danelaw town. Alternatively, it may have been produced locally to meet a demand among the settled population for Scandinavian-looking jewellery. Almost certainly, all three scenarios are represented among the English finds.

Despite these varied histories, with over five hundred objects currently recorded, it is possible to identify patterns which might reveal the geographical sources of Scandinavian and Anglo-Scandinavian jewellery, and the mechanisms by which such items were introduced to England. In the first part of this chapter I examine the possible contexts of manufacture of Scandinavian-style dress items in the light of current archaeological evidence. Taking into account direct evidence for brooch manufacture, in addition to evidence which may be inferred from artefact distribution patterns, I argue that many purely Scandi-

navian dress items found on English soil are likely to have been manufactured within Scandinavia and imported. By contrast, Anglo-Scandinavian brooches are likely to have been produced locally, with evidence suggesting places of manufacture in both the towns of the Danelaw as well as in the countryside.

In the second part of the chapter I consider the date range and lifespan of Scandinavian-style jewellery in England as a means of exploring broader questions of brooch use. The aim is to advance overall understanding of Scandinavian-style dress accessories, as well as to elucidate the relationship between the artefacts and historically-documented Scandinavian settlement. Whereas we might expect the brooches and pendants to be strictly contemporary with the settlement period, there are indications that they both pre- and post-date it, remaining in circulation well into the tenth century, and beyond. This has a number of important implications, not least for providing evidence for continued cultural contact between Denmark and England right up to the time of the Norman Conquest.

The manufacture of Scandinavian-style jewellery

Before considering archaeological evidence for the manufacture of Scandinavian and Anglo-Scandinavian dress items, it is useful to outline briefly the technical processes by which small copper- and lead-alloy brooches were produced. It is now widely acknowledged that, within Scandinavia and England, copper-alloy brooches were normally cast in piece moulds made from sand-tempered clay (Lønborg 1998, 16–32). A brooch model, either an existing brooch or a specially produced prototype made of wax or lead, was impressed on the front and back on to two pieces of clay to form the mould cavity. Usually (in cases where the pin-fittings were not moulded directly from the model), a pattern for the pin-fittings was then impressed into the clay before the two pieces were reassembled to form the upper and lower mould valves, and left to dry.[1] While wax models could be left in place, to be melted out throught later heating, solid models would then be removed from the mould. Once reassembled, the two mould valves were covered in a loam mould, to prevent molten metal from escaping during firing and casting. They were left to dry and then fired. Molten metal was poured into the mould via an in-gate and allowed to cool and solidify into the negative pattern generated by the impressed model. To retrieve the metal object, it was necessary to break the clay mould; each new casting therefore required a new mould, with the used pieces simply being discarded. After casting, the spru would be cut off and the finished object filed or retouched to remove imperfections such as casting seams as well as to refine or add ornamental detail. At this stage, the pin-lugs and catchplates could be perforated or bent into shape as required (Fuglesang 1992; Leahy 2003b, 141).

[1] A possible lead model for a lozenge brooch from Kaupang, Norway, has fittings for a pin, indicating that the lugs could be prepared on the model (Unn Pedersen, pers. comm.). However, such fittings are rare on models, and the piece may be a lead brooch.

This final stage is important for understanding how different pin-fittings evolved. Due to their modified form, pin-fittings on the reverse of ready-to-wear brooches could not form the negative pattern for fittings on new brooches. Instead, the layout and form of the fittings had to be newly generated for each item.

The production process for lead-alloy brooches, well represented in the Anglo-Scandinavian corpus, is likely to have been similar. But since lead has a lower melting point than copper, lead-alloy artefacts could also be produced from solid, reusable moulds made of bone or antler, of the type recorded in York and Ipswich (MacGregor 1985, 195; West 1998, fig. 97.7; Newman 1993). Rather than being discarded after casting, such moulds could be used time and again, facilitating the serial production of base-metal artefacts.

Perhaps the most important practice noted in this summary concerns the use of existing brooches as models for new moulds, observed for oval as well as small brooch types within Scandinavia (Jansson 1981; Maixner 2004, 55). This practice is highly significant, as it implies that brooch production could take place wherever existing brooches were in use. In principle, therefore, a Scandinavian brooch could be produced in England simply with the aid of an existing Scandinavian brooch. Since the process would only require the reproduction of ornament originally designed by others, the craftsman would not need to be trained in Scandinavian art styles or craft techniques. One consequence of this process is that it may not be possible to distinguish imported items from those produced in England using Scandinavian prototypes, especially if the original form of pin-attachments was also copied (Jansson 1981, 6).

The extent to which existing Scandinavian brooches were used as models for new items in England is unclear, however. Very occasionally, particular morphological traits on items found in England suggest the use of an existing Scandinavian object as a direct model. For instance, a coiled snake pendant from Overstone, Northamptonshire, is a mirror image of pendants known from Scandinavia; it may have been produced from a mould formed from an extant pendant, either in Scandinavia or in the British Isles (cat. no. 449) (Richardson 1993, 42–3). Such a process may also be inferred where there are multiple copies of the same brooch type and where a decline in brooch quality is observed, as is the case for Scandinavian Borre-style brooches of Type II A (Chapter 3). It is important to note, however, that within Scandinavia brooches were produced via the same methods (Maixner 2004, 54–5). Lower quality copies found in England need not therefore have been produced locally, but may have been imported.

In practice, the extent to which existing brooches were used as models may have been limited by the degradation in ornamental quality and reduction in size that such copying and recopying necessarily entailed (Fuglesang 1987, 219). Although a craftsman need not be especially trained in Scandinavian craft techniques, familiarity and experience with Scandinavian art styles would

have been desirable, especially for applying the finishing touches to a brooch after casting. This is particularly the case for brooches with elaborate decoration, such as oval and large trefoil brooches. Certainly, the fact that Scandinavian brooches found in England usually retain typical Scandinavian attachment features, including the attachment loop, would appear to suggest that they were made by craftsmen familiar with Scandinavian traditions since, as noted above, these fittings would have been created for each new casting.

Although evidence for such processes is elusive, positive evidence of production can confirm locations of manufacture. Production may be indicated by direct archaeological evidence such as models, moulds, or unfinished or miscast items, or it may be inferred from patterns which traditionally characterize places of manufacture, such as the discovery of multiple brooches at a single site. In fact, there is little positive evidence for Scandinavian brooch manufacture outside the Scandinavian homelands, despite the widespread distribution of such artefacts across the Scandinavian world (Jansson 1981, map 6, note 4). To date, physical evidence for Scandinavian brooch production outside Scandinavia is limited to an unfinished lozenge brooch from Dublin, which may have been imported as scrap metal, and a small number of unfinished items and clay mould fragments, including one for a trefoil brooch, from Swedish colonies in Russia (Jansson 1981, note 4, fig. 6; 1992, 69).

The standardized appearance of Scandinavian brooches from Russia and other colonies suggests instead that most brooches were produced centrally within Scandinavia, at prominent trade and manufacturing sites such as Birka, Hedeby, and Kaupang (Jansson 1981, 6–7; Callmer 1995). The large number of clay mould fragments and unfinished items recorded from such sites supports this model of centralized production (Jansson 1981, note 4, fig. 6). Hedeby, for instance, has produced over fifty mould fragments for trefoil brooches alone, while over three hundred and fifty mould fragments for Berdal brooches (precursors to the oval brooch) were recorded during excavations at Ribe (Maixner 2005, cat. B, I–LXXIII; Feveile and Jensen 2000, 17, fig. 6). Surviving mould fragments also attest the serial production of oval and equal-armed brooches at Birka (Arrhenius 1973).

Dies, models, miscast and unfinished products also come from other types of site within Scandinavia, including so-called 'central places', harbours and coastal settlements, and ordinary rural farmsteads (Bakka 1965, 132, fig. 41; Jansson 1981, 7, note 4; Jørgensen 2003, fig. 15.23; Ulriksen 2006, 193). Patrices to create moulds for lozenge brooches have been recorded at the aristocratic sites of Lejre, Gudme, and Lake Tissø in Denmark (see Appendix A, List 3). To judge from other evidence of manufacturing debris, these sites served as prominent production centres (Christiensen 1991; Jørgensen 2003). The serial manufacture of Borre-style disc brooches in Smiss, Gotland, is indicated by three unfinished Type II A brooches, cast together from a single clay piece and still joined together by intact runners (the solidified metal from channels in

the mould leading to the object matrix) (Zachrisson 1962, fig. 9). Such a dis-covery is particularly notable since such brooches were not worn locally and must therefore have been produced for export (Jansson 1981, 7). These discov-eries imply that, far from monopolizing metalwork production, sites such as Birka and Hedeby were centres of larger networks involved in the manufacture of dress items, no doubt intended to meet the demands of local as well as regional markets.

Evidence of manufacture from England

Scandinavian brooches

In England, archaeological evidence for the manufacture of explicitly Scandi-navian dress items of the type recorded in this survey is absent. Despite the extensive number of extant brooches found on English soil, there are, as yet, no known moulds, dies, or miscast or unfinished items which might indicate local manufacture. A clay mould for a trefoil brooch was recovered during excavations at Blake Street, York (Fig. 4.1) (Kershaw 2008, 263–4). However, the ornament on the mould is not Scandinavian, but comprises tendril and animal motifs drawn from the English Winchester style; it thus belongs to a distinctly Anglo-Scandinavian, rather than Scandinavian, milieu. Notably, its use of Winchester-style ornament assigns the mould to a mid-to-late tenth-century date, indicating a period of production after the floruit of trefoil-shaped brooches in the Scandinavian homelands (Kershaw 2008). One further item, a domed lead object from Badingham in Suffolk, has been tentatively identified as a trial piece or model for convex disc brooches of Scandinavian type (PAS 'Find-ID' SF3977). Yet with a diameter of just 21mm it is too small to have produced any of the brooches in this study, and its early medieval date is not certain.

Of course, absence of evidence is not evidence of absence. Future discoveries may reveal fresh evidence for the insular production of Scandinavian dress items. The discovery in Ketsby, Lincolnshire, of a tongue-shaped die used for creating Jellinge-style mounts suggests that Scandinavian ornament could be created within an insular setting (Leahy 2007, fig. 71.6). Furthermore, two objects—a bronze die from Swinhope, Lincolnshire, and a lead matrix from York—attest to the manufacture in northern England of exclusive precious metal Scandinavian pendants of the Hiddensee type (Naylor et al. 2009, 337, fig. 5b; Roesdahl et al. 1981, YMW13). This jewellery is, however, of a very different character to the mainly bronze and lead-alloy brooches recorded in this book and, to date, no finished pendants of the Hiddensee type have been found in England.

Indirect evidence for the manufacture of Scandinavian dress items in Eng-land is also scarce. Were Scandinavian brooches to have been produced within workshops in England from existing brooches, we would expect a restricted

Fig. 4.1 Trefoil mould fragment with Winchester-style ornament, Blake Street, York, (drawing after MacGregor 1978, fig. 24.8) © York Museums Trust (Yorkshire Museum).

range of recurring brooch types, with multiple duplicate copies of the same brooch. Populated Scandinavian brooch series are known from England, as demonstrated by multiple lozenge brooches and Type II A Borre-style disc brooches. Overall, however, Scandinavian brooches from England exhibit a diverse repertoire of brooch types and subtypes, and, in many cases, are represented in England by just one or two specimens (see Chapters 3 and 7).

As demonstrated by the distribution maps of individual brooch types (see Maps 4.1–6) there is no discernible clustering of Scandinavian brooches which might highlight locations of manufacture. Rather, purely Scandinavian brooches and pendants (in contrast to Anglo-Scandinavian objects, which will be discussed shortly) are widely dispersed throughout northern and eastern England. This is equally true of Borre-style lozenge and disc brooches—established series with multiple representatives—as it is of individual subcategories of brooch, such as the different varieties of trefoil brooch. Such patterns would appear to suggest that neither brooch series nor individual types were produced within the Danelaw (compare Maps 4.1–6, with the brooch type distribution maps in Chapter 3). The one possible exception is the distribution of trefoil brooches with plant ornament (Type P), which show a marked concentration around Thetford (Map 3.10; compare with Map 4.4). However, these brooches date to the mid-to-late ninth century, making them the earliest Scandinavian brooch type recorded in England. Given their early date, these trefoils may be associated with the Viking winter camp recorded at Thetford in AD 870.

Anglo-Scandinavian brooches

As might be expected, archaeological evidence for the manufacture of Anglo-Scandinavian brooches is more extensive. Direct evidence for production remains scarce, the trefoil mould from York providing the only known Anglo-

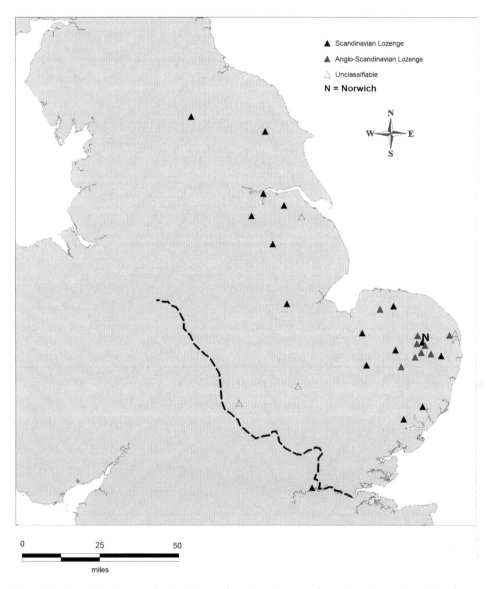

Map 4.1 Scandinavian and Anglo-Scandinavian lozenge brooches in England (excludes three unprovenanced examples)

Scandinavian brooch mould from England. Instead, miscast and unfinished items indicate possible locations of manufacture. Casting bubbles are visible on a devolved Jellinge-style disc from 16–22 Coppergate, York (cat. no. 482). This item, one of two similar lead-alloy discs from the city, was found along with material indicative of non-ferrous metalworking, suggesting that both items were produced on-site (cat. no. 483; Mainman and Rogers 2004, 467). Signifi-

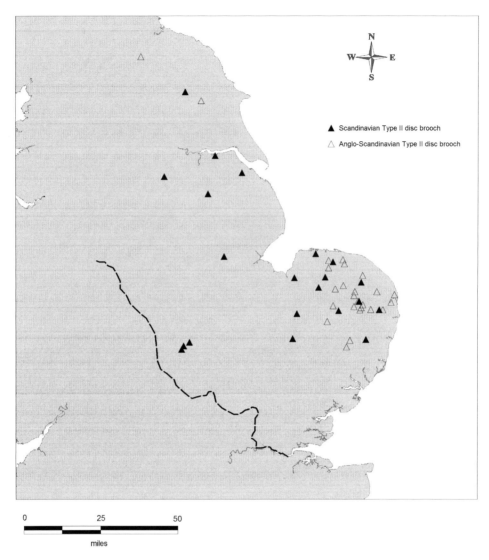

Map 4.2 Scandinavian and Anglo-Scandinavian Borre-style disc brooches in England (Type II)

cantly, York appears to have been a centre of production for the Anglo-Scandinavian Jellinge style. A debased version of the Jellinge style is characteristic of the sculpture from the city, while the appearance of the style on a bone motif-piece from Coppergate hints at the local production of the style in the medium of metalwork (Tweddle 2004, fig. 113).

In other cases, design irregularities point to local production. This is the case with an unusually large lozenge brooch from Towcester, Northamptonshire, which has an unconventional double, stacked pin-lug (cat. no. 32). This item is

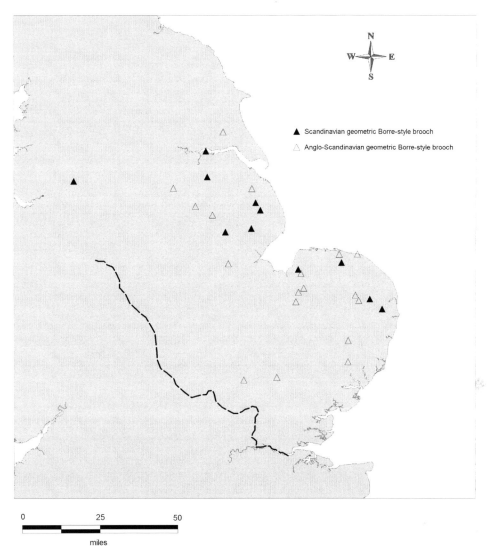

Map 4.3 Scandinavian and Anglo-Scandinavian geometric Borre-style disc brooches and pendants in England (including Terslev types)

recorded only as a drawing, but it appears to lack surface decoration, possibly indicating that it was unsuccessfully cast. It may have been a trial piece, produced locally, perhaps in nearby Northampton where there is evidence for metalworking in the Late Anglo-Saxon period (Bayley 1991).

The spatial clustering of Anglo-Scandinavian brooches in and around Danelaw towns suggests that urban centres played a key role in the production of Scandinavian-looking jewellery. All four mould-identical Borre/Jellinge-style rectangular brooches have been found in and around Thetford, where it is

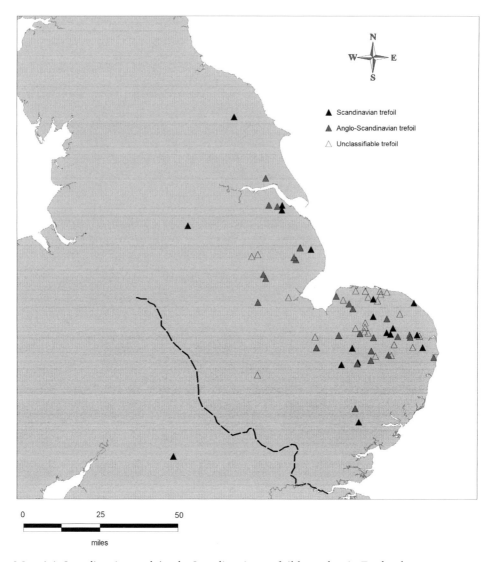

Map 4.4 Scandinavian and Anglo-Scandinavian trefoil brooches in England

likely they were produced (cat. nos. 443–6). Norwich forms the focus of the East Anglian Series distribution (see Maps 4.7–8). To date, it has yielded three East Anglian Series brooches, two of which consist of rare variant types (cat. nos. 219–21). Stylistic variation is often a feature of locations of manufacture, suggesting that this extensive series was, at least in part, produced in the town. This proposal is supported by the fact that two items come from Norwich Castle Bailey, where significant quantities of worked bone and antler, together with a possible motif-piece, point to craft working at the site prior to the establishment of a church in the eleventh century (Ayers 1985).

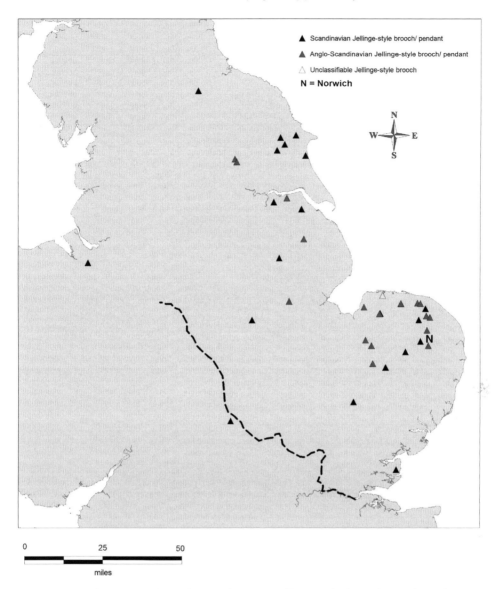

Map 4.5 Scandinavian and Anglo-Scandinavian Jellinge-style brooches and pendants in England (excludes two unprovenanced Scandinavian examples)

Norwich appears to have served as a centre of manufacture for other Anglo-Scandinavian brooches. Anglo-Scandinavian lozenge brooches reveal a distribution concentrated around Norwich (Map 4.1). These items share a common design fault in their elongated terminals, indicating their production from the same model. They seem likely to have been produced from a single workshop, probably located within the town. Although widely distributed within Norfolk, Jellinge-style disc brooches of Type I D may also be products of a Nor-

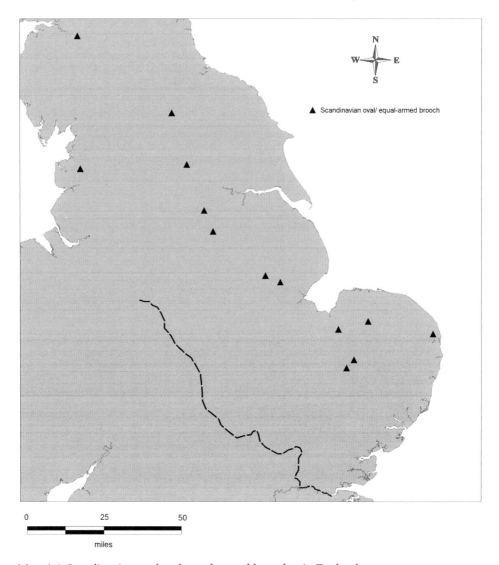

Map 4.6 Scandinavian oval and equal-armed brooches in England

wich workshop. Three items are known from the outskirts of Norwich and a string of finds is identifiable immediately north of the town (Map 4.5; compare with Map 3.21).

While recognizing the prominence of towns such as Norwich as manufacturing centres, we must be careful not to assume that all Anglo-Scandinavian brooches were products of urban workshops. The outskirts of Norwich in particular attract high levels of metal-detecting and it is possible that this pat-

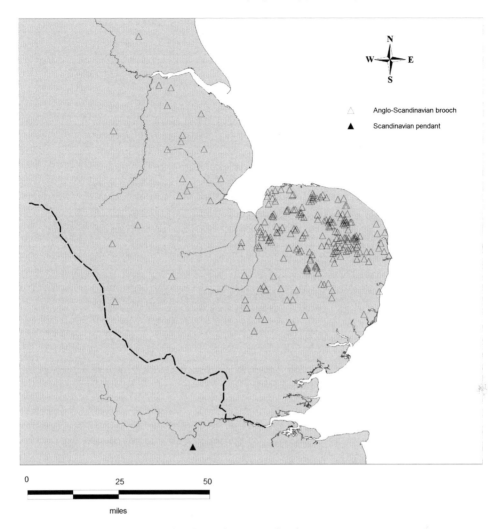

Map 4.7 East Anglian Series disc brooches in England

tern skews the apparent clustering of Anglo-Scandinavian brooches around the town. More broadly, the great stylistic variability observed within the Anglo-Scandinavian corpus as a whole is evidence of a widespread, local reaction to incoming Scandinavian styles, rather than of a restricted number of centralized workshops mass-supplying standard sets of jewellery to the region's inhabitants (see Chapter 7).

There is, in fact, sound evidence to suggest that metalwork production also took place in the countryside. The rural manufacture of Anglo-Scandinavian trefoil brooches is attested by an undecorated and miscast single trefoil lobe from Bradenham in south Norfolk (cat. no. 424). This lobe carries a single, looped pin-lug of Anglo-Saxon type, positioned vertically on the reverse. An

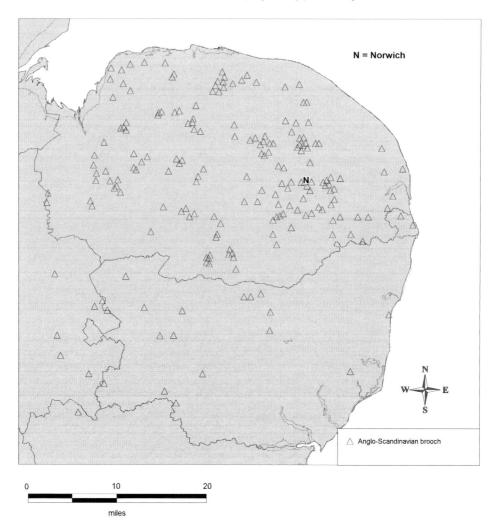

Map 4.8 East Anglian Series disc brooches in Norfolk and Suffolk

off-centre perforation breaches the side of the lug and casting flashes surround the pin-lug, providing clear evidence for the item's unsuccessful casting. Another seemingly unfinished Anglo-Scandinavian brooch, of the East Anglian Series type, comes from Wetheringsett-cum-Brockford in Suffolk (cat. no. 312) (see Fig. 3.22). Atypically for the series, this brooch has a double Scandinavian-type pin-lug, which appears from the available drawing to be unperforated, and thus incomplete. It may have been modelled on a Scandinavian disc brooch and discarded following the realization that an incorrect form of pin-lug had been created.

In many ways, this discovery is surprising. Apart from the existence of two variant designs from Norwich, the East Anglian Series is both stylistically homogenous and prolific, suggesting manufacture in a single workshop.

But this item is one of four East Anglian Series brooches from the same Suffolk parish, a concentration which may support local production (cat. nos. 310–13). The discovery of multiple brooches within individual parishes is, in fact, a recurring trend for this disc brooch series. Fifteen Norfolk parishes record three or more East Anglian Series brooches, with six brooches recorded in both Hainford and Hindringham (cat. nos. 163–8, 179–84). Hainford is located just a few miles north of Norwich and may have consumed high numbers of brooches produced locally. Yet the presence of six brooches in Hindringham, in north Norfolk, cannot be explained by proximity to Norwich. Such rural concentrations, together with the unfinished piece from Wetheringsett, suggest that Anglo-Scandinavian metalwork could be produced at dispersed, rural sites within the Danelaw. In light of the evidence for diverse places of manufacture within the Scandinavian homelands, discussed above, this picture is perhaps to be expected.

To summarize the findings presented above, there is currently no clear evidence for the manufacture in England of characteristically Scandinavian dress accessories of the type under discussion. Existing evidence instead points to the manufacture of such items at production centres within Scandinavia, as well as at network of smaller sites ranging from elite manors to simple farmsteads. For Anglo-Scandinavian jewellery, the picture is different. Both direct and indirect evidence attests the local production of culturally hybrid products, as we would indeed expect. While the current distribution maps highlight the prominence of towns such as Norwich and York as manufacturing centres, metalwork production was not confined to such sites. In England, as in Scandinavia, the manufacture of jewellery can be judged to have been widespread.

The 'lifespan' of Scandinavian-style jewellery in England

When was Scandinavian-style jewellery introduced to England, and for how long was it worn? The *Anglo-Saxon Chronicle* tells us that Scandinavian settlement in northern and eastern England commenced in 876. Independent Danish rule seems to have lasted in the central and eastern Danelaw for 40 or 50 years, until, in the 910s and 920s, the West Saxon kings annexed Scandinavian-controlled territories Mercia and East Anglia. Following these conquests, only the Viking territories centred on York remained, until, in 927, York too came under intermittent control of the West Saxon kings, before finally falling in 954. Against this chronological backdrop, we might expect Scandinavian-style jewellery in Early Viking-Age art styles to fall neatly within the period 876–*c*. 920, with some items perhaps remaining in fashion for longer in northern England, where Scandinavian rule persisted. In fact, the evidence reviewed here suggests a looser, more flexible time bracket, with evidence suggesting that some Scandinavian dress styles remained fashionable in England well beyond the end of independent Danish rule.

Dating Scandinavian-style jewellery from England

Independent dating evidence for Scandinavian-style jewellery in England is frustratingly scarce. Only seven dress accessories derive from datable archaeological contexts and evidence of contaminated deposits renders some of these dates unreliable (see Table 4.1). At Mill Lane, Thetford, for instance, there was evidence for the frequent mixing of 'early' and 'late' Thetford-type wares in the same features (Wallis 2004, 67). For this reason, the association in the fill of a pit of a Borre-style rectangular brooch, dated on stylistic grounds to the tenth century, with eleventh-century pottery, may be unsafe (Wallis 2004, 38). Since dress items found in England are rarely encountered in archaeological contexts such as burials, opportunities to date jewellery via associated finds in sealed contexts are similarly limited.

For most dress items, dating is therefore carried out on stylistic grounds, via comparisons with similar artefacts and motifs from datable contexts in Scandinavia. Here, a high percentage of metalwork is datable by its occurrence in coin-dated hoards, excavated settlements, and burials. Within hoards or burials, repeated find combinations, or 'occurrence seriation', offer a particularly rich source of relative chronological information (Gräslund 1976). Oval brooches are especially useful for determining the relative chronologies of associated artefact types, since they are both common and widespread finds, and have been independently classified and dated (Jansson 1985).

Within Scandinavia, Viking-period art styles such as Borre and Jellinge are also agreeably dated, providing a number of secure pegs on which to hang the chronologies of decorated artefacts from England (Kershaw 2010; 2011). While this relative means of dating jewellery assumes that artefacts from England will occupy broadly the same time periods as their counterparts in Scandinavia, it is acknowledged that there may have been a delay in the transmission of fashions from the Scandinavian homelands to the Danelaw. Since Anglo-Scandinavian metalwork adapted or tried to replicate Scandinavian prototypes, they are likely to post-date the original Scandinavian brooches on which they were partially modelled, as is indeed suggested by the mid-to-late tenth century trefoil brooch mould from York (see above pp. 133–4). Similarly, objects may have experienced truncated or extended lifespans in England compared with their counterparts across the North Sea.

On stylistic grounds, most jewellery items from England can be assigned a broad date range stretching from the late ninth to the mid-to-late tenth century. This period corresponds with the floruit of the Borre, Jellinge, and Mammen styles in Scandinavia, as attested by the appearance of these styles in coin-dated hoards and burials, as well as by dendrochronological dates obtained from sites with diagnostic material, including the relevant burial mounds at Gokstad (dated to AD 900–5), Borre (AD 900), Jelling (AD 958–9) and Mammen (AD 970/1), and the 'fortresses' of Fyrkat (AD 980) and Trelleborg

Table 4.1 Brooches from stratified archaeological contexts

Object	Location	Stratified Context	Stratified Date
Cat. No. 27 Lozenge brooch	Queenhithe, London	Found on a dendrochronologically dated brushwood platform	Late 11th–mid 12th c
Cat. No. 102 East-Anglian Series disc brooch	Flaxengate, Lincoln	Unspecified context from the Flaxengate excavations, dated by pottery	Mid–late 11th c
Cat. No. 219 East-Anglian Series brooch	Norwich, Norfolk	Found in a stratified layer on a possible workshop site in the Castle Bailey	11th c
Cat. No. 353 Terslev-derived disc brooch	Beverley, Yorkshire	Found in a sealed deposit, dated by associated coins and pottery, within a hall	Late 12th c
Cat. No. 446 Borre-style Rectangular brooch	Thetford, Norfolk	Found along with pottery in the fill of a pit	11th c
Cat. No. 452 Jellinge-style Openwork disc brooch	St Mark's Station, Lincoln	Found in association with timber buildings in a stratified archaeological sequence	'Late Saxon–Medieval'
Cat. No. 482 Jellinge-derived disc brooch	16–22 Coppergate, York	Found in a Period 5B build-up deposit in an unspecified context	975–early/mid 11th c

(AD 981) (Roesdahl 1994). The following discussion reviews the archaeological evidence for the dating of object types found in England, grouped for ease of reference according to style. Although it draws mainly on evidence from Scandinavia, it also highlights the small number of artefacts recorded from datable contexts within England, and assesses their contribution to current chronological knowledge.

Plant-ornamented brooches

Among the earliest Scandinavian-style dress items to be found on English soil are plant-ornamented trefoil brooches, decorated either with stylized scroll or naturalistic acanthus (cat. nos. 354–60). None of the finds from England derives from a datable context, so they must be dated by reference to Scandinavian material, as well as art-historical data. In a recent typology, Iben Skibsted Klæsøe proposed a date in the first half of the ninth century for trefoil brooches with stylized scroll, a period which corresponds with the emergence of scroll ornament on the Continent as well as with its appearance on Northumbrian stone sculpture (Skibsted Klæsøe 1999, 106; 2001, 225; Lennartsson 1997/8, 496–7; Webster and Backhouse 1991, nos. 113–16). If correct, this chronology would have profound implications for scroll-ornamented trefoils from England, since it would imply that they pre-date the Scandinavian settlement by several decades.

The underlying principle of Skibsted Klæsøe's chronology, that scroll motifs appeared on trefoil brooches directly from their source, should be questioned, however, for such motifs are likely to have been applied to Scandinavian brooches only after a period of circulation within the Carolingian and Anglo-Saxon realms. This, then, indicates a later date range for the series. This is supported by Scandinavian find combinations, which suggest a date in the second half of the ninth and early tenth century for trefoil brooches with scroll ornament, a date partly contemporary with the Borre style, which appears on some items (*contra* Skibsted Klæsøe 1999, 106; 2001, 225; Maixner 2005, 188–90, tables 1 and 8).

Trefoil brooches with acanthus decoration have traditionally been viewed as the earliest trefoil brooches, being closely related in stylistic terms to Carolingian trefoil mounts (Maixner 2005, 188–9). Yet recent research suggests that naturalistic foliate motifs on the Continent date to the second half of the ninth century, a later date than that proposed for designs incorporating stylized scroll (Westermann-Angerhausen 2006, 109–15; Lennartsson 1997/8, 498, 500). Trefoil brooches with this ornament are difficult to date independently, due to the small number of find complexes containing artefacts of this type (Maixner 2005, 189, table 8). The appearance of the Borre style on some items suggests a broadly contemporary date, perhaps in the mid-to-late ninth century.

Trefoil brooches with geometric ornament (Type G) carry stylized plant ornament. Like brooches with acanthus ornament, they are difficult to date independently: just four items from Scandinavia are recorded from datable contexts (Maixner 2005, 190, table 9). Although Skibsted Klæsøe has proposed a date in the first half of the ninth century for brooches of this type, her chronology is based on a series of incorrect identifications and must be considered inaccurate (1999, 106; 2001, 223, for a full discussion, see Maixner 2005, 54–5). The small number of Scandinavian find combinations containing geometric trefoils instead points to a date in late ninth and early tenth century for the circulation of the type (Maixner 2005, 190, table 9). Overall, then, it seems likely that plant-ornamented trefoils were introduced to England with the onset of Scandinavian settlement and not before.

Borre-style brooches and pendants

The majority of objects presented here carry ornament in or related to the Borre style, which circulated in Scandinavia from the late ninth to the late tenth century (Wilson 1995, 109, but for other views see Fuglesang and Wilson 2006, 16, 86–7). A number of Borre-style brooches found in England seem to be early within this date range. Lozenge brooches appear to have been fashionable from the late ninth century, as indicated by the recovery from one Birka grave of a lozenge brooch along with a dinar of Louis the Pious (814–40), reused as a pendant and probably deposited at this date (Arbman 1940–43, 117; Arwidsson 1989, 70). A similar, early date is indicated for disc brooches with zoomorphic ornament (Jansson Type II). At Birka, disc brooch Types II A and II D are often associated with oval brooch Types P 51 B and C, variously dated to the late ninth or early tenth century (Jansson 1985, 182; Fuglesang 1986, 236; Richardson 1993, 22).

Borre-ornamented trefoil brooches (Types E, Z, F) may similarly be assigned to the late ninth and first half of the tenth century in Scandinavia (Maixner 2005, table 10). In this case, dating evidence comes from forty-five find combinations, enabling various subtypes to be distinguished. While some variants represented in England, such as the Types E 1.2 and Z 1.5, appear to be early within this period, one type with Borre-/Jellinge-style animals (Z 2.4), has been identified as the latest in the series of cast trefoil brooches, on account of Mammen-style characteristics visible in its Jellinge ornament (Maixner 2005; Fuglesang 1991, 95). Another category of large Scandinavian brooch, the equal-armed brooch, is firmly dated to the late ninth and early tenth century on account of the type's association with oval brooches of this date (Aagård 1984, 108; Jansson 1985, 204–5).

Oval brooches are not technically Borre-style brooches since most examples preserve Oseberg ornament, inherited through the mechanical copying and recopying of older, existing brooches. Nonetheless, the corpus from England

includes the most common ninth- and tenth-century types, P 37 and P 51, which were contemporary with the style. The two P 37 brooches from Adwick-le-Street include one early (P 37:3) and one late (P 37:12) variant, suggesting a mid-to-late ninth-century date for the pair (Speed and Walton Rogers 2004, 74–5). The P 51 variants from England are early specimens within the P 51 sequence and may be dated to the later ninth or early tenth century (Jansson 1985, 174, 182; Fuglesang 1986, 236). In addition to these two principal types, the current English corpus includes a precursor to the oval brooch, of a type (Berdal P 23/4) dated to the transition between the Vendel and Viking periods: the late eighth or early ninth century (Jansson 1985, 226). Significantly, this brooch was found at the same isolated cemetery site in Cumwhitton as two tenth-century oval brooches, suggesting its use at that date. It is, then, likely to have been old and considerably outdated when worn and buried in England.

The closed ring-knot motif characteristic of Terslev compositions relates this group to the Borre style in both stylistic and chronological terms. In England, jewellery in Terslev or related geometric motifs is dated exclusively by reference to Scandinavian material, since the only relevant excavated object from England, a disc from Beverley, formed part of a twelfth-century scrap lead collection (cat. no. 353) (Armstrong et al. 1981, 155, 159 fig. 117, 707). The evidence of Scandinavian hoards suggests that the various Terslev compositions encountered in England occupied different chronological ranges, spanning the entire tenth century. Among the early-to-mid tenth-century motifs to appear in England are those classified in this book as Types I, VI, VII, and VIII, the latter of which appears in an altered form on a silver disc brooch from Whitton, Lincolnshire (cat. no. 323). In Scandinavia these motifs are found in silver in coin-dated hoards dated to the early/mid tenth century, for instance, from Vester-Vedsted, Gravlev, and Sejrø, Denmark, deposited after 925, 952, and 953 respectively (Wilson 1995, 109; Wiechmann 1996, 570). To judge from their associated finds, as well as limited stratigraphic evidence, cast imitations circulated concurrently (for instance, Kleingärtner 2007, cat. no. I-70).

A further group of Terslev motifs (Types II, IV, and V) spans the middle of the tenth century. Filigree jewellery in these styles is found in hoards with dates of deposition ranging from the 940s, as at Terslev (deposited after 941), to the 970s, as at Waterneversdorf, Schleswig-Holstein (deposited after 976) (Skovmand 1942, 111–13; Wiechmann 1996, 570). Limited archaeological evidence suggests a similar date range for cast imitations (Kleingärtner 2007, cat. nos. I-28, I-38). Of special interest is the date of the Type II motif, since this appears, in a slightly modified form, on the pendants from Saffron Walden (cat. no. 324). Based on the appearance of this motif in coin-dated contexts within Scandinavia, the pendants can be assigned to the mid-to-late tenth century, as originally suggested by Vera Evison (Kleingärtner 2007, tables 38–9; Evison 1969, 338). This is supported by other stylistic parallels for the pendants, including a brooch from Erikstorp, Östergötland, contained in a hoard deposited

in the last quarter of the tenth century (Stenberger 1950, 37; Kleingärtner 2007, cat. no. F-75).

Two final Terslev compositions (Type III and the unclassified motif which appears on a disc from Manchester) can be assigned to a date in the second half of the tenth century, the Type III motif being found in Scandinavian hoards from this date (Kleingärtner 2007, tables 38–9). The disc brooch from Manchester does not have exact Scandinavian parallels, yet bears some similarity to a pendant from a hoard from Øster Møse, Viborg, Denmark, dated on stylistic grounds to the late tenth century (Skovmand 1942, 61–5, fig. 12).

The dating of Anglo-Scandinavian artefacts, without exact parallels in Scandinavia presents additional challenges. The date of the East Anglian Series, an independent Anglo-Scandinavian brooch group, has been the subject of considerable debate with a number of scholars placing the series in the eleventh century on account of its stylistic affinities with Anglo-Saxon plant ornament of this date (Kendrick 1949, 38; Wilson 1964, 48–9; but see also 1976, 506). Evison, however, assigned the Borre-influenced brooches to the early-to-mid tenth century on account of the occurrence of a brooch with a similar composition in grave 968 at Birka, dated by other grave goods to around 950 (1957, 221). This date fits with more recent chronological evidence from Syvsig, Denmark, where a further Scandinavian brooch with the motif was found in association with a coin of Burgred of Mercia (852–74), which had been rolled up and used as a silver bead (Rieck 1982, 8). A date in the early/mid tenth century therefore seems likely for the East Anglian Series.

Within England, just a handful of Borre-style brooches come from excavated contexts which yield independent dating evidence. Perhaps most significantly, two East Anglian Series brooches come from stratified archaeological contexts: a brooch from Flaxengate, Lincoln, was retrieved from a mid-to-late eleventh-century structure, while a second brooch was retrieved from an eleventh-century context at Castle Bailey, Norwich (cat. nos. 102, 219) (Richardson 1993, 55; Ayers 1985, 29, fig. 24.1). Problems of contaminated deposits were encountered at both excavated sites, raising the possibility that both brooches were residual in later contexts (Jenny Mann, pers. comm.; Ayers 1985, 1). But at Castle Bailey the earliest activity dated to the late tenth century, with excavated material suggesting 'that most occupation and use…was confined to the eleventh century' (Ayers 1985). As noted above, there is sound evidence for locating the manufacture of East Anglian Series brooches at Castle Bailey, where a workshop is thought to have operated prior to the establishment of a church in the eleventh century. Such evidence may, then, indicate the continued production of this Anglo-Scandinavian brooch type into the late tenth or even eleventh centuries.

Two further excavated brooches come from similarly late contexts. At Bull Wharf, London, a Scandinavian lozenge brooch was retrieved from a brushwood platform associated with timber revetments dendrochronologically dated

to between the late eleventh and first half of the twelfth century (cat. no. 27) (Lynn Blackmore pers. comm.). While such a late date range suggests the item was residual in a later deposit, it is notable that this variant displays stylized animal heads and may, therefore, post-date the main lozenge series. Finally, a rectangular Anglo-Scandinavian Borre-style brooch, dated to the tenth century by its stylistic content as well as rectangular brooch shape, was found in the fill of a pit along with eleventh-century pottery, at Mill Lane, Thetford (cat. no. 446) (Wallis 2004, 38). As mentioned above, the intermixing of material from early and late dates characterized pit assemblages at Thetford, and may render the brooch's association with such late pottery unreliable (Wallis 2004, 67). Yet given the similar, eleventh-century context recorded for two East Anglian Series brooches, it at least seems possible that the Mill Lane brooch simply remained in use for an extensive period of time.

Jellinge-style brooches and pendants

Within Scandinavia, the Jellinge style can be assigned a period of currency stretching from the early to late tenth century. The early style adorns objects deposited in the same find complexes as Borre ornament including the Gokstad ship burial, dendrochronologically dated to 900–905 (Wilson 1995, 120–1). Chronological overlap between the two styles is also demonstrated by the styles' fusion on single objects; this gives rise to distinct, composite motifs, dated by their appearance in coin-dated hoards to the first half of the tenth century (Graham-Campbell 1976, 448–9; Capelle 1968a, 53–5, table 6). This date range correlates with independent evidence from York for the date of Jellinge-style sculpture, suggesting that the style was in contemporary use in England (Bailey 1978, 173).

Evidence from Scandinavian grave and hoard assemblages suggests that most motifs which circulated in England can be dated to the early/mid tenth century. Disc brooches Type I D and the pendant Type A3 carry the Jellinge motif of a backwards-turned beast, assigned to the first half of the tenth century within Scandinavia on account of its inclusion in coin-dated hoards of that date (Capelle 1968a, 53–5, table 6). The related motif of two opposed beasts, which occurs on Type I E brooches in England, is encountered in Scandinavia on pendants (Type Fiskeby) of the same date (Callmer 1989, figs. 3:22, 3:39). The brooch Type I A1 may be dated via reference to coin-dated graves in Scandinavia to the mid-late tenth century, and thus represents a slightly later brooch type (Capelle 1964, 223). This is supported by comparative stylistic evidence. The long-necked, looping animal carried on such brooches also appears on oval brooches of Type P 57, assigned to this date (Capelle 1964, 225). Two related brooch types, I B2 and I C, which share stylistic features with the I A1 series, are likely to have been contemporary with it. This is confirmed by the discovery of a Type I C brooch in a stratified context at Hedeby, assigned to a

date in the tenth or early eleventh century on account of an associated coin find (Capelle 1964, 225).

On the basis of Scandinavian evidence, Jellinge-style brooches from England may, then, be assigned a date range from the early to late tenth century. An Anglo-Scandinavian Type I D disc brooch with a debased Jellinge-style beast was found in a late tenth- to early/mid eleventh-century context at York (cat. no. 482). This is a late date, but the piece is a failed casting and may have circulated as scrap metal for some time following its manufacture (Mainman and Rogers 2000, 2571–2). That said, there is independent evidence that Scandinavian brooch styles continued to be manufactured in York into the mid-to-late tenth century. The Winchester-style trefoil brooch mould from Blake Street is firmly dated on stylistic grounds to this period, making it possible that Jellinge-style brooches also continued to be worn (Kershaw 2008, 263–4). One further stratified find from England is a Scandinavian Type I A1 disc brooch retrieved from cultural layers at St Mark's Station, Lincoln, broadly dated by the excavators to the 'Late Saxon and Medieval Period'. Notably, the earliest pottery from the site was recorded as dating to the first quarter of the tenth century, suggesting a contemporary or later date for the disc brooch (City of Lincoln Archaeological Unit 1998, 72).

Mammen-, Ringerike, and Urnes-style brooches

In addition to artefacts decorated in Early Viking-Age art styles, a small number of items from England are ornamented with the Late Viking art styles of Mammen, Ringerike, and Urnes (cat. nos. 491–504). These items are datable on stylistic grounds from the later tenth to the first half of the twelfth century, and are thus associated with England's so-called Second Viking Age, from around 980 to 1042 and the decades beyond (Kershaw 2011). Two Mammen-style brooches feature a bird belonging to a mature Mammen phase, and can probably be assigned to the later tenth century (Fuglesang 1991, 103). This fits with the broad tenth-century date given to Continental rectangular brooches (*Rechteckfibeln*), from which the two Mammen-style brooches take their form (Wamers 2000, fig. 175). The single Ringerike-style brooch from England was found in a hoard together with coins of William the Conqueror (1066–87) thought to have been deposited around 1070 (Backhouse et al. 1984, no. 105). However, the brooch is bereft of its attachment fittings, suggesting it had been used for some time prior to its deposit, and a date in the first half of the eleventh century seems likely for the piece (Backhouse et al. 1984).

The latest Scandinavian-style jewellery from England belongs to the Urnes style. In Scandinavia, openwork animal brooches in the style span the mid-eleventh to the early twelfth century (Ramskou 1955, 184; Bertelsen 1994, 357, notes 8, 13). Bird brooches date from the same period, as indicated by their appearance in coin-dated hoards (Pedersen 2001, 22). Anne Pedersen has

pointed to stylistic similarities between the bird-shaped brooch from Stoke Holy Cross, Norfolk, and the bird depicted on a coin of Magnus the Good (1042–7) from Lund, suggesting a mid-eleventh-century date for the piece (cat. no. 500) (Pederson 2001, 31, figs. 17–18). Within Scandinavia, bird brooches of a more naturalistic form are known only from a small number of archaeological contexts. One example was retrieved from settlement layers at Lund dating to 1020–50, suggesting a mid-eleventh-century period of use (Pederson 2001, 26).

Alongside the Scandinavian Urnes style, a distinct 'English Urnes' style characterizes brooches from Pitney, Somerset, and Wisbech, Cambridgeshire. This style appears to have been a slightly later development, suggesting a late eleventh- or early twelfth-century date for the two brooches (Owen 2001, 220). This is supported by the Pitney brooch's stylistic affinities with a carving from Norwich Cathedral, dated by documentary sources to the decade 1130–40 (Wilson and Klindt-Jensen 1966, 155; Green 1967; Owen 2001, 217–18). These items are, then, likely to be among the last English Urnes-style products, and the latest Scandinavian-style brooches recorded from England.

Evidence of wear and reuse

While the chronologies proposed above suggest dates from which Scandinavian and Anglo-Scandinavian jewellery circulated in England, they do not indicate the length of time such items remained in fashion. Did these items fall out of use in tandem with their Scandinavian counterparts, or did they experience truncated or extended lifespans? This question is difficult to answer, given the small number of items originating in datable archaeological contexts. Careful study of the objects themselves can nonetheless reveal significant levels of wear and repair among the corpus. This opens the possibility that Scandinavian and Anglo-Scandinavian items remained in use in England for prolonged periods, even after they had fallen out of fashion in the Scandinavian homelands.

Since brooch wear, repair, and reuse is detected primarily through visual analysis, it is likely to be under-recorded among a catalogue of items predominantly identified through written records and photographic or drawn images. Yet modern object records, including those by the PAS, will typically record such alterations, enabling an assessment of the state of preservation of the corpus as a whole. Most visible are alterations to brooches which facilitate their secondary use, for instance, as mounts or pendants. Although outside the area of study, an interesting example is provided by a Borre/Jellinge-style double-plated disc brooch recovered from the High Street excavations, Dublin, which was secondarily fitted with a long pin (Graham-Campbell 1980, no. 200). Despite being dated on stylistic grounds to the early-to-mid tenth century, the object was recovered from a mid-to-late eleventh-century context (originally published as tenth-century) and evidently retained its appeal over several

generations (Graham-Campbell and Lloyd-Morgan 1994). Examples of the brooch type from England also exhibit signs of reuse. In two instances, the outer, openwork brooch plate was fitted with pin attachment lugs, enabling it to function as a brooch after the lower plate was discarded or lost (cat. nos. 450, 456).

A number of items within the populous East Anglian Series appear to have been reused. It seems likely that a disc brooch from Leicester bereft of attachment fittings and with a neat circular aperture in place of its central roundel, once served as a mount or pendant (cat. no. 96). Similar reuse may be suggested for a further item, from North Creake, Norfolk (cat. no. 216). On this piece, the pin-fittings had been removed and two iron rivets hammered into the back of the brooch in their place, perhaps in order to attach it to wood or leather. A brooch from Holt, Norfolk, with squashed pin-fittings, has additional perforations in its border, possibly enabling it to function as a pendant (cat. no. 185). A further brooch, from Tattersett, also in Norfolk, may have been similarly reused. It is said to have a flat, plain reverse and an 'iron wire' attached to its side to serve as a secondary attachment loop (cat. no. 267).

Signs of repair, usually related to pin-fitting breakages, are widespread among the corpus of Scandinavian-style jewellery from England. As Evison demonstrated, the 'suspension' loops on both silver pendants from Saffron Walden had been replaced, with the substitute loops themselves also showing signs of considerable wear (cat. no. 324). The replacement of these features fits with evidence for the wear exhibited on the pendants' surface, which had resulted in the granulation-effect beading being 'rubbed almost smooth' (Evison 1969, 338–40). Consequently, Evison suggested that the pendants, dated on stylistic grounds to the second half of the tenth century, were probably buried at 'a date nearer the end of the tenth century' (1969, 340). On a silver trefoil brooch from Thetford, a broken H-shaped pin-lug had been mended by an iron repair attached by two rivets; similar iron remains indicate that the catchplate was also repaired (cat. no. 409). This item similarly appears to have seen prolonged use, as supported by the worn nature of its surface decoration. A further rivet repair is visible on a second high-quality trefoil, from Colton, Norfolk (cat. no. 357) (see Fig. 3.42). Here, an iron rivet appears next to two scars from the missing H-shaped pin-lug and perforates the front surface.

Repairs were also applied to mass-produced and heavily populated series in which we would not expect high levels of investment. Within the East Anglian Series, repair rivets are visible on brooches from Geldeston, Hindringham, Narford, Postwick, Roughton, and Wormegay, all in Norfolk (cat. nos. 157, 184, 213, 225, 239, 284). The two iron rivets which flank the remains of a broken catchplate on the brooch from Wormegay are characteristic, although the brooch from Hindringham preserves silver solder over the scar of the original, missing catchplate. A small trefoil brooch with stylized acanthus decoration from Welney, Norfolk, was also deemed worthy of repair. It preserves a large patch of solder in place of the now missing catchplate (cat. no. 399).

A further avenue for exploring artefact 'lifespans' lies in examining the state of preservation of the object in question. The preservation of items catalogued on the ADS was assessed as either: good, fair, worn, or very worn on the basis of visual information and written descriptions, with the field left blank in cases with insufficient evidence. High levels of wear were observed among all brooch groups; in total, around 58 per cent of all small Borre- and Jellinge-style disc, trefoil, and lozenge brooches which possessed information relating to their preservation were classified as 'worn' or 'very worn'. Particularly high percentages of 'worn' or 'very worn' objects were recorded among trefoil, Borre-style disc (Type II), and Terslev-ornamented artefacts: 62 per cent, 63 per cent, and 63 per cent respectively.

It is important to recognize that the state of preservation of a brooch may partly reflect its metal-alloy composition and find-context, as well as its original use. Wear on brooches caused by the artefacts having spent a long time in the ploughsoil may also disguise subtle traces of original wear. That said, it is likely that the high levels of wear exhibited by the corpus as a whole partly reflects the period of time for which they remained in use as dress clasps or other items. As illustrated by the late eighth- to early ninth-century Berdal brooch from Cumwhitton, worn into the tenth century, artefacts could be retained in use well beyond their 'natural' lifespans. The evidence for poor preservation combined with that of repair and reuse would appear to suggest that many Scandinavian and Anglo-Scandinavian artefacts lived 'long-lives', perhaps remaining in use for several generations.

This suggestion corresponds with the limited archaeological evidence of brooches from excavated contexts, which point to dates in the late tenth and eleventh century for their circulation and, in one possible instance (cat. no. 219), manufacture (Table 4.1). Jewellery in Scandinavian styles appears to have continued in use beyond the end of independent Danish rule in England in the first decades of the tenth century, and well into the period of West Saxon rule in the Danelaw. How can this be explained?

New societies often make reference to the historic past by preserving traditions, social practices, or material culture even after they become outdated in the homelands. In terms of material culture, objects may be worn and kept to reinforce links with the ancestral homelands, acting, in effect, as heirlooms (Lillios 1999). Such treatment has been suggested in other Scandinavian contexts in the British Isles. A ninth-century Scandinavian burial from Westness on Rousay preserved a Celtic brooch which, its typology indicates, could have been up to a century old when buried (Graham-Campbell and Batey 1998, 136, 150, fig. 7.11).

Within the present corpus, it is especially intriguing that poor quality, mass-produced items of relatively low economic value, including Anglo-Scandinavian products, seem to have lived long lives. Such items would appear to have been valued not for their intrinsic economic worth, but for their symbolic

significance. In a recent article Lillios notes that, as heirlooms, artefacts have the capacity to 'objectify memories and histories, acting as mnemonics to remind the living of their link to a distant, ancestral past' (1999, 236). While Anglo-Scandinavian brooches could not have served as heirlooms in the strict sense, since they were not old items imported from Scandinavia, they may have acted in similar ways, encouraging associations with a Scandinavian element, be that cultural, political, or ancestral. In this context, the long lives of such products and their continued display and transmission may have served to promote social identities and differences within the Danelaw, long after its demise as a political entity.

Conclusion

Figure 4.2 summarizes the proposed chronologies for Scandinavian and Anglo-Scandinavian brooches from England. It illustrates two main themes. First, while most items date from the onset of the Scandinavian settlement in the late ninth century, Scandinavian jewellery is not confined to the settlement period. Instead, the appearance of Terslev, Jellinge, and Mammen motifs in England demonstrates that the inhabitants of the Danelaw kept abreast of changing fashions within Scandinavia throughout the tenth century. In this way, female dress items offer tangible archaeological evidence for continuing cultural connections between Denmark and the Danelaw well after the primary phase of Viking conquest and settlement. The continued imitation of Scandinavian brooches of this date, seen in Anglo-Scandinavian products, indicates that

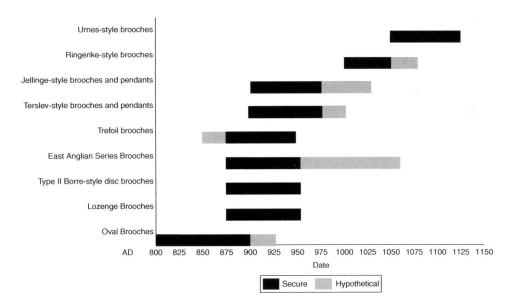

Fig. 4.2 Proposed chronologies for the main brooch groups from England.

Danelaw communities continued to respond and adapt to new cultural influxes over a hundred year period.

What factors may explain such a continuum of contact and connectedness? One possible explanation is that new family and community links simply gave rise to heightened levels of communication, trade, and cultural interplay across the North Sea, creating permanent channels for cultural dissemination. The introduction of new jewellery styles may, for instance, result from newly settled Scandinavian families, and their descendents, travelling back and forth between Scandinavia and their adopted homeland. Yet, as noted in Chapter 3, the transmission of stylistically distinct female dress styles appears to have operated in only one direction, raising doubts about the level of true cultural interplay between England and Denmark. Alternatively, it may be that female fashions in the Danelaw were continually refreshed by the arrival of new generations of Scandinavian migrants, introducing up-to-date dress styles from an evolving Scandinavian repertoire. If this scenario were true, it would imply continuing migration from Scandinavia, throughout the tenth century.

The second point highlighted by Figure 4.2 is that select brooch types appear to have enjoyed an extended currency within the Danelaw compared to their period of use within Scandinavia. It would appear that such artefacts continued to have relevance to the women that wore them even after they ceased to be fashionable in stylistic terms. In this sense, Scandinavian and Anglo-Scandinavian jewellery may have served as mnemonic devices, fostering links to the Scandinavian homelands and preserving a Scandinavian identity within a new society. Significantly, the desire to cultivate Scandinavian affiliations via the use of dress fittings seems to have outlived the period of independent Scandinavian rule in England, possibly suggesting that Danish authority continued in some regions following the demise of the Danelaw as a political entity (see Chapter 7). The potential for Scandinavian-style dress items to act as 'pegs for memory', to adopt Elisabeth van Houts's terminology (1999), is explored further in the following chapter, as we shift attention away from the artefacts themselves, and on to their wearers.

5

Brooch use, culture, and gender

Introduction

In 2001, excavations just east of the Roman Ridge road in Adwick-le-Street, South Yorkshire, recovered the burial of a mature woman, at least in her forties. At some time in the late ninth century she had been buried in a traditional Scandinavian strap-dress, complete with a pair of oval brooches (see Colour Plate 2). Her accompanying grave goods, including an iron knife, key, and a small bronze bowl, suggest that she had links to Norway. This finding was supported by isotopic analysis, which pointed to Norway as the place the woman was most likely to have spent her childhood (Speed and Walton Rogers 2004).

It is unclear exactly how this Scandinavian woman came to be buried in Yorkshire. Although her burial was initially thought to be isolated, more recent excavations have uncovered around thirty-seven further burials of sixth- to tenth-century date, suggesting that she may have been interred in a small cemetery (South Yorkshire HER 04755). Perhaps she lived locally in one of the nearby settlements with a Scandinavian place-name, such as Skellow or Scawsby (Fellows-Jensen 1972, 36, 165). It is possible that she travelled to Yorkshire directly from Norway, using the Humber and other navigable rivers to penetrate the countryside; alternatively, she may have reached eastern England over the Pennines, from a base in Lancashire and the Lake District or one of the early Norse colonies in Ireland (Speed and Walton Rogers 2004, 54; Valante 2008, 37–56). Whatever the case, her burial provides a rare snapshot of a wearer of Scandinavian brooches in England. She was an adult woman, apparently raised in Norway, who transplanted her Scandinavian clothing, dress ornaments, and probably her language, to the northern Danelaw.

Unfortunately, such glimpses of the women behind Scandinavian jewellery in England are rare. During the nineteenth century, a number of oval brooches were excavated from burials, but the circumstances surrounding the discovery of most items are notoriously obscure (Speed and Walton Rogers 2004, 85). The only other modern excavation to have yielded information about the cultural background of wearers of Scandinavian jewellery was that on the outskirts of Cumwhitton near Carlisle in 2004. This exposed four probable male

and two probable female graves in a small, unenclosed cemetery dating to the early-to-mid tenth century (Griffiths 2010, 94–5). One of the female graves was associated with a pair of oval brooches discovered by metal detecting prior to excavation. Acidic soil conditions meant that very little human bone survived, preventing scientific analysis which might reveal the places of origin of the occupants, but other grave goods found at the site indicate strong Scandinavian and Hiberno-Norse influence. The ethnic origins of the inhabitants cannot be proved, but given the site's location in the north-west it seems most likely that this community, including their Scandinavian-clad women, were first- or second-generation settlers from Norse colonies in Ireland (Brennand 2006, 628–9; Griffiths 2009, 23).

Aside from oval brooches, the only other Scandinavian-style jewellery items to be retrieved from a burial are the mid-to-late tenth-century pendants from Saffron Walden, Essex. These were found in 1877 strung around the neck of a probable female skeleton, along with silver, glass, and cornelian beads and a third silver disc pendant in the shape of an equal-armed cross (Evison 1969) (see Colour Plate 5). Although the third disc pendant is likely to have Anglo-Saxon origins, parallels for the beads and matching pendants suggest a southern Scandinavian or Swedish connection, leading Evison to suggest that the burial contained a 'still-pagan woman from Scandinavia, newly arrived in the fresh invasions which began in AD 980 during the reign of Ethelred' (Evison 1969, 340–2).

However well or poorly understood, these graves provide our only direct link with the female wearers of Scandinavian and Anglo-Scandinavian jewellery in England. In order to generate a wider understanding of who wore Scandinavian-style jewellery, and why, it is therefore necessary to turn to an alternative source. This chapter examines the gender and likely ethnicity of Scandinavian-style jewellery wearers in England with reference to the brooches themselves, in particular their pin-fittings and dimensions. By examining recurring traits in artefact form and fittings, I aim to reveal how Scandinavian-style jewellery was used in dress, including the means by which it was attached to clothing and its various practical functions. In exploring daily practices surrounding the use of jewellery I hope to shed light on its consumers, and to expose their cultural and ethnic affiliations and gender in ways that have not previously been possible.

The first part of this chapter considers the uses of Scandinavian and Anglo-Scandinavian brooches in costume. It argues on the basis of extant pin-fittings, as well as the attachment loop present on many Scandinavian brooches, that Scandinavian and Anglo-Scandinavian brooches were fastened to clothing in different ways and formed part of different costume ensembles. Whereas Scandinavian brooches can be seen to belong to an indigenous Scandinavian costume tradition, retaining features which would have been unfamiliar to local, Anglo-Saxon women, Anglo-Scandinavian brooches seem to have been adapted for use by native women, suggesting that they found a ready market among the

local population. The second part of the chapter considers the gender assignment of Scandinavian-style jewellery. Taking into account the brooches' style, size, and pin-fittings, it argues for the items' exclusive use in female dress, and reviews evidence for explicitly male Scandinavian dress items in England. It proposes that, during the settlement period, female dress accessories were harnessed as a means of conveying Scandinavian cultural forms in a way that male dress items were not. This, in turn, prompts a consideration of women's roles in the construction of cultural identities within the Danelaw.

Wearing Scandinavian and Anglo-Scandinavian jewellery

How were Scandinavian and Anglo-Scandinavian brooches attached to clothing and what might this reveal about the cultural contexts in which they were worn? While the Scandinavian archaeological record offers rich evidence for brooch use within Scandinavia, few items from England come from contexts which yield such information, making such questions difficult to answer. Nevertheless, careful study of the brooches themselves—their dimensions, pin-fittings, and additional attachment features—can help to reveal their role in contemporary female dress. This approach suggests that Scandinavian and Anglo-Scandinavian brooches were worn differently, both from indigenous Anglo-Saxon brooches, and from each other.

By way of introduction to this topic, it is worth briefly considering the role of brooches in contemporary women's costume dress in Scandinavia and England. Viking-Age female Scandinavian dress has traditionally been characterized as incorporating oval brooches, worn in pairs to secure the straps of a dress, in addition to 'third' and 'fourth' brooches, worn to fasten outer garments and inner shifts on the chest or neck (see Fig. 5.1). But while these distinct and concrete roles for brooches are well attested at central Scandinavian sites, such as Birka, women's fashions in southern Scandinavia appear to have followed a different trajectory, with the oval brooch going out of fashion at an earlier date in the tenth century. In Viking-Age Denmark, the area of Scandinavia with the closest cultural ties to the Danelaw, the use of a single brooch, or large and small brooch pairings to fasten a mantle, over-tunic, or chemise was more typical at this date (Hedeager Krag 1995). This is supported by the relatively low number of tenth-century oval brooches found in the south, and the correspondingly large number of single brooch finds from sites such as Hedeby, Lake Tissø, and Lejre (Hedeager Madsen 1990). The fashion for single-brooch costume in this region of Scandinavia is likely to reflect the influence of neighbouring Western European fashions, which similarly favoured the single-brooch costume (Wamers 1994, 188–9). It is indeed notable that, across Denmark, settlement sites have yielded a number of small brooches either imported from the Carolingian world or directly modelled on Carolingian prototypes (Baastrup 2009).

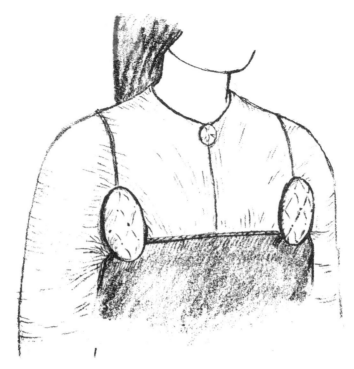

Fig. 5.1 Scandinavian 3-brooch costume (after Hägg 1983, fig. 17.37).

Late Anglo-Saxon women's dress is not well attested archaeologically, but pictorial and documentary evidence suggests that it belonged to a Western European tradition, comprising a chemise, worn under a long-sleeved gown or tunic, an open-fronted cloak or shawl, and a veil or headdress (Owen-Crocker 2004, 148–51, 156–9, 212–26). Brooches were not required for the gown, and were most probably used to fasten an outer garment or chemise centrally on the chest. Anglo-Saxon and Carolingian sources depict open-fronted gowns or shawls fastened centrally with a single, large disc brooch (see Colour Plate 8) (Frick 1992/3, 348–9, fig. 13; Owen-Crocker 2004, 148–9, figs. 104–5, 107–8). Small disc brooches are likely to have fulfilled similar roles with lighter shawls, as has been suggested for similarly sized Carolingian brooches, although they may have also secured the chemise or a lightweight veil to the gown (Owen-Crocker 2004, 207–8; Schulze-Dörlamm 1991, 68; Frick 1992/3, 350–3).

This evidence suggests broadly comparable roles for brooches in Anglo-Saxon and southern Scandinavian female dress, as fasteners for cloaks, shawls, chemises, or headdresses. The one exception is the oval brooch, which could only be worn in combination with the distinctive Scandinavian strap-dress. Yet despite these broad similarities, Scandinavian brooches possess a different layout of attachment features to Anglo-Saxon brooches, indicating that they would have been attached to clothing in a different manner. The following

section discusses evidence for the fastening mechanisms on both Scandinavian and Anglo-Scandinavian items before going on to consider the function and significance of the attachment loop.

Pin-fitting layout

To understand how brooches were fastened on to clothing, it is necessary to reconstruct the arrangement and orientation of the pin attachment features. Archaeological evidence for pin-fitting layouts may be deduced from the position of brooches found in undisturbed graves in Scandinavia, but is unfortunately rarely available. Instead, reconstructions may be attempted on the basis of certain ergonomic and aesthetic principles (Maixner 2005, 211). The first and most obvious of these principles is that pins must fulfil their primary function of piercing two pieces of cloth and accommodating fabric. In addition, it is expected that the catchplate, either in a hooked or C-shaped form, faced downwards: an optimal position for weighing down the brooch pin and preventing injury to the wearer caused by an unfastened pin. A further consideration is the preference of the brooch wearer. We may expect most, right-handed, brooch wearers to have fastened a pin from right to left and to have chosen to orientate the pin away from the body. Finally, it may also be supposed that the wearer wanted to position a brooch in a way that would ensure its shape, as well as its ornamentation, was symmetrical (Maixner 2005, 211). This point is of particular concern to trefoil, rectangular, and lozenge brooches, since disc shapes are, by nature, symmetrical regardless of their position or orientation on clothing.

With the exception of select trefoil brooches, discussed below, and oval brooches with vertical pins, the arrangement of the fastening mechanisms on the reverse of Scandinavian brooches is consonant with all of these theoretical principles. They suggest that on disc, lozenge, equal-armed, and most trefoil brooches the H-shaped pin-lug was placed on the right and the catchplate on the left on a horizontal axis, when viewed from the reverse (see Fig. 2.1). If we assume most brooch wearers were right-handed, this layout may have encouraged Scandinavian brooches to have been worn either centrally, or on the left chest. In this position, the attachment loop, where present, is usually positioned at the base of the brooch, although there are a few exceptions, perhaps attributable to rushed or faulty castings or a desire for the item to be occasionally worn as a pendant. This fitting arrangement is confirmed by a small number of brooches whose orientation in Scandinavian graves was assiduously recorded upon excavation, such as a large trefoil brooch from Birka grave 839, whose orientation is revealed by a downward-facing loop (Maixner 2005, cat. no. 539, pl. 64,1).

Significantly, the same pin-lug arrangement was not adopted for Anglo-Scandinavian brooches. While these items preserve a horizontal axis, they

consistently carry pin-lugs on the left and catchplates on the right when viewed from the reverse, a position not well suited to right-handed brooch wearers. If one were to turn the brooch 180°, the position of the pin attachments would match that of the Scandinavian brooches. In this position, however, the catchplate (either in hooked or C-shaped form) would open at the top and would therefore not effectively hold the pin. This pin-fitting layout appears on disc brooches of Jansson's Type II A and II D, lozenge brooches, East Anglian Series brooches, and different varieties of Terslev brooches, indicating its wide application to Anglo-Scandinavian products. Bearing in mind the principle of orientating the pin away from the body, these items were best suited to either a central fastening, or to attachment on the right chest (see Fig. 2.14).

Rather than following Scandinavian conventions, the layout of the pin-fittings on Anglo-Scandinavian brooches instead matches that observed on indigenous, Anglo-Saxon products. Notwithstanding some variability in the alignment of the pin-lug and catchplate on Anglo-Saxon brooches, which can include diagonal as well as horizontal axes, the pin-lugs on these items are typically placed on the left, and the catchplates on the right, when viewed from the reverse (see Fig. 2.2) (Smedley and Owles 1965). In this way, the mechanism of attaching Anglo-Scandinavian brooches to clothing would have been more familiar to women accustomed to fastening Anglo-Saxon brooches than those used to wearing Scandinavian brooches, perhaps implying that Anglo-Scandinavian brooches were intended for use at least in part by native Anglo-Saxon women. The retention by many Anglo-Scandinavian brooches of a Scandinavian-type catchplate nonetheless demonstrates the existence of a distinct workshop tradition for culturally hybrid items: one which was influenced by both Anglo-Saxon and Scandinavian traditions but remained independent of both.

In the context of different pin-fitting layouts, it is noteworthy that a small number of Anglo-Scandinavian brooches possess a different arrangement, in stronger accordance with Scandinavian traditions. A series of disc brooches with a backwards-biting Jellinge-style beast have been tentatively identified as Anglo-Scandinavian because they lack the feature of the attachment loop (see Chapter 3). Despite this absence, the layout of their attachment features, with the pin-lug on the right and catchplate on the left when viewed from the reverse, indicates that they were attached to clothing in the traditional, Scandinavian manner. The absence of a loop on such items does, however, suggest that they were worn differently from their counterparts in Scandinavia.

The function and significance of the attachment loop

An attachment loop or 'eye' fixed to the reverse of a brooch at a right angle to the pin-lug and catchplate is a characteristic component of Viking-Age

brooches from the Scandinavian and Baltic homelands. This feature, while not integral to all Viking-Age brooches, is a familiar and widespread element among Scandinavian brooches, although on equal-armed and trefoil brooches the loop is occasionally substituted by one or two perforations through the brooch surface (Capelle 1968b, 5; Aagård 1984, 96). During the Viking Age, attachment loops were associated exclusively with brooches of Scandinavian and Baltic origin. When encountered on Viking-Age brooches found in England, the loop therefore indicates a distinctly Scandinavian device. The following discussion of their function suggests that, in many instances, this feature would have enabled brooches to be worn as part of a uniquely Scandinavian costume ensemble.

Although attachment 'eyes' are a recognized feature of many Viking-Age Scandinavian brooches, there has been considerable debate concerning their function (Jansson 1984b, 58; Hårdh 1984, 88; Richardson 1993, 20). The remains of iron and bronze rings are preserved in the 'eyes' of a multitude of Scandinavian brooches, from both burials and settlements (see Fig. 5.2).[1] At Birka, equal-armed, trefoil, and large disc brooches are occasionally attached to oval brooches by means of a small chain or necklace, prompting suggestions that 'eyes' acted as fixtures for safety chains, guarding against brooch loss or displacement (Aargård 1984, 96; Richardson 1993, 20). There is no suggestion as to how or where the other end of a safety chain would have been attached in the case of single-brooch costumes, but fixture directly on to clothing, perhaps by sewing, is one possibility. Alternatively, it is possible that an iron pin pierced the clothing and passed through the loop to provide extra security for the brooch, although there is no evidence to support such an arrangement. The use of attachment loops as safety devices might have also incorporated the desire to have the brooch handy, when needed for use, by keeping it attached to the garment (James Graham-Campbell, pers. comm.).

Fig. 5.2 Scandinavian disc brooch with metal ring, Birka, Sweden © National Historical Museum Stockholm.

[1] For instance, from Birka, Hedeby, Lake Tissø, and Hesselbjerg (Birka graves 151, 462, 559, 594, 645, 854, 967: Arbman 1940–43, figs. 81.6, 77.4, 73.1, 80.5, 77.2, 76, 70.14; Hedeby: WMH Hb 2003/2407, 2004/9132; Lake Tissø: NMK 1423/75 KN1360; Hesselbjerg: Andersen and Klindt-Jensen 1971, fig. 8).

In other instances, there is evidence that loops were used to suspend brooches from necklaces, enabling their occasional reuse as pendants (Petersen 1928, 121; Jansson 1984b, 58). Grave 948 at Birka included a beaded necklace to which a Borre-style convex disc brooch was attached by means of a bronze loop (Arbman 1940–43, pl. 124). As noted above however, the attachment loop is routinely positioned at the base of brooches, rather than in a position at the top which would better suit its use on a necklace. It is clear, then, that suspension from a necklace was not the primary function of the loop.

Another, seemingly more common, function of the attachment loop was to suspend vertical metal or textile chains, to which pendants, beads, and non-decorative items such as toilet implements and weaving equipment could be attached (Jansson 1984b, 58; Eilbracht 1999, 96–7). This would have effectively enabled brooches with loops to function as chatelaine brooches, known in different guises in some areas of Europe from the Roman period onwards (Eckardt 2008). The possibility that iron or bronze rings affixed to the 'suspension' loop were used to attach metal chains was first suggested by Capelle in his article on trefoil brooches, but rejected by Hårdh on the basis that wire rings preserved with trefoil brooches at Birka were too delicate to support the weight of heavy metal chains (Capelle 1968b; Hårdh 1984, 88). Hårdh nonetheless cited three graves (Bj 507, 517, 968) in which fragments of chains were associated with trefoil brooches. In the first two cases, an iron knife hung from the chain; in the third case, a key (Hårdh 1984, 88).

The suspension of vertical metal chains and accompanying accoutrements from metal rings on Scandinavian brooches is in fact well attested. The best preserved examples are found with high-status silver disc brooches. Eilbracht notes four silver filigree and granulation brooches from southern Scandinavia which preserve multiple, elaborate silver chains (see Fig. 5.3) (1999, cat. nos. 189, 197, 198, 231). In these instances, the metal chains appear to have had a primarily decorative function; the rings are embellished with pendants and beads and suspend ornamental plaques. On these brooches, the loops themselves are also often embellished, along with the other attachment features. On the reverse of the gold disc brooch from the Hiddensee hoard, for instance, ribbed metal strips outlined in fine beaded wire spirals decorate the attachment features (see Fig. 5.4) (Armbruster and Eilbracht 2006, 34, fig. 15). Such embellishment on the reverse of a brooch suggests that the fashion for wearing suspended chains from brooches was considered a marker of high-status dress, and associated with display as well as functionality.

Less expensive objects in base metals are similarly accompanied by suspension chains, perhaps in imitation of elite fashion. Functionally, oval brooches were perhaps best suited for the suspension of chains and other items, since they would have provided vertical support for downward weight. Although oval brooches do not have a separate attachment loop, surviving examples suggest that chains could be threaded through the vertical pin-fittings; alternatively,

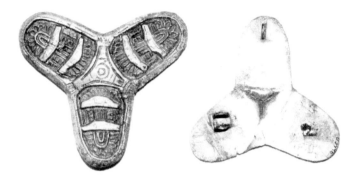

Plate 1: Scandinavian trefoil brooch with tinned reverse, Uppåkra, Skåne. © Lunds Universitet Historiska Museum.

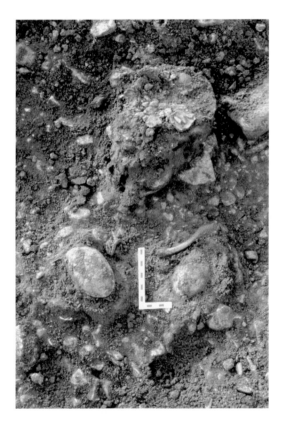

Plate 2: The probable female burial at Adwick-le-Street, near Doncaster. The woman, who may have been raised in Norway, was buried with a pair of oval brooches. © Northern Archaeological Associates.

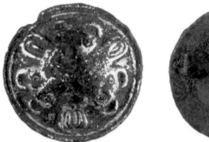

Plate 3: Type II A Borre-style disc brooch, Hindringham, Norfolk. © Norfolk County Council.

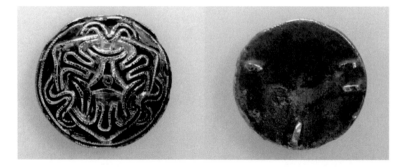

Plate 4: Scandinavian silver disc brooch with Terslev ornament, Whitton, Lincolnshire. © The author, reproduced with permission of North Lincolnshire Museum.

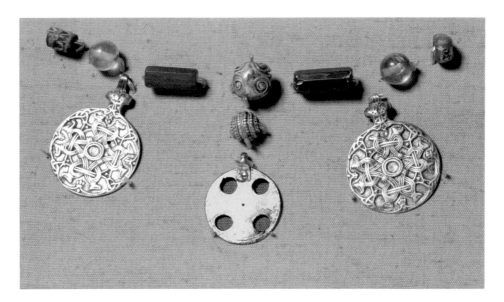

Plate 5: Pair of silver pendants with Terslev-derived ornament on a necklace, Saffron Walden, Essex. The necklace was found in what is likely to have been a female grave. © Saffron Walden Museum.

Plate 6: Geometric trefoil brooch (Type G 1.3 A), Asgarby and Howell, Lincolnshire. Over 40 geometric trefoil brooches have been found in England to date. © Portable Antiquities Scheme.

Plate 7: Fragmentary equal-armed brooch, Harworth Bircotes, Nottinghamshire. © Portable Antiquities Scheme.

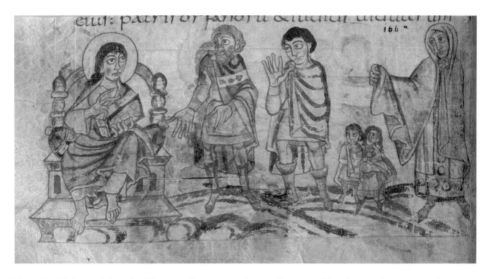

Plate 8: Male and female Western European dress, illustrated in the ninth-century *Stuttgart Psalter*, Fol.76a. © Württembergische Landesbibliothek.

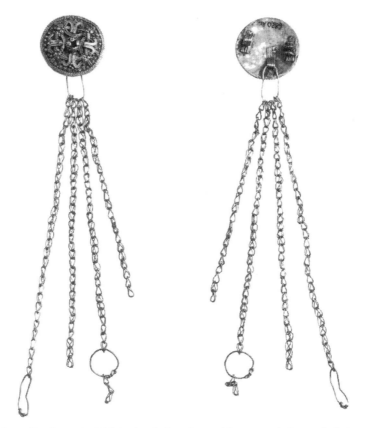

Fig. 5.3 Silver disc brooch, Hälsingland, Sweden, with suspended metal chains (after Eilbracht 1999, pl. 16).

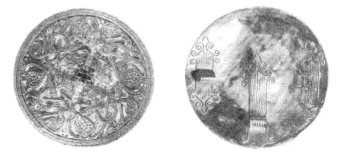

Fig. 5.4 Gold disc brooch, Hiddensee, Rügen, Germany, with embellished attachment loop (after Eilbracht 1999, pl. 23).

loops could be hooked around the openwork outer plate of the brooch, as appears to have been the case in Birka grave 60 (Arbman 1940–43, 24, fig. 19). In Birka grave 464, a 30 cm long bronze chain suspended from the pin-lug of an oval brooch was used to attach a knife and a pair of tweezers via an X-shaped

link (see Fig. 5.5). The same grave contained an equal-armed brooch attached to the oval brooch pair by a silver chain, demonstrating the dual function of the loop or equivalent feature in this instance.

Evidence for the suspension of chains and objects from brooches is not confined to oval brooches. Two bronze disc brooches found in Iceland have multiple, decorative suspension chains (Petersen 1928, fig. 126 a–b). One item, from Vað, preserves a ring with two chains. These, in turn, support a rectangular-shaped plaque decorated with a classic Borre-style gripping-beast, from which hang three further chains (Hayeur-Smith 2004, 46, fig. 45). A very similar brooch, with an attachment loop, is recorded from southern Lincolnshire, and may have been worn in a similar manner (cat. no. 447). In other cases, items may have been attached directly to the loop. This is the case with a Borre-style disc brooch from Haugen, Norway, on which a needle is suspended directly from a silver ring (Rygh 1885, fig. 666). Such examples indicate that

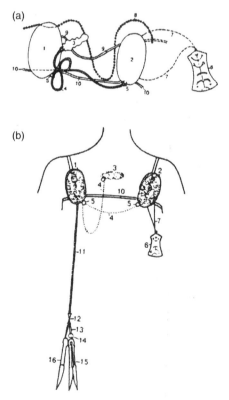

Fig. 5.5 Birka grave 464, a) brooch and accessory finds; b) reconstructed costume (after Hägg 1974, figs. 32, 33). 1–2: Oval brooches; 3: Equal-armed brooch; 4: Silver chain; 5: Oval brooch suspension loops; 6: Needle holder; 7: Leather band; 8: Beaded necklace; 9: Leather band; 10: Dress ties; 11: Bronze chain; 12: X-shaped link with traces of leather; 13: Leather band; 14: Suspension ring for shears; 15: Shears; 16: Knife.

attachment loops could be used for the suspension of both decorative and utilitarian items.

Metal rings and chains were not the only devices which could be used to suspend objects from brooches. Evidence from Birka suggests that textile ties were used to similar effect (Hägg 1986, 58). Analysis of the textile remains preserved on the pins of oval brooches has revealed that silk ties were occasionally threaded through the vertically positioned pin-lug. These came not from the straps of apron dresses, which oval brooches secured in place, but instead matched the textile fragments preserved on the rings of various tools, such as iron knives, scissors, and needle holders (Hägg 1986, 59). Such objects must have been suspended from the oval brooch lugs, via silk ties. An interesting parallel for the use of textile suspension ties comes from Frankish women's costume, in which leather and cloth ties were used to fasten amulets and other accessories to bow brooches worn at the waist (Hinz 1966; Christlein 1978, 78, fig. 54).

The possibility that perishable textiles were used in place of metal chains in Scandinavia is significant, since it may explain why complete costume sets—brooches, together with their various suspended accoutrements—rarely survive in full in the archaeological record. In addition to silk ties, other organic materials including leather, cloth ties, and wooden strips have been recorded in graves at Birka, and have been similarly interpreted as suspension devices (Hägg 1986, 59). The layout of burial goods in documented grave plans suggests that these organic materials, many of which survive only through contact with metal artefacts, were used to suspend objects from brooches. In Birka grave 946, for instance, an iron key and tweezers appear to have hung from a disc brooch, while an oval brooch suspended iron shears and a knife (see Fig. 5.6). The key preserves fragments of cloth, suggesting that it was originally attached to the disc brooch with a cloth cord, which has since perished (Arbman 1940–43, 372–3, fig. 323).

Fig. 5.6 Birka grave 946. The position of the key (12) and tweezers (10) suggests they were suspended from the disc brooch (2) (after Arbman 1940–43, fig. 323).

Excellent textile preservation in grave 464 at Birka helps to confirm such an arrangement. In addition to the silver and bronze chains already discussed, complete leather straps were recorded linking a needle case to an oval brooch (Fig. 5.5). Leather ties were also documented on the suspension rings of the aforementioned knife and tweezers, as well as on the X-shaped link at the end of the bronze chain. This material suggests that the tools were attached to the link with leather ties (Hägg 1974, 40–2, figs. 32–3).

The role of the loop as a suspension device for metal or textile chains may account for the absence of loops on small trefoil brooches, including the small geometric type which is so common in England (Type G 1.3). These brooches have slight dimensions and are unlikely to have been able to sustain the weight of suspended objects. This is especially the case for small trefoils, since, on large items, the attachment loop or substitute feature is usually positioned at the end of one lobe (Capelle 1968b). On small trefoil brooches, lobes were especially vulnerable to breakage, as indicated by the number of fragmentary lobes found in both Scandinavia and England.

The evidence discussed above derives from the Scandinavian archaeological record, leaving open the possibility that loops functioned differently in costume in England. Evidence for the use of loops on Scandinavian brooches found in England is frustratingly meagre, a reflection, in part, of the low numbers of brooches recovered from contexts which may preserve ferrous material and textiles. Nevertheless, an indication that loops enabled items to function as chatelaine brooches in the Scandinavian manner is provided by the burial from Adwick-le-Street, South Yorkshire. One of the pair of oval brooches from this grave preserves a coarse plied cord around its pin-lug (cat. no. 434). This was interpreted by the excavators as a suspension cord for a small iron knife, discovered near the left upper arm of the skeleton (see Fig. 5.7) (Speed and Walton Rogers 2004, 60, 76–7, fig. 17).

Further evidence for the function of the 'eye' in England comes from the author's examination of the brooches themselves. Ferrous material is preserved in the loops of a number of large trefoil brooches, including items from Maltby, Yorkshire, and Bures Hamlet, Essex (cat. nos. 406, 410). The possibility that the ferrous remains once formed part of metal rings or chains is suggested by the preservation of 'traces of iron chain' in the loop of a Borre-style trefoil brooch found near Pickering but unfortunately now lost (cat. no. 412) (Kirk 1927, 526). The loop on a further trefoil brooch, from Stallingborough, North Lincolnshire, is misshapen, having been elongated through wear and traction (cat. no. 413). The cause is uncertain, but may have been downward weight exerted on the feature by suspended objects.

With the exception of the Adwick-le-Street burial, there are no instances in which brooches have been recovered in association with items to which they may have once been attached. A complicating factor is that textiles could have been used in place of metal chains, in which case evidence of such costume sets

Fig. 5.7 Reconstruction of brooches and dress from the female burial at Adwick-le-Street, Yorkshire, by Roger Simpson © Northern Archaeological Associates.

would not normally survive in the archaeological record. Even within Scandinavia, brooches with loops recovered from settlement contexts are rarely preserved with their associated artefacts. The difficulty in precisely dating pins, knives, and tweezers also prevents archaeologists linking items such as toilet implements to particular brooches on chronological grounds. We may speculate that items such as Valkyrie figures and Thor's hammers were suspended from brooches. Around a dozen Thor's hammers have been recovered in England (Ager 2003). Although most items are silver and are therefore unlikely to have been paired with base-metal brooches, examples in lead are also known (for instance, Norfolk HER 36681; 3257). When found in graves in Scandinavia, Thor's hammer pendants are usually associated with women and may have formed part of female jewellery assemblages (Staecker 2003, 468–70, fig. 29,4). The discovery of a silver Thor's hammer together with two beads at the neck of a male in a burial at Repton, Derbyshire, demonstrates, however, that these

items were also suspended from necklaces, and were not gender-specific (Staecker 2003, 468–70, fig. 29.4; Biddle and Kjølbye-Biddle 2001, 61, fig. 4.14, 1–4; see too Graham-Campbell 1980, no. 523).

Among the brooches considered in this study, loops are almost entirely confined to brooches of Scandinavian origin: brooches either imported from Scandinavia or produced in England in a Scandinavian manner. Just one Anglo-Scandinavian brooch attempts to incorporate a loop: a flat disc brooch with debased Jellinge-style ornament from Gooderstone, Norfolk (cat. no. 479) (see Fig. 3.65). On this item, however, the loop is positioned horizontally, rather than vertically, suggesting that the brooch manufacturer was unfamiliar with its conventional form and arrangement. Furthermore, the loop is not drilled and is therefore unfinished. It may have been abandoned because of its design faults or because the component was not required for a brooch of this type.

In short, while there is a good case for the attachment loop having been multifunctional, occasionally serving as a safety mechanism or allowing brooches to be hung as pendants, the suspension of vertical metal or textile chains and supported accessories from brooches appears to have been commonplace. This suggests that, in many instances, brooches with attachment loops comprise just one element of a much more diverse costume ensemble which would have originally included chains and items such as knives, scissors, or ornaments. That this function was performed by Scandinavian brooches recovered in England is likely, but cannot be proved beyond doubt. In any case, the absence of functioning loops on Anglo-Scandinavian brooches indicates that the practice of suspending chains and objects from brooches was not generally transferred to female costume in the Danelaw.

In this sense, Anglo-Scandinavian brooches seem to have been employed in a manner distinct from that of Scandinavian brooches; they were worn singly, without accompanying chains and accoutrements, and without associated safety benefits such features may have also introduced. Since native, Anglo-Saxon brooches also lacked loops, the absence of this feature on the reverse of Anglo-Scandinavian brooches may be interpreted as a response to local fashion. By apparently ceasing to use metal or textile chains and wearing brooches in a manner more familiar to Anglo-Saxon than to Scandinavian costume, the wearers of Anglo-Scandinavian brooches could be seen to have assimilated with existing, local fashions. As such, Anglo-Scandinavian brooches offer positive evidence for cultural assimilation between settled and incoming populations in the Danelaw.

Gender

Throughout this book, the brooches and pendants under discussion have been described as female dress items, a status which reflects their types' almost

exclusive association with female graves in the Scandinavian homelands (Jansson 1984b, table 8:1; Hårdh 1984, 85; Aagård 1984, 97; Maixner 2005, 205–6; Riebau 1999, 59; Callmer 1989, 19, note 4). The following discussion reviews this gender assignment and considers evidence for the circulation in the Danelaw of explicitly male Scandinavian dress items. In the later ninth and tenth centuries, there are grounds for suggesting that female metal dress items, more than male, were used in displaying Scandinavian art styles. This, in turn, suggests a clear role for women in negotiating cultural identity within the Danelaw.

The gender associations of Scandinavian-style jewellery

Within England, independent evidence for the gender associations of Scandinavian-style brooches and pendants is frustratingly sparse. A handful of objects, including oval brooches and a pair of pendants from Saffron Walden, derive from probable female inhumations (cat. nos. 324, 433–5, 437, 439). But apart from these examples, all objects are isolated finds, usually without associated archaeological contexts. Notably, illustrations in Anglo-Saxon and Continental manuscripts suggest that Western European male dress occasionally incorporated disc brooches (Colour Plate 8). In light of this evidence, could any of the dress items discussed here have been worn or used by men?

It is highly unlikely that the brooches and pendants at the heart of this study were used in male dress. Surviving manuscript illustrations suggest that, in England, male tunics were close-fitted with round neck openings, making the cloak the only component which required a clasp (Owen-Crocker 2004, 246, figs. 198–9). Tight-fitting shirts with round or square neck openings, occasionally closed and tightened with the aid of slip knots, also appear to have been worn by men in Scandinavia, as demonstrated by a remarkably well-preserved eleventh-century linen shirt from Viborg, Denmark (Ewing 2006, 83–4, 90; figs. 50–1). Later literary references further support the fashion for tight-fitting shirts in Scandinavian male dress. In the Icelandic family saga *Laxdæla saga*, written in the thirteenth century, a woman divorces her husband for wearing a loose-necked shirt, which is considered effeminate (Magnusson and Pálsson 1969, ch. 34).

The heavy outer garment of the cloak or mantle was, then, the only male dress component which required a fastener. In Western European illuminated manuscripts, male cloaks are often depicted as fastened on the shoulder by a single brooch, usually disc-shaped (Colour Plate 8) (Owen-Crocker 2004, 199, 234, figs. 192–5). Given that there is, at present, no archaeological evidence to support the use of disc brooches as male cloak fasteners either in Anglo-Saxon England or Viking-Age Scandinavia, it is possible that manuscript depictions simply reflect the influence of classical models. The costume of a cloak fastened on the right shoulder by a disc-shaped brooch represented a particular form of

imperial state dress in the early Roman Empire and is a common motif in contemporary figural depictions (Janes 1996, 127–8, 135).

The ability of small Scandinavian-style brooches, such as the disc or lozenge brooches, to secure a mantle is also questionable. Preserved textiles from mantles, from sites in Scandinavia and the British Isles, suggest that contemporary male outer garments were often made of coarse pile-weave cloth, which could incorporate short lengths of wool to produce a fleecy texture (Owen-Crocker 2004, 296; Wilson 2008a, 36; Gabra-Saunders 1998, 181–2; Ewing 2006, 145). Such heavy cloaks would therefore have required large, robust clasps to accommodate the fabric and withstand their weight. Moreover, when worn fastened at the shoulder, leaving one arm free, the mantle would generate two overlapping diagonal fabric edges, which could be securely fastened only by a diagonal pin (Ginters 1981, 11). A diagonal fastening alignment was therefore required to secure the two ends of the mantle.

Within Scandinavia and in Scandinavian contexts overseas, the only dress clasps consistently associated with Viking-Age male graves are large penannular brooches and ringed pins; with a robust form and diagonal fastening arrangement, these met both requirements for mantle clasps (Thålin 1984, 19–20; Thunmark-Nylén 1984, 5). The layout of objects within graves indicates that such artefacts were usually worn at the right hip or shoulder, confirming their use as mantle clasps (Thålin 1984, 21; Thunmark-Nylén 1984, 11, fig. 2.3). In addition to penannular brooches and ringed pins, Birgit Maixner has highlighted the presence in six Scandinavian male graves of trefoil brooches, early (ninth century) geometric-decorated examples of which possessed either a vertical or diagonal fastening arrangement and were thus well suited to male dress (Maixner 2005, 205–6, 210, 212–13, fig. 40, A). However, the association between trefoil brooches and male dress appears to be an early, short-lived phenomenon, which soon gave way to the brooches' exclusive use within female dress (Maixner 2005, 213–14). The initial association of trefoil brooches with male dress is likely to reflect the evolution of the trefoil brooch from Carolingian baldric mounts, an accessory type worn on the Continent by men, and cannot be paralleled in any other brooch type. Trefoil brooches with diagonal fittings are also recorded from graves with female grave goods, indicating that they were also worn by women (Maixner 2005, cat. nos. 190, 192, 252, 253).

The possibility remains that small disc, trefoil, and lozenge brooches were attached to the cloak or other elements of male dress for purely decorative purposes. In this context, it is worth noting that manuscript illustrations suggest that clasps worn with cloaks were used to fasten together the two ends of the mantle and did not attach the mantle to the undergarment (Owen-Crocker 2004, 235). Cloaks could therefore be removed over the head without the need to unfasten the brooch, and it may be that the join was sewn or permanently secured in another way, and the brooch pinned over the fastening (Owen-Crocker, pers. comm.). In such a case, the inability of the brooch to hold the

fabric together would become less important, although the horizontal fastening arrangement of Scandinavian-style brooches would remain unsuited to the arrangement.[2]

For most of the Scandinavian-style objects considered in this study, this scenario would still have required men in England to have adopted dress fittings which, in Scandinavia, carried clear female associations. The East Anglian Series brooches, of flat, Anglo-Saxon disc form, may provide an exception. The Scandinavian version of this brooch type is recorded in a female grave from Birka, where it was worn as a 'fourth' brooch, along with a pair of oval brooches and a trefoil brooch, in the traditional manner (Arbman 1940–43, fig. 346). In England, however, the large number and standardized appearance of the East Anglian Series brooches may suggest that these objects functioned not as typical brooches, but as some type of symbolic badge. In such a context, the artefact type may have lost its conventional gender associations, perhaps being adopted more widely by men, women, and also children. This is, of course, speculation. It remains the case that the style, size, and shape of these disc brooches, as well as their horizontal pin-fitting arrangement, points to their sole use in female dress.

Women as bearers of cultural tradition

Female dress items were not the only accessories to carry Scandinavian styles. In England, a small number of artefacts attest to the adoption of Scandinavian motifs in male costume. A copper-alloy belt slide and strap-end from Wharram Percy in the Yorkshire Wolds, both with Borre-style interlace, provide examples of two explicitly Scandinavian dress accessories probably worn as a set in male dress (see Fig. 5.8) (Stamper and Croft 2000, 128–9, pl. 11). A Jellinge-decorated scabbard chape from York is also likely to have formed part of male kit (Roesdahl et al. 1981, YD 41). Around forty ringed pins have been recorded from England, from locations including York, Chester, and Meols on the Wirral peninsula (Fanning 1994, 19, 32, figs. 7, 12; Mainman and Rogers 2000, 2580–2; Mason 2007, 114; Griffiths et al. 2007). Although most examples are insular products, of types known to have been mass-produced in Dublin, and are thus likely to reflect Hiberno-Norse connections, insular ringed pins are also found in Denmark, raising the possibility that some examples were introduced to the Danelaw via the Scandinavian homelands.

Large penannular brooches of the type found in Norway and Sweden are known from silver hoards in northern England, including those from Goldsborough, Yorkshire, and Orton Scar and 'Flusco Pike (1)', Cumbria, the latter

[2] In this context it is interesting to note that some Anglo-Saxon disc brooches with a backwards-turned quadruped motif carry a diagonal arrangement of pin-fittings, potentially hinting at their use in male dress (Smedley and Owles 1965).

Fig. 5.8 Borre-style strap-end and belt slide, Wharram Percy, Yorkshire, drawn by C. Philo (after Stamper and Croft 2000, fig. 61, nos. 22 and 23).

appearing to consist exclusively of large penannular brooches (Graham-Campbell 2001c; Williams 2009). At present, none are known from eastern England, although this probably reflects their Hiberno-Norse origins. A handful of buckles decorated with Borre and Jellinge motifs have been recorded from England, for instance, from Sculthorpe, Norfolk, and South Ferriby and Caistor, Lincolnshire, the latter finding a close parallel in a buckle from grave 1076 at Birka (Margeson 1997, fig. 25; Richardson 1993, 13, 47–8; Arbman 1940–43, pl. 87,1). These items may have formed matching sets with strap-ends, as appears to have been common in Scandinavian male dress (Arbman 1940–43, pls. 86–7; Edwards 1998, 9, fig. 1; Bersu and Wilson 1966, 7, 36–9, pl. VII, B–D; pl. VIII, A–B). Finally, a small number of Scandinavian strap-ends with Borre-style ring-chain ornament have also been recorded from England. These are outweighed by a larger number of Anglo-Scandinavian products, with different combinations of Borre-derived ring-knot and zoomorphic features (Thomas 2000b, 244–6).

The total number of male fittings decorated in Scandinavian styles is thus small compared with the quantity of recorded female items. Moreover, strap-ends, buckles, and ringed-pins were not exclusive to male dress, but were worn by both men and women, as indicated by their discovery in female graves (Leahy and Paterson 2001, 197; Graham-Campbell and Batey 1998, 136, fig. 7.11; Petersen 1928, 197; Fanning 1994, 21, 48). There are a number of

possible explanations for the relatively low profile of Scandinavian male dress items in England. Viking-Age male costume utilized fewer items of metalwork than female costume, and those items it did employ, such as ringed-pins, offered fewer opportunities for ornamental styles. It is possible that tasks undertaken by men in particular were less likely to result in the loss of everyday dress items, compared to the work undertaken by women. Another possibility is that men who settled in the Danelaw following years of military activity in a Viking army had lost or discarded their everyday dress fittings at an earlier date, particularly if they left Scandinavia decades before.

Whatever the reasons for the low number of Scandinavian male dress items in ninth- and tenth-century England, the relative ratio of male to female Scandinavian-style accessories can be shown to have shifted over time. In contrast to items in Early Viking-Age styles, metalwork in the Late Viking-Age art styles of Ringerike and Urnes appears to be more 'masculine' in character. As recent reviews have highlighted, these eleventh-century styles, most often in stylized Anglicized versions, commonly adorn pieces of equestrian equipment. Examples include bit-pieces, and bridle and stirrup-strap mounts, over five hundred examples of which have now been recorded (Williams 1997; Owen 2001, 209). Late Viking-Age styles have also been identified on a small number of weaponry fittings, including on two scabbard mounts from Hibaldstow and Middle Rasen, Lincolnshire, in addition to strap-ends and buckles which may have been worn by men or women (PAS 'Find-ID' NLM-876836; NLM-FD16A4; Fuglesang 1980, cat. no. 48, pl. 27 c; Graham-Campbell 1980, no. 185).

In a reversal of the earlier situation, female brooches in later Viking-Age art styles are scarce in England, despite their popularity in the Scandinavian homelands (Bertelsen 1994; Pedersen 2001). Just two openwork animal brooches in the Urnes style have been found on English soil (cat. nos. 494–5). The number of Scandinavian bird-shaped brooches is also small, totalling just seven items (cat. nos. 498–504). Compared to the large number of male artefacts in the Ringerike and Urnes styles, this suggests that, over time, the relationship between Scandinavian styles of adornment and female accessories was replaced by the association of Scandinavian styles with items normally used by men. What factors could explain such a shift?

One interpretation is that during the late ninth and tenth centuries, female metalwork, more than male, was visibly associated with Scandinavian cultural symbols. Recalling the potential of objects to evoke memories and preserve histories, this may point to a pronounced role for women as bearers of Scandinavian tradition within the Danelaw. As Elisabeth van Houts has demonstrated, conserving cultural memory was frequently a female task in medieval societies, carried out via the transmission of oral histories, the commemoration of the dead, and the bequeathing and receipt of artefacts, including jewellery (1999). Such a role is likely to have reflected the reproductive capacity of women and their embedded role as wives, mothers, and matriarchs in kin groups. In a

period of migration, when cultural memories were likely to be challenged, the need to articulate historical ties and generate a sense of cultural belonging may have achieved heightened importance. Indeed, anthropological studies of more recent settler communities stress the critical role played by women in passing on their language ('mother tongue') to children, upholding social rituals and traditions and maintaining family connections in their 'mother country', activities aimed at stabilizing recently-arrived family groups and reaffirming group identity in an unfamiliar setting (James Hammerton 2004; Paisley 2004). In the context of the Danelaw, the use of Scandinavian-style jewellery could be interpreted as one such strategy in cultural guardianship.

Not all Scandinavian-style jewellery found in England reproduced Scandinavian motifs. East Anglian Series brooches, together with a handful of other types, show a genuine fusion of local and foreign styles. These items are products of intercultural exchange and are likely to post-date explicitly Scandinavian jewellery (see Chapter 4). They communicated a different message: one which expressed a mixed heritage and signalled cultural likeness, rather than difference. The integration of Scandinavian and Anglo-Saxon communities is considered in more detail in Chapter 7. Here, the important point is that, in terms of metal dress accessories, female costume again served as the principal medium for the display of cultural values.

This phenomenon has a number of parallels in the early medieval period. In seventh-century England, for instance, funerary evidence indicates a radical change in female dress, which saw women abandon traditional Germanic dress in favour of new Roman-inspired fashions introduced via the Church. At the same time, men's dress remained largely unchanged (Geake 1999, 203–4; Owen Crocker 2004, 166). A similar process has been noted for Visigothic women's costume (Heather 1996, 305–6; Smith 2000, 556). For this reason, women have been described as 'particularly sensitive agents' in periods of cultural reorientation, their jewellery and dress styles in particular serving to renegotiate cultural values (Smith 2000, 556). Within the Danelaw, it is possible that the role played by women in the expression of new, Anglo-Scandinavian identities partially reflected their experience in other social strategies, such as intermarriage. Indeed, the use of Anglo-Scandinavian jewellery by Danelaw women may have actively facilitated their role as cultural brokers or mediators, their jewellery acting as a tangible symbol of intercultural exchange and open, shifting identities.

The case for a prominent role of women as bearers of cultural identity in the decades immediately following the Scandinavian settlement is consistent with an apparent weakening of their relevance in the eleventh century. From the turn of the millennium to the mid-eleventh century, horse trappings appear to replace brooches as the preferred medium for the expression of Scandinavian styles. This shift may partly reflect contemporary changes to female fashion within Scandinavia. From the later tenth century, this region bore witness to a

marked decline in the use of oval and other mass-produced brooches, reflecting changing dress fashions, as well as the channelling of resources into creative media for the newly established church (Fuglesang 1991, 85). By the eleventh century, however, copper-alloy accessories had been reinstated, as demonstrated by the vast numbers of openwork Urnes-style brooches, among other contemporary types, now recorded from Scandinavia (Bertelsen 1994; Lønborg 1994). We therefore need to consider deeper, structural explanations for such a shift in the gender association of Scandinavian metalwork.

There is now a consensus that Urnes- and Ringerike-style riding equipment, including cheek pieces, stirrup mounts, and pendants, originated in Denmark before being introduced to England (Pedersen 2004, 51–5; Roesdahl 2007, 22–3). Indeed, such fittings seem likely to have been associated with a cavalry elite operating under King Cnut during a period when his rule stretched from England to Denmark and, later, to Norway. The large numbers of low-quality copies indicate that elite Scandinavian cavalry styles were widely imitated in England; these items thus seem to signal affiliation with the emerging Scandinavian political and military hegemony of eleventh-century England (Graham-Campbell 1992, 88; Roesdahl 2007, 26). Why female Scandinavian dress items should decline in use at the same time is unclear, but cannot be explained by a lack of access to Scandinavian styles or changing costume requirements. One possibility is that the emergence of a Scandinavian, and presumably male-dominated, court in the eleventh century gave rise to a new symbolic language which privileged militarized, masculine displays. Following a period of violent conquest and empire building, women's dress items may have lost significance as tools for communicating cultural identity.

It is important to recognize that ornamental metalwork is just one of the ways in which cultural identity may be articulated. Men may have expressed cultural affiliation through other means, such as via the patronage of stone sculpture in Scandinavian styles, participation in a Scandinavian bullion economy, or via the adoption of other personal appearance cues, such as distinctive hairstyles. This is the implication in one tenth- or eleventh-century letter, in which a man named Edward is berated for dressing 'in Danish fashion with bared necks and blinded eyes', presumably a reference to the cropped haircuts and long fringes favoured by Scandinavian men (Whitelock 1979, no. 232). Men, as well as women, may have expressed cultural affiliations in ways that are less visible in the archaeological record, through the use of decorated leather sheaths, for instance, or distinct types of headgear (Cameron and Mould 2003; Henry 2003).

These examples serve as a reminder of the multiple ways in which Scandinavian cultural identity could be communicated in Late Saxon and Viking-Age England. The current corpus of metalwork nonetheless provides fresh evidence that, in the realm of dress, women's metal costume fittings played a relatively significant role in harnessing historical, ideological, and political associations

in order to confer meaning in times of social or political change. In this light, we may speculate that women, whether ethnically Scandinavian or not, had a clear role in reconfiguring and communicating Scandinavian identity in northern and eastern England up to the time of Cnut.

Conclusion

Close study of the form and attachment fittings of Scandinavian-style jewellery provides new insights into their contexts of use and the possible backgrounds of their wearers. The layout of the pin-lug and catchplate on Scandinavian and Anglo-Scandinavian brooches suggests that these items were attached to clothing in different ways from each other. In contrast to Scandinavian brooches, Anglo-Scandinavian brooches adopted a fastening familiar to Anglo-Saxon women, possibly indicating that such items were produced for an indigenous market. This interpretation finds further support in the uniform absence of attachment loops on Anglo-Scandinavian brooches, a phenomenon which signals an end to the traditional Scandinavian practice of suspending artefacts from brooches. In these ways, Anglo-Scandinavian brooches can be understood as products of Anglo-Saxon and Scandinavian cultural interaction. At the same time, the retention of conventional Scandinavian pin-layouts and attachment loops on Scandinavian brooches in England demonstrates that 'foreign' brooch traditions could also be transplanted from Denmark to the Danelaw, a phenomenon which hints at the use of such items within Scandinavian circles. Taken together, this evidence points to the existence of two, distinct female costume traditions within the Danelaw and, in turn, at least two groups of wearers.

In the realm of dress in the later ninth and tenth centuries, Scandinavian styles may have been particularly associated with women. Despite the circulation of Borre- and Jellinge-decorated male dress accessories within Scandinavia, the number of Scandinavian items found in England that can be attributed to male dress or use is limited. This pattern, reversed in the later tenth and eleventh centuries, suggests that female dress had a role in conveying messages about Scandinavian heritage during the settlement period, whether to promote separateness or assimilation. This implies a clear role for women in the Danelaw as agents of cultural communication.

6

Locating Scandinavian influence: the distribution of Scandinavian-style jewellery in England

Introduction

Within Viking studies few questions have generated as much interest and debate as the location and density of Scandinavian settlement in England. The diverse evidence afforded by linguistic, archaeological, and documentary sources, while sometimes contradictory, suggests that settlement was densest in the northern and central Danelaw, with traditional markers of Scandinavian activity, including place-names and Scandinavian-style stone sculpture and burials, firmly concentrated in areas such as Yorkshire and the north-east Midlands (see Map 6.1). While there is now widespread recognition that such 'indicators' cannot simply be correlated with an ethnic Scandinavian presence, it remains a commonly-held view that Danelaw areas with apparently fewer cultural markers, such as East Anglia, were less intensively settled (Williamson 1993, 107; Insley 1999, 53). With relatively few Scandinavian place-names and burials, and little documentary record for a Viking presence, East Anglia has even been excluded from some definitions of the historic Danelaw (Chadwick 1905, 200).

The distribution of Scandinavian jewellery has the potential to alter significantly this familiar 'settlement' map. The find-spots of just over five hundred dress items suggest that Scandinavian influence over female dress was most strongly felt not in Yorkshire or the Midlands, but in Norfolk, Suffolk, and Lincolnshire. Of course, as highly portable metalwork mainly representing casual losses, jewellery represents an altogether different category of evidence to permanent monuments in the landscape, such as sculpture, and these factors must be considered in any assessment of the jewellery distribution. This chapter recognizes these issues but nonetheless argues that the current distribution record is likely to provide a reliable guide to original patterns of jewellery use. As such, it provides fresh and meaningful insights into locations of Scandinavian cultural influence and, potentially, settlement.

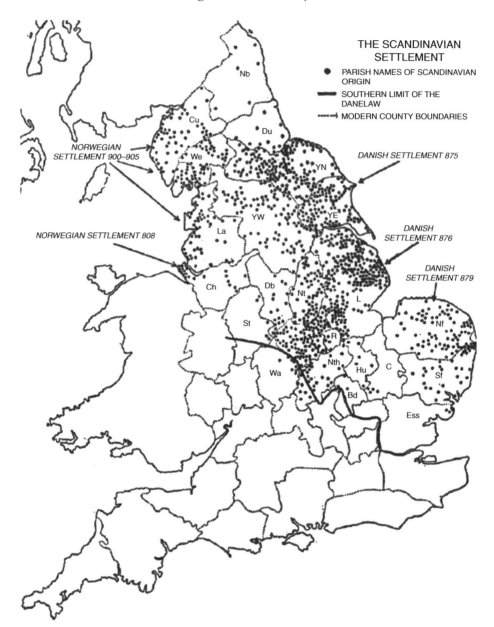

Map 6.1 The traditional map of Scandinavian settlement in England, showing the location of Scandinavian place-names (after A. H. Smith, 1956) © English place-name Society

Following a brief consideration of the biases involved in mapping detected metalwork, this chapter looks briefly at the site contexts of Scandinavian-style jewellery. It then explores the distribution of the jewellery at both national and regional levels, focusing on those areas with the densest concentration of finds. The chapter then moves to examine changes in the distribution of

Scandinavian jewellery over time, comparing the extent of late ninth- and early tenth-century objects, in the Borre and Jellinge styles, with those in the later tenth- and eleventh-century styles of Mammen, Ringerike, and Urnes. This approach reveals significant geographical and chronological trends in the consumption of Scandinavian jewellery, highlighting, for instance, a shift in the geographical focus of Scandinavian-style jewellery during the tenth century. In order to compare the distribution of Scandinavian brooches with that of other cultural indicators, the chapter then assesses the brooch distribution against that of Scandinavian place-names. It is worth noting here that the distribution of Scandinavian jewellery cannot act as a reliable guide to locations of settlement any more than place-names, sculpture, or burial. Scandinavian cultural influence is nevertheless likely to be tied to locations of Scandinavian settlement and activity. The distribution of Scandinavian-style dress items, especially those argued to have been imported, certainly has the potential to elucidate the Scandinavian presence.

Mapping portable metalwork

There are a number of challenges in using the distribution of small dress items as a guide to Scandinavian influence and settlement in England. Unlike stone sculpture or burials, Scandinavian jewellery is small and highly portable. It may, therefore, be carried by its wearers or transported via trade networks over some distances. Notwithstanding a few instances in which dress items are known to derive from burials and towns, it is presumed that most artefacts represent accidental losses, associated with everyday activity and movement around the countryside (see below). Rural settlement patterns and varying regional patterns of metalwork consumption are thus also likely to influence the distribution of Scandinavian-style jewellery. The recovery of brooches and pendants will undoubtedly be influenced by modern-day constraints on metal detecting, such as the amounts of land under the plough. These constraints were highlighted in Chapter 1, but are considered in more depth within regional frameworks in this chapter. Finally, future discoveries made through metal detecting have the potential to alter the current distribution map. This is suggested for Yorkshire in particular, where the Portable Antiquities Scheme (PAS) has only recently established good working relationships with local detectorists, but is unlikely to significantly modify the broad trends presented here.

Fortunately, the distribution of Scandinavian-style jewellery can be compared with that of other metal-detector finds dated from the prehistoric to post-medieval periods recorded by the PAS, objects we may describe as 'multi-period' finds. The distribution of contemporary Anglo-Saxon material can also be examined to provide a control against which the find locations of Scandinavian jewellery can be assessed. For instance, while the low number of

Scandinavian artefacts recovered from southern Suffolk appears to be inconsistent with the large number of finds recovered from East Anglia more generally, the presence of substantial quantities of contemporary Anglo-Saxon and Carolingian metalwork from the region suggest that the low profile of Scandinavian jewellery in this region is genuine (see Appendix C). Such controls are applied throughout this chapter, as a means of interrogating the patterns presented by the detector material.

Site contexts

The distribution pattern of Scandinavian-style metalwork will highlight locations of artefact use, but tells us little about the character of sites at which jewellery was worn. In order to understand the contexts of use, as well as loss, of Scandinavian-style jewellery, we therefore need to investigate the nature of those sites that have yielded relevant metalwork. Current evidence suggests that Scandinavian-style dress accessories derive from three main find contexts: burials, urban centres, and rural settlements. As previously stated, only a small number of objects can be confidently assigned to the first category, burials. A few more dress items are recorded from the towns of the Danelaw, from Thetford, Norwich, Lincoln and York (cat. nos. 102, 219–22, 335, 387, 396, 409, 422, 446, 452, 478, 482–3). In some instances, the presence of jewellery may be linked to the location of a workshop. This appears to be the case at 16–22 Coppergate, York, for instance, where a Jellinge-style brooch with casting bubbles was found along with other items suggestive of on-site non-ferrous metalworking (cat. no. 482) (Mainman and Rogers 2004, 467). Trade, rather than manufacturing, may account for the presence of a lozenge brooch at one of the few non-Danelaw locations to have produced Scandinavian-style jewellery: the waterfront site of Bull Wharf (Queenhithe), London (cat. no. 27). This site, identified as 'Æthelred's Hythe' in two late ninth-century charters, formed an important centre for river trade following King Alfred's occupation of the city and has yielded multiple Continental and Anglo-Scandinavian small finds (Hooke 2007, 40–1; Ayre et al. 1996).

More broadly, the widespread and predominantly rural find-spots of Scandinavian-style dress items suggest that most artefacts represent casual losses from rural settlements.[1] This is supported by the abraded and often fragmentary condition of many artefacts, suggesting their prolonged presence in topsoil, as well as by the absence on all single finds of textile remains, which may be preserved

[1] Two brooches in the present corpus are said to have been found in Torksey, Lincolnshire, where the Viking army overwintered in 872/3. A direct association with the camp cannot be demonstrated, however, since neither have a reliable grid reference. While one brooch could plausibly date to this early period (cat. no. 37), stylistic parallels point to a much later date, in the mid-tenth century, for the second item (cat. no. 343) (see Chapter 5).

in corrosive salts where metalwork has come into sustained contact with clothing, as in burials (Walton Rogers 2007, 49). Yet the precise nature of the sites which have yielded Scandinavian-style jewellery, as well as the depositional context of the objects themselves, remains difficult to determine. Due to the current policy of minimizing excavation and preserving sites *in situ*, few English rural sites with early medieval metalwork scatters have seen archaeological investigation. This stands in contrast to the situation in Denmark, where areas of concentrated metal-detector finds have also been subject to excavation, often on a large scale. Such an approach has enabled a detailed understanding of the relationship between settlement structures and metal-detector finds, which is, at present, largely lacking on this side of the North Sea (Christiansen 2008).

Nevertheless, recent excavation, as well as field walking and survey at a small number of metal-detected sites, provide a few opportunities to consider the site backdrops of a small number of dress items. At Cottam on the Yorkshire Wolds the plotting of metal-detector finds against settlement features recorded during a magnetometer survey revealed a cluster of tenth-century metalwork, including a Jellinge-style brooch (cat. no. 458), in association with a farmstead comprising several subrectangular enclosures and a prominent entrance way with bank and ditch (Richards 2003). The recovery from the same area of tenth-century pottery and other Anglo-Saxon and Scandinavian-influenced metalwork, including lead weights, suggests a permanent, though short-lived, relatively high-status settlement with associated trading activity (Richards 2003, 164). Other sites associated with Scandinavian-style jewellery appear to have been of lower social standing. At West Fen Road, Ely, a fragmentary East Anglian Series brooch was recorded from an unknown location within a relatively low-status, rural settlement with possible connections to the monastic site at Ely (cat. no. 88) (Mortimer et al. 2005, 56, no. 15, fig. 4.1, no. 15).

Field surveys by Gareth Davies have elucidated the find contexts of a number of dress accessories recovered at several west Norfolk sites (Davies 2010). At Burnham near the north Norfolk coast, metal-detecting yielded one of the densest concentrations of Scandinavian-style jewellery in the county, in addition to other artefacts indicative of strong Scandinavian influence, including an Arabic dirham (cat. nos. 44–5, 130, 377, 471). Geophysical survey by Davies has shown the metalwork to be located within and nearby a major enclosure and contemporary droveway potentially dating to the Anglo-Saxon period (Davies 2010, 111–12, fig. 10). The site appears to represent a new settlement in the Late Anglo-Saxon period, having expanded from a Middle Anglo-Saxon trading centre to the north (Rogerson 2003, 114–15). The discovery in Burnham of Middle and Late Anglo-Saxon pottery and metalwork, and Late Anglo-Saxon coins, suggests to Davies that the site may have formed 'a focus of trade/exchange that was most likely under Scandinavian control or influence' (2010, 113; Norfolk HER 34581).

Adjacent site activity at Congham, also in Norfolk, may provide a backdrop for the loss there of three Anglo-Scandinavian brooches (cat. nos. 136–8), among other Middle and Late Anglo-Saxon metalwork, coins, and pottery. Recent surveying at the site has shown the finds to be located north of an east–west aligned boundary feature, which, Davies suggests, may have enclosed a settlement to the south (Davies 2010, 104–6, fig. 6). North–south aligned geophysical anomalies indicative of droveway ditches are correlated with the finds assemblage, suggesting that the area did indeed fall outside a zone of core habitation (Davies 2010). Adjoining site activity may also account for the loss of an Anglo-Scandinavian disc brooch in Sedgeford, Norfolk. The brooch (cat. no. 245) was found south of the main focus of Middle and Late Saxon settlement as revealed through excavation, in an area in which test pitting confirmed the absence of settlement (Cabot et al. 2004, 322, fig. 3).

Combined, this information suggests that Scandinavian-style dress items are likely to be casual losses, worn and lost on or nearby permanent rural settlements, some of which appear to have been associated with market and other ancillary functions. The loss of jewellery seems most likely to be correlated with everyday activity, such as travel to and from settlements and participation in local markets and manufacturing activities. This finding is significant, and serves as a reminder of the influence of rural settlement patterns in shaping the current jewellery map. It also helps us to understand better the national and regional distribution patterns of Scandinavian-style jewellery, to which we can now turn.

The national distribution of Scandinavian jewellery

With a few exceptions, the find-spots of ninth- and tenth-century jewellery in explicitly Scandinavian forms and styles confirms the Danelaw as a cultural boundary, marking the extent of Scandinavian metalwork. Anglo-Scandinavian artefacts, with a mixture of Scandinavian and Anglo-Saxon forms and styles, reveal a similarly restricted distribution within the documented area of Scandinavian settlement and a marked concentration around Norwich, where it is likely many such items were produced (see Map 6.2). Overall, Scandinavian-style jewellery is heavily concentrated in Norfolk, which has 60 per cent of all finds, with a significant proportion of finds, 14 per cent, also coming from Lincolnshire. Compared to contemporary non-Scandinavian metalwork, both Norfolk and Lincolnshire have a high proportion of Scandinavian-style metalwork, a theme explored further in the next chapter. Such a weighted concentration is notable, since East Anglia, with just a scattering of Scandinavian place-names, is not a traditional focus for studies of Scandinavian settlement.

Within the Danelaw, there are no finds north of the River Tees and surprisingly few north of the River Humber given prior academic focus on Yorkshire

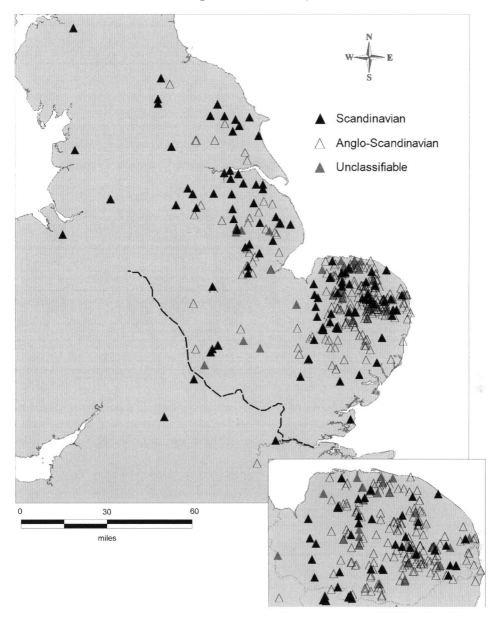

Map 6.2 National distribution of Scandinavian-style jewellery

as an area of Scandinavian activity and settlement. Cambridgeshire and central counties such as Nottinghamshire, Leicestershire, and Northamptonshire have produced only a scattering of Scandinavian and Anglo-Scandinavian brooches, despite producing a healthy corpus of other types of early medieval metalwork (Richards et al. 2009, fig. 42). The southern extent of Scandinavian metalwork in England is marked by the Stour Valley on the Essex/Suffolk

border, with the exception of one find from London. This London piece, a lozenge-shaped brooch from Queenhithe, contributes to the relatively small number of non-Danelaw finds. A few items in the north–west, at Cumwhitton (Carlisle) and Chester, for instance, fit into this category but may be attributable to Norse influence in the area or Danish–Norse exchange. There is, however, a discernible string of outliers, predominantly focused along the line of the Rivers Nene and Great Ouse; as discussed further below, these items may have been traded along such waterways. The most south-westerly find, a trefoil brooch from Bampton in the Oxfordshire Thames Valley, is similarly located near the Thames and may also owe its find-spot to its proximity to a watercourse.

To an extent, the observed concentration of Scandinavian-style jewellery in Norfolk and Lincolnshire can be seen as a reflection both of high levels of metal-detecting activity and each county's long history of successful liaison between museum curators and metal detectorists, although this does not explain the higher ratio of Scandinavian to non-Scandinavian metalwork in these areas (see Chapter 7). In Norfolk, the county Historic Environment Record (HER) has been recording individual finds since the 1970s, resulting in a wealth of finds being made publically available. In Lincolnshire, too, finds reporting began at an early date, thanks to the efforts of the North Lincolnshire Museum curator, Kevin Leahy. Nonetheless, Norfolk and Lincolnshire are not the only Danelaw regions to see high levels of metal detecting and reporting. Annual finds-reporting statistics from the PAS, piloted in 1997 in Kent, Norfolk, North Lincolnshire, the West Midlands, North West England, and Yorkshire, and established on a national scale in 2001, indicate that between 2003 and 2008 the Danelaw county which generated the highest total number of finds records, for any object type, was Suffolk (discounting Norfolk's record for 2007, which largely represents a transferral of older object records from the HER to the PAS) (see Table 6.1). Despite this, Scandinavian metalwork from the county is only infrequently found.

Regional distributions of Scandinavian jewellery

To understand in more detail the distribution of Scandinavian-style jewellery it is necessary to examine the three regions with the densest distribution of finds, namely East Anglia, eastern England (particularly Lincolnshire), and northeast England. While a scattering of brooches are known from the north-west, for instance, from Chester and Manchester, jewellery has not been recorded on a sufficient scale in this region to reveal meaningful distribution patterns. The small number of southern Scandinavian-style jewellery items recovered from the north-west is of interest, since this region was settled not from Denmark but from Norway, via Ireland and Scotland. The lack of exposure of this region to specifically Danish settlement would appear to be consistent with the fact

Table 6.1 The total number of object records generated each year for the Portable Antiquities Scheme (only Danelaw counties have been included).

	2004	2005	2006	2007	2008
Cambridgeshire	430	409	1297	1062	1334
Derbyshire	123	231	200	207	241
Essex	913	1104	1074	1046	1301
Leicestershire	911	1637	1040	962	1473
Lincolnshire	1351	2647	2518	2204	3122
Norfolk	816	1989	2792	13651	2286
Northamptonshire	883	1669	612	686	1069
North and North East Lincolnshire	583	558	427	621	836
Northumberland and Tyne and Wear	201	163	126	183	99
Nottinghamshire	285	601	571	741	947
Suffolk	3479	2725	3558	3468	2691
Yorkshire (North and East)	1382	1012	1912	2175	3865
Yorkshire (South and West)	277	388	176	448	576

Source: Portable Antiquities Scheme

that not much Danish-style jewellery is found. However, early medieval metal-work of any type is also scarce and levels of metal detecting relatively low, the north-west constituting a heavily urbanized and highland region, where much land is unavailable for detecting due to its use as pasture (Richards et al. 2009, 2.4.2.1). It is possible, then, that the low profile of southern Scandinavian-style jewellery partly reflects biases in metalwork retrieval.

East Anglia (Maps 6.3–6.7)

As emphasized in Chapter 1, metal-detector finds are recorded in high numbers across Norfolk and Suffolk and, to a lesser extent, Essex. Some constraints on the locations of detecting activity in East Anglia are imposed by modern topographical features (see Map 6.3). Examples include urbanized areas along the Essex coast, Thetford Forest Park, and an adjacent military training zone, as well as wetlands and lakes, particularly in the Broads and west Norfolk—all areas which have yielded low numbers of Scandinavian-style jewellery. Overall, however, constraints on metal-detecting activity in this low-lying, predominantly agricultural region are low, reflecting, in part, East Anglia's status as the least urbanized area of England (Richards et al. 2009, 2.4.2.4). In Norfolk, 309,848 hectares, or 56.4 per cent of land, is currently classified as crops or

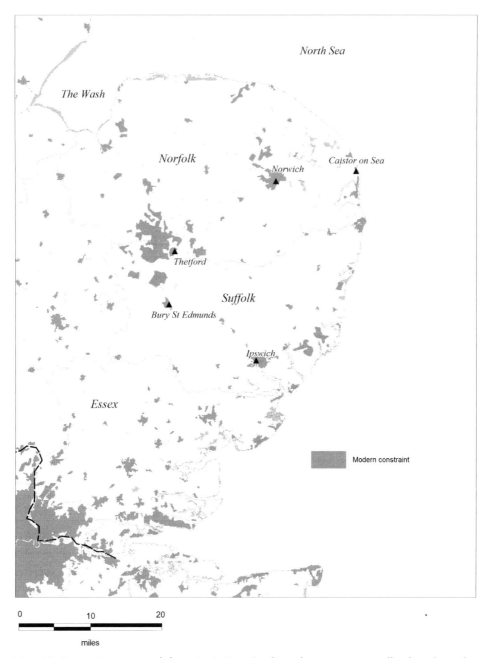

Map 6.3 Constraints on metal-detecting in East Anglia: urban centres, woodland, and marshes

bare fallow and is therefore suitable for detecting; in Suffolk, 224,316 hectares, or 59 per cent of land could, in theory, be detected (DEFRA Agricultural and Horticultural Survey 2008).

The distribution of multi-period finds recorded by the PAS and Norfolk HER confirms the wide coverage of metal-detecting in East Anglia (see Map 6.5).

Early medieval finds, including non-Scandinavian metalwork, are found in almost all areas of Norfolk, as demonstrated by the distribution of Middle and Late Anglo-Saxon coins, metalwork, and pottery recorded in the county (see Map 6.4). Except in the north-east, the same is true of Suffolk, which records the most finds per county for the PAS, contributing over 6,000 items, around 10% of all finds, in 2005–6 (Table 6.1 and see Map 6.5). In Essex, multi-period finds are also widespread, with particular concentrations in the north, although the overall pattern is sparser than in northern East Anglia (Map 6.5). The extensive, county-wide coverage in Norfolk and Suffolk contrasts markedly with the uneven distribution of metal-detector finds just ten years ago, when find-spots appeared to reflect concentrations of activity at key, productive sites, such as Hindringham, Congham, and Quidenham in Norfolk and Mendlesham, Wetheringsett-cum-Brockford, and Brandon in Suffolk (Gurney 1997; West 1998, 317, 320, figs. 158–9). This expansion in coverage is clearly seen in the huge rise in the number of metal-detecting 'events' (recorded visits to a parish) on the Norfolk HER: from 1,250 in 1997 to over 9,000 in 2006 (Hutcheson 2006, 82). Such widespread coverage of metal-detector finds in Norfolk and Suffolk is significant, providing as it does a full background against which the distribution of Scandinavian-style brooches can be assessed.

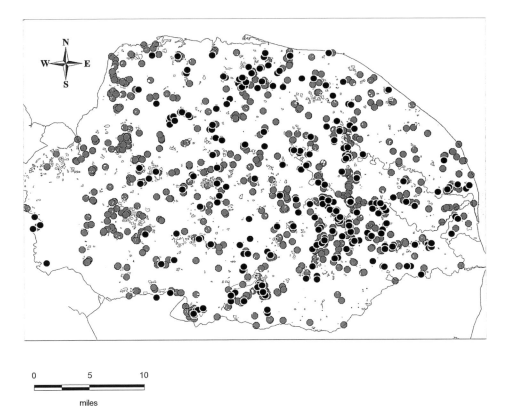

Map 6.4 Scandinavian jewellery in Norfolk (black) and Middle and Late Anglo-Saxon pottery and metalwork, including coins (grey)

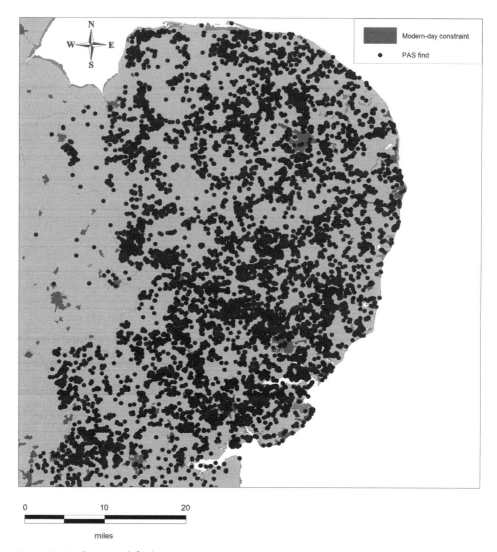

Map 6.5 Multi-period finds in East Anglia recorded by the PAS

As Map 6.6 illustrates, Scandinavian jewellery within East Anglia is both numerous and widespread, a distribution which is consistent with the diffuse settlement pattern documented in Viking-Age Denmark (Margeson 1996, 52). However, jewellery is clearly concentrated within Norfolk and northern Suffolk: on the outskirts of Thetford Forest, for instance, and in the area around Eye further east. There are comparatively few finds in southern Suffolk and

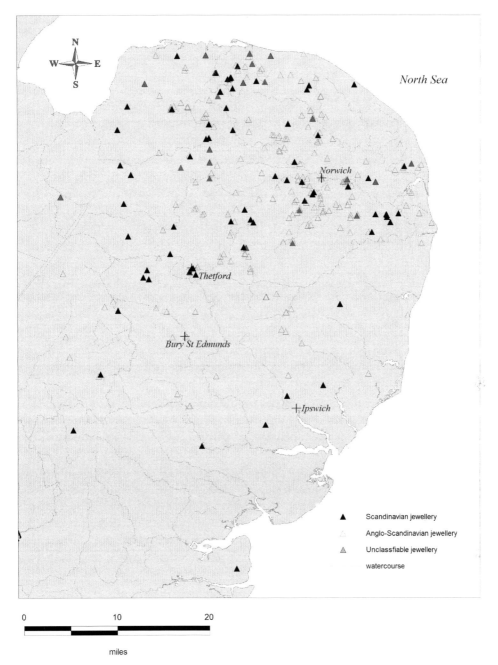

Map 6.6 Scandinavian-style jewellery in East Anglia

Essex. Given the extensive and widespread evidence for contemporary non-Scandinavian finds from Suffolk (Appendix C, Map 6.5), this pattern can be assessed as genuine, reflecting the original use of Scandinavian jewellery.

The apparent change in the relative density of finds crossing Norfolk/northern Suffolk and southern Suffolk is of great interest, since it appears to correspond with evidence for the existence of two distinct cultural zones in East Anglia, separated by the so-called 'Gipping divide', that is, the Gipping and Lark river corridor stretching from south-east Suffolk (around Ipswich) to north-west Suffolk (around Bury St Edmunds) (Martin 2007; Martin and Satchell 2008). These two zones are primarily distinguished by different farming methods which emerged during the later Middle Ages. Block holdings (that is, farms surrounded by their own land) characterize the area south-west of the 'Gipping divide', whereas common fields (farmed communally) are typical to the north-east. Such differences are likely to reflect adaptations to local topography, and may, in themselves, have resulted in different rates of metalwork deposition in the two regions (such rates potentially being influenced by different farming practices). Yet Edward Martin has suggested that the two regions can also be shown to have followed different cultural trajectories. In particular, he suggests that the use of common fields in Norfolk and north-west Suffolk may be associated with Scandinavian settlement in the area, with the disruption caused by a Scandinavian influx resulting in the equitable sharing of good farmland (Martin 2007, 133–5).

As Martin highlights, stronger Scandinavian influence over northern East Anglia compared to the south is supported by linguistic evidence as well as by the regional distribution of Scandinavian place-names (2007, 132–3). Although Scandinavian place-names are not as numerous in East Anglia as they are in areas of the northern and central Danelaw, they are more common in Norfolk and northern Suffolk than in southern Suffolk and Essex (Map 6.1) (Martin and Satchell 2008, fig. 38). The 'English' character of southern East Anglia may reflect the preeminence of Ipswich as an East Anglian royal *wic* and administrative centre during the Middle Anglo-Saxon period. Despite evidence for ninth- and tenth-century metalworking at the Buttermarket site, it is notable that Ipswich has yet to yield evidence of metalwork in Scandinavian styles (Wade 1993, 148). The evidence of metalwork, then, would appear to add a further layer of support for the existence of two, distinct cultural zones in Viking-Age East Anglia.

Within this area of northern East Anglia there is a particular concentration of finds around Norwich, especially along watercourses to the south, east and west of the city (see Map 6.7). These brooches are predominantly Anglo-Scandinavian, comprising several of the types identified in Chapter 3 as locally produced versions of Scandinavian lozenge, trefoil, and disc brooches. The outskirts of Norwich are a focus for metal detecting, attracting detectorists living within the town looking for the nearest possible searchable land. Nevertheless, the cluster in this region of Anglo-Scandinavian jewellery in particular

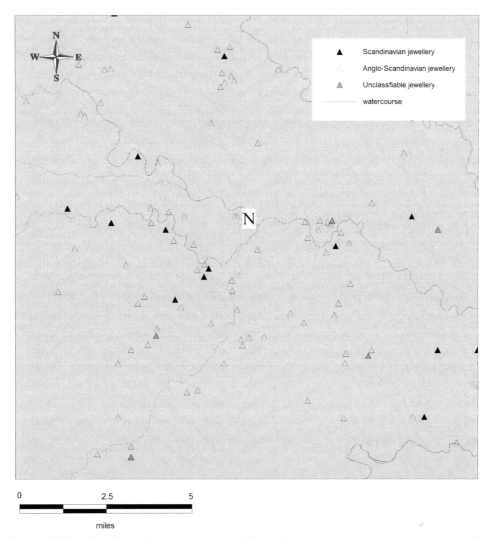

Map 6.7 Scandinavian-style jewellery around Norwich (N)

points to Norwich as a centre of manufacture for locally made brooches of Scandinavian form and appearance. In this context, it is notable that excavations in the 1970s and 1980s at Norwich Castle Bailey uncovered a significant quantity of worked bone and antler, including a possible motif piece, leading excavators to suggest the site's use as a workshop prior to the establishment of an eleventh-century church (Ayers 1985, 27).

Within Norfolk, there is a clear gap in the brooch distribution in the northeast of the county (Map 6.6). Just one item, a Scandinavian trefoil brooch fragment from Paston, is recorded from the region, although finds flank the areas to the west and south. This absence is surprising, since this region of rich loam soils is

extremely fertile, supporting, in parts, one of the densest concentrations of population recorded in Domesday Book (Ashwin and Davison 2005, 8–9, 38–9). Moreover, although the area does not see high levels of detecting, it is regularly surveyed by the (somewhat frustrated) members of the East Norfolk metal-detecting club, meaning that the absence of finds cannot be attributed to a lack of detecting activity (Chester-Kadwell 2009, pl. I).

Significantly, Scandinavian-style jewellery is not the only class of early medieval artefact to reveal this gap. Only a small number of early Anglo-Saxon settlements and cemeteries are known from the region (Wade 1983; Ashwin and Davison 2005, 30–1). Very little in the way of Middle Anglo-Saxon metalwork or coinage is known from north-east Norfolk, although Ipswich ware, a durable, Middle Anglo-Saxon greyware, produced in Ipswich, is somewhat better represented (Ashwin and Davison 2005, 32–3; Hutcheson 2006, fig. 3). The paucity of Scandinavian jewellery from this region therefore fits with broader trends in early medieval artefact patterning, and would not appear to reflect differences in the use or consumption of Scandinavian metalwork in particular. It is possible that this distribution instead reflects areas of dense woodland, which are alluded to in later place-name elements, such as '*feld*' ('open country', implying adjacent areas of dense woodland) and '*leah*' and '*thveit*' ('clearance') (Williamson 1993, 60–2). It may also result from pockets of low-density settlement within this high-population region, as reflected in the population records of Domesday (Ashwin and Davison 2005, 38–9).

Eastern England (Maps 6.8–6.12)

The area of eastern England encompasses Lincolnshire, Nottinghamshire, Leicestershire, Northamptonshire, Cambridgeshire, and, here, South Yorkshire. With the exception of the Cambridgeshire and Lincolnshire fens and coastal marshes, and modern built-up areas in the west, there are few modern constraints to metal detecting (see Map 6.8). Indeed, as a region, eastern England has yielded a healthy spread of multi-period finds, with particular concentrations in Lincolnshire and Northamptonshire (see Map 6.9; Richards and Naylor 2010, 342). Early medieval material in particular is sparser and its distribution more patchy. Yet it is still found in significant quantities, except in Nottinghamshire and Cambridgeshire where it appears to be less common (Richards et al. 2009, 3.3.3.2, fig. 77). The low number of finds from Cambridgeshire may reflect the earlier poor record of the Cambridgeshire PAS, which has struggled in the past to maintain an up-to-date finds database. In 2004/5, Cambridgeshire recorded an average of just twenty-one finds per month, although this number jumped dramatically, to one hundred and thirty-nine, in 2005/6 (see Table 6.1). However, levels of metal-detecting activity also appear to be low here (*PAS Annual Report* 2004/5, table 7b; 2005/6, table 7b; 2008, table 1a), with many local detectorists

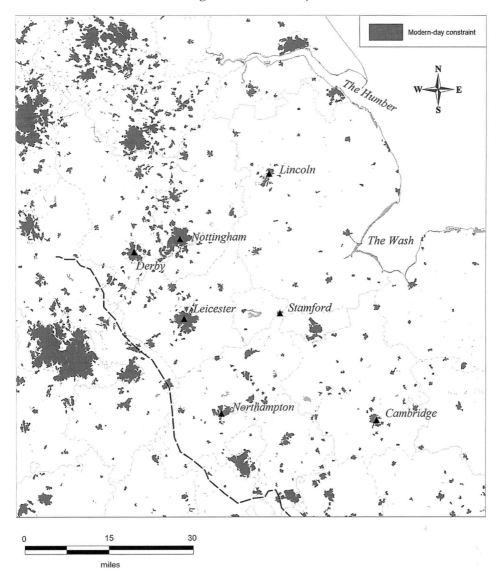

Map 6.8 Modern-day constraints on metal detecting in eastern England

preferring to detect in Norfolk or Suffolk (Andrew Rogerson, pers. comm.). This bias in detecting activity would appear to explain why most Scandinavian-style jewellery from Cambridgeshire, along with other, multi-period finds, is located near the Norfolk and Suffolk borders.

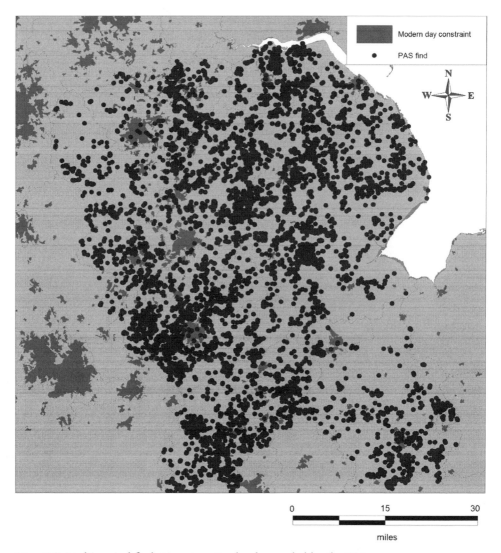

Map 6.9 Multi-period finds in eastern England recorded by the PAS

Despite widespread metal-detecting and recording in this eastern region, just a scattering of Scandinavian and Anglo-Scandinavian brooches come from Nottinghamshire, Leicestershire, and Northamptonshire (see Map 6.10). These items represent outliers from the main distribution, and may indicate something other than Scandinavian activity or settlement. In Northamptonshire, finds are concentrated along the lines of the Rivers Nene and Great Ouse, which extend

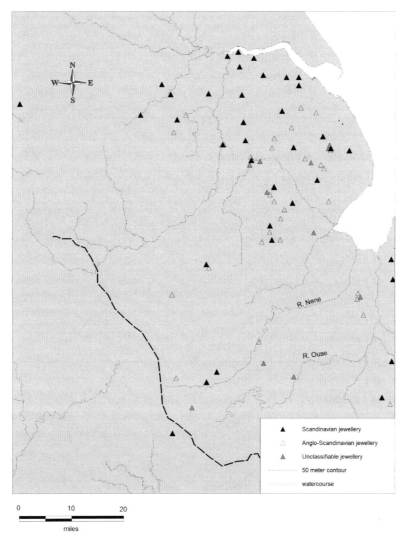

Map 6.10 Scandinavian-style jewellery in eastern England

from the Wash to the south-west of the county. While these items may have been dropped by travellers from East Anglia, we must remember that the river systems of the Wash served as important trade routes in the Late Anglo-Saxon period, transporting goods such as Stamford ware to East Anglia and the Midlands (Blair 2007a, 15, fig. 5). Evidence of tenth-century coin loss also indicates that the Nene formed part of a corridor of commercial activity extending into the south-west Midlands, and raises the possibility that Scandinavian brooches were traded along this route (Blair 2007a, 17). Within this outlying group, multiple, explicitly Scandinavian brooches and pendants come from

Northampton and nearby Overstone. These items may be associated with Scandinavian settlement, possibly in connection with one of the Danish armies based in the town during the late ninth century.

The low number of Scandinavian-style dress items recovered from the Midlands is in many ways unexpected. This is the region of the 'Five Boroughs' and the area where Scandinavian influence in place-naming is most clear; we might therefore expect other forms of Scandinavian culture, such as dress, to have been similarly adopted. The low number of jewellery items from the region is difficult to explain, but may reflect a number of different factors. It is possible that access to metalwork was more restricted in the Midlands than in the eastern counties, resulting in different patterns of metalwork consumption. Early and Middle Anglo-Saxon material culture is relatively rare in the Midlands, a pattern which has been causally linked to the region's economic isolation following the rise of the North Sea trading zone in the seventh century (Richards et al. 2009, 2.5.1, fig. 78; Loveluck and Tys 2006). For the later Anglo-Saxon period, however, PAS records demonstrate an increase in the circulation of metalwork in the Midlands, in line with national trends (Richards et al. 2009, figs. 59, 78). Indeed, this period is one of economic growth in the region, as indicated by rapid urban development and the emergence in towns of vibrant pottery industries: precisely the sort of economic context in which a culture in small consumables may be expected to flourish.

Another possibility is that underlying settlement patterns affect the visibility of metalwork scatters. It has long been appreciated that medieval England comprised two major landscape zones. In brief, nucleated villages with large open fields, cultivated in common, characterized a broad middle band of lowland England, including the Midlands, Lincolnshire, and Yorkshire. By contrast, a more dispersed settlement pattern, consisting of small hamlets and isolated farms with small fields less reliant on communal labour, characterized the regions to the south-west and south-east, including East Anglia (Williamson 2003; Roberts and Wrathmell 2000). This model is not strictly binary, nor is its chronological development well understood (Williamson 2003, 89; Rippon 2008, 6–9). Recent scholarship has nevertheless argued convincingly that nucleated villages with their attendant open fields were in existence in the Midland counties by *c.* 850, that is, prior to the introduction of Scandinavian jewellery (Williamson 2003, 67; Jones 2005).

What impact might the prevalence of nucleated, as opposed to dispersed, settlement patterns have on the distribution of Scandinavian-style jewellery? In the absence of detailed research on this topic, we may only speculate. Arguably, brooches were less likely to be permanently lost on nucleated sites than in areas of dispersed settlement since, as in towns, there would simply be more people to retrieve lost items. Because nucleated settlements were also more stable than dispersed settlements, and often lie beneath modern villages, they may be masked by modern occupation to a greater extent than villages which stabilized at a

later date (Martin and Satchell 2008, 217; Williamson 2003, 67, 89). Conse-
quently, it may be argued that contemporary metalwork has a better chance of
being recovered through field walking and metal detecting in areas of histor-
ically dispersed settlement compared to areas with historically nucleated vil-
lages. It is clear, however, that the relationship between rural settlement patterns
and metalwork distribution is not straightforward. Lincolnshire also falls
within the zone of Late Anglo-Saxon nucleated settlement, yet, as we shall see,
patterns of loss in this region are more in keeping with those observed in East
Anglia than in the Midlands. Historically low levels of metal detecting and
recording in the Midland counties are also likely to partly account for the rela-
tive paucity of Scandinavian-style metalwork from the region.

The densest concentration of finds in eastern England comes from Lincoln-
shire. Here, hundreds of small finds recorded by curator Kevin Leahy at North
Lincolnshire Museum provide a particularly rich dataset. The distribution of
Scandinavian jewellery in Lincolnshire is broadly aligned with that of contem-
porary, non-Scandinavian finds, with both categories of artefact reflecting set-
tlement on the Lincolnshire Wolds in northern Lincolnshire (historic Lindsey),
and on the limestone escarpment known as the Lincoln Cliff in the south (his-
toric Kesteven) (see Maps 6.11 and 6.12) (Leahy and Paterson 2001, figs. 10.3
and 10.4). One peculiarity is the absence of material at Goltho and Flixbor-
ough, both excavated, high-status rural sites with settlement sequences con-
tinuing into the tenth century, and beyond (Beresford 1987; Loveluck 2007,
158). The paucity of late ninth- to early tenth-century material culture at
Flixborough may reflect the site's temporary decline during this period, possibly
resulting from disruption caused by the break-up of estates following Scandina-
vian settlement (Loveluck 2007, 154). This county-wide distribution pattern
suggests that Scandinavian material culture and, potentially, settlement, was
both widespread throughout Lincolnshire and clustered in distinct regions.

Kevin Leahy and Caroline Paterson have suggested that the distribution of
Scandinavian jewellery in Lincolnshire is confined to isolated pockets in the
east of the county, a finding which is not, however, upheld here (2001, 189).
Rather, the distribution of both Scandinavian and non-Scandinavian metal-
work reflects the limits of contemporary settlement. As we would expect,
jewellery is not typically found in areas of historic wetland or marshes,
namely the Wash and Lincolnshire coastline, the River Witham south-east of
Lincoln, and the surrounds of the island of Axeholme in the north-west
corner of Lincolnshire (Symonds 2003, 23, 27, figs. 6 and 7) (Maps 6.11
and 6.12). Just three brooches are located in the southern fenland zone
(historic Holland), two of which come from an area which has also yielded
small amounts of Middle Anglo-Saxon metalwork and pottery (Leahy
2003a, 143, fig. 12.3). Two additional 'gaps', evident in both the Scandina-
vian and non-Scandinavian distribution, are seen immediately south of
Lincoln and in southern Lincolnshire to the west of King Street (Leahy and

Paterson 2001, figs. 10.3 and 10.4). While the former may reflect a modern military presence in the area and a subsequent lack of detecting, the latter is more difficult to explain. Finds from other periods are known from the region and the distribution of Domesday settlements indicates extensive settlement there (Symonds 2003, fig. 7).

On the Wolds and Lincoln Cliff, the jewellery distribution clearly reflects the axes of prominent overland communication routes, a pattern similarly observed by Katharina Ulmschneider for Middle Anglo-Saxon artefacts and coins (2000b, 59). In southern Lincolnshire (historic Kesteven), Scandinavian brooches are found east of the axis of King Street; a Roman road which runs

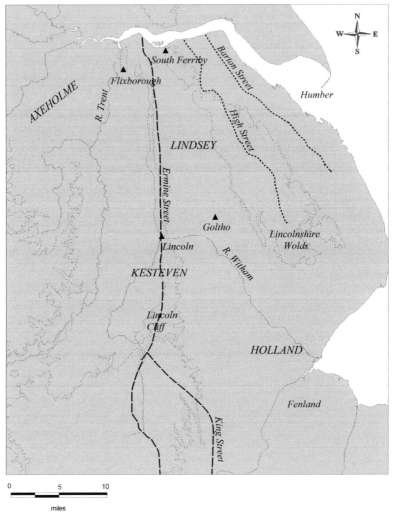

Map 6.11 Lincolnshire with place-names and routeways mentioned in text

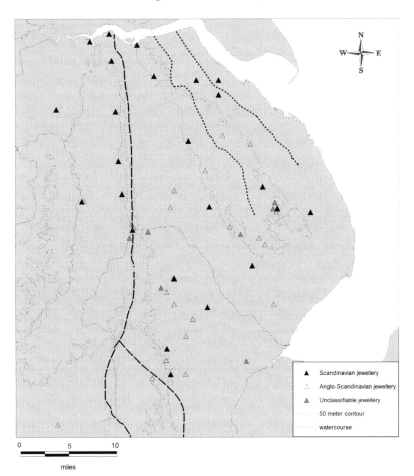

Map 6.12 Scandinavian-style jewellery in Lincolnshire

parallel to Ermine Street. In the north, strings of brooches outline the prehis-
toric trackways of High Street and Barton Street, occurring, for instance, at
South Ferriby, Brocklesby, and Ketsby. The one anomaly in this pattern is the
lack of items along Ermine Street south of Lincoln. Middle Anglo-Saxon finds
are also absent along this axis, however, and parts of this low-lying route may
have experienced occasional flooding, limiting contemporary settlement as
well as modern archaeological recovery (Ulmschneider 2000a, 21, maps 3–7).

 Notably, a similar clustering is not apparent along Lincolnshire's navigable
rivers, with the exception of prominent port sites along the Humber, which
guard entry to northern Lincolnshire: South Ferriby, Whitton, Adlingfleet, and,
on the River Trent, Torksey, recorded in the *Anglo-Saxon Chronicle* as the site of
a Viking winter camp in 872–3. This clustering along overland routes rather than
watercourses is a pattern also observed in the distribution of locally produced
pottery, as recently demonstrated by Leigh Symonds (2003, 128, 135, figs. 65–71).
However, as also noted by Symonds, non-local wares, imported into Lincolnshire,

revealed a different transport network dominated by waterways, rather than roads (Symonds 2003, 142, 149, 161; Blair 2007a, 15). The distribution of jewellery is thus correlated with that of local, rather than imported, pottery wares. This synchronization with locally-produced pottery is significant, for it would appear to suggest that Scandinavian-style jewellery was also sourced locally—produced in local workshops, or introduced by local women—rather than imported as trade goods.

North-east England (Maps 6.13–6.15)

Compared to the extensive number of brooches recorded from eastern England, relatively few items are known north of the Humber (see Map 6.15). Fewer than twenty brooches are recorded from this area; all are located south of the River Tees, predominantly in East and North Yorkshire. This low number is surprising given that Yorkshire, and York in particular, has a high number of Scandinavian place-names and sculptures, making it a traditional focus for studies of Scandinavian settlement in England. Certainly, the record of the PAS in Yorkshire is not particularly strong, making it possible that many more Scandinavian brooches have been recovered from the region than are known to the author. Although one of the areas piloted in the PAS scheme in 1997, Yorkshire has struggled in the past to build relations with local detectorists and to maintain a balanced finds database, as reflected in the comparatively low number of items recorded each year by the Yorkshire region (Table 6.1). In the last few years, these problems have largely been addressed, and a scattering of brooches discovered after December 2008, when this study stopped collecting material, suggests that Scandinavian dress items may have been more common here than current records indicate (for instance, PAS 'Find-ID' SWYOR-4243E2). This is what we would expect from the local hoard evidence, which points to frequent use and deposition of characteristically Scandinavian metalwork in the tenth century (Williams 2009). That said, the small number of Scandinavian dress items recovered from excavations at York itself is commensurate with the current low profile of Scandinavian-style jewellery from the surrounding region, and we must be open to the possibility that the Scandinavian settlement here was of a different nature to that in the southern Danelaw.

Multi-period finds recorded by the PAS indicate regions visited by metal detectorists, providing a backdrop against which the current distribution of Scandinavian-style brooches can be assessed (see Maps 6.13 and 6.14). Detector finds cover most low-lying areas, with particular concentrations on the Yorkshire Wolds and in the Vales of York and Pickering, where finds appear to be clustered along the rivers leading to the Humber and the Roman roads to York. This pattern is largely expected. The Yorkshire Wolds supported a high Domesday population, and have been described by Higham as the 'natural material, cultural and demographic focus in Northern England, and therefore, a natural contender for the status of a "core" area' (1987, 43). Nonetheless, the high

density of finds from the Wolds is enhanced by the fact that this area, rich in deserted medieval villages, acts as a magnet for both metal detectorists and archaeologists. The north and south edges in particular are rich in 'productive sites'; indeed, detectorists travel from outside the area to detect on the Wolds (Naylor 2007, 53, fig. 8).

By contrast, the Holderness Plain has yielded few multiperiod finds (see Map 6.14). This area, together with the southern Vale of York (from the River Aire to York) and the Hull Valley, was subject to periodic flooding during the early

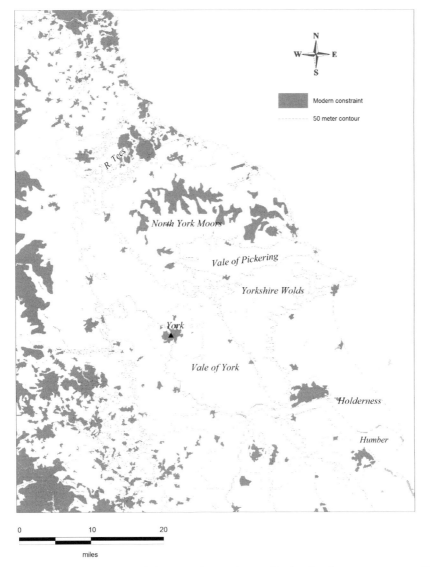

Map 6.13 Constraints on metal detecting in north-east England: urban centres, woodland, and land above 300m

Locating Scandinavian influence

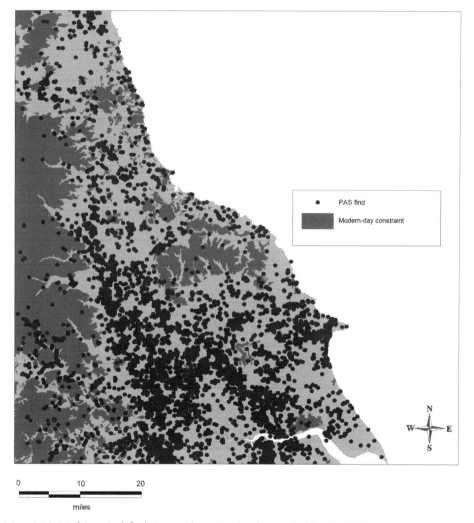

Map 6.14 Multi-period finds in northern England recorded by the PAS

medieval period (Van de Noort and Davies 1993; Van de Noort 2000, 123–7, fig. 10.2). In addition, much archaeology on southern Holderness may have been destroyed by erosion following a shift in the course of the Humber estuary during the medieval period (Van de Noort 2000, 123). The other area which has yielded few multi-period PAS finds is the North York Moors (Maps 6.13 and 6.14). Contemporary settlement is likely to have been restricted on these high lands and poor-quality soils (Higham 1987). This area is not frequented by detectorists, the distribution of Middle and Late Anglo-Saxon material recorded

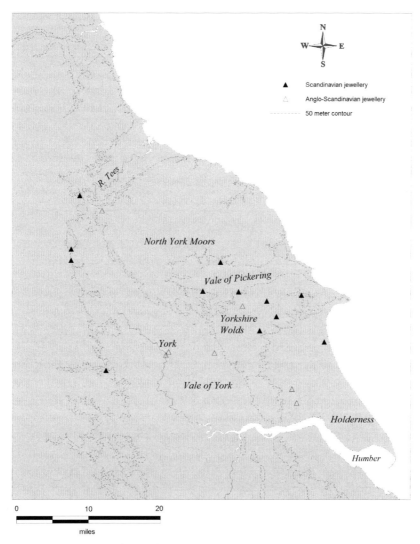

Map 6.15 Scandinavian-style jewellery in north-east England

by the PAS revealing only a small number of items around the Moors' edges (Map 6.14).

The distribution of Scandinavian-style jewellery reflects the concentration of both contemporary settlement and modern-day artefact recovery on the York-shire Wolds (Map 6.15). There is a notable clustering of brooches on the Wolds, at sites such as Cottam, Wharram-le-Street, Wetwang, Burton Fleming, and Wea-verthorpe, a scattering of finds in the Vale of Pickering and around the edges of the North York Moors, including at Hambleton, and a complete absence of items from the Holderness Plain. The most northerly find comes from Dalton-on-Tees, on

the south bank of the Tees, which marks the northern boundary of the Danelaw. Although metal-detecting north of the Tees is restricted by the refusal of large estate owners to grant detectorists permission to detect on their land (Rob Collins, PAS, pers. comm.), sufficient quantities of multi-period, including early medieval, small finds have been recovered from this region to suggest that the absence of Scandinavian brooches is genuine (see Map 6.14). Given this background, the low number of dress accessories from Yorkshire may indicate that Scandinavian settlement here was of a fundamentally different nature to settlement elsewhere in the Danelaw, possibly being military-based, involving fewer families, and thus women.

One inconsistency in the distribution of Scandinavian-style jewellery is the small number of items from the Vale of York, where early medieval finds are dense and where a silver hoard of Scandinavian character has recently been recovered (Ager and Williams 2010). Excluding the penannular brooch fragment from this hoard, just four Scandinavian brooches (including an oval brooch pair from Bedale) are recorded in the Vale of York, in addition to two Anglo-Scandinavian Jellinge-style brooches from York itself. It is in many ways remarkable that York, often described as the capital of a Viking kingdom, has yielded so few relevant brooches, especially given the considerable quantity of other styles of dress accessory recorded during extensive archaeological excavations (Roesdahl et al. 1981, YD6–11, YD15–17). Just two non-dress items from the city—a Jellinge-style scabbard chape and a lead matrix for the manufacture of bird-shaped pendants—can be considered 'purely' Scandinavian (Roesdahl et al. 1981, YG41, YMW13).

Instead, dress styles at York appear to have been fairly typically English, as demonstrated by the range of disc brooches, strap-ends, rings, and hooked tags of Anglo-Saxon form and ornamental style (Tweddle 2004, 450–2). When Scandinavian styles do appear on metalwork such as strap-ends and brooches, they appear in an altered form, preserving, as Dominic Tweddle suggests, only 'echoes and resonances' of their original Scandinavian appearance (2004, 453). As such, these items contrast sharply with the explicitly Scandinavian character of many rural finds from the region. This characterization can be extended outside the realm of metalwork to include other media, such as bone, leather, and wood, notwithstanding the appearance of the traditional, Scandinavian Jellinge style on a bone motif-piece from Coppergate (Tweddle 2004, fig. 106, 6982, figs. 107–9, 113). The influential 'York metropolitan school' of sculpture made frequent use of the Scandinavian Jellinge style, but in an altered form (Lang 1978; 1991, 33–5, 39–40). The prevalence of Anglo-Scandinavian styles in the town contrasts with the strong Scandinavian signature of the few finds from rural Yorkshire, and would seem to suggest a more diverse, cosmopolitan population. Although a historically-attested political and administrative centre of various Viking kings, 'Viking York' does not look very Scandinavian at all, at least in terms of dress.

Changes in the distribution of Scandinavian jewellery over time

The Scandinavian-style jewellery described in Chapter 3 occupies a broad date range, stretching from the late ninth to the late eleventh century. By comparing the distribution of brooches in the ninth- and tenth-century Borre and Jellinge styles with those in the later tenth- and eleventh-century Mammen, Ringerike, and Urnes styles it should, in principle, be possible to track changes in the location and extent of Scandinavian influence over time. In practice, however, this task is hampered by the fact that the tally of brooches of later tenth- and eleventh-century date is small, preventing useful comparison with earlier material. The distribution of the fourteen known items suggests that, with the exception of an Anglo-Scandinavian Urnes-style brooch from Pitney, Somerset, eleventh-century Scandinavian brooches were restricted to eastern and northern England (see Map 6.16). The Norfolk bias, so evident in earlier material, is no longer clear, with material more or less evenly distributed across Norfolk, Cambridgeshire, Suffolk, and Lincolnshire.

The restricted distribution of Ringerike- and Urnes-style brooches within the former Danelaw region is based on a small dataset, and may change as new discoveries come to light. Yet it is notable that the current pattern contrasts with the widespread distribution of Anglo-Scandinavian equestrian equipment in the same styles, as demonstrated both in the work of David Williams and in the PAS dataset (Williams 1998, fig.10; Richards et al. 2009, 3.4.2, and interactive map). Other artefact types in the 'English Urnes' style, such as buckles and strap-ends, also reveal a broad, non-Danelaw distribution (Owen 2001, fig. 11.2). In contrast to brooches, such items appear to have enjoyed widespread popularity in England, including in the south, most likely having been popularized under the influence of the Scandinavian court of Cnut and his dynasty in London and Winchester (Chapter 5). On the basis of this, admittedly limited, evidence, we may conjecture that female dress items in later art styles were being consumed in a different way, and perhaps communicated a different message, to more 'male' items such as horse fittings. While equestrian items seem likely to have signalled affiliation with an elite Scandinavian cavalry group, perhaps female articles preserved more traditional forms of Scandinavian identity, based on kin networks and ethnic heritage, within the original area of Scandinavian settlement.

Jewellery and Scandinavian place-names

In revealing a concentration of finds in East Anglia, the distribution of Scandinavian-style jewellery appears to be at variance with that of other, more conventional, indicators of Scandinavian influence. In the following section, this pattern is interrogated by comparing the find-spots of jewellery with that of Scandinavian place-names (Map 6.1). There is, of course, significant uncertainty

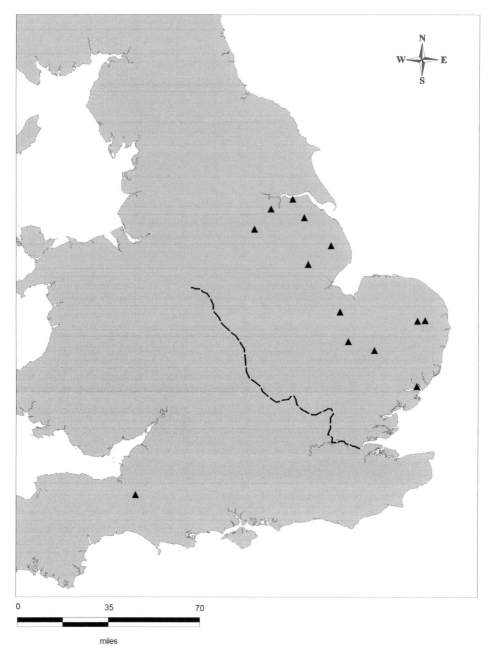

Map 6.16 Late Viking-Age jewellery in England

surrounding how, when, and by whom Scandinavian place-names were origin-
ally coined. The methodological complexities in assessing place-name evidence,
particularly 'major' place-names (used to describe anything the size of a parish
or above), as an index to Scandinavian settlement are well known and need not

be elaborated upon here (Parsons 2006; Abrams and Parsons 2004, 392–4). The extensive number of Scandinavian settlement, topographic and personal names may nonetheless help locate areas of Scandinavian linguistic influence, in some cases pointing to the presence of Norse-speaking communities (Abrams and Parsons 2004). A comparison of the brooch and place-name distributions may therefore reveal areas of heightened Scandinavian influence within the Danelaw, while deepening our understanding of the factors which shape the two datasets.

Scandinavian influence over major place-names is denoted by the elements -*bȳ*, 'farmstead/settlement', and *thorp*-, 'outlying settlement', as well as by so-called Grimston-hybrids, which compound the English '*tūn*', 'settlement' or 'farm', with a Norse personal name, such as *Grimr*. Is there a positive correlation between the distribution of Scandinavian place-names and jewellery in Scandinavian styles? While both Scandinavian brooches and major place-names lie within the same, broad area of eastern and northern England, the foci of the two distributions are notably different. In contrast to Scandinavian brooches, found predominantly in Norfolk and northern Suffolk and, to a lesser extent, in Lincolnshire, Scandinavian place-names are most common in Yorkshire and in the East Midlands, the latter forming the territory of the Five Boroughs. Isolating place-names with the element -*bȳ*, North Yorkshire, particularly the northern Vale of York, is especially prominent on the place-name map (Cameron 1965; Abrams and Parsons 2004, fig. 2). This region has, however, yielded very few items of jewellery, although the few items which are known have a strong Scandinavian character and are likely to have been imported from the Scandinavian homelands. Scandinavian brooches are rare in the East Midlands, where Scandinavian influence over place-names is most clear. Just two, Anglo-Scandinavian brooches are known from Leicestershire, for instance, with fifty-six Scandinavian *bȳ*-names (Abrams and Parsons 2004, fig. 2). This inconsistency is pronounced and unexpected, and raises important questions about why so few Scandinavian-style dress items are documented from this region.

Conversely, comparatively few major Scandinavian place-names are recorded in East Anglia, where Scandinavian-style jewellery dominates. Beyond the cluster of thirteen *bȳ*-names found on the 'isle' of Flegg in south-east Norfolk (see below p. 211). just nine other *bȳ*-names are recorded in Norfolk. Three *bȳ*-names are documented in Suffolk, while just one is known from Essex (Abrams and Parsons 2004, 415, fig. 3). *Thorp*- names are similarly rare in East Anglia. They occur in combination with a Norse personal name just thirteen times in Norfolk, and are virtually absent in Suffolk and Essex (Abrams and Parsons 2004; Reaney 1935, 569). As a region, East Anglia is better served by so-called Grimston-hybrids, place-names traditionally associated with primary Viking land-taking (Insley 1999). Overall, however, major Scandinavian place-names in East Anglia are few and dispersed, encouraging the view that Scandinavian settlement there was numerically insignificant (Davis 1955, 30).

However, the presence in Norfolk of Scandinavian minor place-names points to greater Scandinavian linguistic influence in the region than the small number of major place-names would suggest (Abrams and Parsons 2004, 415–17, fig. 3; Parsons 2006). Work by Karl Inge Sandred has shown that in areas of Norfolk with surviving medieval records, Scandinavian elements were often preserved in minor and field-names (1979). In the fenlands and the west Norfolk parish of Flitcham cum Appleton, for instance, words such as *bekkr* (stream), *mikill* (large), *sík* (ditch), and *stígr* (path) were incorporated into field-names, suggesting strong Scandinavian influence over vocabulary used to describe the local landscape. Importantly for the East Anglian evidence, Scandinavian influence was preserved in minor names even in areas where Scandinavian influence over major place-names was lacking. In this context, it should be remembered that there may be any one of a number of reasons why Scandinavian place-names, particularly major place-names, are not preserved in the historical or modern record, such as regional peculiarities in landholding patterns or the abandonment of Scandinavian language at an early date. Consequently, as Abrams and Parsons note, an 'absence of evidence on the place-name map is certainly not evidence of absence' and need not imply that an area was devoid of Scandinavian activity or culture (2004, 411).

It is notable that several Norfolk field-names preserve Scandinavian female names, such as the eastern Scandinavian name 'Ulfhild', recorded in the field-names *Wlfildiswong, Wolfytteswong*, and *Ulffdeswong* in the parish of Flitcham (Sandred 1979, 102). Indeed, Scandinavian personal names are widely attested in East Anglia. Domesday records show that 45 per cent of the landholders of Norfolk possessed a Scandinavian name in 1066; in Suffolk, the figure was 33 per cent (Parsons 2002, fig. 4). To some extent, the popularity of such names is likely to reflect naming fashions introduced in the early eleventh century during the reign of Cnut. But in assessing the influence of a small elite on naming practices, it is important to note that the Norse name pool is fundamentally different to the repertoire of Norman names introduced after the Conquest, in that it is much more variegated and dynamic (Abrams 2005, 312). Importantly, it includes names that are rare within Scandinavia and that are first coined in a Norse-speaking context in England (Townend 2002, 47; Parsons 2002). This would appear to indicate the presence of sizeable Norse-speaking communities, rather than simply the influence of a trend-setting elite (Parsons 2002).

At a regional level it is sometimes possible to point to areas which have yielded both Scandinavian place-names and metalwork as locations of clear Scandinavian character. North of the Humber, Scandinavian place-names are dense on the southern Yorkshire Wolds, where brooches are also concentrated, including at sites with Scandinavian place-name elements, such as Weaverthorpe (Fellows Jensen 1972). Within Lincolnshire, Scandinavian place-names are clustered on the southern Wolds, along the prehistoric track-

ways extending from the Humber to the Wolds and in historic Kesteven in the south of the county (Leahy and Paterson 2001, fig. 10.1). This distribution correlates with that of Scandinavian metalwork, with the exception of the south-east Wolds. Here, Scandinavian place-names are frequent but Scandinavian brooches few (Leahy and Paterson 2001, 189). Contemporary Anglo-Saxon metalwork is similarly rare from this region, however, suggesting a bias in the recovery of archaeological material in general (Leahy and Paterson 2001).

Within Norfolk, several late ninth- and early tenth-century brooches are known from the southern fringes of Flegg, an area which, due to its concentration of *by*-names, has been suggested as an early, ninth-century Viking settlement (Campbell 2001; Abrams 2005). These brooches include both Anglo-Scandinavian products and items likely to have been directly sourced from Scandinavia, including a fragment of a probable oval brooch, found, along with other contemporary material, at Mautby (cat. no. 441). Another concentration of Scandinavian and Scandinavian-influenced names in Norfolk occurs to the south-east of Norwich, itself home to a considerable number of minor Scandinavian place-names, such as *staithe*, 'landing stage', found along river Wensum in the town (Sandred 2001, 52–3; Abrams and Parsons 2004, fig. 3). This area has also produced a significant number of brooches, including tens of Anglo-Scandinavian products likely to have been manufactured and worn locally. In light of both place-name and small-finds evidence, it is difficult to deny the strongly Scandinavian character of south-east Norfolk.

Within northern and eastern England there are also areas in which both Scandinavian place-names and metalwork are unexpectedly absent. Like Scandinavian brooches, Scandinavian place-names are rare in southern Suffolk and Essex, adding weight to the suggestion made above that Scandinavian influence in the region was confined to northern East Anglia (Martin 2007, 132–4, with map). The scattering of Grimston-hybrids around Ipswich is nonetheless notable, since Scandinavian metalwork is rare in this southern Suffolk region (Abrams and Parsons 2004, fig. 3). Another area in which both metalwork and place-names are largely absent is Cambridgeshire. In the previous section, doubts were raised over the reliability of the finds record from Cambridgeshire, given the low level of finds recording within the county. The failure of Domesday Book to record a single *by*-name in Cambridgeshire would appear to suggest that Scandinavian activity and influence in this region was genuinely small-scale (Abrams and Parsons 2004, fig. 2). Perhaps incoming migrants avoided Cambridgeshire because it was perceived as a border region, as originally proposed by Abrams and Parsons (2004, 405).

Very few items of Scandinavian ornamental metalwork are recorded in and around the Five Boroughs: Derby, Nottingham, Leicester, Stamford, and Lincoln. With the exception of Derby, the Danelaw *burhs* reveal a similar paucity of Scandinavian place-names, possibly indicating a continuity of West Saxon administration or occupation (Abrams and Parsons 2004, 411–12). The lack of Scandinavian

material from these centres is likely to reflect lower rates of metalwork loss in towns compared to the countryside; in areas with high-density populations, possibly with paved streets, a lost brooch is more likely to be heard as it hits the ground, and spotted and picked up, than if it is lost in a field, for instance. That said, modern excavations at Lincoln, Norwich, Thetford, and York have produced multiple Anglo-Saxon brooches, as well as a few Anglo-Scandinavian items (see for instance Roesdahl et al. 1981, YD12, 13, 38, 40, YMW14). They have, however, revealed only a handful of Scandinavian objects: a composite Jellinge-style disc brooch from St Mark's Station, Lincoln, and a silver Borre-style trefoil brooch from Thetford provide two, rare examples (cat. nos. 452 and 409). In terms of ornamental metalwork, Scandinavian cultural influence does not appear to have been strongly felt in the towns of the Danelaw. This may in part reflect their ethnically mixed populations and cosmopolitan nature.

To summarize, the combined evidence of place-names and ornamental metalwork introduces new perspectives on the form and location of Scandinavian cultural practice in England, pointing to areas of both weak and strong Scandinavian influence. The most striking anomalies arise in Yorkshire and the East Midlands where *by*-names point to sizeable Norse-speaking communities, yet Scandinavian dress items are uncommon. This discrepancy is not easily explained, and may partially reflect the methodological pitfalls in using place-name evidence, and indeed portable metalwork, as a geographical guide to Scandinavian activity and influence. It may also be the case that Scandinavian settlement in these areas was of a fundamentally different character to that in East Anglia and Lincolnshire, being composed mainly of settled war-bands and lacking a sizeable familial element, and thus resulting in fewer explicitly female dress accessories. Another possibility is that individuals living in an area with a Scandinavian name felt less need to express Scandinavian cultural affiliation through their personal dress and appearance. Whatever the case, such a contrasting pattern serves as a reminder of the multiple forms and strategies in which Scandinavian identity or culture could be expressed.

Conclusion

The geographical distribution of Viking-Age Scandinavian-style jewellery provides important new perspectives on the location of Scandinavian influence and activity in England. As items likely to have been imported, rather than produced locally, Scandinavian brooches point to areas of potential Scandinavian settlement in England. Their diffuse distribution throughout northern and eastern England suggests a widespread, rural Scandinavian settlement pattern, in line with that observed in the Scandinavian homelands. The distribution of Anglo-Scandinavian brooches highlights locations of Scandinavian cultural influence, rather than settlement per se, although the two phenomena are likely to be closely linked. Even in the context of regional variation in historic levels

of finds recording, these artefacts point to northern East Anglia as an area especially receptive to new Scandinavian dress styles.

It is of course important to remember that the current distribution is influenced by modern-day restraints on detector activity, as well as by contemporary patterns of metal use. Consequently, an absence of Scandinavian-style metalwork does not necessarily equate with a lack of Scandinavian activity, although this may be the case where other indicators are also lacking, as in the far northeast. It was suggested that, due to its chequered history of finds recording, Yorkshire in particular may yield further items of metalwork in future, although it is also possible that fewer female settlers from Scandinavia lived in this region than elsewhere in the Danelaw. The cosmopolitan populations of Danelaw towns may also account for why few overtly Scandinavian dress items are found there, in contrast to rural areas. Differences in contemporary settlement patterns may also adversely affect the picture of metal use in the Midlands. The potential reasons for apparent absences of metalwork should of course be explored, but it is also possible that Scandinavian jewellery was simply less common in these areas compared with the east due to fundamental differences in the nature and extent of localized Scandinavian settlement.

We are on firmer ground where concentrations of dress items can be positively identified. The jewellery distribution shows that Scandinavian dress styles gained a ready foothold in Lincolnshire and parts of East Anglia. As such, it brings into focus a region not traditionally associated with Scandinavian settlement, and changes the traditional map of Scandinavian influence in England. A key finding from this chapter, then, is that East Anglia and Lincolnshire were vibrant centres of Scandinavian culture in England in the ninth and tenth centuries. Although this finding goes against the commonly held view that Scandinavian settlement in East Anglia was less intense than elsewhere in the Danelaw, a longer-term perspective reveals that the relationship between Scandinavia and East Anglia was, in fact, deep-rooted.

By the ninth century, as John Hines's work has shown, East Anglia had a long tradition of settlement from Scandinavia. Highlighting parallels in female brooches, wrist-clasps, and bracteates found in England and Scandinavia, Hines has revealed 'extensive and significant' connections between Anglian England (eastern England north of the Thames) and southern and western Scandinavia from the late fifth to the sixth centuries, connections which Hines views as arising partly through migration from Norway (in the case of wrist-clasps) and partly as a result of travelling craftsmen (in the case of square-headed brooches) (1984, 109, 198, 286). Archaeological evidence similarly indicates that contact between East Anglia and Scandinavia was sustained throughout the seventh and eighth centuries, as attested, most famously, in the Scandinavian character of the seventh-century Sutton Hoo ship burial (Hines 1984, 286–301). After this period, the evidence for connections between England and Scandinavia fades, but at least one recent metal-detector find: an

oval-shaped brooch from Norfolk, almost certainly imported from Scandinavia, provides evidence for direct links between eastern England and southern Scandinavia in the later eighth and first half of the ninth century (Rogerson and Ashley 2008, 428–9, with fig.). Viewed in this light, East Anglia may be seen as an area long open to Scandinavian influence, a characterization which enables us to better make sense of the large number of Scandinavian-style dress items now recorded from the area. This region, with a history of settlement from Scandinavia, may have been more receptive than other regions of England to renewed immigration from across the North Sea.

7

Synthesis and conclusion: constructing cultural identities

Introduction

Thus far, this book has discussed evidence for Scandinavian and Anglo-Scandinavian brooches and pendants from England. It has drawn attention to their distribution and chronology as well as their varied stylistic treatment and cultural background. This final chapter draws together some of these themes to generate a synthesis of the material, aimed at revealing how jewellery was used to negotiate social identity and difference in the late ninth- and tenth-century Danelaw. It also provides some explanations as to why such jewellery items are found in relatively high numbers in England and what the items may have signified to those that wore them or viewed them on others.

In examining how brooches and pendants were used to construct cultural identities, this chapter adopts three distinct, yet complementary approaches. It begins with a comparison of the relative frequencies of brooch types in England and Scandinavia. The aim is to reveal patterns of brooch use in the two regions and to outline the extent to which indigenous, Scandinavian brooch traditions were preserved or modified within the Danelaw. Following on from this theme, the chapter moves to consider evidence for cross-cultural exchange through an examination of changes in brooch style. Processes of Anglicization and Scandinavianization are highlighted, revealing different stages in the integration of Scandinavian brooches with existing, Anglo-Saxon fashions. Placing the evidence for Scandinavian-style jewellery within the broader context of late ninth- and tenth-century ornamental metalwork in England, the final section compares the ratio of contemporary non-Scandinavian (Anglo-Saxon and Continental) and Scandinavian brooches in the counties of Norfolk, Suffolk, and Lincolnshire. This approach enables meaningful statements to be made about the relative popularity of different cultural dress styles and facilitates assessments of the 'Scandinavian-ness' of brooch fashions in different Danelaw regions.

The chapter concludes with an assessment of the overall significance of Scandinavian and Anglo-Scandinavian female dress items from England. It summarizes

the main findings of the book and draws on these in exploring the reasons why women's Scandinavian-style jewellery has been found in high numbers across some parts of the Danelaw. I propose that the most likely explanation for the circulation of characteristically Scandinavian dress items in England is the presence of significant numbers of Scandinavian women, dressed in a traditional Scandinavian manner. This, in turn, suggests that the Scandinavian settlement of England was far from an all male affair, as is normally assumed, and points instead to the presence of settled Danish families. I suggest that Anglo-Scandinavian brooches are best understood as a response on behalf of indigenous women and probably also women of Scandinavian descent to the influx of new Scandinavian dress styles. Ultimately, they signal the popularity of Scandinavian fashions in areas of the Danelaw and reveal a desire among the local inhabitants to appropriate a Scandinavian appearance.

Relative frequencies of brooch use in England and Scandinavia

It is clear from the preceding chapters that Scandinavian-style jewellery found in England is markedly varied, encompassing almost the full range of main brooch types (lozenge, trefoil, domed disc, *et cetera*) current in the Scandinavian homelands. This section assesses in more detail the range of Scandinavian brooch styles represented by the insular corpus by making comparisons between brooch subtypes circulating in England and Scandinavia. It considers which Scandinavian brooch types are not represented in the English archaeological record, and why. Patterns of brooch use across Scandinavia and England, revealed in the rate of occurrence of different brooch subtypes, are also considered, with particular reference to Anglo-Scandinavian brooches. This approach highlights how Scandinavian brooch use in England preserved brooch traditions from the Scandinavian homelands, while also departing from established Scandinavian practices.

Brooch repertoire

Figures 7.1–7.5 illustrate the range and frequency of Scandinavian brooch subtypes recorded from England and Scandinavia. Since brooches from England find particularly close parallels in material from southern Scandinavia, the area of Viking-Age Denmark (modern-day Denmark, northern Germany, and Skåne) has been isolated as a distinct region. Scandinavian data for trefoil and Terslev-style brooches were derived from recently-published catalogues (Maixner 2005; Kleingärtner 2007), while information for the remaining brooch types was adapted from the author's own finds lists, collated from Scandinavian museum records and published literature (see Appendix A). Since oval and equal-armed brooches are recorded from England in only a few instances, they

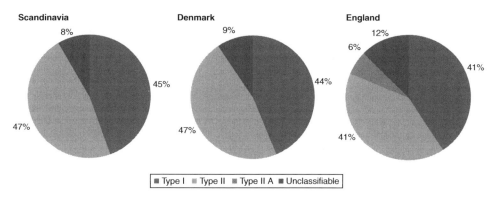

Fig. 7.1 Relative frequency of lozenge brooch variants in Scandinavia, Denmark, and England.

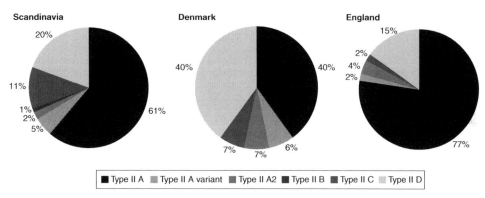

Fig. 7.2 Relative frequency of Borre-style disc brooch variants (Type II) in Scandinavia, Denmark, and England.

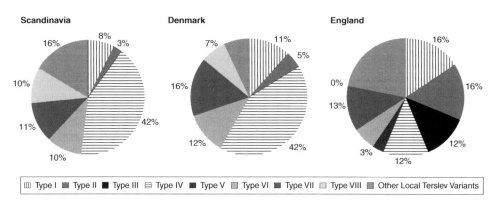

Fig. 7.3 Relative frequency of Terslev-style brooch variants in Scandinavia, Denmark, and England.

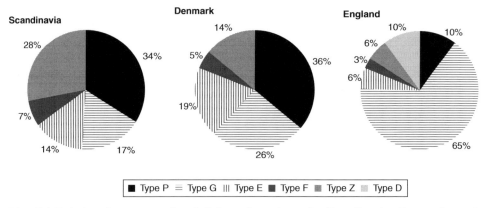

Fig. 7.4 Relative frequency of trefoil brooch variants in Scandinavia, Denmark, and England.

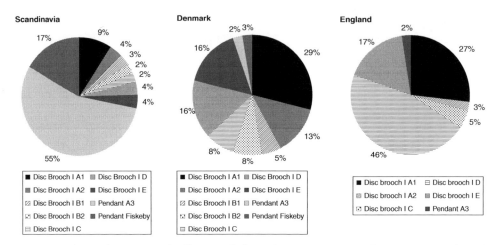

Fig. 7.5 Relative frequency of Jellinge-style brooch variants in Scandinavia, Denmark and England.

have not been included here; their low visibility in the English archaeological record is discussed separately below.

Overall, the charts (Figs. 7.1–7.5) give a clear impression of the rich typological variety of the Scandinavian and Anglo-Scandinavian brooches recorded from England. The repertoire of Scandinavian brooch types represented in England includes not just the main brooch variants, but extends to cover a range of various subtypes. Thus, both categories of lozenge brooch recorded from Scandinavia appear in England, as do all the main trefoil brooch varieties and five of six Borre-style disc brooch variants. The English corpus of Jellinge-style artefacts encompasses six of nine brooch and pendant types identified in the Scandinavian homelands. The repertoire of Terslev-style brooches in England is

similarly diverse, including all the major motif groups. For brooch types with very detailed classifications, it is possible to trace the relationship between the insular and Scandinavian evidence further still. For instance, plant-ornamented trefoils from England include the subtypes P 2.4, P 4.2, P 5.1, and P 7.12, encompassing a significant number of the variants documented in Scandinavia (Maixner 2005).

Notably, it appears that diversity in brooch repertoire is a character of Anglo-Scandinavian as well as Scandinavian brooches. With the exception of oval and equal-armed brooches, all Scandinavian brooch types found in England have Anglo-Scandinavian counterparts (Figs. 7.6–7.10). The two main categories of lozenge brooch, Types I and II, both have Anglo-Scandinavian representatives, as do the two most common Borre-style zoomorphic disc brooches: Types II A and II D (see Figs. 7.6 and 7.7). Of six variant types of Scandinavian Terslev disc brooch recorded in England, five have Anglo-Scandinavian counterparts. Indeed, the variants Type III and V, are recorded in England only in Anglo-Scandinavian formats, yet must have originally derived from Scandinavian prototypes (see Fig. 7.8).

It appears that the market for Anglo-Scandinavian metalwork was diverse and vibrant, since the range of Scandinavian brooch types which served as inspiration was broad. In this context, Anglo-Scandinavian products may be seen as local, widespread, and pragmatic reactions to available Scandinavian models or prototypes. Such a finding runs counter to Thomas's suggestions that brooches in forms familiar to native Anglo-Saxons, namely flat disc

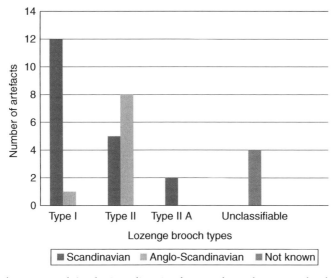

Fig. 7.6 Scandinavian and Anglo-Scandinavian lozenge brooches in England.

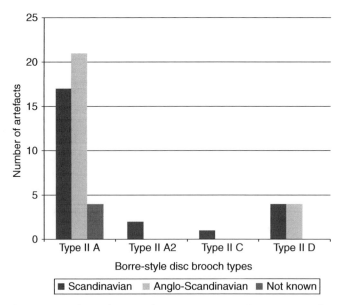

Fig. 7.7 Scandinavian and Anglo-Scandinavian Borre-style (Type II) disc brooches in England.

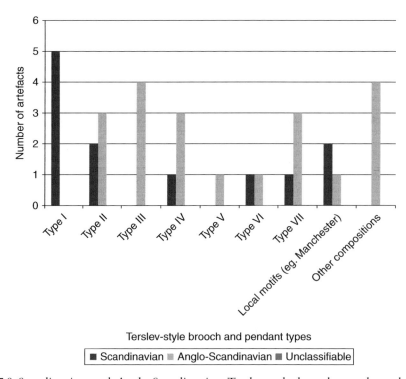

Fig. 7.8 Scandinavian and Anglo-Scandinavian Terslev-style brooches and pendants in England.

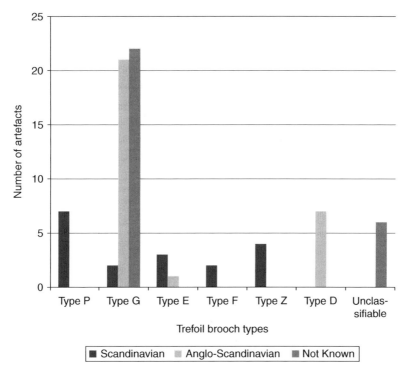

Fig. 7.9 Scandinavian and Anglo-Scandinavian trefoil brooches in England.

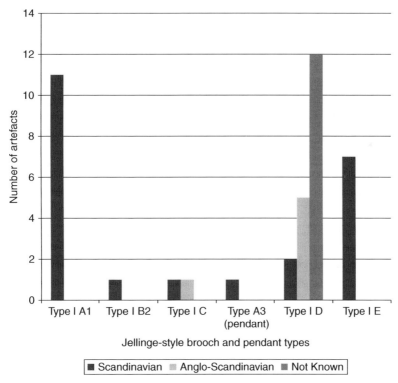

Fig. 7.10 Scandinavian and Anglo-Scandinavian Jellinge-style brooches and pendants in England.

brooches, were specially selected over other brooch types for the display of Anglo-Scandinavian styles (Thomas 2000b, 252).

Returning to the characteristically Scandinavian brooches, it is striking that the insular repertoire encompasses a significant number of rare Scandinavian brooch types. The Jellinge brooch Types I B2 and I C are found in England, despite the small tally of such items within Scandinavia (cat. nos. 461–3). Borre-style disc brooches found infrequently in Scandinavia nonetheless occur in England. Two Scandinavian Type II A2 brooches are recorded from England, the same number currently known within Scandinavia (cat. nos. 75–6). A Scandinavian trefoil brooch from Bures Hamlet, Essex, with decoration comprising prominent Borre-style gripping feet, belongs to a trefoil series with just five other representatives, all from eastern Sweden (cat. no. 410) (Maixner 2005, map 22, Type F 3.1).

Scandinavian brooches from England also include hitherto unrecorded variants of Scandinavian brooch types. For instance, two lozenge brooches with stylized animal heads are recorded from England (Type II A). They have no known Scandinavian counterparts, yet their brooch form and pin-fittings indicate a Scandinavian origin (cat. nos. 27–8). 'New' Scandinavian trefoil brooch types are also represented among finds from England. A brooch fragment from Thurlton, Norfolk, carries a unique ornamental decorative scheme based on a foliate motif, introducing a further variant to Maixner's Type P repertoire (cat. no. 360) (Maixner 2005).

In other examples of the same phenomenon, Scandinavian brooches from England carry unique designs generated by the amalgamation of two or more existing Scandinavian styles. A silver disc brooch from Whitton, Lincolnshire, of typical Scandinavian construction, is one such compound (cat. no. 323) (see Colour Plate 4). It has no exact Scandinavian parallels, but its design meaningfully combines elements from multiple Terslev designs to generate a new motif. A similar process can be identified on a domed silver disc from Manchester (cat. no. 322) (see Fig. 3.24). This piece combines several familiar Terslev components, including four circular fields and overlying 'arms', to produce an unparalleled composition of clear Scandinavian character. In merging existing styles in a meaningful way, these Scandinavian items add to the current register of Scandinavian brooch designs.

Within the main brooch categories discussed here, only a few variant styles are not represented in material from England. That some brooch types were not transferred to the Danelaw is likely to reflect their restricted distribution within Scandinavia, although, as we have just seen, this was not necessarily a barrier to the adoption of Scandinavian brooch types in England. The only Scandinavian Borre-style disc brooch variant not represented in England is the Type II B, but this is known from Scandinavia in just one instance, from Birka, Sweden (Jansson 1984b, 62, fig. 8: 2 II B). Among Terslev-style brooches from England, the Type VIII motif (Kleingärtner's Type Dreipass) is poorly represented, appearing on just one brooch, from Whitton, Lincolnshire (cat. no. 322).

However, outside England, this motif occurs only on brooches from Sweden or Russia; in this context, it is remarkable that the composition is encountered on brooches in England at all (Kleingärtner 2007, 64–5, map 11).

Brooch preferences

The range of Scandinavian brooches present in England encapsulates almost the full range of items in use in contemporary Scandinavia. But how similar are patterns in brooch use in England and Scandinavia? In other words, with what frequency are the same brooch types found in the two regions?

In the Danelaw, it might be expected that brooch fashions differed markedly from those followed in Scandinavia, with Scandinavian brooch styles drawing new inspiration from local sources. In fact, patterns of use vary according to brooch type. For some brooches, the variants most commonly found in Scandinavia are also the types most commonly found in England, indicating a straightforward transferral of brooch fashions from the Scandinavian homelands to the Danelaw. In both Scandinavia and England, the Borre-style disc brooch Type II A is the most popular variant of the brooch series, followed by Type II D, with the remaining variants composing minor types only (although, in Denmark, II A and II D are recorded with the same frequency) (see Fig. 7.2). Similarly, the two main categories of lozenge brooch, Types I and II, are registered in roughly equal numbers across the two regions (see Fig. 7.1). This pattern is notable, since the English finds include Anglo-Scandinavian products alongside Scandinavian brooches. This indicates that, in these instances, Anglo-Scandinavian fashions accurately reflected brooch preferences from the Scandinavian homelands.

For other brooch categories, patterns of use are not equivalent. In some instances, apparent discrepancies may be explained by chronological or methodological bias. For instance, in England trefoil brooches with plant ornament (Type P) form just 10 per cent of all recorded trefoil brooches, compared with 36 per cent in Denmark and 34 per cent across Scandinavia (see Fig. 7.4). However, their low visibility in England may simply reflect their early date: plant-ornamented trefoils date to the second half of the ninth century and probably circulated in Scandinavia before the onset of Scandinavian settlement in England. In other cases, the low number of recorded brooches may have the effect of exaggerating only slight differences in observed patterns. Several variants of Terslev-ornamented brooch are recorded in just a few cases, for instance, which may explain why the uptake of different Terslev styles appears to vary between England and Scandinavia (see Fig. 7.3).

Other discrepancies are more meaningful, and appear to reveal areas where Anglo-Scandinavian fashions diverged from established Scandinavian traditions. Geometric trefoil brooches (Type G) make up 65 per cent of all trefoil brooches recorded from England yet form just 26 per cent of examples from Denmark

and 17 per cent from Scandinavia more widely (see Fig. 7.4). Brooches with the motif of a Jellinge-style backwards-turned animal (Type I D) also appear to be more popular in England than in Denmark, where the type originated (see Fig. 7.5). Both geometric trefoils and Jellinge-style disc brooches can be demonstrated to have been produced on a serial scale within the Danelaw, each type apparently entering the repertoire of native craftsmen. Why these brooches were selected over other types for serial reproduction is unclear. The popularity of the geometric trefoils may lie in their simple form and ornament, facilitating their reproduction by Anglo-Saxon craftsmen. East Anglia had its own, native backwards-biting beast motif (Smedley and Owles 1965). Perhaps the popularity of the Jellinge beast within England reflected the local inhabitants' familiarity with, and predisposition towards, motifs of this type.

A particularly sharp distinction in artefact use between England and Scandinavia applies to Jellinge-style artefacts, in particular, Jellinge-style pendants. Across Scandinavia, pendants make up a substantial proportion of Jellinge-style jewellery: pendants with paired, asymmetrical Jellinge-style beasts (Type I E) form 17 per cent of the wider Scandinavian corpus, and pendants with a backwards-looking beast (Type I D) 55 per cent. By contrast, just one Jellinge-style pendant is recorded from England (cat. no. 464) (see Fig. 7.5). In a region where necklace wearing was rare, the motif typically adorned brooches instead. Backwards-turned animal brooches constitute 46 per cent of all surveyed Jellinge-style items from England; brooches depicting asymmetrical beasts form 17 per cent.

This pattern might suggest that the Scandinavian fashion for pendants was not preserved in the Danelaw, with motifs instead having different artefact associations in Scandinavian and colonial contexts, as recently agued by Caroline Paterson (2002). However, the pattern of pendant use in Denmark, as distinct from northern or eastern Scandinavia, is much more closely aligned with the pattern observed in England. Backwards-biting beast pendants (Type A3) form just 2 per cent of the Danish corpus of Jellinge-style items, and asymmetrical beast pendants 3 per cent, suggesting that the fashion for pendants within Scandinavia was largely confined to Norway and Sweden. In Denmark as in England, these motifs appear instead on brooches: 16 per cent of the Danish corpus consists of backwards-turned beast brooches (Type I D), and a further 16 per cent of asymmetrical beast brooches (Type I E). Since the fashion for brooches over pendants was shared by Denmark and England, the argument that brooches were substituted for pendants in England cannot be sustained. The appearance of backwards-turned beast brooches in England is, then, likely to reflect the adoption of a distinctly Danish fashion, rather than the substitution of a pan-Scandinavian one.

The 'oval brooch question'

The above comparisons of brooch frequency in England and Scandinavia excluded those brooch types recorded in England in only a few instances,

namely oval and equal-armed brooches. The low tally of these brooch types stands in stark contrast to the numerous oval brooch finds from Scandinavian settlements in Russia, Latvia, Iceland, Ireland, and Scotland (Jansson 1992; 1999; Hayeur-Smith 2004; Shetelig 1940–54) and also with the multitude of smaller Scandinavian brooch forms recovered in England, leading to suggestions that large, diagnostically Scandinavian brooch types were not transferred to England (Thomas 2000b, 252). Indeed, it has been suggested that such items were discarded by early Scandinavian settlers in favour of brooches which could be assimilated into native, Anglo-Saxon costume, such as small disc brooches (Leahy and Paterson 2001, 193; Thomas 2000b, 252; Trafford 2007). Gabor Thomas has commented that 'it is possible that those aspects of costume and dress which represented a "foreign" unfamiliar identity may have been actively abandoned in favour of other aspects of material culture which could be used to express unity and cultural likeness' (Thomas 2000b, 252).

The question of whether oval brooches in particular were worn in the Danelaw is important, since these brooches were worn exclusively with a Scandinavian-type strap dress. They therefore provide evidence not just of Scandinavian jewellery, but of Scandinavian costume. Where they are found—in the Scandinavian homelands as well as in Scandinavian settlements overseas—they are usually taken as secure indicators of Scandinavian appearance and cultural affiliation (Graham-Campbell 2001a, 33). The 'oval brooch question' therefore leads directly to the much larger question of the scale and nature of Scandinavian settlement. For this reason, it has formed the focal point of recent academic debate about women and the Scandinavian settlement in England (Speed and Walton Rogers 2004, 85–6; Trafford 2007).

Ten years ago, it was widely accepted that there was a genuine paucity of oval brooches from England. Just three pairs of oval brooches had been recorded, only two of which could be located within the Danelaw. All three pairs came from graves unscientifically excavated during the nineteenth century, from contexts difficult to interpret on the evidence of contemporary accounts. In particular, all items appear to have been associated with exclusively 'male' grave goods, raising questions about their original function (Speed and Walton Rogers 2004, 85). For instance, the pair of oval brooches from Claughton Hall, Lancashire, found in a mound otherwise containing 'typically male' grave goods, was said to have been positioned back-to-back and used as a container for two beads and a molar tooth (cat. no. 436) (Edwards 1970). On the basis of this evidence, Edwards has suggested that the brooches served not as dress clasps, but as a 'memento' or 'keepsake' of the dead man's wife (Edwards 1998, 14–17; Richards 2002, 158).

More recent evidence has increased considerably the total number of oval brooches recorded from England. Since 2001, five oval brooches have been recovered from burial contexts, including a pair from Adwick-le-Street, near

Doncaster, found *in situ* on either side of the chest of a female skeleton (cat. no. 434) (Speed and Walton Rogers 2004). Three oval brooches, including one pair, were found at Cumwhitton, Cumbria; while the single brooch is not associated with a particular burial, the paired brooches are thought to have derived from one of the two female inhumation revealed through excavation (cat. nos. 433, 435) (Adam Parsons, Oxford Archaeology, pers. comm.).

In addition to these brooches, recent metal detecting has recovered the remains of four further specimens. One oval brooch fragment, from Kiln-wick, East Yorkshire, was reused as decoration for a lead weight, although it may have once been worn as a complete brooch within the Danelaw (cat. no. 440). The remaining oval brooches, also recovered as brooch fragments, are not associated with other archaeological material, making it difficult to assess whether they represent the remains of damaged brooches, perhaps from disturbed inhumations hit by ploughing, or copper-alloy scrap intended for recycling (Speed and Walton Rogers 2004, 75). It is possible that two brooch fragments belonging to the same oval brooch from Wormegay, Norfolk, originated from a burial (cat. no. 438). The field in Wormegay from which both fragments were recovered, also the proposed location of a Middle Anglo-Saxon 'productive site', is known locally as 'Big Men's Bones Field', reflecting a tradition of skeletal remains discovered there (Norfolk HER 17286). The brooch fragments were recovered from the same area as concentrations of bone; the same field has also revealed a scatter of Late Anglo-Saxon pottery (Norfolk HER 16167).

Oval brooches are not the only large, diagnostically Scandinavian brooch type recorded from England. Fourteen large trefoil brooches are recorded from England, all with complex Borre- or Jellinge-style ornament. The tally of equal-armed brooches has also increased in recent years: the current corpus contains five finds, three of which survive in more or less complete forms. Nevertheless, compared with the numbers of other Scandinavian brooch types now known from the eastern counties, oval and equal-armed brooches are relatively rare Danelaw finds. Moreover, it must be remembered that the Claughton Hall, Cumwhitton, and possibly Adwick-le-Street burials are located in areas colonized by the Hiberno-Norse, rather than Danes and, as such, belong to a different Scandinavian cultural sphere within England.

The fact that such brooches are not recovered in particularly high numbers need not indicate that Scandinavian dress styles were abandoned by early Scandinavian settlers. Equal-armed brooches have a predominantly eastern Scandinavian distribution and began to fall out of fashion in Denmark and Norway in the ninth century, at which point trefoil and large disc brooches started to be worn in their place (Aagård 1984, 96, 106–10; Callmer 1999). While oval brooches are the most common Viking-Age brooch type, they are not, as is often stated, ubiquitous in all regions of Scandinavia (Jansson 1985, 12). The

brooch type is much more common in Sweden and Norway than in Denmark: in 1995, just 289 oval brooches were known from Denmark, a fifth of the number recorded from Sweden or Norway (Jansson 1985; Hedeager Krag 1995, 65–9). Regional divergences in oval brooch use are sharply revealed by finds from Hedeby (Schleswig) and Birka (Sweden). The former site has yielded just twenty-nine oval brooches from 1,500 graves; by contrast, two hundred and ninety brooches are recorded from Birka's 1,100 graves (Arents 1992, 86–8; Jansson 1985, 11–12). Given the strongly southern Scandinavian character of the Danelaw corpus of Scandinavian metalwork, it is not surprising that few oval brooches are found on English soil.

The fashion for oval brooches declined in Denmark during the tenth century, as new Western European fashions for brooch-less, *peplos*-style gowns spread eastwards. In Denmark, oval brooches of ninth-century date occur twice as often as brooches dated to the tenth century (Hedeager Madsen 1990). This is reflected among the Hedeby finds, most examples of which are eighth- and early ninth-century types: just three oval brooches from the site date to the tenth century (Arents 1992, 86–8). The low number of oval brooches found in England may, therefore, reflect changing fashions in brooch use in southern Scandinavia. This may in part account for why oval brooches are found with greater frequency in areas colonized by settlers from Norway or Sweden, where female fashions were slower to change.

As large, expensive brooches fulfilling a primary function holding together the straps of a dress, oval brooches were also far more likely to have been recovered by their owners if dropped or lost than smaller, cheaper, and more easily replaced items such as disc or lozenge brooches. In this sense, oval brooches and other large brooch types are less likely to be represented among recent detector-finds, the nature and distribution of which points to their status as settlement, rather than burial, finds. Indeed, in Scandinavia and the Scandinavian overseas settlements, oval brooches are retrieved from burials with greater frequency than other brooch types, a pattern which may highlight a particular role for the brooch type in 'best dress' (Jansson 1999, 48). Oval brooches are unknown among the recent detector finds from the settlement sites at Hedeby and Lake Tissø. A considerable number of fragments are known from Uppåkra, but these are fragmentary pieces, intended for recycling; they reflect the special role of Uppåkra as a centre of metalwork production (Tegnér 1999, 231). At Birka, two hundred and ninety oval brooches derive from inhumations, compared to just twenty-six from the settlement layer, the 'Black Earth', and some of these brooches may have also originated in disturbed burials (Jansson 1985, 11–12). Patterns in original brooch use as well as modern-day recovery may, therefore, also help to account for the low visibility of oval brooches in England.

Brooch style and cultural assimilation

Highly visible dress items such as brooches and pendants have enormous potential to both reflect and help construct aspects of individual and group identity. Since style may be actively manipulated to convey certain messages, changes in brooch appearance over time are likely to be socially meaningful, and may both symbolize and reinforce changing patterns in social relationships and identities. In this section, I consider in detail how brooch forms and styles were adapted and modified from Scandinavian sources within the Danelaw. I aim to demonstrate that different stages in the integration of Scandinavian designs with existing, local fashions can be revealed by tracing developments in artefact style over time. In highlighting how contemporaries adapted dress styles, this approach provides valuable insights into processes of social integration within the Danelaw.

The impact of Scandinavian brooch forms

By way of an introduction to the topic of exploring cultural exchange through Anglo-Scandinavian brooches, it is worth considering the impact of Scandinavian brooch forms and motifs on the material culture and values of the Danelaw. To what extent did Scandinavian brooch types and motifs represent new artistic stimuli and how might Anglo-Saxons have reacted to the influx of new, Scandinavian cultural forms?

Scandinavian brooches recorded in England encompass a plethora of types, all matched in object form and ornamental detail by brooches found in Scandinavia. These include oval brooches, worn exclusively with a Scandinavian-type strap dress, in addition to a suite of equal-armed, trefoil, lozenge, and domed disc shapes. By contrast, the use of brooches in tenth-century Anglo-Saxon female dress was conservative, focusing on the use of just one brooch type: flat disc brooches. Since the pluralism of Scandinavian brooch forms was not replicated in indigenous, Anglo-Saxon fashion, they are likely to have represented a distinctly 'foreign' dress tradition. The same is true of pendants, strung on necklaces. While necklaces were common in some regions of Scandinavia, they did not form part of Anglo-Saxon women's costumes and are likely to have made a strong visual impact when worn in the Danelaw. The impact of Scandinavian brooch forms and shapes on fashions and personal appearance in the Danelaw is likely to have been especially profound since other aspects of Anglo-Saxon and Danish dress were more similar, sharing such components as under-tunics, dresses, and outer garments or shawls (Hedeager Krag 1995, 56; Owen-Crocker 2004, 148–51, 156–9, 212–26).

The ornamental schemes of Scandinavian brooches represented similarly novel stimuli in the context of the Danelaw. They were drawn from a tradition of pre-Christian, Scandinavian artistic traditions, which had evolved over the

preceding centuries with only limited influence from Western Europe: from the Borre style, ring-chain, and knot motifs, together with cat-like animals with symmetrical, gripping bodies, and, from the Jellinge repertoire, profiled beasts with open jaws, ear lappets, and sinuous, interlacing double-contoured bodies (Wilson 1995, 89–90, 115–16). The fantastic beasts and complex geometric schemes familiar to Scandinavian art were far removed from the semi-naturalistic animal and foliate patterns of the contemporary Anglo-Saxon Trewhiddle and Winchester styles, and may have been difficult to reproduce by craftsmen trained in insular traditions. Via their distinct forms and new art styles, Scandinavian brooches were therefore well placed to articulate social differences and mark out a distinct Scandinavian cultural affiliation.

Strategies of cultural integration: Anglo-Scandinavian brooches

Despite local unfamiliarity with Scandinavian brooch forms and designs, brooches in Scandinavian shapes and styles were reproduced in the Danelaw in substantial numbers. The diverse styles encompassed by Anglo-Scandinavian brooches reveal marked differences in their treatment: while some brooches preserve Scandinavian brooch morphologies and ornament, others adopt the Anglo-Saxon flat disc brooch form, and cloak it in a Scandinavian style. Evidence for such differing treatment is notable, for it suggests multiple strategies in the use of ornamental metalwork to shape identities and facilitate cultural integration within the Danelaw.

The appearance of many Anglo-Scandinavian brooches differed little from that of their Scandinavian prototypes. Anglo-Scandinavian geometric trefoils, Borre-style disc brooches, lozenge brooches, and select Jellinge-style backwards-beast brooches are visually indistinguishable from their Scandinavian counterparts: they retain their Scandinavian brooch shapes, including, where relevant, their convex profile, and preserve the Scandinavian art styles which generate their decorative content. Their insular origins are evident solely in the form and arrangement of their pin-fittings: these reflect a mix of Scandinavian and Anglo-Saxon styles and do not include the attachment loop, which is common on finds from Scandinavia.

The retention on Anglo-Scandinavian brooches of salient Scandinavian features reveals a vibrant local market for brooches which 'looked' Scandinavian and accurately replicated Scandinavian shapes and styles, but which could be attached to clothing in a way familiar to Anglo-Saxon women. The modifications made to the pin-fittings on the reverse of these brooches, may, to some extent, be seen as minor. In most instances, the Scandinavian-type double pin-lug was replaced by an Anglo-Saxon style single pin-lug, a form better suited to small brooches and one which Scandinavian brooches eventually came to adopt (see Chapter 5). Significantly, most Anglo-Scandinavian brooches retain one Scandinavian-style pin-fitting, suggesting that brooch pin-fittings were

essentially copied from Scandinavian models, with some modification where necessary. Indeed, a group of Anglo-Scandinavian Jellinge-style brooches (Type I D) retains both a Scandinavian pin-lug and catchplate. Their insular origin is revealed only by the absence of an attachment loop, which features on all known examples of the disc brooch from Scandinavia.

However, the removal of the attachment loop, an absence common to almost all Anglo-Scandinavian brooches, does represent a significant change and cannot be explained as a mere technological improvement. Since the loop was regularly used to suspend metal and textile chains and their accompanying implements, its absence indicates a different context of use for Anglo-Scandinavian brooches. In particular, it suggests that they were worn singly, as in Anglo-Saxon dress, rather than as part of more elaborate accessory sets, involving additional chains and tools, as was traditional in Scandinavia. Anglo-Scandinavian brooches may have looked Scandinavian, but they represent a different costume tradition. Such a change in brooch use, or style, offers a clear indication of accommodation by brooch wearers to existing, local fashions and tastes.

In what contexts and by what mechanisms were these 'Scandinavian-looking' Anglo-Scandinavian products manufactured? In a few instances, design faults encountered on brooches from Scandinavia are preserved on Anglo-Scandinavian products, as is the case with a small group of Type I A1 Jellinge-style brooches from England, with a design anomaly (truncated necks) similarly encountered on brooches of the type from Scandinavia (see above, p. 105–6). This would appear to suggest that they were produced from moulds derived from the same models as brooches within Scandinavia. In other instances, Scandinavian brooches may have served as models for new products manufactured in the Danelaw. Either scenario could apply to select small geometric trefoil brooches found in England, which retain a misalignment in one trefoil lobe similarly encountered on small trefoils from Scandinavia (p. 83). Given the observed degradation in ornamental quality, the second scenario would seem to apply to Anglo-Scandinavian lozenge brooches and disc brooches of Jansson's Type II A, which reveal flatter, less crisp designs and slightly smaller dimensions compared with their Scandinavian counterparts.

Although the identity and ethnic affiliation of the manufacturers of these Anglo-Scandinavian brooches will never be known with certainty, analysis of the metal-alloy composition of Anglo-Scandinavian products points to the manufacture of a few items within workshops with access to Scandinavian metals, perhaps in the form of recycled Scandinavian products (see Appendix B). This is suggested for select geometric trefoil (Type G) and Jellinge-style disc brooches with a backwards-biting beast (Type I D), which XRF analysis revealed to be brass, a common alloy used for brooches within Scandinavia. Notably, however, these brooch types possess other indicators of strong Scandinavian influence, in ways which are atypical of Anglo-Scandinavian brooches as a whole:

the geometric trefoil brooch carries the same casting fault as Scandinavian tre-foils, while the Jellinge-style brooch replicates both the Scandinavian pin-lug and catchplate.

The evidence from other Anglo-Scandinavian brooch types points instead to their production in an insular setting, independent of Scandinavian influence. This was most clearly revealed by the metal-alloy composition of thirteen Anglo-Scandinavian brooches examined by the author (Appendix B, Table 3). Unlike Scandinavian products, which have been shown to consist either of bronzes or brasses, XRF tests revealed the majority of these items to be lead-alloy, with just two exceptions highlighted above. Lead-alloys are often encoun-tered in native, Anglo-Saxon brooches of this date but are rarely used for brooches within Scandinavia, suggesting the adoption of indigenous metal-working techniques. Many Anglo-Scandinavian brooches possess relatively simple shapes and ornamental schemes, which is likely to have facilitated their reproduction from Scandinavian brooches. They may have been reproduced by Anglo-Saxon craftsmen influenced by Scandinavian fashions, with modest changes to their attachment fittings to suit their small size.

However, the recurring pairing on most Anglo-Scandinavian brooches of an Anglo-Saxon-type pin-lug with a Scandinavian-type catchplate is indicative of a distinct workshop tradition, divorced from both local Anglo-Saxon and Scandinavian metalwork traditions, but influenced by both. The positioning of these features, with the pin-lug on the left and catchplate on the right when viewed from the reverse, nonetheless reflects the positioning of the pin-fittings on Anglo-Saxon brooches. It might suggest that this group of Anglo-Scandi-navian brooches was produced by craftsmen trained in insular practices, who embraced new Scandinavian brooch forms and designs, modifying some fea-tures while preserving others.

The brooches discussed above represent a process by which Scandinavian brooch forms and designs were reproduced in the Danelaw, with limited modi-fications. Other brooches from the Danelaw provide evidence for an entirely different process: the application of Scandinavian motifs to brooches of indi-genous, Anglo-Saxon form. This tradition preserved the flat disc brooch form familiar to indigenous costume while embracing the new artistic impulses of the Borre (including Terslev) and Jellinge styles. Brooches associated with this process indicate the active modification of imported Scandinavian styles. As such, they may be seen as indigenous responses to new, 'foreign' media.

Anglo-Scandinavian brooches belonging to this group possess a typical Anglo-Saxon flat disc form. As we would expect, these brooches do not possess attachment loops. A Jellinge-derived disc brooch from Gooderstone, Norfolk, carries an incorrectly positioned horizontal lug, but this is not pierced and appears to have been abandoned before completion (cat. no. 479). Notably, however, some Scandinavian influence is preserved in the form of the pin catchplates. Like the brooches discussed above, these brooches often retain a

Scandinavian-type catchplate alongside a pin-lug of Anglo-Saxon form, in positions characteristic of insular brooches. Indeed, the only brooch type to adopt both an Anglo-Saxon style catchplate *and* pin-lug, and thus to become fully integrated into the Anglo-Saxon brooch repertoire, is the East Anglian Series, one hundred and forty examples of which possess two Anglo-Saxon-style fittings.

The Scandinavian motifs adopted and used on flat disc brooches from the Danelaw include the motif of the Jellinge-style backward-turned beast, select Terslev compositions, and the Borre-derived interlace motif characteristic of the East Anglian Series. With over two hundred and thirty specimens, the latter forms the chief representative of the group, which otherwise comprises a relatively small number of items, including just five Jellinge-style brooches. For the most part, Scandinavian designs which appear on Anglo-Saxon-type brooches remain close to their original, Scandinavian appearance. The interlacing tendril motif of East Anglian Series brooches is remarkably similar to its appearance on Scandinavian brooches from Denmark, for instance, with just one substitution in the form of a sunken central roundel in place of the raised one.

Slight alterations in ornament are occasionally discernible, providing further evidence for contact between Scandinavians and Anglo-Saxons. Occasionally, modifications arise through what appears to be the unsuccessful copying of a Scandinavian design. This appears to be the case with a Terslev-ornamented disc brooch from Torksey, Lincolnshire, with an unbalanced volute design (cat. no. 343) (see Fig. 3.35). In rare instances, Scandinavian designs encountered on indigenous-type brooches are heavily modified from their original form. A group of flat, Jellinge-style disc brooches, which include two specimens from York, carry an altered version of a classic Scandinavian backwards-looking beast (cat. nos. 479–83). On these items, the animal has a broader body and larger, rounder eye than its Scandinavian counterpart and has little in common with the lean S-shaped animals depicted on Scandinavian brooches.

While such designs may be classed as 'debased' or 'devolved', it is important to remember that modified motifs may have been produced within a different aesthetic framework, and should not necessarily be attributed to the misunderstanding or inability of the brooch maker. Such design discrepancies, along with the native form of the brooch on which the motif was carried, nevertheless suggest that the Jellinge-style beast was incorporated into the repertoire of craftsmen not trained in Scandinavian metalwork traditions. The idiosyncratic designs of these brooches may have suited the tastes of 'native women with an eye for the exotic, or...Scandinavian customers who were not too fussed about the details of a familiar motif' (Paterson 2002, 273).

Significantly, however, native artistic features are generally rare on Scandinavian and Anglo-Scandinavian brooches. Only a handful of items attest to the merging of Anglo-Saxon and Scandinavian designs on a single product. The group of Jellinge-derived brooches described above is notable for incorporating Anglo-Saxon stylistic features. Their use of a triple, beaded rim to surround

the Jellinge beast reflects the Anglo-Saxon taste for heavy border schemes, not evident in Scandinavia. It has been suggested that the use of a 'trilobate foliate stud' on the central panel of a Borre-style trefoil brooch from Stallingborough, Lincolnshire (cat. no. 413) (see Fig. 3.46) may represent a local addition, but a similar stud of Continental origin is found on a mount from the Hoen hoard, Norway, and the Stallingborough stud need not have an insular background (Leahy and Paterson 2001, 194).

On Anglo-Scandinavian brooches, central sunken roundels often substitute features traditionally found on Scandinavian brooches, suggesting an insular preference for such an element. This is seen on a Terslev-ornamented disc brooch from Hemingstone, Suffolk, for instance, on which a central roundel appears in place of the regular Scandinavian triangular feature (cat. no. 345) (see Fig. 3.37), as well as on East Anglian Series brooches of Group I, which replace the raised, bordered circle encountered on Scandinavian disc brooches with a simple sunken depression. Central roundels were not an insular innovation, however, but appear on a range of Scandinavian lozenge, disc, and trefoil brooch types (for instance, Jansson 1984b, 63, fig. 8.2, III A, III B). They are not, therefore, evidence of a blending of Anglo-Saxon and Scandinavian motifs.

Innovation in Anglo-Scandinavian products, resulting in the creation of new brooch types worn and used for the first time in the Danelaw, is extremely rare. Borre/Jellinge-style rectangular brooches are distinctive in merging Scandinavian ornament and Continental brooch forms. Just four items are recorded from England, however, and the series appears to have been local to Thetford (cat. nos. 443–6). Another new, yet uncommon, brooch type is represented by the Urnes-style finds from Pitney, Somerset, and Wisbech, Cambridgeshire: these brooches are unique in combining Scandinavian Urnes-style ornament and openwork execution with an Anglo-Saxon disc brooch form (cat. nos. 496–7). In some instances, new decorative content arises from the meaningful amalgamation of two or more existing Scandinavian designs. A flat disc brooch from Lincoln combines elements from two known Terslev compositions, generating a novel art style unique to the Danelaw (cat. no. 335). By and large, however, Anglo-Scandinavian brooch traditions are conservative, preserving Scandinavian brooch forms and/or ornament.

The application of Scandinavian designs to disc brooches of Anglo-Saxon form was not widespread, but was restricted to certain compositions. For instance, Borre-style zoomorphic designs, seen on Type II A and II D disc brooches, do not appear on brooches of indigenous form in England, despite circulating in large numbers on convex disc brooches. The same is true of Jellinge-style designs involving complex, interweaving animals, including the motif of two asymmetrical beasts (Type I E). The Scandinavian designs selected for use on indigenous brooch types instead privilege the inanimate geometric designs of the Borre style, especially Terslev compositions, the backwards-biting Jellinge-style beast providing one notable exception. Such designs

would appear to reflect the Anglo-Saxon taste for interlace. They may also have been easier to reproduce by Anglo-Saxon craftsmen, with a tradition of executing foliate and interlace patterns.

In this context it is worth considering why the East Anglian Series tendril motif in particular was reproduced on such a large scale in the territories of eastern England. To judge from the current tally of finds, its uptake in England did not reflect its popularity in Denmark, where just a handful of specimens are recorded. Nor was it unique in combining a Scandinavian motif with an Anglo-Saxon brooch form. Perhaps its popularity rested on the fact that its motif was consonant with existing Anglo-Saxon artistic tastes. The tendril motif is an inanimate, semi-naturalistic tendril design, similar in character to Late Anglo-Saxon foliate styles; indeed, the motif is thought by some scholars to possess insular origins (Wilson 1964, 49; Jansson 1984b, 63–4). An additional possibility is that the cruciform shape generated by the tendril design resonated with a Christian, Anglo-Saxon population, in a way in which it failed to do in pre-Christian Denmark. This possibility speaks in favour of the series being worn by local women, perhaps in addition to settlers of Scandinavian descent, keen to express their allegiance or conversion to Christianity.

Also notable in regard to the East Anglian series is the circulation of a second mass-produced disc brooch series with a backwards-turned quadruped set within a border of twenty-eight pellets (Fig. 2.13f). This 'quadruped series' is dated by some scholars to the eighth and ninth centuries (Smedley and Owles 1965, 174; Hinton 2008, 66) but examples from dated archaeological contexts in York and Ipswich in fact indicate a date in the later ninth and tenth centuries for the brooches, making them contemporary with the East Anglian Series (Roesdahl et al. 1981, YD11; Mainman and Rogers 2000, 2571). This is supported by the fact that small disc brooches are otherwise not known to have been in fashion during the eighth century, when dress pins instead were the norm. The quadruped brooch series is equivalent to the East Anglian Series in terms of brooch form and dimensions; extant examples indicate that it too was produced on a serial scale (see Appendix C). In addition, it has a broadly similar geographical distribution within East Anglia, although, unlike the Anglo-Scandinavian series, the quadruped brooches do appear in southern Suffolk (West 1998, 322, fig. 159).

The main distinguishing feature of the two brooch types is the motif. While the Borre-style interlace design descends from Scandinavia, the backwards-turned quadruped seems to have originated as an indigenous, regional motif. Although its precise source is unclear, the motif has been linked to East Anglian sceatta designs (Brønsted 1924, 146; but see Gannon 2003, 186, note 34) and, more convincingly, animal stamps applied to fifth- and sixth-century Anglo-Saxon cremation urns, for instance, from Spong Hill, Norfolk (although there is currently nothing which fills the stylistic gap between the early cremation urns and the later brooches) (Hills 1983, 105, fig. 2a–b). As Catherine Hills notes, while

'too much should not be made of the similarity of a fairly obvious and simple motif...it may be that in East Anglia in particular there was a predilection for such representations' (Hills 1983, 105). Viewed in this light, we may speculate that the two brooch series, with motifs rooted in Scandinavian and Anglo-Saxon traditions respectively, were understood by contemporaries in relation to each other. These two mass-produced disc brooch types, which circulated concurrently, may have been worn to articulate the Anglo-Saxon or Anglo-Scandinavian cultural heritage or affiliation of the wearer, serving as tools for social differentiation. The popularity of the East Anglian Series, then, may attest to the desire of local inhabitants to form Scandinavian associations, in opposition to Anglo-Saxon values.

Limitations to cultural assimilation

The East Anglian Series disc brooches represents a process in which motifs of Scandinavian origin were applied to brooches of Anglo-Saxon form. Importantly, the reverse process is not well attested among Danelaw finds. Just one item, a mould for a trefoil brooch from Blake Street, York, is suggestive of a practice in which indigenous Anglo-Saxon motifs, in this case drawn from the Winchester style, were applied to Scandinavian-type brooches, although no extant brooches of the type survive (Fig. 4.1). It is significant that the brooch mould came from York, a town which, like other towns with recorded Scandinavian activity, has yielded an eclectic mix of metalwork. Such cultural eclecticism appears to be a particular trait of towns at this date, perhaps as a result of what Gabor Thomas has described as 'heightened levels of cultural integration and assimilation existent in Viking trading communities' (2000b, 240).

The restricted application of indigenous, Anglo-Saxon ornament to brooches of Scandinavian form contrasts greatly with the blending of cultural forms in ornamental metalwork following the Roman conquest of Britain. As has long been recognized, Romano-British brooches worn in England frequently merged existing Celtic La Tène decoration with traditional Roman brooch forms, including trumpet, bow, and disc brooches, to generate genuinely hybrid dress items (Hunter 2008, 138, fig. 8.3). Like the brooches presented here, Romano-British brooches were produced on a large scale and were widely used, indicating high demand for such styles. Against this evidence, the failure to apply Anglo-Saxon styles to Scandinavian brooch forms speaks of the conservatism of Anglo-Scandinavian brooches. Scandinavian brooch forms were reserved for Scandinavian styles, and appear to have promoted difference, rather than likeness.

Perhaps even more remarkably, given the vibrancy of indigenous artistic traditions in ninth- and tenth-century England, there is practically no evidence for the occurrence on the same brooch of both Scandinavian and Anglo-Saxon art styles. The Anglo-Saxon Trewhiddle style rarely appears on artefacts with

Borre- or Jellinge-style ornament, for instance, even though the styles are now known to have overlapped chronologically (Tweddle 2004, 451; Thomas 2006, 157; but see Wilson 1964, 42). The separation of Anglo-Saxon and Scandinavian styles at this date stands in sharp contrast to the frequent mingling of later tenth- and eleventh-century Scandinavian and Anglo-Saxon art styles, such as Winchester and Ringerike, on ornamental metalwork and other media (Kershaw 2008, 265). These patterns signal limits to the extent of cultural assimilation in the Danelaw, or, more precisely, to the role of ornamental metalwork in negotiating such processes. Cultural influence, as expressed on Anglo-Scandinavian brooches, appears to be one-directional, with the Anglo-Saxons receiving Scandinavian influence, but little evidence for the reverse process. In this sense, the brooches signal local attempts at 'keeping up with the Scandinavians', and cannot be read as evidence of mutual cultural assimilation.

Non-Scandinavian brooches in the Danelaw

The focus of this book has been Scandinavian and Anglo-Scandinavian jewellery from England. Of course, Scandinavian styles of jewellery were not the only styles available to consumers of metal dress fittings in the ninth and tenth centuries. Metal detecting in the eastern and northern counties of England has also yielded metalwork in native Anglo-Saxon, Irish, and Continental styles. To assess the impact of Scandinavian influence on contemporary metalwork from the Danelaw, the use of Scandinavian brooches must therefore be compared with that of non-Scandinavian items.

The following section assesses the ratio of Scandinavian to non-Scandinavian metalwork in the counties of Norfolk, Suffolk, and Lincolnshire, in an attempt to answer the question: how Scandinavian is late ninth- and tenth-century metalwork from eastern England, and how Anglo-Saxon or Continental? It brings together results of the author's survey of contemporary Anglo-Saxon and Continental brooches from the three counties, recorded before December 2008. Data collection was designed to be comprehensive, utilizing published catalogues (for instance, Wilson 1964; Hinton 1974; Frick 1992/3), museum records, county Historic Environment Records (HERs), and the Portable Antiquities Scheme (PAS) database.

Before discussing the findings of the survey, it is important to highlight significant methodological constraints on the search for, and identification of, relevant non-Scandinavian brooches. The survey aimed to identify non-Scandinavian brooches which circulated alongside brooches in Scandinavian styles during the late ninth and tenth centuries, a task which sometimes proved difficult. The 'Late Anglo-Saxon' period is defined by both PAS and HER dating conventions as 850–1065, and it is to this broad period that most items are attributed (rather than centuries or half centuries, for instance). While chronologies for some well-studied brooch types, such as enamelled disc brooches, can be refined, enabling

them to be included or excluded from the survey where appropriate, many brooches lack specific date ranges (Buckton 1986; 1989). They may pre- or post-date Scandinavian brooches, but cannot be excluded from the survey. As a result, this survey will over-represent the number of Anglo-Saxon and Continental brooches in contemporary use. Despite this bias towards non-Scandinavian material, the findings below suggest that Scandinavian items dominated the repertoire of ninth- and tenth-century brooches in both Lincolnshire and Norfolk.

Appendix C lists the non-Scandinavian brooches from Norfolk, Suffolk, and Lincolnshire, dated to the Late Anglo-Saxon period. This list includes a number of recurring brooch types, such as the backwards-turned quadruped disc brooch, mentioned above (Smedley and Owles 1965). Flat, lead-alloy disc brooches decorated with geometric compositions form a second type of indigenous Anglo-Saxon brooch broadly contemporary with brooches in the Borre and Jellinge styles (for instance, Mainman and Rogers 2000, 2572–3, fig. 1268; see also Fig. 2.13). Although the presence of Continental brooch types has only recently started to attract attention (Thomas 2007), there is a steadily growing corpus of such items, which span the eighth to eleventh centuries. Continental brooches current in the ninth and tenth centuries include certain forms of rectangular brooch (*Rechteckfibeln*), in addition to a selection of disc brooches with enamelled cross motifs (*Kreuzemailfibeln*) and so-called saints brooches (*Heiligenfibeln*) (Wamers 2000, 176–8, 183–7, figs. 175, 182–3). Coin brooches (*Munzfibeln*) were worn in both England and on the Continent. The tradition for such brooches came from the Continent, however, and it is likely that some finds from England represent imports (Leahy 2006, 277).

The relative presence of Scandinavian and non-Scandinavian metalwork in Norfolk, Lincolnshire, and Suffolk

The results of this survey, summarized in Figure 7.11, are twofold. First, they indicate that in eastern England there was wide choice in brooch styles during the late ninth and tenth centuries. Scandinavian, Anglo-Scandinavian, Anglo-Saxon, and Continental brooches are recorded in all three counties in sufficient quantities to suggest that they were readily available to consumers of metal dress items. Second, within the context of varied stylistic choice, Scandinavian forms and styles appear to have dominated the repertoire of ninth- and tenth-century brooches in Norfolk and Lincolnshire. By contrast, in Suffolk, Scandinavian styles were subordinate to indigenous, Anglo-Saxon designs.

The most striking results were obtained from Norfolk, where close to five hundred brooches of Late Anglo-Saxon date were surveyed: a considerably higher number than in Suffolk or Lincolnshire and one which reflects the county's long tradition of recording metal-detector finds (see Fig. 7.12). The assemblage of contemporary brooches from Norfolk is diverse. The author recorded

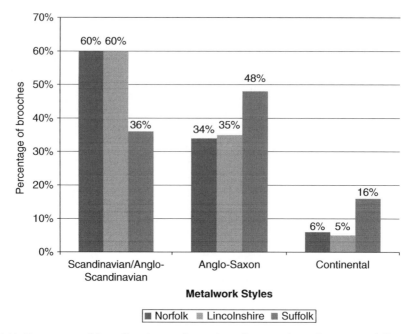

Fig. 7.11 Frequency of Scandinavian and non-Scandinavian brooches in Norfolk, Suffolk, and Lincolnshire.

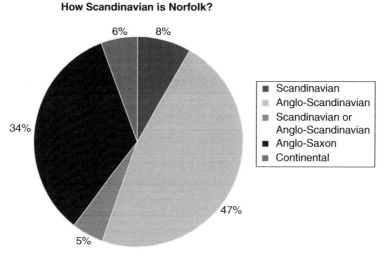

Fig. 7.12 Ratio of Scandinavian to non-Scandinavian brooches from Norfolk (total: 497 items).

twenty-eight Continental brooches, in addition to one hundred and seventy Anglo-Saxon items, a tally which attests the culturally eclectic mix of available brooch forms. However, within this assortment of brooches, Scandinavian styles clearly dominate. Of all brooches documented in Norfolk, 60 per cent

could be classified as either Scandinavian or Anglo-Scandinavian (three hundred items); Anglo-Saxon brooches form 34 per cent of the corpus (169 brooches), and Continental brooches just 6 per cent (28 items). Given the noted over-representation of contemporary non-Scandinavian material, Norfolk appears very Scandinavian indeed.

Results from Lincolnshire, based on a smaller total number of items, are comparable (see Fig. 7.13). Of the ninth- and tenth-century brooches from Lincolnshire, 60 per cent could be classified as Scandinavian or Anglo-Scandinavian (seventy-two items), 35 per cent as Anglo-Saxon (forty-two items), and 5 per cent as Continental (eight items). The total number of Continental brooches from Lincolnshire is considerably lower than in Norfolk or Suffolk.

In both Norfolk and Lincolnshire, brooches in Scandinavian styles outnumber brooches in Anglo-Saxon or Continental fashions. Conversely, in Suffolk, Anglo-Saxon styles dominate: 48 per cent of one hundred and thirteen brooches surveyed could be classified as native Anglo-Saxon (fifty-four brooches), 16 per cent (eighteen brooches) as Continental, and 36 per cent (forty-one brooches) as Scandinavian or Anglo-Scandinavian (see Fig. 7.14). The Scandinavian percentage is not negligible, especially when compared to the quantity of Scandinavian-style products found in Essex to the south (one brooch and two pendants) and Cambridgeshire to the west (ten brooches). However, when the spatial distribution of these objects is considered, it becomes clear that most Scandinavian-style brooches from Suffolk are confined to the north of the county, particularly in the north-west along the border with Norfolk (Map 6.6).

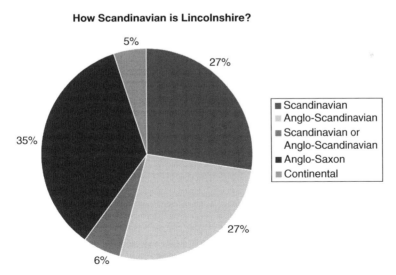

Fig. 7.13 Ratio of Scandinavian to non-Scandinavian brooches in Lincolnshire (total: 96 items).

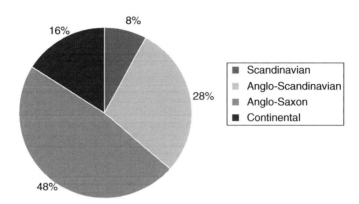

Figure 7.14 Ratio of Scandinavian to non-Scandinavian brooches from Suffolk (total: 113 items).

By contrast, south Suffolk reveals just a scattering of Scandinavian metal-work. This distribution contrasts with that of brooches in Anglo-Saxon and Continental styles, which are common in the area. These contrasting distri-butions were discussed earlier in Chapter 6, where evidence of metalwork was compared to other indications of Scandinavian influence in two, distinct cultural zones in East Anglia, separated by the Gipping-Lark river corridor. Here, it is important to note that the observed ratio of Scandinavian to non-Scandinavian metalwork within Suffolk is likely to conceal stark regional differences in brooch preferences. If this survey distinguished northern Suf-folk and Norfolk from southern Suffolk, the dominance of non-Scandinavian metalwork in the south would be even more striking than current figures for the county as a whole suggest.

The results of this survey also enable a more detailed scrutiny of the relative ratios of Scandinavian and Anglo-Scandinavian brooches in circulation in each county. In this respect there is an interesting discrepancy between Nor-folk and Lincolnshire. Within the Lincolnshire corpus of Scandinavian and Anglo-Scandinavian finds, Scandinavian brooches slightly outnumber Anglo-Scandinavian objects: thirty-four Scandinavian brooches are recorded, com-pared to thirty-two Anglo-Scandinavian items, in addition to seven items which cannot be assigned to either category. This pattern contrasts sharply with the picture in Norfolk, where Anglo-Scandinavian brooches dwarf the number of Scandinavian finds. The number of Anglo-Scandinavian brooches recorded from the county is two hundred and thirty-four, compared to just forty-one Scandinavian brooches, a number which is, nonetheless, higher than that for Lincolnshire. A similar, though less pronounced, pattern is evident in Suffolk, although this is again likely to reflect the continuation of Norfolk brooch tradi-tions into northern Suffolk.

The profusion of Anglo-Scandinavian brooches in Norfolk reflects the high number of East Anglian Series disc brooches recorded from, and probably produced in, the county (one hundred and seventy-eight). Yet the circulation of these brooches alone cannot explain why Anglo-Scandinavian brooches outnumber Scandinavian items in Norfolk to such an extent. A wide range of Anglo-Scandinavian brooch types have been found in Norfolk; to judge from their form and pin-fittings, many are likely to have been worn by the native population, perhaps in addition to settlers of Scandinavian descent. The results of this survey highlight the existence in Norfolk of a vibrant Anglo-Scandinavian metalworking tradition, one which does not appear to have been as pronounced in other areas of eastern England.

The marked trend for Anglo-Scandinavian jewellery in Norfolk suggests that it was fashionable for women to bear Scandinavian styles, to 'appear Scandinavian', whether or not they could genuinely claim Scandinavian heritage. Why this trend was particularly manifest in northern East Anglia remains unclear. Issues affecting the recovery of metalwork from different regions are potentially significant. It is possible, for instance, that the alloys used in Anglo-Scandinavian brooches manufactured in Norfolk were especially robust, resulting in their better preservation. Alternatively, Anglo-Scandinavian metalwork may have been produced in response to large-scale localized Scandinavian settlement: to satisfy a demand by local Scandinavian women for jewellery which resembled that which they wore at home. Here, however, it is salutary to note that the total number of Scandinavian objects in Lincolnshire and Norfolk (items which could have been imported) is not dramatically different: thirty-four and forty-one respectively.

Since Anglo-Scandinavian items are likely to date mainly to the tenth century, another possibility is that Scandinavian cultural influence continued for a longer period in Norfolk than further north. This would appear to contradict the historical record, which places the end of Scandinavian rule in East Anglia with the West Saxon Conquest in *c.* 917, an earlier date than that suggested for Lincolnshire (Whitelock 1979, 218; Leahy 2007, 162). It also presents an uneasy fit with the tentative suggestions by one place-name scholar that the Scandinavian language was abandoned at an earlier date in Norfolk than elsewhere in the Danelaw (Parsons 2006, 175). But popular fashions tend to emulate the tastes of the elite, making it likely that the trend for Anglo-Scandinavian metalwork in Norfolk reflected the jewellery worn by the upper echelons of society. In this context, we may ask: who were the elite in East Anglia during the tenth century? Did West Saxon and Mercian conquest really signal an end to Scandinavian rule and authority in this part of the Danelaw, as implied in the *Anglo-Saxon Chronicle*?

These questions are ones which numismatists and historians have also recently sought to address. Mark Blackburn has argued on the basis of coin evidence that the West Saxon King Edward the Elder failed to establish monetary

control over East Anglia following his apparent conquest of the region; Edward appears to have produced only an imitative coin series, characterized by blundered inscriptions, struck to a weight standard originally established by Scandinavian rulers (Blackburn 2001, 138; Lyon 2001, 74). After Edward's imitative coins came to an end with his death in 924, it took his successor, Æthelstan, ten years to establish a regular coinage in the region. These apparent failures, observable in the coin data, suggest genuine limitations to the strength and effectiveness of royal government. They imply continued Scandinavian involvement in some key aspects of administration, even after independent Danish rule came to an official end.

Numismatists have further suggested that the failure of West Saxon kings to establish good mints in former Danelaw territories was not restricted to East Anglia, but may have characterized Lincolnshire as well as parts of the east Midlands (Blackburn 2001, 137–8; Lyon 2001, 73). The establishment of royal monetary and administrative control in East Anglia appears to have been a particularly hard fought and drawn-out process, however, which may not have been completed until the eleventh century (Marten 2008). The historian Lucy Marten has recently demonstrated that the imposition in East Anglia of shires, a West Saxon administrative unit, is unlikely to date to the period of Edward's conquest, as is traditionally assumed. Rather, it appears to have been part of a programme of reforms introduced a century later by Cnut in an attempt to integrate East Anglian institutions with those of the rest of the country (Marten 2008). This important finding casts doubt on Edward's ability to introduce administrative reforms in East Anglia immediately following its takeover and highlights the continued administrative independence of the region up to the eleventh century.

Further doubts over the completeness of the English conquest of East Anglia are raised by careful reading of the *Anglo-Saxon Chronicle*'s descriptions of the event. As Lucy Marten has noted, the language employed by the 'A' text to describe the terms agreed between King Edward and East Anglia in 917 is distinct from that used to describe agreements between Edward and other regions of the Danelaw (Marten 2008, 4). In 917 in Northampton, for instance, we are told that 'Jarl Thurferth and the landholders submitted to him (Edward), together with the entire host which owed allegiance to Northampton and made submission to him as their lord and protector'. Similar language is used to describe oaths taken by Scandinavians in Bedford, Cambridge, and Stamford, but the entry concerning negotiations with the East Anglians is very different in both tone and language: 'And the entire Danish host in East Anglia swore union with him [Edward], that they wished all that he wished, protecting all that he protected, by sea and on land'. As Marten states, this is not a submission (Marten 2008). The entry may instead refer to one in a series of treaties between the East Anglians and West Saxon Kings, a 'negotiated "union"', to quote Marten, the nature of which is unclear, but which cannot be classed as a

complete submission (Marten 2008, 5). In sum, such historical evidence, combined with the jewellery and coinage data, casts doubts on the strength and nature of English rule over East Anglia in the decades following its 'conquest'.

While the trend for locally-produced jewellery, which looked Scandinavian, is especially marked in Norfolk, it is worth noting that high-status Scandinavian jewellery, which might signal elite presence, is widespread throughout the Danelaw. Silver pendants with a Terslev design closely modelled on filigree and granulation compositions come from Saffron Walden, Essex, while a cluster of elite items are known from the northern Danelaw (cat. nos. 322–4). Here, the presence of objects used in the manufacture of gold or silver pendants in the so-called Hiddensee style also attests to the manufacture of the highest-calibre Scandinavian jewellery. The possibility that Hiddensee-style jewellery circulated in the northern Danelaw is intriguing, since complete artefacts in the style are only found within Scandinavia at high-status sites under the control of the Danish Jelling kings (Svanberg 1998; Naylor et al. 2009, 337). Moreover, the mid-to-late tenth-century date for Hiddensee-style jewellery, in addition to the other high-status Terslev items, points to their period of use at a time when the Danelaw was under West Saxon, rather than Scandinavian, control. This jewellery would seem to suggest the presence in northern and eastern England of high-ranking Scandinavians, even after the end of Scandinavian rule.

Conclusions: the significance of Scandinavian and Anglo-Scandinavian jewellery

Before providing some general conclusions about the importance of Scandinavian-style jewellery in England, it is worth summarizing and putting into context the results from this chapter. When analysed from an empirical perspective, the material culture of the Danelaw reveals meaningful patterns in brooch use and consumption. The Scandinavian-style brooches and pendants under discussion encompass many of the different varieties encountered in southern Scandinavia, including those that are rare or currently unrecorded within a domestic context. They tend to preserve Danish fashions for particular brooch types, a pattern which indicates the wholesale transferral of brooch fashions from Denmark to the Danelaw. With a few exceptions, Anglo-Scandinavian brooches are heavily influenced by Scandinavian styles and borrow less from indigenous, Anglo-Saxon designs; only rarely do they innovate or combine cultural motifs to create genuinely hybrid products. Comparing the ratio of Scandinavian to non-Scandinavian metalwork revealed Scandinavian-style jewellery to have been particularly popular in Norfolk, as well as Lincolnshire, whereas, in Suffolk, Anglo-Saxon styles were in the majority. The particular fondness for Anglo-Scandinavian (tenth-century) brooches in Norfolk hints at

a sustained Scandinavian influence in the region, after the supposed conquest of the West Saxons.

In addition to these observations, this study has made a number of findings which help to account for the presence in England of a substantial number of Scandinavian-style dress items. Beginning with the description of the artefacts in Chapter 3, it was demonstrated that most of the collated material is paralleled by finds from Viking-Age Denmark, although a small number of artefacts also attest to links to western and eastern Scandinavia, including Iceland, Norway, and eastern Sweden. Yet despite the close coupling of Scandinavian brooch styles in England and southern Scandinavia, there is little evidence for the adoption of Anglo-Saxon dress items within Denmark. The implication is that whatever processes bought Scandinavian-style metalwork to England did not operate in the reverse direction.

Chapter 4 revealed that there is currently no evidence to suggest that 'purely' Scandinavian jewellery was manufactured in England. Indeed, the results of XRF tests on a small number of brooches suggest that large Scandinavian brooch types in England are frequently fashioned from brass, a metal which was widely accessible within Scandinavia in the ninth and tenth centuries but which is not thought to have been routinely used in England at this time (Chapters 2, 5, 7, and Appendix B). Anglo-Scandinavian items, often with a different metal profile and pin-fitting layout to Scandinavian products, appear to have been manufactured in a separate context to both Scandinavian and Anglo-Saxon artefacts. They were produced in the towns as well as in the countryside of the Danelaw, under strong Scandinavian influence in England.

Chapter 4 also demonstrated that, rather than being confined to the early settlement period, the jewellery spanned an extended period of time, starting in the later ninth century and continuing in circulation throughout the tenth century, with a small number of objects in the Ringerike and Urnes styles coinciding with the reign of Cnut. Significantly, female jewellery in England and Denmark was stylistically synchronized; a finding which indicates sustained contact between Denmark and the Danelaw beyond the conventional end-dates of independent Scandinavian rule.

In Chapter 5 it was argued that the brooches and pendants were worn exclusively by women, there being few indicators at present that male dress was similarly associated with the display of Scandinavian motifs until the later Viking period. The introduction of female Scandinavian dress fashions in the Danelaw signals some level of familial settlement, a theme explored further below. The same chapter revealed that Scandinavian brooches found in England retain key features which suggest their use in a traditional Scandinavian manner, including the conventional Scandinavian pin-fitting form and layout and the attachment loop, commonly used to suspend artefacts from the brooch. Significantly, this feature was not observed on native Anglo-Saxon or Anglo-Scandinavian brooches, indicating one way in which

Anglo-Scandinavian products modified Scandinavian fashions to suit local needs and tastes.

In Chapter 6 the geographic distribution of Scandinavian-style artefacts was shown to be concentrated within the historic Danelaw, with particular concentrations in Norfolk and Lincolnshire. In these two regions, Scandinavian styles of brooch were also shown to dominate the range of metalwork available locally (Chapter 7). Unexpectedly, Yorkshire and the east Midlands, the traditional foci of study of the Danish settlement and the areas with the highest concentrations of Scandinavian place-names, yielded few items of women's jewellery, raising questions both of the nature of metalwork survival and finds recording in those regions and the original character of potential Scandinavian settlement. Perhaps the most important observation was the concentration of metalwork in Norfolk and the dominance there of Scandinavian-styles of metalwork. While single finds of metalwork cannot act as an index to Scandinavian settlement, such concentrations and ratios should encourage a significant revision of the history of Scandinavian settlement in this region, which has, in the past, been viewed as peripheral to or even outside the Danelaw.

What, then, can we learn from these conclusions about the reasons why Scandinavian-style jewellery is found in relatively high numbers in some areas of northern and eastern England? Does the presence of characteristically Scandinavian metalwork require the presence of Scandinavian women, or can some objects be otherwise explained, as trade goods, for instance, or as items produced locally to meet a demand for Scandinavian-looking jewellery? The wide range of Scandinavian brooch styles and designs documented in England is not commensurate with items having been introduced as trade goods for the mass market. Nor do they suggest the local production of Scandinavian metalwork by native, Anglo-Saxon craftsmen, at least without the original, Scandinavian items to use as models. Were items manufactured locally or introduced via trade, we would expect a restricted number of mainstream brooch types to prevail. With trade in Scandinavian jewellery, we might also expect Anglo-Saxon metalwork to circulate in equivalent numbers within Scandinavia, and for artefacts to show a clustered geographic distribution, which is not the case. Rather, the typological diversity exhibited by characteristically Scandinavian jewellery from England strongly suggests that the most likely reason for their introduction to England was their use by female settlers from Scandinavia, as is usually assumed for Scandinavian jewellery found in colonial environments, such as Swedish settlements in Russia (Jansson 1992; 1999; Stalsberg 1987). The fact that Scandinavian brooches in England retain Scandinavian forms of attachment, including a loop which could be used to suspend accessories, also points to their use by women familiar with such features. In this way, the extensive numbers of Scandinavian brooches and pendants from England point to substantial female involvement in the Scandinavian settlement.

This finding challenges the commonly held view that the Viking settlement of England was a largely masculine affair. In the absence of clear archaeological evidence for a female Scandinavian presence, and faced with complex and often contradictory evidence from (usually late) onomastic and documentary sources, historians have tended to assume that the settlement process was largely carried out by men, who took wives among the local population (Clark 1979, 17–18; 1982, 59–60; Hadley 2006, 82–3; Trafford 2007). Although such a view is understandable, given the limitations of current evidence for Scandinavian women, it presents the Scandinavian settlement of England as fundamentally different to that of Russia, Ireland, Scotland, and Iceland, where, thanks to higher numbers of available sources for women, the involvement of significant numbers of Scandinavian women in settlement processes has never really been questioned.

A review of the wider evidence for and against the presence of Scandinavian women in England is beyond the scope of this volume. Here, it must suffice to note that archaeological as well as onomastic evidence in favour of a significant Scandinavian female contribution to the Viking settlement is steadily accumulating. The recent discovery of burials at Adwick-le-Street, Yorkshire, and Cumwhitton, Cumbria, has almost doubled the number of furnished female Scandinavian burials from England, although the corpus undoubtedly remains small (Brennand 2006; Speed and Walton Rogers 2004, 85). The tally of recognized Scandinavian feminine names preserved in English place-names is also expanding (Hough 2002; Jesch 2008). Although most of these are preserved in late (thirteenth- or fourteenth-century) sources, some are independently recorded in the tenth century, suggesting the presence of Scandinavian women among the early colonists (Hough 2002, 65–6, 68). Other recent work on place-names in England has suggested that place-names with the Scandinavian element '-bȳ' are likely to have been coined by a Norse-speaking community (Abrams and Parsons 2003). The vast number of bȳ-names in England is thus likely to reflect a large number of settlers speaking a Scandinavian language, which, in turn, is likely to reflect Scandinavian-speaking females using Scandinavian speech in the home (Jesch 2008).

The Scandinavian jewellery described earlier would appear to offer the first tangible archaeological evidence for a significant female Scandinavian population in Viking-Age England, a population which otherwise remains largely elusive in material terms. Placing a figure on a 'significant' number of Scandinavian women is difficult. Due to the mechanics of original loss as well as modern-day recovery, the jewellery discussed in this volume is likely to represent only a small percentage of the number of objects originally in circulation; with one hundred and twenty-four characteristically Scandinavian jewellery items currently recorded, the present corpus probably points towards a number in the thousands rather than hundreds. We are on firmer ground in responding to the question: when did women arrive? To judge from

the broad chronological range of the artefacts, it seems clear that there was female involvement from the onset of settlement in the 880s, and possibly even before, during the period of Viking raiding in the 860s and 870s. Importantly, the Scandinavian female population was not confined to this period, but seems likely to have been continually refreshed by the arrival of new settlers throughout the later ninth and tenth centuries. A theory of secondary migration by Scandinavian families to England 'not very long after the conquest of eastern England' has long been posited by place-name scholars to explain the strong influence of the Scandinavian language on English place-names (Cameron 1965, 11; Lund 1969, 196). The evidence for the close coupling of brooch styles between Denmark and England throughout the later ninth and tenth centuries suggests an even more sustained level of contact, with a constant flow of migration continually reinforcing eastern England's Scandinavian population.

Anglo-Scandinavian brooches were, of course, not imported, but produced locally. What is their contribution to the study of Scandinavian settlement and Danelaw society? The wide range of Anglo-Scandinavian brooches recorded from England challenges earlier suggestions that brooches with diagnostically Scandinavian forms were discarded by Scandinavian settlers in favour of brooch types which could be assimilated into native costume (Thomas 2000b, 252). Instead, this chapter demonstrated that diagnostically Scandinavian types were maintained, and even reproduced, throughout eastern England, often in ratios which reflected their popularity within Scandinavia. At the same time, changes to their attachment fittings suggest that Anglo-Scandinavian brooches were adapted to be worn in a manner more familiar to Anglo-Saxon than Scandinavian women. In this sense, these objects tell us something of the response of indigenous women, perhaps as well as that of second-generation settlers or those of mixed descent, to new cultural media. They signal the popularity of foreign, Danish fashions among the settled Danelaw population.

In seeking to explain the desire of local women to appropriate a Scandinavian appearance, David Hinton has suggested that Anglo-Scandinavian products may be the result of a growing population going into Danelaw towns 'and buying trinkets like those worn by the townspeople' (2005, 140). Certainly, towns such as Norwich, Thetford, and York appear to have served as the backdrop for the mingling of Anglo-Saxon and Scandinavian populations. It is clear that these centres gave rise to a distinct Anglo-Scandinavian material culture, which, in some cases, seems to have dominated the jewellery market. The extent to which the popularity of such items simply represents the rural uptake of urban fashions, facilitated, as Hinton implies, by the objects' production on a serial scale, is questionable, however. With the exception of the East Anglian Series, the heterogeneity of Anglo-Scandinavian brooches and the small numbers which make up some brooch groups is marked, and these features speak against their serial manufacture to supply a mass market.

Moreover, the strongest Scandinavian signature in metalwork comes not from towns, but from the countryside. This makes it unlikely that the purchase of Anglo-Scandinavian products in towns was intended to ape a specifically urban trend.

More broadly, we have to recognize that Anglo-Scandinavian dress items were fashionable and must have been fashionable for a reason. Jewellery in other cultural styles was available to inhabitants of the Danelaw, yet Anglo-Scandinavian styles were the preferred fashion in Norfolk and Lincolnshire. There may be a number of contributing factors to the popularity of certain types of jewellery in Anglo-Scandinavian styles. As noted above, for instance, it is possible that the popularity of the East Anglian Series in England lay in its cruciform motif and potential Christian symbolism. These brooches may have also been worn to articulate a distinct regional identity, one centred on northern East Anglia, rather than the south, although such regional identities are also likely to have been tied to corresponding cultural histories. These examples serve as a reminder that identities expressed through dress items could be multilayered. Scandinavian-style jewellery may have conveyed different meanings to different people, at different times. Yet the fact that Anglo-Scandinavian dress items largely preserve a Scandinavian appearance, and circulated only within areas settled by Scandinavians, suggests that their Scandinavian origin and background were fundamentally meaningful to the inhabitants of the Danelaw. The common copying of a diverse range of Scandinavian brooch forms within England and the careful retention of brooch styles through that process suggests that the 'Scandinavianness' of these dress items would have been significant to, and understood by, their wearers.

The adoption of Scandinavian styles is likely to have been beneficial, entailing social or political gain. The presence of a Scandinavian fashion-setting elite group seems likely, probably supported by a large and widely settled immigrant population who helped to popularize elite fashions. In this context, it is significant that so many Scandinavian-style dress items have been recorded from northern East Anglia. The dominance of Scandinavian brooch styles from this region (observed in the relative ratios discussed earlier in this chapter) cannot be explained by its long history of finds recording and must reflect deep-rooted Scandinavian cultural influence, no doubt supported by dense Scandinavian settlement. While we must continue to question the reasons for relative 'absences' of material from regions such as the Midlands, we must also accept and try to account for established 'presences'. In doing so, we ought to refocus attention on East Anglia as a region of core Scandinavian settlement and culture in the Danelaw.

Finally, it is highly significant that Early Viking-Age Scandinavian brooch forms and styles were available in England throughout the tenth century and, in some cases, into the eleventh. It seems to have been desirable to appear

Scandinavian even following the historically conventional end of Danish rule in eastern England. The evidence of jewellery suggests that the cessation of Scandinavian control in the Danelaw was not followed by the seamless integration of the Scandinavian and indigenous populations. Ornamental metalwork continued to be used to express difference, in a way that revealed continuing and strong Scandinavian cultural influence even after the West Saxon conquest.

Appendix A: Scandinavian finds lists

List 1: *Lozenge brooches, Type I (beaded arms)*

1. Sweden, Uppland, Sigtuna (SM Kv. Guldet, 290, E4:2)
2. Sweden, Uppland, Skillingeberget grave 1 (Althin 1963, fig. 18)
3. Germany, Schleswig-Holstein, Hedeby (Capelle 1968a, 107, cat. no. 99, pl. 9, 2)
4. Germany, Schleswig-Holstein, Hedeby (Capelle 1968a, 107, cat. no. 100, pl. 9, 3)
5–16. Germany, Schleswig-Holstein, Hedeby. 21 examples recovered since 2003, of which 12 are Type I (Hilberg 2009, 95, fig. 11)

List 2: *Lozenge brooches, Type II (ridged arms)*

1. Norway, Møre og Romsdal, Sunnmøre, Fjørtoft (BGM 11769)
2. Sweden, Uppland, Birka grave 418 (Arbman 1940–43, pl. 85, 5)
3. Sweden, Skåne, Uppåkra (LUHM 3642)
4. Denmark, Zealand, Lejre (NMK C 32244)
5. Denmark, Fyn, Strandby Gammeltoft (Gramtorp and Henrikson 2000, fig. 13)
6. Denmark, Zealand, Lake Tissø (NMK C 32167 KN 895)
7. Denmark, Jutland, Træhede grave 213 (Eisenschmidt 2004, 101, pl. 60, 12)
8. Denmark, Jutland, Hesselbjerg (Jeppesen 1999, 8)
9. Denmark, Jutland, Hesselbjerg (Jeppesen 1999, 8)
10. Denmark, Zealand, Glim (NMK C 32244)
11. Denmark, Zealand, Vester Egesborg (Ulriksen 2006, fig. 9)
12–17. Germany, Schleswig-Holstein, Hedeby. 21 examples recovered since 2003, of which 6 are Type II (Hilberg 2009, 95, fig. 11)

List 3: *Lozenge brooch patrices*

1. Denmark, Zealand, Lejre (ROM 641/85 op x 25)
2. Denmark, Fyn, Gudme (NMK C 6222 x 382) (Thrane 1987, fig. 12g, 1:382)
3. Denmark, Zealand, Lake Tissø (NMK 32167 KN 1082) (Jørgensen 2003, 201, fig. 15.23 no. 4)
4. Denmark, Bornholm, Bornholms Amt, Dalshøj II (BHM 3065 x 53)
5. Germany, Schleswig-Holstein, Hedeby (WMH 2003/4572) (Hilberg 2009, fig. 11.1)
6. Germany, Schleswig-Holstein, Hedeby (WMH 2003/2723) (Hilberg 2009, fig. 11.3)

List 4: *Lozenge brooch moulds*

1. Germany, Schleswig-Holstein, Hedeby (WMH KS 13710) (Capelle 1968a, pl. 10, 2)

List 5: Borre-style disc brooches, Type II A

1. Norway, Nordheim, Vestfold (UO C 22381; Petersen 1928, 122, fig. 128)
2. Norway, Sør-Trøndelag, Haugen (VNTNU 1747; Petersen 1928, 122)
3. Norway, Sogn og Fjordane, Hyllestad (UO 31745; Jansson 1984b, 62—incorrectly described as unprovenanced)
4–27. Sweden, Uppland, Birka: 23 examples, including 21 from graves and 2 from the Black Earth (Jansson 1984b, 59, 62)
28–35. Sweden, Uppland: 8 further examples (Jansson 1984b, 62)
36–9. Sweden, Hälsingland; Jämtland; Öland; Småland, 1–4 examples from each location (Jansson 1984b, 62)
40. Sweden, Södermanland, Husby (SHM 17804:8; Capelle 1968a, 114)
41. Sweden, Östergötland, Fiskeby (Lundström 1965, 113, no. 557, pl. 22, 12)
42. Sweden, Gästrikland, Grisskogen (Thorén 1994, fig. 17a)
43. Sweden, Gotland, Hemse (SHM 7897)
44–6. Sweden, Gotland, Smiss. 3 unfinished brooches (Zachrisson 1962, fig. 9)
47. Sweden, Skåne, Uppåkra (LUHM 3387)
48. Sweden, Skåne, Uppåkra (LUHM 4813)
49. Sweden, Skåne, Uppåkra (LUHM 5353)
50. Denmark, Jutland, Nørholm Skole (NMK C 36096)
51. Denmark, Jutland, Nodre Randlev (NMK journ. no. 112)
52. Denmark, Jutland, Humlebakken (NMK C 33449)
53. Denmark, Zealand, Hellig Kors Kilde (ROM, on display)
54. Denmark, Zealand, Lake Tissø (NMK C 1423/75 KN 1332) (schematic variant)
55–6. Denmark, Zealand, Hørgården, 2 examples including schematic variant (Hansen 2000, 17)
57. Denmark, Bornholm, Rosmannegård (Finn Ole Nielsen pers. comm.)
58. Germany, Schleswig-Holstein, Hedeby (WMH 2005/T2000)
59. Germany, Schleswig-Holstein, Hedeby (WMH 2003/1074)
60. Germany, Schleswig-Holstein, Hedeby (WMH 2003/1420)
61. Germany, Hamburg-Waltershof (Först 1993) (schematic variant)
62. Iceland, Þorljótsstaðir, Lýtingstaðahreppur (Eldjárn 1956, 105–6, 312; Hayeur-Smith 2004, fig. 17) (schematic variant)
63. Iceland, Kálfborgará, Bárðdælahreppur (Eldjárn 1956, 155–6, 312 fig. 130; Hayeur-Smith 2004, fig. 16) (schematic variant)
64. Finland, Åland, Saltvik, Kvarnbakken (ÅM 345:202; Kivikoski 1973, pl. 74, fig. 667)
65–70. Russia, 6 examples (Jansson 1984b, 62)

List 6: Borre-style disc brooches, Type II A2

1. Denmark, Fyn, Gudme (Thrane 1987, fig. 11c, 4:592)
2. Sweden, Skåne, Uppåkra (LUHM 36592)

List 7: Borre-style disc brooches, Type II C

1. Norway, Sogn og Fjordane, Nordfjord (BGM 5525) (Capelle 1968a, 117)
2. Sweden, Uppland, Birka grave 554 (Jansson 1984b, 62, fig. 8:2 IIC)

3. Sweden, Uppland, Birka, The Black Earth (SHM 7542:1)
4. Sweden, Småland, Vimmerby, Gästgivarhagen (SHM 507:8) (Jansson 1984b, 63)
5. Sweden, Uppland, Alsike, Tuna (SHM 10289:X) (Arne 1934, pl. 15, 3; Jansson 1984b, 63)
6. Sweden, Uppland, Sollentuna, Bög (SHM 23257:3) (Jansson 1984b, 63)
7. Sweden, Västergötland, Larv (Jansson 1984b, 63)
8. Sweden, Ågermanland, Nora, Bölesta (SHM 2108) (Paulsen 1933, pl. 35, 8)
9. Denmark, Zealand, Lejre (Christiansen 1991, 62, fig. 31g)
10. Germany, Schleswig-Holstein, Hedeby (WMH 2003/2407)
11. Russia, Gnezdovo, Smolensk (Jansson 1984b, 62–3)

List 8: *Borre-style disc brooches, Type II D*

1. Sweden, Uppland, Grindtorp (SHM 31685; Wigren 1981, fig. 65; Jansson 1984b, 63)
2. Sweden, Västmanland, Jämmertuna (SHM 25006:3; Jansson 1984b, 63)
3–6. Sweden, Uppland, Björkö, Birka: 4 examples, including 1 from the Black Earth (Jansson 1984b, 59, 63)
7. Denmark, Jutland, Kongelunden (NMK C 30619)
8. Denmark, Jutland, Vorbasse (NMK journ. no. 1124/75)
9. Denmark, Zealand, Lake Tissø (NMK C 32167 KN 745)
10. Denmark, Zealand, Lake Tissø (NMK C 32167 KN 1360)
11. Denmark, Zealand, Trelleborg grave 50 (Nørlund 1948, 128 pl. 25, 7)
12–15. Germany, Schleswig-Holstein, Hedeby: 4 examples (Capelle 1968a, 46, cat. nos. 76–7, pl. 11, 9; Jansson 1984b, 63)
16. Germany, Schleswig-Holstein, Hedeby (WMH 2004/9274)
17. Germany, Schleswig-Holstein, Hedeby (WMH 2003/8007)
18. Germany, Schleswig-Holstein, Hedeby (WMH 2003/3638)
19. Faroe Island, Toftanes, Eysturoy, Tórshavn (Stumann Hansen 1989, fig. 11a)

List 9: *Disc brooches with Borre-style interlace*

1. Sweden, Uppland, Birka, grave 968 (variant) (Arbman 1940–43, pl. 71, 14) (Jansson 1984, fig. 8:2 III E)
2. Denmark, Zealand, Kalmergården, Store Fuglede (NMK KN938)
3. Denmark, Zealand, Kalmergården, Store Fuglede (NMK KN1647)
4. Denmark, Zealand, Boeslunde, Langetofte (NMK C 32661)
5. Denmark, Zealand, Lejre (ROM: LE op x 93)
6. Denmark, Jutland, Syvsig (Rieck 1982, 8)
7. Denmark, Jutland, Sebbersund (Leahy and Paterson 2001, 197)
8. Denmark, Jutland, Ålborg, Lindholm Høje (NMK C 30703)
9. Germany, Schleswig-Holstein, Hedeby (WMH 2003/1773)

List 10: *Pendants with Borre-style interlace*

1. Denmark, Zealand, Kalmergården, Store Fuglede (NMK C 32167 KN 1)

List 11: Models for producing disc brooches with Borre-style interlace

1. Denmark, Zealand, Lake Tissø (Jørgensen 2003, fig. 15.23 no. 1)

List 12: Pendants and brooches with a design paralleled on a brooch from Akenham, Suffolk

1. Denmark, Fyn, Nonnebakken (Herrmann 1982, 165, fig. 182) (pendant)
2. Denmark, Jutland, Naboskab (Johannessen 2001, 17) (brooch)
3. Denmark, Zealand, Lake Tissø (NMK 1423/75 KN 904) (brooch)
4. Denmark, Jutland, Over Randlev (Andersen and Klindt-Jansen 1971, fig. 8) (brooch)
5. Denmark, Fyn, Odense (NMK C 35196) (brooch)
6. Denmark, Fyn, Gudme (NMK C 36550) (brooch)
7. Denmark, Zeland, Sorø (NMK C 4715) (brooch)

List 13: Jellinge-style disc brooches, Type I A1

1. Sweden, Uppland, Birka grave 777 (Jansson 1984b, 59; Arbman 1940–43, pl. 70, 19)
2. Sweden, Södermanland, Berga and Folkesta, Tumbo (SHM 18212:6; Jansson 1984b, 60)
3. Sweden, unprovenanced (UUM 1225; Jansson 1984b, 60)
4. Denmark, Jutland, Albøge, Kumlhøj (NMK C 30822)
5. Denmark, Jutland, Hvorup (NMK C 30615)
6. Denmark, Jutland, Haldum (Damm 2005, 73)
7–8. Denmark, Lolland, 2 examples (Jens Jeppesen, pers. comm.)
9. Denmark, Zealand, Boeslunde, Langetofte (NMK C 32668)
10. Germany, Schleswig-Holstein, Hedeby (WMH 2003/4268)
11. Germany, Schleswig-Holstein, Hedeby (WMH 2004/6011)
12. Germany, Schleswig-Holstein, Hedeby (WMH 2004/8270)
13. Germany, Saxony-Anhalt, Dähre (Muhl 2006)
14. Iceland, Hofsstaðir, Garðabær (Robinson 2004)

List 14: Jellinge-style disc brooches, Type I B2

1. Norway, Sogn og Fjordane, Sogndal (Shetelig 1920, fig. 313)
2. Denmark, Zealand, Brordrup (NMK journ. no. 825/36)
3. Germany, Schleswig-Holstein, Hedeby (Capelle 1968a, 52, pl. 12, 2)
4. Germany, Schleswig-Holstein, Hedeby (WMH 2003/3706)

List 15: Jellinge-style disc brooches, Type I C

1. Denmark, Zealand, Himmelev, Søndersø (NMK C 30231)
2. Denmark, Zealand, Lejre (Christiansen 1991, fig. 31f)
3. Denmark, Jutland, Nørholm Skole (NMK C 33006)
4. Norway, Vestfold, Kaupang (Blindheim and Heyerdahl-Larsen 1999, pl. 66h)

List 16: *Jellinge-style disc brooches, Type I D*

1. Sweden, Skåne, Uppåkra (LUHM 2016)
2. Denmark, Zealand, Lake Tissø (NMK 1423/75 KU21)
3. Denmark, Jutland, Stentinget (NMK C 31438) (Nilsson 1994, fig. 5b)
4. Germany, Schleswig-Holstein, Hedeby (Callmer 1989, 40)
5. Germany, Schleswig-Holstein, Hedeby (WMH 2006/12347)
6. Germany, Schleswig-Holstein, Hedeby (WMH 2006/13765)

List 17: *Jellinge-style disc brooches, Type I E*

1. Denmark, Jutland, Viborg (Kristensen and Vellev 1982, 4)
2. Denmark, Zealand, Lake Tissø (Jørgensen 2003, fig. 15.10 no. 4)
3. Denmark, Zealand, Lille Lyngby (NMK C 34198)
4. Denmark, Fyn, Hårby, Tjørnehøj (NMK C 35199)
5. Denmark, Zealand, Holbæk, Bakkendrup (NMK C 35731 7947/97)
6. Germany, Schleswig-Holstein, Hedeby (WMH 2004/9132)

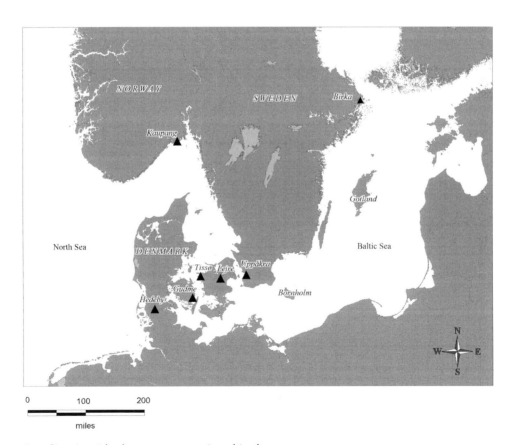

Scandinavia with place-names mentioned in the text

Appendix B: XRF analysis of Scandinavian and Anglo-Scandinavian brooches

Introduction

Recent XRF analysis of Viking-Age Scandinavian artefacts, including brooches, has revealed many items to be brass (copper + zinc), rather than bronze (copper + tin) as is traditionally assumed (Eremin 1996; 1997; Eremin et al. 1998; Arrhenius 1989). This is true of items found within Scandinavia, as well as artefacts found in the British Isles on sites with a known Scandinavian presence, such as York, Lincoln, and Dublin (Bayley 1992, 809–10; 2009; Fanning 1994). The importance of brass within Scandinavian metalworking practices is at odds with its rare employment in insular metals, with analysis suggesting that brass was infrequently used within Britain between the Late Roman and Late Anglo-Saxon periods (Bayley 1990, 22). In this context, the presence of low levels of brass observed in insular artefacts with Scandinavian stylistic influence, found at Scandinavian sites within Britain, is likely to reflect the recycling of brass from existing, Scandinavian metals (Eremin 1996; 1997; Eremin et al. 1998).

The possibility that there existed different metal-alloy traditions for Scandinavian and insular artefacts prompted the present writer to test the compositions of Scandinavian and Anglo-Scandinavian brooches found in England. It was hoped that such analysis might reveal the place of manufacture of Scandinavian and Anglo-Scandinavian items, with moderate to high levels of zinc suggesting production within Scandinavia, or on Scandinavian sites in England. Low levels of zinc observed in Scandinavian or Anglo-Scandinavian products may be due to the recycling of brasses with a high zinc content, suggesting the availability of Scandinavian metals and metalworking techniques.

Methods

The author, in collaboration with Dr Adrian Allsop of Oxford University, analysed nine Scandinavian and thirteen Anglo-Scandinavian brooches found in England, all of which came from the collections of North Lincolnshire and Norwich Castle Museums. In order to increase the amount of available data for Scandinavian brooches found in Scandinavia, analysis was also conducted on three Scandinavian brooches from Denmark, currently on loan to Norwich Castle Museum from the National Museum, Copenhagen.

The brooches were analysed at the Research Laboratory for Archaeology, Oxford University, using non-destructive Energy Dispersive X-ray fluorescence (XRF). Quantitative data was obtained for eight elements: copper (Cu), zinc (Zn), lead (Pb), iron (Fe), nickel (Ni), arsenic (As), silver (Ag) and tin (Sn). As XRF achieves a penetration depth of just 1–2 mm, the recorded compositions relate to the surface of the brooch and may not be representative of the underlying alloy. This is a potentially significant factor where the brooch surface is corroded, since corrosion is thought to increase levels of lead and tin, and decrease levels of zinc in some instances (Eremin et al. 1998, 3). The analyses were conducted without any sample preparation; although only clean, flat surfaces free of visible signs of corrosion were sampled, the results can only be considered semi-quantitative.

Results

The results of the XRF analysis are presented in the Tables 1–3 with the Scandinavian brooches from Denmark, and Scandinavian and Anglo-Scandinavian brooches found in England, presented separately.

Table 1: Scandinavian brooches from Denmark: The results obtained for the three brooches found in Denmark highlighted an appreciable quantity of zinc in a lozenge brooch but insignificant levels in the remaining two brooches, suggesting variability in the use of brass for small Scandinavian brooches. With a moderate zinc content of just under 8 per cent and also a significant lead element, the lozenge brooch could be confidently identified as a leaded brass, with the two remaining brooches constituting copper-alloys, with the addition of lead in one case. Notably, all three Scandinavian brooches analysed were small brooches (a lozenge, disc, and small trefoil brooch), and are thus distinct from the large brooch types (oval, large trefoil, and equal-armed brooches) which have formed the focus of earlier analyses (Eremin 1996, 1997; Richardson 1997). While brass is consistently found to dominate in collections of large, ostentatious Scandinavian brooches, the current results suggest that brass was used more selectively for smaller brooches, perhaps considered less valuable. This suggestion is significant, since many of the Scandinavian brooches found in England represent small brooch types. It is hoped that future analyses of equivalent items will test the validity of these results.

Table 2: Scandinavian brooches found in England: In total, nine Scandinavian brooches found in England were subject to XRF analysis, including two large and seven small brooches. The two large brooches (cat. nos. 357, 407) were both found to be brasses with moderate zinc components of around 12 per cent and 9 per cent, suggesting their manufacture within Scandinavia or at

Table 1 Scandinavian brooches from Denmark

Item	Cu	Sn	Zn	Pb	As	Fe	Ag	Alloy
Trefoil brooch Lake Tissø, Denmark	83.75%	5.92%	3.83%	3.40%	0.10%	2.92%	0.08%	*copper-alloy/gunmetal*
Lozenge brooch Lake Tissø, Denmark	67.22%	1.33%	7.99%	9.81%	0.43%	5.85%	0.56%	*leaded brass*
Convex disc brooch Lake Tissø, Denmark	83.95%	3.07%	1.42%	7.41%	<0.20%	3.09%	0.28%	*leaded copper-alloy/gunmetal*

Table 2 Scandinavian brooches from England

Item	Cu	Sn	Zn	Pb	As	Fe	Ag	Alloy
Cat. no. 4 Lozenge brooch	81.69%	0.13%	4.13%	13.67%	0.06%	0.22%	0.10%	*leaded copper-alloy*
Cat. no. 9 Lozenge brooch	83.38%	0.15%	12.29%	2.54%	<0.50%	0.85%	0.34%	*brass*
Cat. no. 15 Lozenge brooch	23.96%	<0.04%	3.20%	66.90%	<0.07%	5.84%	0.10%	*lead-alloy*
Cat. no. 327 Terslev-style disc brooch	85.23%	3.49%	2.68%	5.70%	0.43%	2.44%	0.31%	*copper-alloy/ gunmetal*
Cat. no. 357 Large trefoil brooch	74.91%	4.39%	11.80%	2.96%	1.60%	3.80%	0.32%	*brass*
Cat. no. 407 Large trefoil brooch	82.41%	0.77%	8.97%	3.53%	<0.14%	4.06%	0.17%	*brass*
Cat. no. 473 Jellinge-style disc brooch	89.60%	0.22%	3.15%	4.73%	0.12%	1.22%	0.32%	*copper-alloy*
Cat. no. 486 Jellinge-style disc brooch	89.77%	0.12%	1.93%	7.16%	0.05%	0.24%	0.22%	*leaded copper-alloy*
Cat. no. 487 Jellinge-style disc brooch	77.82%	1.43%	9.35%	8.80%	0.47%	1.97%	0.21%	*leaded brass*

Table 3 Anglo-Scandinavian brooches from England

Item	Cu	Sn	Zn	Pb	As	Fe	Ag	Alloy
Cat. no. 10 Lozenge brooch	86.84%	0.15%	3.43%	8.60%	0.08%	0.91%	0.07%	*lead-alloy*
Cat. no. 56 Borre-style disc brooch	83.89%	<0.08%	3.32%	12.91%	<0.07%	1.47%	0.08%	*lead-alloy*
Cat. no. 84 Borre-style disc brooch	86.26%	0.19%	4.30%	8.15%	0.07%	0.83%	0.09%	*lead-alloy*
Cat. no. 222 East Anglian Series brooch	85.07%	3.80%	0.07%	9.54%	0.19%	1.25%	0.10%	*leaded copper-alloy*
Cat. no. 272 East Anglian Series brooch	86.38%	0.07%	1.69%	10.90%	0.07%	0.82%	0.09%	*lead-alloy*
Cat. no. 314 East Anglian Series brooch	81.29%	0.18%	1.76%	16.10%	0.08%	0.52%	0.12%	*lead-alloy*
Cat. no. 363 Small trefoil brooch	46.11%	9.90%	1.93%	26.18%	0.06%	6.84%	0.11%	*lead-alloy*
Cat. no. 366 Small trefoil brooch	67.18%	<0.07%	0.89%	26.01%	<0.06%	5.76%	0.10%	*lead-alloy*
Cat. no. 384 Small trefoil brooch	80.70%	0.08%	3.45%	15.31%	0.07%	0.46%	0.08%	*lead-alloy*
Cat. no. 396 Small trefoil brooch	73.08%	0.08%	7.69%	18.37%	0.07%	0.64%	0.10%	*leaded brass*
Cat. no. 421 Small trefoil brooch	34.75%	0.91%	2.02%	53.52%	0.33%	7.37%	0.15%	*lead-alloy*
Cat. no. 475 Jellinge-style disc brooch	63.06%	0.04%	12.13%	19.23%	0.39%	5.21%	0.26%	*leaded brass*

Scandinavian sites within England. Brasses were also recorded for two small brooches, including a lozenge brooch (cat. no. 9), which had the highest observed zinc content, at over 12 per cent. The remaining artefacts were mainly judged to be copper-alloys, with metal-alloys consistent with those recorded for small brooches from Denmark. However, a Scandinavian lozenge brooch was assessed as a lead-alloy, with a high lead content (cat. no. 15). This item, from Elsham, Lincolnshire, is the finest lozenge brooch recorded from England, with crisp, intricate beading along its arms. The use of lead in this instance is likely to have facilitated the application of such fine stylistic detail, since lead is a softer material than copper-alloy and easier to shape after casting.

Table 3: Anglo-Scandinavian brooches from England: Among the thirteen Anglo-Scandinavian brooches analysed, just two items were found to consist of brass, in both instances with appreciable quantities of lead (cat. nos. 396, 475). These items may have been produced in a Scandinavian setting within England, perhaps using brass from recycled, Scandinavian metals. Significantly, these items show strong Scandinavian features in other ways. The Jellinge-style disc brooch (cat. no. 475) is identical to its Scandinavian counterparts, only being classed as Anglo-Scandinavian due to the absence of an attachment loop, while the geometric trefoil brooch (cat. no. 396) displays a casting flaw also found on brooches within Scandinavia, indicating that it came from the same model as brooches produced there. Taken together, the brass content and design features of these items strongly suggest that they were the products of Scandinavian craftsmen working in England.

The remaining Anglo-Scandinavian brooches showed consistently high levels of lead, not observed among the Scandinavian corpus. Although zinc appears to have been used in some alloys, it was not observed at a level which would suggest the recycling of Scandinavian metals. Zinc levels were especially low among East Anglian Series brooches, which could be classed as leaded copper-alloys. These items show no influence from Scandinavian metalworking practices and may have been produced in Anglo-Saxon workshops within the Danelaw, as their insular brooch form and attachment mechanisms would suggest. Overall, the frequent use of lead as the dominant metal Anglo-Scandinavian products finds parallels among Late Anglo-Saxon brooches and strap-ends, but not among Scandinavian jewellery, where lead use is infrequent (Leahy 2007, 179, fig. 80). In this sense, the Anglo-Scandinavian brooches have a closer affinity with Anglo-Saxon, rather than Scandinavian, artefacts.

Conclusions

The mix of copper-alloys and brasses recorded among the brooches from Denmark hints at variability in Scandinavian metalworking practices, at least in

the use of brass to make small brooch types. Within England, the artefacts iden-
tified by the author as Scandinavian and Anglo-Scandinavian were each charac-
terized by different metal-alloy compositions, with lead-alloys dominating the
assemblage of Anglo-Scandinavian items and brasses and copper-alloys prevail-
ing among Scandinavian items. The presence of brass among the Scandinavian
artefacts strongly suggests that select items were manufactured in line with
Scandinavian techniques, either within Scandinavia, or within Scandinavian
workshops in England. With two notable exceptions, Anglo-Scandinavian items
exhibit distinct compositions involving high levels of lead. Variation in the use
of brass across the Anglo-Scandinavian corpus is likely to reflect the different
contexts in which such items were produced. However, most Anglo-Scandi-
navian items included in this survey look insular in terms of their metal-alloys,
perhaps reflecting their manufacture by craftsmen trained in Anglo-Saxon
traditions.

Appendix C: Anglo-Saxon and Continental brooches from Norfolk, Suffolk, and Lincolnshire

Appendix C: Anglo-Saxon and Continental brooches from Norfolk, Suffolk, and Lincolnshire

County	Parish	Brooch Type	Reference	Culture
Norfolk	unprovenanced	Quadruped brooch	Hattat 1989, no. 3032	Anglo-Saxon
Norfolk	Narborough	Quadruped brooch	PAS 'Find-ID' NMS-BCFB26	Anglo-Saxon
Norfolk	Hillington	Quadruped brooch	Norfolk HER 20176	Anglo-Saxon
Norfolk	Little Snoring	Quadruped brooch	Norfolk HER 29132	Anglo-Saxon
Norfolk	Forncett	Quadruped brooch	Norfolk HER 24658	Anglo-Saxon
Norfolk	Mundham	Quadruped brooch	Norfolk HER 24894	Anglo-Saxon
Norfolk	Elsing	Quadruped brooch	Norfolk HER 28643	Anglo-Saxon
Norfolk	Hevingham	Quadruped brooch	Norfolk HER 29292	Anglo-Saxon
Norfolk	Salle	Quadruped brooch	Norfolk HER 30429	Anglo-Saxon
Norfolk	Thompson	Quadruped brooch	Norfolk HER 39736	Anglo-Saxon
Norfolk	Martham	Quadruped brooch	Norfolk HER 41693	Anglo-Saxon
Norfolk	Norwich	Quadruped brooch	Norfolk HER 148N/780N	Anglo-Saxon
Norfolk	Marham	Quadruped brooch	Norfolk HER 51156	Anglo-Saxon
Norfolk	Fincham	Quadruped brooch	Norfolk HER 33345	Anglo-Saxon
Norfolk	Fincham	Quadruped brooch	Norfolk HER 33345	Anglo-Saxon
Norfolk	Crimplesham	Quadruped brooch	Norfolk HER 15539	Anglo-Saxon
Norfolk	Kenninghall	Quadruped brooch	Norfolk HER 19545	Anglo-Saxon
Norfolk	Bracon Ash	Quadruped brooch	Norfolk HER 29304	Anglo-Saxon
Norfolk	Attleborough	Quadruped brooch	Norfolk HER 29896	Anglo-Saxon
Norfolk	Kelling	Quadruped brooch	Norfolk HER 30248	Anglo-Saxon
Norfolk	Foulden	Quadruped brooch	Norfolk HER 50090	Anglo-Saxon

Norfolk	Colney	Quadruped brooch	PAS 'Find-ID' NMS117	Anglo-Saxon
Norfolk	Felthorpe	Quadruped brooch	PAS 'Find-ID' NMS81	Anglo-Saxon
Norfolk	unprovenanced	Quadruped brooch	Hattat, 1987, 315, fig. 103, 1310	Anglo-Saxon
Norfolk	Bunwell	Quadruped brooch	Norfolk HER 10007	Anglo-Saxon
Norfolk	Brampton	Quadruped brooch	Norfolk HER 1006	Anglo-Saxon
Norfolk	Bradwell and Great Yarmouth	Quadruped brooch	Norfolk HER 11787	Anglo-Saxon
Norfolk	Norton Subcourse	Quadruped brooch	Norfolk HER 15015	Anglo-Saxon
Norfolk	Lingwood and Burlingham	Quadruped brooch	Norfolk HER 20249	Anglo-Saxon
Norfolk	Hainford	Quadruped brooch	Norfolk HER 1663	Anglo-Saxon
Norfolk	Burnham Market and Overy	Quadruped brooch	Norfolk HER 18496	Anglo-Saxon
Norfolk	Howe	Quadruped brooch	Norfolk HER 20252	Anglo-Saxon
Norfolk	Oxborough	Quadruped brooch	Norfolk HER 1021 SF 12	Anglo-Saxon
Norfolk	Oxborough	Quadruped brooch	Norfolk HER 1021 SF20	Anglo-Saxon
Norfolk	Fring	Quadruped brooch	Norfolk HER 23001	Anglo-Saxon
Norfolk	Hillington	Quadruped brooch	Norfolk HER 23492	Anglo-Saxon
Norfolk	Tattersett	Quadruped brooch	Norfolk HER 2373	Anglo-Saxon
Norfolk	Spixworth	Quadruped brooch	Norfolk HER 25101	Anglo-Saxon
Norfolk	Gunthorpe	Quadruped brooch	Norfolk HER 24568	Anglo-Saxon

(*continued*)

(continued)

County	Parish	Brooch Type	Reference	Culture
Norfolk	Bylaugh	Quadruped brooch	Norfolk HER 25690	Anglo-Saxon
Norfolk	Wells next the Sea	Quadruped brooch	Norfolk HER 24668	Anglo-Saxon
Norfolk	Skeyton	Quadruped brooch	Norfolk HER 25682	Anglo-Saxon
Norfolk	Little Dunham	Quadruped brooch	Norfolk HER 30272	Anglo-Saxon
Norfolk	Postwick	Quadruped brooch	Norfolk HER 30475	Anglo-Saxon
Norfolk	Congham	Quadruped brooch	Norfolk HER 30754	Anglo-Saxon
Norfolk	Bawburgh	Quadruped brooch	Norfolk HER 31100	Anglo-Saxon
Norfolk	Whissonsett	Quadruped brooch	Norfolk HER 31800	Anglo-Saxon
Norfolk	Postwick	Quadruped brooch	Norfolk HER 33265	Anglo-Saxon
Norfolk	Carleton Rode	Quadruped brooch	Norfolk HER 34589	Anglo-Saxon
Norfolk	Surlingham	Quadruped brooch	Norfolk HER 35077	Anglo-Saxon
Norfolk	Saxlingham Nethergate	Quadruped brooch	Norfolk HER 35142	Anglo-Saxon
Norfolk	Stratton Strawless	Quadruped brooch	Norfolk HER 36793	Anglo-Saxon
Norfolk	Kenninghall	Quadruped brooch	Norfolk HER 39626	Anglo-Saxon
Norfolk	Great Witchingham	Quadruped brooch	Norfolk HER 39544	Anglo-Saxon
Norfolk	Great Witchingham	Quadruped brooch	Norfolk HER 40668	Anglo-Saxon
Norfolk	Outwell	Quadruped brooch	Norfolk HER 41077	Anglo-Saxon
Norfolk	East Rudham	Quadruped brooch	Norfolk HER 41690	Anglo-Saxon
Norfolk	Aldeby	Quadruped brooch	Norfolk HER 41979	Anglo-Saxon

Norfolk	Little Cressingham/ Threxton	Quadruped brooch	Norfolk HER 4707	Anglo-Saxon
Norfolk	Thurton	Quadruped brooch	Norfolk HER 1663	Anglo-Saxon
Norfolk	Rocklands	Quadruped brooch	Norfolk HER 44736	Anglo-Saxon
Norfolk	Sisland	Quadruped brooch	Norfolk HER 45417	Anglo-Saxon
Norfolk	Horning	Quadruped brooch	Norfolk HER 39636	Anglo-Saxon
Norfolk	Heacham	Quadruped brooch	Norfolk HER 51073	Anglo-Saxon
Norfolk	Swaffham	Quadruped brooch	Frick 1992/3, 389, no. 40	Anglo-Saxon
Norfolk	Swainsthorpe	Quadruped brooch	Norfolk HER 9721–2	Anglo-Saxon
Norfolk	Burgh Castle	Quadruped brooch	Norfolk HER 13227	Anglo-Saxon
Norfolk	Rockland St Mary	Quadruped brooch	Norfolk HER 51213	Anglo-Saxon
Norfolk	unprovenanced	Quadruped brooch variant	Frick 1992/3, fig. 11, 49	Anglo-Saxon
Norfolk	Riddlesworth	Quadruped brooch variant	Norfolk HER 36076	Anglo-Saxon
Norfolk	Thetford	Quadruped brooch variant	Smedley and Owles 1965, 174	Anglo-Saxon
Norfolk	Thetford	Disc brooch	Norfolk HER 11521	Anglo-Saxon
Norfolk	Postwick	Disc brooch with cross motif	Norfolk HER 13603	Anglo-Saxon
Norfolk	Cockley Cley	Rectangular brooch	Norfolk HER 15017	Anglo-Saxon
Norfolk	Hainford	Nummular brooch	Norfolk HER 16738	Anglo-Saxon
Norfolk	Pentney	Nummular brooch	Norfolk HER 17761	Anglo-Saxon
Norfolk	Cawston	Lead disc brooch	Norfolk HER 19522	Anglo-Saxon
Norfolk	South Creake	Lead disc brooch	Norfolk HER 1958	Anglo-Saxon

(continued)

(continued)

County	Parish	Brooch Type	Reference	Culture
Norfolk	Walsingham	Nummular brooch	Norfolk HER 2024	Anglo-Saxon
Norfolk	Walpole St Peter	Lead disc brooch	Norfolk HER 20274	Anglo-Saxon
Norfolk	Walople St Peter	Lead disc brooch	Norfolk HER 20274	Anglo-Saxon
Norfolk	Shotesham	Cross-shaped brooch	Norfolk HER 21165	Anglo-Saxon
Norfolk	Westacre	Lead disc brooch	Norfolk HER 21302	Anglo-Saxon
Norfolk	Pulham St Mary	Disc brooch	Norfolk HER 22621	Anglo-Saxon
Norfolk	Brockdish	Nummular brooch	Norfolk HER 25665	Anglo-Saxon
Norfolk	Trowse with Newton	Disc brooch with cross motif	Norfolk HER 24793	Anglo-Saxon
Norfolk	Wramplingham	Nummular brooch	Norfolk HER 33055	Anglo-Saxon
Norfolk	Dereham	Rectangular brooch	Norfolk HER 25593	Anglo-Saxon
Norfolk	Hainford	Cross-shaped brooch	Norfolk HER 25775	Anglo-Saxon
Norfolk	North Creake	Nummular brooch	Norfolk HER 25777	Anglo-Saxon
Norfolk	Beachamwell	Disc brooch with equal-armed cross	Norfolk HER 2635	Anglo-Saxon
Norfolk	West Rudham	Disc brooch with equal-armed cross	Norfolk HER 28130	Anglo-Saxon
Norfolk	Ashill	Disc brooch	Norfolk HER 28571	Anglo-Saxon
Norfolk	Wrengingham	Nummular brooch	Norfolk HER 28622	Anglo-Saxon
Norfolk	Tibenham	Nummular brooch	Norfolk HER 28632	Anglo-Saxon
Norfolk	Barwick	Lead brooch	Norfolk HER 28705	Anglo-Saxon
Norfolk	Tattersett	Brooch with equal-armed cross	Norfolk HER 31825	Anglo-Saxon

Norfolk	Croxton	Brooch with equal-armed cross	Norfolk HER 31834	Anglo-Saxon
Norfolk	Aylsham	Nummular brooch	Norfolk HER 29275	Anglo-Saxon
Norfolk	North Creake	Brooch with cross motif	Norfolk HER 29428	Anglo-Saxon
Norfolk	Quidenham	Brooch with equal-armed cross	Norfolk HER 29447	Anglo-Saxon
Norfolk	Sculthorpe	Brooch with equal-armed cross	Norfolk HER 29821	Anglo-Saxon
Norfolk	Deopham	Disc brooch	Norfolk HER 29875	Anglo-Saxon
Norfolk	Marham	Cross-shaped brooch	Norfolk HER 30111	Anglo-Saxon
Norfolk	Bradenham	Lead disc brooch	Norfolk HER 30636	Anglo-Saxon
Norfolk	Congham	Disc brooch with equal-armed cross	Norfolk HER 30754	Anglo-Saxon
Norfolk	East Rudham	Disc brooch	Norfolk HER 30761	Anglo-Saxon
Norfolk	Ryston	Disc brooch	Norfolk HER 31096	Anglo-Saxon
Norfolk	East Walton	Lead brooch	Norfolk HER 31125	Anglo-Saxon
Norfolk	East Walton	Lead brooch	Norfolk HER 31125	Anglo-Saxon
Norfolk	Beachamwell	Nummular brooch	Norfolk HER 31911	Anglo-Saxon
Norfolk	Merton	Nummular brooch	Norfolk HER 31926	Anglo-Saxon
Norfolk	Saham Toney	Disc brooch with cruciform motif	Norfolk HER 32019	Anglo-Saxon
Norfolk	Felthorpe	Disc brooch with equal-armed cross	Norfolk HER 31649	Anglo-Saxon
Norfolk	West Rudham	Nummular brooch	Norfolk HER 32133	Anglo-Saxon
Norfolk	West Rudham	Disc brooch	Norfolk HER 32133	Anglo-Saxon

(continued)

(continued)

County	Parish	Brooch Type	Reference	Culture
Norfolk	Wiveton	Nummular brooch	Norfolk HER 33250	Anglo-Saxon
Norfolk	Blakeney	Nummular brooch	PAS 'Find-ID' NMS-5FA413	Anglo-Saxon
Norfolk	Burnham Market	Nummular brooch	Norfolk HER 44627	Anglo-Saxon
Norfolk	Westacre	Nummular brooch	Norfolk HER 32619	Anglo-Saxon
Norfolk	Wramplingham	Lead disc brooch with cruci-form motif	Norfolk HER 25697	Anglo-Saxon
Norfolk	Sporle with Palgrave	Nummular brooch	Norfolk HER 32940	Anglo-Saxon
Norfolk	Felthorpe	Cross-shaped brooch	Norfolk HER 33091	Anglo-Saxon
Norfolk	Marsham	Disc brooch	Norfolk HER 33807	Anglo-Saxon
Norfolk	Norwich, Fye Bridge/Fishergate	Disc brooch	Norfolk HER 26515	Anglo-Saxon
Norfolk	Costessey	Nummular brooch	Norfolk HER 34875	Anglo-Saxon
Norfolk	Thetford	Disc brooch	Norfolk HER 35335	Anglo-Saxon
Norfolk	Weeting with Broomhill	Nummular brooch	PAS 'Find-ID' SF3885	Anglo-Saxon
Norfolk	Tacolneston	Disc brooch	Norfolk HER 35834	Anglo-Saxon
Norfolk	Swanton Morley	Equal-armed cross fleury brooch	Norfolk HER 12299	Anglo-Saxon
Norfolk	Seething	Equal-armed cross fleury brooch	Norfolk HER 40302	Anglo-Saxon
Norfolk	Stratton Strawless	Equal-armed cross fleury brooch	Norfolk HER 24031	Anglo-Saxon

Norfolk	Quidenham	Equal-armed cross fleury brooch	Norfolk HER 31315	Anglo-Saxon
Norfolk	Norton Subcourse	Equal-armed cross fleury brooch	Norfolk HER 36227	Anglo-Saxon
Norfolk	Norton Subcourse	Equal-armed cross fleury brooch	Norfolk HER 36227	Anglo-Saxon
Norfolk	Norton Subcourse	Equal-armed cross fleury brooch	Norfolk HER 36227	Anglo-Saxon
Norfolk	Quidenham	Lead brooch	Norfolk HER 29448	Anglo-Saxon
Norfolk	Quidenham	Lead disc brooch with cruci-form motif	Norfolk HER 29448	Anglo-Saxon
Norfolk	South Walsham	Equal-armed cross fleury brooch	Norfolk HER 36546	Anglo-Saxon
Norfolk	Letheringsett with Glandford	Lead disc brooch	Norfolk HER 28045	Anglo-Saxon
Norfolk	Merton	Lead disc brooch with cross motif	Norfolk HER 38055	Anglo-Saxon
Norfolk	Whissonsett	Nummular brooch	Norfolk HER 39273	Anglo-Saxon
Norfolk	Field Dalling	Lead brooch	Norfolk HER 39982	Anglo-Saxon
Norfolk	Shotesham	Nummular brooch	Norfolk HER 40000	Anglo-Saxon
Norfolk	Merton	Nummular brooch	Norfolk HER 40116	Anglo-Saxon
Norfolk	Thetford	Pewter and glass brooch	Norfolk HER 40942	Anglo-Saxon
Norfolk	Norwich	Nummular brooch	Norfolk HER 41193	Anglo-Saxon
Norfolk	Upwell	Composite disc brooch	Norfolk HER 41359	Anglo-Saxon

(continued)

(continued)

County	Parish	Brooch Type	Reference	Culture
Norfolk	Burnham Market	Disc brooch with equal-armed cross	Norfolk HER 41977	Anglo-Saxon
Norfolk	Lyng	Nummular brooch	Norfolk HER 43112	Anglo-Saxon
Norfolk	Burnham Market	Nummular brooch	Norfolk HER 44627	Anglo-Saxon
Norfolk	Postwick	Disc brooch with cross motif	Norfolk HER 49093	Anglo-Saxon
Norfolk	Bracon Ash	Disc brooch with cross motif	Norfolk HER 50372	Anglo-Saxon
Norfolk	Stody	Disc brooch	Norfolk HER 51150	Anglo-Saxon
Norfolk	Outwell	Disc brooch	Norfolk HER 51930	Anglo-Saxon
Norfolk	Swaffham	Nummular brooch	PAS 'Find-ID' NMS-69A740	Anglo-Saxon
Norfolk	Swaffham	Disc brooch with equal-armed cross	PAS 'Find-ID' NMS-698432	Anglo-Saxon
Norfolk	Dereham	Disc brooch with equal-armed cross	PAS 'Find-ID' NMS-8B7666	Anglo-Saxon
Norfolk	Westacre	Nummular brooch	PAS 'Find-ID' NMS-109141	Anglo-Saxon
Norfolk	Westacre	Nummular brooch	PAS 'Find-ID' NMS-895D26	Anglo-Saxon
Norfolk	Swaffham	Disc brooch with equal-armed cross	PAS 'Find-ID' NMS-993175	Anglo-Saxon
Norfolk	Thetford	Lead disc brooch	PAS 'Find-ID' SF-4BD9B2	Anglo-Saxon
Norfolk	Oxborough	Lead disc brooch	PAS 'Find-ID' NMS542	Anglo-Saxon
Norfolk	Gaywood	Disc brooch with fleury cross	Norfolk HER 5544	Anglo-Saxon
Norfolk	Hindringham	Disc brooch with fleury cross	Norfolk HER 25659	Anglo-Saxon

Norfolk	Thetford	Lead disc brooch	Goodall 1984, fig. 109,6	Anglo-Saxon
Norfolk	Thetford	Lead disc brooch	Goodall 1984, fig. 109,8	Anglo-Saxon
Norfolk	Middle Harling	Lead disc brooch	Margeson 1995, 53 fig. 34,3	Anglo-Saxon
Norfolk	Middle Harling	Pewter disc brooch	Margeson 1995, 53 fig. 34,4	Anglo-Saxon
Norfolk	Castle Acre	*Kreuzemailfibel*	Wamers 1994, List 5, 66	Continental
Norfolk	Hilgay	*Kreuzemailfibel*	Wamers 1994, List 5, 67	Continental
Norfolk	Little Cressingham	*Kreuzemailfibel*	Wamers 1994, List 5, 68	Continental
Norfolk	Thetford	*Kreuzemailfibel*	Goodall 1984, 68, fig. 109,7	Continental
Norfolk	Thetford	*Kreuzemailfibel*	Goodall 1994, 68, fig. 109,7	Continental
Norfolk	Thetford	*Heiligenfibel*	Wamers 1994, 217, no. 13a	Continental
Norfolk	Elsing	*Heiligenfibel*	Norfolk HER 36591	Continental
Norfolk	Aswell Thorpe	*Heiligenfibel*	Norfolk HER 30585	Continental
Norfolk	Thetford	*Heiligenfibel*	Wamers 1994, 217, no. 13b	Continental
Norfolk	unprovenanced	*Kreuzemailfibel*	Hattat 1987, 315, fig. 103, 1309	Continental
Norfolk	Spixworth	*Kreuzemailfibel*	Norfolk HER 39564	Continental
Norfolk	Shropham	*Kreuzemailfibel*	Frick 1992/3, 371, no. 196	Continental
Norfolk	Castle Acre	*Scheibenfibel mit Kreuzmotiv*	Frick 1992/3, 373, no. 19	Continental
Norfolk	South Lopham	*Scheibenfibel mit Kreuzmotiv*	Norfolk HER 31336	Continental
Norfolk	East Harling	*Scheibenfibel mit Kreuzmotiv*	Hattat 1989, 216, fig. 103, 1690	Continental
Norfolk	Barton Bendish	*Scheibenfibel mit Kreuzmotiv*	PAS 'Find-ID' NMS-003F74	Continental
Norfolk	Grimston	*Scheibenfibel mit Kreuzmotiv*	Norfolk HER 32100	Continental

(*continued*)

(continued)

County	Parish	Brooch Type	Reference	Culture
Norfolk	Thetford	*Scheibenfibel mit Kreuzmotiv*	Goodall 1984, 23, 68 fig. 109,1	Continental
Norfolk	Thetford	*Scheibenfibel mit Kreuzmotiv*	Goodall 1984, 23, 68 fig. 109,3	Continental
Norfolk	Twaithe St Mary	*Scheibenfibel mit Peltaverzierung*	Hattat 1989, 221 fig. 105,1696	Continental
Norfolk	Norwich	*Munzfibel*	Ayers 1985, 63, fig. 55,2	Continental
Norfolk	Oxborough	*Munzfibel*	Frick 1992/3, 395, no. 58	Continental
Norfolk	Barton Bendish	*Rechtekfibel*	PAS 'Find-ID' NMS-931FD7	Continental
Norfolk	Loddon	*Rechtekfibel*	Norfolk HER 21933	Continental
Norfolk	Oxborough	*Rechtekfibel*	Norfolk HER 1021	Continental
Norfolk	Fincham	*Rechtekfibel*	Norfolk HER 30053	Continental
Norfolk	Beachamwell	Navel or wheel brooch	PAS 'Find-ID' NMS-CBABC6	Continental
Norfolk	Attleborough	*Kreuzfibel*	Norfolk HER 36681	Continental
Lincs	Horncastle	Lead disc brooch	NLM4364	Anglo-Saxon
Lincs	North Willingham	Lead disc brooch	NLM4905	Anglo-Saxon
Lincs	Alford	Lead disc brooch	NLM Alford	Anglo-Saxon
Lincs	South Ferriby	Lead disc brooch	NLM255	Anglo-Saxon
Lincs	Swinhope	Lead disc brooch	NLM4239	Anglo-Saxon
Lincs	Nettleton	Lead disc brooch	NLM3908	Anglo-Saxon
Lincs	Folkingham	Lead disc brooch	NLM3581	Anglo-Saxon
Lincs	nr. Ruskington	Lead disc brooch	NLM3330	Anglo-Saxon

Lincs	Thimbleby	Lead disc brooch	NLM2252	Anglo-Saxon
Lincs	Thimbleby	Lead disc brooch	NLM2251	Anglo-Saxon
Lincs	Elsham	Lead disc brooch	NLM0444	Anglo-Saxon
Lincs	Edlington	Lead disc brooch	NLM0216	Anglo-Saxon
Lincs	Ketsby	Lead disc brooch	NLM1242	Anglo-Saxon
Lincs	Ketsby	Lead disc brooch	NLM1243	Anglo-Saxon
Lincs	Owston Ferry	Lead disc brooch	NLM1248	Anglo-Saxon
Lincs	Ketsby	Lead disc brooch	NLM Ketsby 43	Anglo-Saxon
Lincs	Barrow upon Humber	Lead disc brooch	NLM Barrow	Anglo-Saxon
Lincs	Ketsby	Lead disc brooch	NLM233	Anglo-Saxon
Lincs	Fulletby	Lead disc brooch	PAS 'Find-ID' DENO-6C04E1	Anglo-Saxon
Lincs	Osbournby	Lead disc brooch	PAS 'Find-ID' LIN-900B71	Anglo-Saxon
Lincs	Harlaxton	Lead disc brooch	PAS 'Find-ID' NLM-861E47	Anglo-Saxon
Lincs	Binbrook	Lead disc brooch	Leahy 2007, fig. 80.2	Anglo-Saxon
Lincs	Scopwick	Lead disc brooch	NLM Scopwick	Anglo-Saxon
Lincs	Osgodby	Quadruped brooch	NLM1239	Anglo-Saxon
Lincs	Swallow	Quadruped brooch	NLM1241	Anglo-Saxon
Lincs	Glentham	Quadruped brooch	NLM1246	Anglo-Saxon
Lincs	Boston	Quadruped brooch	NLM4637	Anglo-Saxon
Lincs	Lindsey	Quadruped brooch	Frick 1992/3, 389, no. 37	Anglo-Saxon
Lincs	Lindsey	Quadruped brooch	Frick 1992/3, 389, no. 38	Anglo-Saxon
Lincs	nr. Rippingale	Quadruped brooch	Pers. comm. James Graham-Campbell	Anglo-Saxon

(*continued*)

(continued)

County	Parish	Brooch Type	Reference	Culture
Lincs	East Kirkby	Quadruped brooch	PAS 'Find-ID' NCL-76F167	Anglo-Saxon
Lincs	East Kirkby	Quadruped brooch	PAS 'Find-ID' NCL-E79A74	Anglo-Saxon
Lincs	Sutterton	Quadruped brooch	PAS 'Find-ID' NLM4637	Anglo-Saxon
Lincs	Kirmington	Quadruped brooch	NLM 1244	Anglo-Saxon
Lincs	Roxby	Quadruped brooch	NLM 1240	Anglo-Saxon
Lincs	South Ferrriby	Quadruped brooch	NLM 1245	Anglo-Saxon
Lincs	Aunsby and Dembleby	Nummular brooch	PAS LIN-DA08E0	Anglo-Saxon
Lincs	Barnetby le Wold	Nummular brooch	Leahy 2007, fig. 82.5	Anglo-Saxon
Lincs	Aylesby	Nummular brooch	NLM 1999,081	Anglo-Saxon
Lincs	Ashby de la Launde	Nummular brooch	Leahy 2006, pl. 13,9	Anglo-Saxon
Lincs	Ryther	Cross-shaped brooch	NLM A51	Anglo-Saxon
Lincs	Caistor	*Scheibenfibel*	NLM Caistor	Anglo-Saxon
Lincs	Lincoln	*Scheibenfibel mit Peltaverzierung*	Frick 1992/3, 376, 12	Continental
Lincs	Sleaford	*Scheibenfibel mit Peltaverzierung*	Hattat 1989, 218 fig. 104,1691	Continental
Lincs	Glentham	*Kreuzemailfibel*	NLM1247	Continental
Lincs	Blyborough	*Rechteckfibel*	PAS 'Find-ID' LIN-B7B0C6	Continental
Lincs	Heighington	*Rechteckfibel*	PAS Find-ID LIN-5FCA06	Continental
Lincs	Braceby and Sapperton	*Kreuzfibel*	PAS 'Find-ID' NLM-D33EF6	Continental
Lincs	South Ferriby	*Kreuzfibel*	NLM1257	Continental

Lincs	Barnetby le Wold	*Munzfibel*	NLM 1999.050	Continental
Suffolk	Little Saxham	Nummular brooch	PAS 'Find-ID' SF-5081B5	Anglo-Saxon
Suffolk	Somerton	Nummular brooch	PAS 'Find-ID' SF-7796	Anglo-Saxon
Suffolk	Hesset	Nummular brooch	PAS 'Find-ID' SF-5095A6	Anglo-Saxon
Suffolk	Ingham	Nummular brooch	PAS 'Find-ID' SF-6880	Anglo-Saxon
Suffolk	Westerfield	Nummular brooch	PAS 'Find-ID' SF-7561	Anglo-Saxon
Suffolk	Rishangles	Nummular brooch	PAS 'Find-ID' SF-6D7152	Anglo-Saxon
Suffolk	Great Barton	Nummular brooch	PAS 'Find-ID' SF-C76146	Anglo-Saxon
Suffolk	Coddenham	Cross-shape brooch with florid arms	PAS 'Find-ID' SF-C42F44	Anglo-Saxon
Suffolk	Wyverstone	Cross-shape brooch with florid arms	PAS 'Find-ID' SF-BABE11	Anglo-Saxon
Suffolk	Akenham	Cross-shape brooch with florid arms	PAS 'Find-ID' SF-AF2167	Anglo-Saxon
Suffolk	Trimley St Mary	Disc brooch with glass setting	PAS 'Find-ID' SF-2DF342	Anglo-Saxon
Suffolk	Wyverstone	Disc brooch with glass setting	PAS 'Find-ID' SF-E66913	Anglo-Saxon
Suffolk	Mellis	Disc brooch with glass setting	PAS 'Find-ID' SF-7F2271	Anglo-Saxon
Suffolk	Renham	Nummular brooch	PAS 'Find-ID' SF-88E700	Anglo-Saxon
Suffolk	Ixworth	Disc brooch with cross motif	PAS 'Find-ID' SF-F634E3	Anglo-Saxon
Suffolk	Eye	Disc brooch with cross motif	PAS 'Find-ID' SF-28C726	Anglo-Saxon
Suffolk	Westerfield	Disc brooch with concentric decoration	PAS 'Find-ID' SF-CBDDE0	Anglo-Saxon
Suffolk	Worlington	Cross-shaped brooch	PAS 'Find-ID' SF-0DDCE5	Anglo-Saxon

(continued)

(continued)

County	Parish	Brooch Type	Reference	Culture
Suffolk	Freckenham	Openwork disc brooch with cross motif	PAS 'Find-ID' SF-E11DD4	Anglo-Saxon
Suffolk	Rattlesden	Disc brooch	PSIA 1994, fig. 48C	Anglo-Saxon
Suffolk	Hasketon	Disc brooch	West 1998, fig. 47, no. 19	Anglo-Saxon
Suffolk	Westerfield	Disc brooch	West 1998, fig. 96, no. 2	Anglo-Saxon
Suffolk	Ipswich	Disc brooch	West 1998, fig. 97, no. 8	Anglo-Saxon
Suffolk	Suffolk/Essex border	Pewter disc brooch	West 1998, fig. 135, no. 7	Anglo-Saxon
Suffolk	Mildenhall	Quadruped brooch	PAS 'Find-ID' SF-0CEA72	Anglo-Saxon
Suffolk	Holbrook	Quadruped brooch	PAS 'Find-ID' SF-B91713	Anglo-Saxon
Suffolk	Ramsholt	Quadruped brooch	PAS 'Find-ID' SF8D3536	Anglo-Saxon
Suffolk	Sternfield	Quadruped brooch	PAS 'Find-ID' SF10497	Anglo-Saxon
Suffolk	Aldeburgh	Quadruped brooch	PAS 'Find-ID' SF3964	Anglo-Saxon
Suffolk	Felixstowe	Quadruped brooch	Frick 1992/3, 389, no. 30	Anglo-Saxon
Suffolk	Foxhall	Quadruped brooch	Frick 1992/3, 389, no. 31	Anglo-Saxon
Suffolk	Ipswich (School St.)	Quadruped brooch	West 1998, 215, fig. 97, no. 6	Anglo-Saxon
Suffolk	Icklingham	Quadruped brooch	Frick 1992/3, 389, no. 33	Anglo-Saxon
Suffolk	Icklingham	Quadruped brooch	West 1998, fig. 56, no. 9	Anglo-Saxon
Suffolk	Gisleham	Quadruped brooch	West 1998, 164, fig. 47, no. 6	Anglo-Saxon
Suffolk	Cavenham	Quadruped brooch	West 1998, 133, fig. 17, no. 2	Anglo-Saxon
Suffolk	Brantham	Quadruped brooch	West 1998, 127, fig. 11, no. 2	Anglo-Saxon
Suffolk	Great Blakenham	Quadruped brooch	West 1998, 126 fig. 10, no. 4	Anglo-Saxon
Suffolk	Barnham	Quadruped brooch	Frick 1992/3, 388, no. 21	Anglo-Saxon

Suffolk	Butley	Quadruped brooch	Frick 1992/3, 388, no. 24	Anglo-Saxon
Suffolk	Dunwich	Quadruped brooch	Suffolk HER DUN22	Anglo-Saxon
Suffolk	Butley Priory	Quadruped brooch	Frick 1992/3, 388, no. 25	Anglo-Saxon
Suffolk	Ixworth	Quadruped brooch	Frick 1992/3, 389, no. 35	Anglo-Saxon
Suffolk	Lakenheath	Quadruped brooch	Frick 1992/3, 389, no. 36	Anglo-Saxon
Suffolk	Tuddenham St Martin	Quadruped brooch	Pers. comm. James Graham-Campbell	Anglo-Saxon
Suffolk	Thelnetham	Quadruped brooch	*PSIA* 1993 fig. 21G	Anglo-Saxon
Suffolk	Wortham	Quadruped brooch	PAS 'Find-ID' SF-3B3127	Anglo-Saxon
Suffolk	Westley	Quadruped brooch	Frick 1992/3, 389, no. 43, fig. 10	Anglo-Saxon
Suffolk	Levington	Quadruped brooch	Pers. comm. James Graham-Campbell	Anglo-Saxon
Suffolk	unprovenanced	Quadruped brooch	Hattat 2000, no. 1311	Anglo-Saxon
Suffolk	Dunwich	Quadruped brooch ariant	Frick 1992/3, 389, no. 28	Anglo-Saxon
Suffolk	Ipswich	Quadruped brooch variant	West 1998, 214, fig. 96, no. 3	Anglo-Saxon
Suffolk	Butley	Quadruped brooch variant	West 1998, 131, fig. 15, no. 6	Anglo-Saxon
Suffolk	unprovenanced	Quadruped brooch variant	Frick 1992/3, fig. 11, 50	Anglo-Saxon
Suffolk	Ipswich	Quadruped brooch variant	Frick 1992/3, 389, no. 34	Anglo-Saxon
Suffolk	Barham	*Heiligenfibel*	BM 1989,0502.1	Continental
Suffolk	Billingsgate	*Heiligenfibel*	Buckton 1991, 144, 145 fig. 3.24a–c	Continental
Suffolk	Ixworth	*Heiligenfibel*	PAS 'Find-ID' SF-733814	Continental
Suffolk	Hessett	*Heiligenfibel*	PAS 'Find-ID' SF-27F435	Continental
Suffolk	Wetheringsett-cum-Brockford	*Heiligenfibel*	Suffolk HER WCB016	Continental

(*continued*)

(continued)

County	Parish	Brooch Type	Reference	Culture
Suffolk	Bures St Mary	*Kreuzemailfibel*	Suffolk HER BSM038	Continental
Suffolk	Barham	*Kreuzemailfibel*	Suffolk HER BRH041	Continental
Suffolk	Santon Downham	*Kreuzemailfibel*	PAS 'Find-ID' SF-29EFB2	Continental
Suffolk	Wattisfield	*Kreuzemailfibel*	West 1998, fig. 133.2	Continental
Suffolk	Mildenhall	*Scheibenfibel mit Kreuzmotiv*	Wilson 1964, 156, fig. 26, 54	Continental
Suffolk	Market Weston	*Scheibenfibel mit Peltaverzierung*	Frick 1992/3, 377 no. 17	Continental
Suffolk	Bramford	*Kreuzfibel*	West 1998, fig. 10.12	Continental
Suffolk	Lowestoft	*Munzfibel*	Frick 1992/3, 395 no. 56	Continental
Suffolk	Barnham	*Munzfibel*	Frick 1992/3, 195, no. 52	Continental
Suffolk	Pakenham	*Rechteckfibel*	PAS 'Find-ID' SF-ED1145	Continental
Suffolk	Woodbridge	*Rechteckfibel (possible)*	PAS 'Find-ID' PAS-D45A87	Continental
Suffolk	Playford	*Rechteckfibel*	Suffolk HER PLY015-MSF1124	Continental
Suffolk	Coddenham	*Rechteckfibel*	PAS 'Find-ID' SF178	Continental

Bibliography

Aagård, G.-B. (1984), 'Gleicharmige Spangen', in Arwidsson (ed.), *Systematische Analysen*, 95–110.

Abrams, L. (2001), 'Edward the Elder's Danelaw', in Higham and Hill (eds.), *Edward the Elder*, 128–43.

——(2005), 'Scandinavian Place-Names and Settlement-History: Flegg, Norfolk, and East Anglia in the Viking Age', in A. Mortensen and S. V. Arge (eds.), *Viking and Norse in the North Atlantic* (Tórshavn: Foya Fródskaparfeleg), 307–23.

——and Parsons, D. N. (2004), 'Place-Names and the History of Scandinavian Settlement in England', in Hines et al. (eds.), *Land, Sea and Home*, 379–431.

Adams, L. (1980), *Lincoln: a Viking Town*, Lincolnshire Museums Information Sheet, Archaeology Series, 20 (Lincoln: Lincolnshire County Council).

Ager, B. (2003), *Potential Find of Treasure: a Silver Thor's Hammer Pendant with Gold Insert from Great Witchingham, Norfolk*, Treasure Report 2003/T241.

—— and Williams, G. (2010), *The Vale of York Hoard* (London: The British Museum Press).

Althin, A. (1963), *Några Gravfynd och Fornlämningar I Norra Sollentuna, Uppland*, unpublished seminar paper, Stockholm University.

Andersen, H. H. and Klindt-Jensen, O. (1971), 'Hesselbjerg. En Gravplads fra Vikingetid', *Kuml. Årbøg for Jysk Arkæologisk Selskab*, 31–43.

Arbman, H. (1940–43), *Birka I. Die Gräber*. 2 vols. (Uppsala: Almqvist and Wiksell).

Arents, U. (1992), *Die Wikingerzeitlichen Grabfunde von Haithabu*, unpublished PhD dissertation, University of Kiel.

Armbruster, B. (2004), 'Goldsmiths' Tools at Hedeby', in Hines et al. (eds.), *Land, Sea and Home*, 109–24.

——and Eilbracht, H. (2006), 'The Art of the Early Medieval Goldsmith. Technological Aspects of the Viking-Age Gold Treasure from Hiddensee, Germany', *Historical Metallurgy* 40 (1), 27–42.

Armstrong, P., Tomlinson, D., and Evans, D. H. (eds.) (1991), *Excavations at Lurk Lane Beverley, 1979–82* (Sheffield: Collis).

Arne, T. J. (1934), *Das Bootgräberfeld von Tuna in Alsike, Uppland* (Stockholm: Kungl. Vitterhets, Historie och Antikvitets Akademien).

Arrhenius, B. (1973), 'Gjutformar och Deglar, påträffade i Birka', in B. Ambrosiani (ed.) *Birka. Svarta Jordens Hamnområde. Arkeologisk Undersökning 1970–1971* (Stockholm: RAÄ-Rapport C1), 99–114.

——(1989), 'Kan metallanalyser ge en anvisning om när metallurgi blir inhemsk?', in *Icke-Järnmetaller—Malmfyndigheter och Metallurgi. Föredrag från Jernkontorets Berghistoriska utkotts Symposium på Statens Historiska Museer, 9 November 1988* (Stockholm: Jernkontorets Bergshistoriska Utskott), 11–20.

Arwidsson, G. (ed.) (1984), *Systematische Analysen der Gräberfunde. Birka II: 1* (Stockholm: Almqvist and Wiksell International).

——(ed.) (1986), *Systematische Analysen der Gräberfunde. Birka II: 2* (Stockholm: Almqvist and Wiksell International).

Arwidsson, (1989), 'Spangen, Fibeln und Beschläge/Anhänger verschiedener Formen', in Arwidsson (ed.), *Systematische Analysen*, 67–72.

——(ed.) (1989), *Systematische Analysen der Gräberfunde. Birka II*: 3 (Stockholm: Almqvist and Wiksell International).

Ashwin, T. and Davison, A. (eds.) (2005), *An Historical Atlas of Norfolk*, 3rd edn. (Chichester: Phillimore).

Ayers, B. (1985), *Excavations within the North-East Bailey of Norwich Castle, 1979*, East Anglian Archaeology Report 28 (Dereham: Norfolk Archaeology Unit).

Ayre, J., Wroe-Brown, R., and Malt, R. (1996), 'Aethelred's Hythe to Queenhithe: The Origin of a London Dock', *Medieval Life 5*, 14–25.

Baastrup, M. (2009), 'Småfibler af Karolingiske og Ottonske Typer i Danmark', *Aarbøger for Nordisk Oldkyndighed og Historie* 2005 (2009), 209–55.

Backhouse, J., Turner, D. H., and Webster, L. E. (eds.) (1984), *The Golden Age of Anglo-Saxon Art, 966–1066* (London: British Museum Press).

Bailey, R. N. (1978), 'The Chronology of Viking-Age Sculpture in Northumbria', in J. Lang (ed.), *Anglo-Saxon and Viking Age Sculpture*, BAR Brit. Series 49 (Oxford: British Archaeological Reports), 173–204.

——(1980), *Viking-Age Sculpture in Northern England* (London: Collins).

Bakka, E. (1965), 'Ytre Moa', *Viking* 29, 121–47.

Bayley, J. (1991), 'Anglo-Saxon Non-Ferrous Metalworking: a Survey', *World Archaeology* 23.1, 115–30.

——(1992), *Anglo-Scandinavian Non-Ferrous Metalworking from 16–22 Coppergate*, The Archaeology of York, The Small Finds, 17/7 (London: CBA for the York Archaeological Trust).

——(2009), 'Metalworking in Viking Dublin in its Insular Context', paper given at the UCL/British Museum Medieval Archaeology Seminar Series, 12th May 2009.

——with contributions by P. Budd (2008), *Lincoln: Evidence for Metalworking on Flaxengate and Other Sites in the City* (Portsmouth: English Heritage).

——Crossley, D. W., and Ponting, D. (2008), *Metals and Metalworking: a Research Framework for Archaeometallurgy* (London: Historical Metallurgy Society).

Beresford, G. (1987), *Goltho: the Development of an Early Medieval Manor c850–1150* (London: Historic Buildings & Monuments Commission for England).

Beresford, M. and Hurst, J. (1990), *English Heritage Book of Wharram Percy: Deserted Medieval Village* (London: Batsford).

Bergman, K. and Billberg, I. (1976), 'Metallhantverk', in A. W. Mårtensson (ed.), *Uppgrävt Förflutet för PKbanken i Lund* (Lund: Kulturhistoriska Museet).

Bersu, G. and Wilson, D. M. (1966), *Three Viking Graves in the Isle of Man* (London: Society for Medieval Archaeology).

Bertelsen, L. G. (1992), 'Præsentation af Ålborg-Gruppen—en Gruppe Dyrefibler uden Dyreslyng', *Aarbøger for Nordisk Oldkyndighed og Historie* (1991), 237–64.

——(1994), 'Urnesfibler i Danmark', *Aarbøger for Nordisk Oldkyndighed og Historie* (1992), 345–70.

Biddle, M. and Kjølbye-Biddle, B. (2001), 'Repton and the "Great Heathen Army", 873–4', in Graham-Campbell et al. (eds.), *Vikings and the Danelaw*, 45–96.

Bjørn, A. and Shetelig, H. (1940), 'Viking Antiquities in England', in H. Shetelig (ed.), *Viking Antiquities in Great Britain and Ireland*, Part IV (Oslo: H. Aschehoug).

Blackburn, M. A. S. (2001), 'Expansion and Control: Aspects of Anglo-Scandinavian Minting South of the Humber', in Graham-Campbell et al. (eds.), *Vikings and the Danelaw*, 125–42.

Blades, N. W. (1995), *Copper Alloys from English Archaeological Sites, 400–1600 AD*, unpublished PhD thesis, University of London.

Blair, J. (2007a), 'Introduction', in Blair (ed.), *Waterways and Canal-Building*, 1–18.

——(ed.) (2007b), *Waterways and Canal-Building in Medieval England* (Oxford: Oxford University Press).

Blindheim, C. and Heyerdahl-Larsen, B. (1999), *Kaupang-Funnene. Bind III. Gravplassene I Bikjholbergene/Lamøya: Undersøkelsene 1950–1957/Del A. Gravskikk* (Oslo: Universitets Oldsaksamling).

Brennand, M. (2006), 'Finding the Viking Dead', *Current Archaeology* 204, 623–9.

Brinch Madsen, H. B. (1984), 'Metal-Casting: Technique, Production and Workshops', in M. Bencard (ed.), *Ribe Excavations 1970–76, II* (Esbjerg: Sydjysk Universitetsforlag), 15–189.

Brøndsted, J. (1924), *Early English Ornament* (London: Hachette Ltd).

——(1936), 'Danish Inhumation Graves of the Viking Age', *Acta Archaeologica* VII, 81–228.

Buckton, D. (1986), 'Late 10th-and 11th-century Cloisonné Enamel Brooches', *Medieval Archaeology* 30, 8–18.

——1989, 'Late Anglo-Saxon or Early Anglo-Norman Cloisonné Enamel Brooches', *Medieval Archaeology* 33, 153–5.

Bu'lock, J. D. (1958), 'An East Scandinavian Disc-Brooch from Manchester', *Transactions of the Lancashire and Cheshire Antiquarian Society* LXVII, 113–14.

Cabot, S., Davies, G., and Hoggett, R. (2004), 'Sedgeford: Excavations of a Rural Settlement in Norfolk', in Hines et al. (eds.), *Land, Sea and Home*, 313–24.

Callmer, J. (1989), 'Gegossene Schmuckanhänger mit Nordischer Ornamentik', in Arwidsson (ed.), *Systematische Analysen*, 19–42.

——(1995), 'Hantverksproduktion, Samhällsförändringar och Bebyggelse. Iakttagelser från Östra Skandinavien ca 600–1100 e.Kr', in H. G. Resi (ed.), *Produksjon og Samfunn. Beretning fra 2. Nordiske Jernalderssymposium på Granavolden 7.–10. mai 1992. Varia* 30, 39–72.

——(1999), 'Vikingatidens Likarmade Spännen', in Hårdh (ed.), *Fynden i Centrum*, 201–20.

Cameron, E. and Mould, Q. (2003), 'Saxon Shoes, Viking Sheaths? Cultural Identity in Anglo-Scandinavian York', in Hines et al. (eds.), *Land, Sea and Home*, 457–66.

Cameron, K. (1965), 'Scandinavian Settlement in the Territory of the Five Boroughs: the Place-Name Evidence', first published as an inaugural lecture (Nottingham); reprinted in K. Cameron (ed.), *Place-Name Evidence for the Anglo-Saxon Invasion and Scandinavian Settlements*, Nottingham English Place-Name Society.

Campbell, J. (2001), 'What is Not Known about the Reign of Edward the Elder?', in Higham and Hill (eds.), *Edward the Elder*, 12–24.

Capelle, T. (1964), 'Eine im Jellingestil verzierte Schalenspange aus Haithabu', *Germania* 42, 216–27.

——(1968a), *Der Metallschmuck von Haithabu* (Neumünster: K. Wachholtz).

——(1968b), 'Kleeblattfibeln und Zierketten', *Fornvännen* 63, 1–9.

——(1999), 'Zwei Wikingische Modeln aus Stora Uppåkra', in Hårdh (ed.), *Fynden i Centrum*, 221–4.

——and Vierck, H. (1975), 'Weitere Modeln der Merowinger- und Wikingerzeit', *Frühmittelalterliche Studien* 9, 110–43.

Chadwick, H. M. (1905), *Studies on Anglo-Saxon Institutions* (Cambridge: Cambridge University Press).

Chester-Kadwell, M. (2005), 'Metal-Detector Finds in Context: New Light on "Dark Age" Cemeteries in the Landscape of Norfolk', *Archaeological Review from Cambridge* 20(1), 70–96.

——(2009), *Early Anglo-Saxon Communities in the Landscape of Norfolk*, BAR Brit. Series 481 (Oxford: Archaeopress).

Chilton, E. S. (1999), 'Material Meanings and Meaningful Materials: An Introduction', in E. S. Chilton (ed.), *Material Meanings: Critical Approaches to the Interpretation of Material Culture* (Salt Lake City: University of Utah Press), 1–6.

Christensen, T. (1991), 'Lejre: Fact and Fable', in J. D. Niles (ed.), *Beowulf and Lejre*, (Tempe, Arizona: ACMRS), 21–102.

——(2008), 'Detektorfund og Bebyggelse. Det Østlige Limfjordsområde i Yngre Jernalder og Vikingetid', *Kuml. Årbog for Jysk Arkæologisk Selskab* (2008), 101–43.

Christlein, R. (1978), *Die Alamannen. Archäologie eines Lebendigen Volkes* (Stuttgart: K. Theiss).

Cinthio, M. (1999), 'Guldsmed i Lund', in G. Fellows-Jensen and N. Lund (eds.), *Beretning fra Attende Tværfaglige Vikingesymposium*, Højbjerg: Forlaget Hikuin og Afdeling for Middelalderarkaeologi, 35–52.

City of Lincoln Archaeological Unit 1998, 'St Mark's Station, High Street, Lincoln. Archaeological Investigation', 2 vols. Archaeological Report 338.

Clark, C. (1979), 'Clark's First Three Laws of Applied Anthroponymics', *Nomina* 3, 13–18.

——(1982), 'The Early Personal Names of King's Lynn: an Essay in Socio-Cultural History, Part 1: Baptismal Names', *Nomina* 6, 51–71.

Clark, J. (1989), *Saxon and Norman London* (London: HMSO).

Craddock, P. T. (1989), 'Metalworking Techniques', in S. M. Youngs (ed.), *'The Work of Angels': Masterpieces of Celtic Metalwork 6th—9th Centuries AD* (London: British Museum Press for the Trustees of the British Museum in association with the National Museum of Ireland and the National Museums of Scotland), 170–211.

——Wallis, J. M., and Merkel, J. F. (2001), 'The Rapid Qualitative Analysis of Groups of Metalwork: Making a Dream Come True', in Redknap et al. (eds.), *Pattern and Purpose*, 117–24.

Damm, A. (ed.) (2005), *Viking Aros* (Århus: Moesgård Museum).

Davies, G. (2010), 'Early Medieval "Rural Centres" and West Norfolk: A Growing Picture of Diversity, Complexity and Changing Lifestyles', *Medieval Archaeology* 54, 89–122.

Davis, R. H. C. (1955), 'East Anglia and the Danelaw', *Transations of the Royal Historical Society*, 5th series, vol. 5 (1955), 23–39.

Dickinson, T. (1991), 'Material Culture as Social Expression: the Case of Saxon Saucer Brooches with Running Spiral Decoration', *Studien zur Sachsenforschung* 7, 39–70.

Dobinson, C. and Denison, S. (1995), *Metal Detecting and Archaeology in England* (London: English Heritage/Council for British Archaeology).

Downham, C. (2007), *Viking Kings of Britain and Ireland: the Dynasty of Ívarr to AD 1014* (Edinburgh: Dunedin Academic).

Dumville, D. (1992), *Wessex and England from Alfred to Edgar: Six Essays on Political, Cultural, and Ecclesiastical Revival* (Woodbridge: Boydell).

Eckardt, H. (2008), 'Technologies of the Body: Iron Age and Roman Gooming and Display', in Garrow et al. (eds.), *Rethinking Celtic Art*, 113–28.

Edwards, B. J. N. (1970), 'The Claughton Viking Burial', *Transactions of the Historic Society of Lancashire and Cheshire* 121 (1969), 109–16.

——(1998), *Vikings in North-West England: the Artifacts* (Lancaster, Centre for North-West Regional Studies: University of Lancaster).

Eilbracht, H. (1999), *Filigran- und Granulationskunst im Wikingischen Norden. Untersuchungen zum Transfer Frühmittelalterlicher Gold- und Silberschmiedetechniken Zwischen dem Kontinent und Nordeuropa* (Bonn: R. Habelt).

Eisenschmidt, S. (2004), *Grabfunde des 8. bis 11. Jahrhunderts zwischen Kongeå und Eider. Zur Bestattungssitte der Wikingerzeit im Südlichen Altdanemark*. Studien zur Siedlungsgeschichte und Archaologie der Ostseegebiete 5.1 & 5.2 (Neumünster: K. Wachholtz Verlag).

Eldjárn, K. (1956), *Kuml og Haugfé. Úrheiðnumsið á Íslandi* (Reykjavík: University of Iceland).

——and Fridriksson A. (2000), *Kuml og Haugfé í Heiðnum Sið á Íslandi* (2nd ed., revised by A. Fridriksson) (Reykjavík: Mál og Menning).

Eremin, K. (1996), 'Analysis of Three Insular Trefoil Strap Distributors', unpublished Analytical Research Laboratory Report No. 96/35, National Museums Scotland.

——(1997), 'Analysis of Norse Insular Strap-Fittings and Buckles', unpublished Analytical Research Laboratory Report No. 97/53, National Museums Scotland.

——Graham-Campbell, J., and Wilthew, P. (1998), 'Analysis of Copper-Alloy Artefacts from Pagan Norse Graves in Scotland', paper presented at the 31st International Symposium on Archaeometry. Budapest, 27 April–1 May 1998.

Evison, V. I. (1957), 'A Group of Late Saxon Brooches', *Antiquaries Journal* 37, 220–2.

——(1969), 'A Viking Grave at Sonning, Berkshire', *Antiquaries Journal* 49, 330–45.

Ewing, T. (2006), *Viking Clothing* (Stroud: Tempus).

Fairbrother, J. R. (1990), *Faccombe Netherton: Excavations of a Saxon and Medieval Manorial Complex* (London: British Museum).

Fairholt, F. W. (1847), 'Remarks on Ancient Fibula', *The Journal of the British Archaeological Association* II, 309–15.

Fanning, T. (1994), *Viking Age Ringed Pins from Dublin* (Dublin: Royal Irish Academy).

Fellows-Jensen, G. (1972), *Scandinavian Settlement Names in Yorkshire* (Copenhagen: Akademisk Forlag).

Feveile, C. and Jensen, S. (2000), 'Ribe in the 8th and 9th Century. A Contribution to the Archaeological Chronology of North Western Europe', *Acta Archaeologica* 71, 9–24.

Först, E. (1993), 'Wikingerschmuck aus der Elbe', *Archaologie in Deutschland* 3 (Juli–September), 45.

Frick, H.-J. (1992/3), 'Karolingische-Ottonische Scheibenfibeln des Nördlichen Formenkreises', *Offa* 49/50, 243–463.

Friis Johansen, K. (1912), 'Sølvskatten fra Terslev', *Aarbøger for Nordisk Oldkyndighed og Historie* (1912), 189–263.

Fuglesang, S. H. (1980), *Some Aspects of the Ringerike Style: a Phase of 11th Century Scandinavian Art* (Odense: Odense University Press).

——(1981), 'Stylistic Groups in Late Viking and Early Romanesque Art', *Acta ad Archaeologiam et Artium Historiam Pertinentia. Series altera in 8*, 1, 79–125.

Fuglesang, S. H. (1982), 'Early Viking Art'. *Acta ad Archaeologiam et Artium Historiam Pertinentia. Series altera in 8*, 2, 125–73.

——(1986), 'Recensioner. Ingmar Jansson, Ovala Spännbucklor: En Studie av Vikingatida Standardsmycken med Utgångspunket från Björkö-Fynden (1985)', *Fornvännen* 8, 234–7.

——(1987), ' "The Personal Touch", on the Identification of Workshops', in J. E. Knirk (ed.), *Proceedings of the 10th Viking Congress, Larkollen, Norway 1985. Universitets Oldsakamling Skrifter* 9, 219–30.

——(1991), 'The Axehead from Mammen and the Mammen Style', in Iversen (ed.), *Mammen*, 83–107.

——(1992), 'Bronzeguß und Serienproduktion in der Wikingerzeit', in A. Muhl and R.-M. Weiss (eds.), *Wikinger, Waräger, Normannen. Die Skandinavier und Europe 800–1200* (Berlin: Preußischer Kulturbesitz), 198–9.

——(2001), 'Animal Ornament: the Late Viking Period', in M. Müller-Wille and L. O. Larsson (eds.), *Tiere, Menschen, Götter: Wikingerzeitliche Kunststile und Ihre Neuzeitliche Rezeption* (Göttingen: Vandenhoeck and Ruprecht), 157–94.

——and Wilson, D. M. (eds.) (2006), *The Hoen Hoard: a Viking Gold Treasure of the Ninth Century* (Rome, Bardi Editore).

Gabra-Sanders, T. (1998), 'A Review of Viking-Age Textiles and Fibres from Scotland: An Interim Report', in L. B. Jørgensen and C. Rinaldo (eds.), *Textiles in European Archaeology: Reports from the 6th NESAT Symposium, 7–11th May 1996 in Borås, Sweden* (Göteborg: Göteborg: University), 177–85.

Gannon, A. (2003), *The Iconography of Early Anglo-Saxon Coinage: Sixth to Eighth Centuries* (Oxford: Oxford University Press).

Garrow, D., Gosden, C., and Hill, J. D. (eds.) (2008), *Rethinking Celtic Art* (Oxford: Oxbow Books).

Geake, H. (1999), 'Invisible Kingdoms: the Use of Grave-Goods in Seventh-Century England', *Anglo-Saxon Studies in Archaeology and History* 10, 203–15.

——(ed.) (2004), 'Medieval Britain and Ireland in 2003. Portable Antiquities Scheme Report', *Medieval Archaeology* 38, 232–47.

Gell, A. (1998), *Art and Agency: an Anthropological Theory* (Oxford: Clarendon Press).

Gilmore, G. R. and Metcalf, P. M. (1980), 'The Alloys of the Northumbrian Coinage in the Mid-Ninth Century', in D. M. Metcalf and W. A. Oddy (eds.), *Metallurgy in Numismatics* 1, 83–99.

Ginters, V. (1981), *Tracht und Schmuck in Birka und im Ostbaltischen Raum: Eine Vergleichende Studie* (Stockholm: Almqvist and Wiksell International).

Glørstad, Z. (2010), 'Sign of the Times? The Transfer and Transformation of Irish Pennannular Brooches in Viking-Age Norway', unpublished research paper.

Goodall, A. R. (1984), 'Non-ferrous metal objects', in A. Rogerson and C. Dallas, *Excavations in Thetford 1948–59 and 1973–80. East Anglian Archaeology Report* 22 (Dereham: Norfolk Archaeology Unit).

Graham-Campbell, J. (1976), 'Two Scandinavian Disc Brooches of Viking-Age Date from England', *The Antiquaries Journal* 65, 448–9.

——(1980), *Viking Artefacts* (London: British Museum Publications).

——(1983), 'An Anglo-Scandinavian Silver Ornament of Tenth-Century Date from Manchester', in M. Morris (ed.), *Medieval Manchester*, vol. 1 (Manchester, Greater Manchester Archaeological Unit), 7–8.

——(1987a), 'Western Penannular Brooches and Their Viking-Age Copies in Norway: a New Classification', in J. E. Knirk (ed.), *Proceedings of the Tenth Viking Congress* (Oslo: Universitetets Oldsaksamling Skrifter), 231–46.

——(1987b), 'From Scandinavia to the Irish Sea: Viking Art Reviewed', in M. Ryan (ed.), *Ireland and Insular Art, A.D. 500–1200: Proceedings of a Conference at University College Cork, 31 October–3 November 1985* (Dublin: Royal Irish Academy), 144–52.

——(1992), 'Anglo-Scandinavian Equestrian Equipment in Eleventh-Century England', *Anglo-Norman Studies* 14, 77–89.

——(1999), 'Rings and Things. Some Observations on the Hon hoard', in G. Fellows-Jensen and N. Lund (eds.), *Beretning fra Attende Tværfaglige Vikingesymposium*, Højbjerg: Forlaget Hikuin og Afdeling for Middelalderarkaeologi, 53–64.

——(2001a), 'National and Regional Identities: the "Glittering Prizes"', in Redknap et al. (eds.), *Pattern and Purpose*, 27–38.

——(2001b), 'Pagan Scandinavian Burial in the Central and Southern Danelaw', in Graham-Campbell et al. (eds.), *Vikings and the Danelaw*, 105–23.

——(2001c), 'The Northern Hoards. From Cuerdale to Bossall/Flaxton', in Higham and Hill (eds.), *Edward the Elder*, 212–29.

——and Batey, C. E. (1998), *Vikings in Scotland: An Archaeological Survey*. (Edinburgh: Edinburgh University Press).

——and Lloyd-Morgan, G. (1994), 'Copper Alloy', in S. W. Ward (ed.), *Excavations at Chester: Saxon Occupation Within the Fortress, Sites Excavated 1971–1984* (Chester: Chester City Council), 66–7.

——and Philpott, R. (eds.) (2009), *The Huxley Hoard: Scandinavian Settlement in the North West* (Liverpool: National Museums Liverpool).

——Hall, R., Jesch, J., and Parsons, D. N. (eds.) (2001) *Vikings and the Danelaw: Selected Papers from the Proceedings of the Thirteenth Viking Congress, Nottingham and York, 21–30 August 1997* (Oxford: Oxbow).

Gramtorp, D. and Henriksen, M. B. (2000), 'Fint Skal det Være—om Tinbelægning på Bronzesmykker fra Yngre Germansk Jernalder og Vikingetid', *Fynske Minder* 2000, 135–56.

Gräslund, B. (1976), 'Relative Chronology: Dating Methods in Scandinavian Archaeology', *Norwegian Archaeological Review* 9 (2), 69–83.

Green, C. (1967), 'The Urnes Style in East Anglia', *Norfolk Archaeology* 32, Part II, 240–2.

Greenwell, W. (1870), 'Scandinavian Brooches Found at Santon in Norfolk', *Proceedings of the Society of Antiquaries of London* IV, Part 4, 207–17.

Gregory, T. and Rogerson, A. J. G. (1984), 'Metal-Detecting in Archaeological Excavation', *Antiquity* 58, 179–84.

Griffiths, D. (2009), 'The Archaeological Background', in Graham-Campbell and Philpott (eds.), *The Huxley Hoard*, 13–21.

——(2010), *Vikings of the Irish Sea. Conflict and Assimiliation AD 790–1050* (Stroud: The History Press).

——Philpott, R. and Egan, G. (eds.) (2007), *Meols, The Archaeology of the North Wirral Coast, Discoveries and Observations in the 19th and 20th Centuries, with a Catalogue of Collections*, Oxford University School of Archaeology Monograph Series 68 (Oxford: Oxford University School of Archaeology).

Gurney, D. (1997), 'A Note on the Distribution of Metal-Detecting in Norfolk', *Norfolk Archaeology* 42, Part IV, 528–32.

Gustafson, G. (1906), *Norges Oldtid: Mindesmærker og Oldsager* (Kristiania: A. Cammermeyer).

Hadley, D. M. (1997), ' "And They Proceeded to Plough and Support Themselves": The Scandinavian Settlement of England', *Anglo-Norman Studies* 19, 69–96.

——(2002), 'Viking and Native: Re–thinking Identity in the Danelaw', *Early Medieval Europe* 11(1), 45–70.

——(2006), *The Vikings in England: Settlement, Society and Culture* (Manchester: Manchester University Press).

——and Richards, J. D. (2000), *Cultures in Contact: Scandinavian Settlement in England in the Ninth and Tenth Centuries* (Turnhout: Brepols).

Hägg, I. (1974), *Kvinnodräkten i Birka. Livplaggens Rekonstruktion på Grundval av Det Arkeologiska Materialet* (Uppsala: Institutionen for Arkeologi, Gustavianum).

——(1983), 'Viking Women's Dress at Birka: A Reconstruction by Archaeological Methods', in E. M. Carus-Wilson, N. B. Harte, and K. G. Ponting (eds.), *Cloth and Clothing in Medieval Europe: Essays in Memory of Professor E.M. Carus-Wilson* (London: Heinemann Educational Books), 316–50.

——(1986), 'Die Tracht', in Arwidsson (ed.), *Systematische Analysen, 51–72.

Halsall, G. (2000), 'The Viking Presence in England? The Burial Evidence Reconsidered', in Hadley and Richards (eds.), *Cultures in Contact*, 259–76.

Hansen, K. M. (2000), 'Hørgården', *Skalk* 2000 (1), 12–17.

Hårdh, B. (1984), 'Kleeblattfibeln' in Arwidsson (ed.), *Systematische Analysen, 85–94.

——(ed.) (1999), *Fynden i Centrum: Keramik, Glas och Metal från Uppåkra*. Uppåkrastudier 2. (Stockholm: Almqvist and Wiksell International).

——(2011), 'Scandinavian Metalwork', in D. Skre (ed.), *Things from the Town. Artefacts and Inhabitants in Viking-age Kaupang*. Norske Oldfunn XIV (Oslo: Aarhus University Press & the Kaupang Excavation Project), 29–64.

Hattatt, R. (2000), *A Visual Catalogue of Richard Hattatt's Ancient Brooches* (Oxford: Oxbow).

Hayeur Smith, M. (2004), *Draupnir's Sweat and Mardöll's Tears: An Archaeology of Jewellery, Gender and Identity in Viking-Age Iceland*, BAR Internat. Ser. 1276 (Oxford: Hedges).

Heather, P. J. (1996), *The Goths* (Oxford: Blackwell).

Hedeager Krag, A. (1995), 'Dragtudviklingen fra 8.–10. Årh. e. Kr. i Sydskandinavien—med Udgangspunkt i Skålformede Spænder', *LAG* 5, 7–71.

Hedeager Madsen, A. (1990), 'Women's Dress in the Viking Period in Denmark, Based on the Tortoise Brooches and Textile Remains', in P. Walton Rogers and J. P. Wild (eds.), *Textiles in Northern Archaeology: NESAT III: Textile Symposium in York, 6–9 May 1987* (London: Archetype Publications), 101–6.

Henry, P. A. (2004), 'Changing Weaving Styles and Fabric Types: The Scandinavian Influence', in Hines et al. (eds.), *Land, Sea and Home*, 443–56.

Herrmann, J. (1982), *Wikinger und Slaven. Zur Frühgeschichte der Ostseevölker* (Berlin: Akademie-Verlag).

Hickes, G. (1705), *Linguarum Vett. Septentrionalium Thesaurus*, 2 vols. (Oxford).

Higham, N. J. (1987), 'Landscape and Land Use in Northern England: A Survey of Agricultural Potential, c. 500 B.C.–A.D. 1000', *Landscape History* 9, 35–43.

——and Hill, D. (eds.) (2001), *Edward the Elder, 899–924* (London: Routledge).

Hilberg, V. (2009), 'Hedeby in Wulfstan's Days: A Danish Emporium of the Viking Age between East and West', in A. E. A. Trakadas (ed.), *Wulfstan's Voyage* (Roskilde: Viking Ship Museum), 79–113.

Hills, C. (1983), 'Animal Stamps on Anglo-Saxon Pottery in East Anglia', *Studien zur Sachsenforschung* 4, 93–110.

Hines, J. (1984), *The Scandinavian Character of Anglian England in the Pre-Viking Period*, BAR Brit. Series 124 (Oxford: BAR).

——Lane, A., and Redknap, M. (eds.) (2004), *Land, Sea and Home. Settlement in the Viking Period. Proceedings of a Conference on Viking-period Settlement, at Cardiff, July 2001* (Leeds: Maney).

Hinton, D. A. (1974), *A Catalogue of the Anglo-Saxon Ornamental Metalwork in the Department of Antiquities, Ashmolean Museum* (Oxford: Clarendon Press).

——(1990), *Archaeology, Economy and Society: England from the Fifth to the Fifteenth Century* (London: Routledge).

——(2005), *Gold and Gilt, Pots and Pins: Possessions and People in Medieval Britain* (Oxford: Oxford University Press).

——(2008), *The Alfred Jewel, and Other Late Anglo-Saxon Decorated Metalwork* (Oxford: Ashmolean Museum).

Hinz, H. (1966), 'Am Langen Band Getragene Bergkristallanhänger der Merowingerzeit', *Jahrbuch des Römische-Germanischen Zentralmuseums Mainz* 13, 212–30.

Hodder, I. (1982), *Symbols in Action: Ethnoarchaeological Studies of Material Culture* (Cambridge: Cambridge University Press).

Hooke, D. (2007), 'Uses of Waterways in Anglo-Saxon England', in Blair (ed.), *Waterways and Canal-Building*, 37–54.

Hough, C. (2002), 'Women in English Place-Names', in C. Hough and K. A. Lowe (eds.), *'Lastworda Betst': Essays in Memory of Christine E. Fell with her Unpublished Writings* (Donington: Shaun Tyas), 41–106.

Hunter, F. (2008), 'Celtic Art in Roman Britain', in Garrow et al. (eds.), *Rethinking Celtic Art*, 129–45.

Hutcheson, A. R. J. (2006), 'The Origins of King's Lynn? Control of Wealth on the Wash Prior to the Norman Conquest', *Medieval Archaeology* 50, 71–104.

Insley, J. (1999), 'Grimston-Hybrids', in H. Beck et al. (eds.), *Reallexikon der Germanischen Altertumskunde von Johannes Hoops*, 2nd edn., XIII (Berlin: Walter de Gruyter).

Iversen, M. (ed.) (1991), *Mammen: Grav, Kunst og Samfund i Vikingetid* (Højbjerg: Jysk Arkeologisk Selskab).

——Robinson, D. E., Hjermind, J., and Christensen, C. (eds.) (2005), *Viborg Søndersø 1018–1030. Arkæologi og Naturvidenskab i et Værkstedsområde fra Vikingetid* (Moesgård: Jysk Arkæologisk Selskab).

James Hammerton, A. (2004), 'Gender and Migration', in Levine (ed.), *Gender and Empire*, 156–80.

Janes, D. (1996), 'The Golden Clasp of the Late Roman State', *Early Medieval Europe* 5 (2), 127–53.

Jansson, I. (1981), 'Economic Aspects of Fine Metalworking in Viking-Age Scandinavia', in D. M. W. Wilson and M. Caygill (eds.), *Economic Aspects of the Viking Age*, British Museum Occasional Paper 30 (London: British Museum), 1–17.

——(1984a), 'Ovale Schalenspangen', in Arwidsson (ed.), *Systematische Analysen*, 45–57.

——(1984b), 'Kleine Rundspangen', in Arwidsson (ed.), *Systematische Analysen*, 58–74.

——(1984c), 'Grosse Rundspangen', in Arwidsson (ed.), *Systematische Analysen*, 75–84.

——(1985), *Ovala Spännbucklor: En Studie av Vikingatida Standardsmycken med Utgångspunkt från Björkö-fynden. Aun 7* (Uppsala: Institutionen för Arkeologi).

——(1991), 'År 970/971 och Vikingatidens Kronologi', in Iversen (ed.), *Mammen*, 267–84.

Jansson, I. (1992), 'Scandinavian Oval Brooches found in Latvia', *Studia Baltica Stockholmiensia. Die Kontake zwischen Ostbaltikum und Skandinavien im Frühen Mittelalter* 9 (Stockholm: Almqvist and Wiksell International), 61–77.

——(1999), 'Scandinavian Finds from the 9th–10th Centuries on Ryurikovo Gorodishche', in P. Purhonen (ed.), *Papers Presented by the Participants in the Archaeological Symposium 'Cultural Contacts in the Area of the Gulf of Finland in the 9th–13th Centuries', 13–14 May 1997 in the National Museum of Finland* (Helsinki: Museovirasto), 44–59.

Jensen, S. (1990), 'Metalfund fra Vikingetidsgårdene ved Gl. Hviding og Vilslev', *By, Marsk og Geest* 3, 27–40.

Jeppesen, J. (1999), 'Hesselbjerg', *Skalk* 1999 (6), 5–9.

Jesch, J. (2008), 'Scandinavian Women's Names in English Place-Names', in O. J. Padel and D. N. Parsons (eds.), *A Commodity of Good Names: Essays in Honour of Margaret Gelling* (Donington: Shaun Tyas), 154–62.

Johannessen, K. (2001), 'Naboskab', *Skalk* 2001 (5), 13–17.

Jones, R. (2005), 'Signatures in the Soil: the Use of Pottery in Manure Scatters in the Identification of Medieval Arable Farming Regimes', *Archaeological Journal* 161 (2005), 159–88.

Jørgensen, L. (1990), *Bækkegård and Glasergård. Two Cemeteries from the Late Iron Age on Bornholm*, (Copenhagen: Akamenisk Forlag).

——(2003), 'Manor and Market at Lake Tissø in the Sixth to Eleventh Centuries: The Danish "Productive" Sites', in Pestell and Ulmschneider (eds.), *Markets in Early Medieval Europe*, 175–207.

——and Pedersen, L. (1996), 'Vikinger ved Tissø. Gamle og Nye Fund fra et Handels- og Håndværkscenter', in S. Hvass (ed.), *Nationalmuseets Arbejdsmark 1996* (Copenhagen: Nationalmuseet), 22–36.

Kendrick, T. D. (1949), *Late Saxon and Viking Art* (London: Methuen).

Kershaw, J. (2008), 'The Distribution of the "Winchester" Style in Late Saxon England: Metalwork Finds from the Danelaw', *Anglo-Saxon Studies in Archaeology and History* 15, 254–69.

——(2010), *Viking-Age Scandinavian Art Styles and Their Appearance in the British Isles Part 1: Early Viking-Age Art Styles*, Finds Research Group AD700–1700, Datasheet no. 42.

——(2011), *Viking-Age Scandinavian Art Styles and Their Appearance in the British Isles. Part 2: Late Viking-Age Art Styles*, Finds Research Group AD700–1700, Datasheet no. 43.

Kirk, D. (1927), 'Trefoil Brooch from Yorkshire', *The Antiquaries Journal* VII, 526–8.

Kivikoski, E. (1938), 'Likarmade Spännen från Vikingatiden', *Finskt Museum* 45, 10–28.

——(1973), *Die Eisenzeit Finnlands: Bildwerk und Text* (Helsinki: Weilin and Göös).

Kleingärtner, S. (2004), 'Fibeln und Anhänger vom Typ Terslev und Ihre Gegossenen Imitationen', in Müller-Wille (ed.), *Zwischen Tier und Kreuz*, 205–376.

——(2007), *Der Pressmodelfund aus dem Hafen von Haithabu*, Ausgrabungen in Haithabu 12 (Neumünster: Wachholtz).

Kristensen, H. K. and Vellev, J. (1982), 'En Ikkeringeære for Byen', *Skalk* 1982 (5), 3–9.

Lang, J. (1978), 'Continuity and Innovation in Anglo-Scandinavian Sculpture', in J. Lang (ed.), *Anglo-Saxon and Viking-Age Sculpture and its Context: Papers from*

the *Collingwood Symposium on Insular Sculpture from 800 to 1066*, BAR British series 49, (Oxford: BAR), 145–72.

——(1991), *Corpus of Anglo-Saxon Stone Sculpture. Volume III. York and Eastern Yorkshire* (Oxford: Oxford University Press).

Laux, F. (2005), 'Eine Skandinavische Scheibenfibel aus Hamburg-Stellingen', *Offa* 52, 149–52.

Leahy, K. (2003a), 'Middle Anglo-Saxon Lincolnshire: An Emerging Picture', in Pestell and Ulmschneider (eds.), *Markets in Early Medieval Europe*, 138–54.

——(2003b), *Anglo-Saxon Crafts* (Stroud: Tempus).

——(2006), 'Anglo-Saxon Coin Brooches', in B. Cook, G. Williams, and M. Archibald (eds.), *Coinage and History in the North Sea World, c. AD 500–1250* (Leiden, Boston: Brill), 267–85.

——(2007), *The Anglo-Saxon Kingdom of Lindsey* (Stroud: Tempus).

——and Paterson, C. (2001), 'New Light on the Viking Presence in Lincolnshire: The Artefactual Evidence', in Graham-Campbell et al. (ed.), *Vikings and the Danelaw*, 181–202.

Lennartsson, M. (1997/8), 'Karolingische Metallarbeiten mit Pflanzenornanmentik', *Offa* 54/55, 431–619.

Levine, P. (ed.) (2004), *Gender and Empire*, The Oxford History of the British Empire Companion Series (Oxford: Oxford University Press).

Lillios, K. T. (1999), 'Objects of Memory: The Ethnography and Archaeology of Heirlooms', *Journal of Archaeological Method and Theory* 6 (3), 235–62.

Lønborg, B. (1994), 'Massenproduktion af Urnesfibler', *Aarbøger for Nordisk Old-kyndighed og Historie* (1992), 371–8.

——(1998), *Vikingetidens Metalbearbejdning*. Fynske Studier 17 (Odense: Odense Bys Museer).

Longstaff, W. H. (1848), 'Archaeological Intelligence: Anglo-Saxon Period', *Archaeological Journal* V, 220–1.

Loveluck, C. (2007), *Rural Settlement, Lifestyles and Social Change in the Later First Millennium AD: Anglo-Saxon Flixborough in its Wider Context* (Oxford: Oxbow).

——and Tys, D. (2006), 'Coastal Societies, Exchange and Identity along the Channel and Southern North Sea Shores of Europe, AD 600–1000', *Journal of Maritime Archaeology* (2006) 1, 140–69.

Lund, N. (1969), 'The Secondary Migration', *Mediaeval Scandinavia* 2, 196–201.

Lundström, P. (1965), *Gravfälten vid Fiskeby i Norrköping* (Stockholm: Almqvist and Wiksell).

Lyon, S. (2001), 'The Coinage of Edward the Elder', in Higham and Hill (eds.), *Edward the Elder*, 67–78.

MacGregor, A. (1978), 'Industry and Commerce in Anglo-Scandinavian York', in R. A. Hall (ed.), *Viking-Age York and the North*, (London: Council for British Archaeology), 37–57.

——(1985), *Bone, Antler, Ivory and Horn. The Technology of Skeletal Materials since the Roman Period* (London: Croom Helm).

Magnusson, M. and Pálsson, H. (eds.) (1969), *Laxdæla Saga* (London: Penguin).

Mainman, A. J. and Rogers, N. S. H. (2000), *Craft, Industry and Everyday Life: Finds from Anglo-Scandinavian York* (York: Published for the York Archaeological Trust by the Council for British Archaeology).

——— (2004), 'Craft and Economy in Anglo-Scandinavian York', in R. A. Hall et al. (eds.), *Aspects of Anglo-Scandinavian York*. Anglo-Scandinavian York 8/4 (York: Published for the York Archaeological Trust by the Council for British Archaeology), 459–87.

Maixner, B. (2004), 'Die Tierstilverzierten Metallarbeiten der Wikingerzeit aus Birka unter Besonderer Berücksichtigung des Borrestils im Norden', in Müller-Wille (ed.), *Zwischen Tier und Kreuz*, 9–203.

—— (2005), *Die Gegossenen Kleeblattformigen Fibeln der Wikingerzeit aus Skandinavien* (Bonn: R. Habelt).

Margeson, S. (1982), 'Viking Period Trefoil Brooches', *Norfolk Archaeology* 38, Part II, 208–10.

—— (1996), 'Viking Settlement in Norfolk: A Study of New Evidence', in S. Margeson, B. Ayers, and S. Heywood (eds.), *A Festival of Norfolk Archaeology* (Huntstanton: Norfolk and Norwich Archaeological Society), 47–57.

—— (1997), *The Vikings in Norfolk* (Norwich: Norfolk Museums Service).

—— and Willliams, V. (1985), 'The Finds', in B. Ayers (ed.), *Excavations within the North-East Bailey of Norwich Castle, 1979*, East Anglian Archaeology Report 28 (Dereham: Norfolk Archaeological Unit), 27–33.

Marten, L. (2008), 'The Shiring of East Anglia: An Alternative Hypothesis', *Historical Research* vol. 81 (211), 1–27.

Martin, E. (2007), '"Wheare most Inclosures be": The Making of the East Anglian Landscape', in M. Gardiner and S. Rippon (eds.), *Medieval Landscapes* (Macclesfield: Windgather), 122–36.

—— and Satchell, M. (2008), *'Wheare most Inclosures be'. East Anglian Fields: History, Morphology and Management* (Ipswich: Suffolk County Council Archaeological Service).

Mason, D. J. P. (2007), *Chester AD 400–1066: From Roman Fortress to English Town* (Stroud: The History Press).

Moltke, E. (1985), *Runes and Their Origin: Denmark and Elsewhere* (Copenhagen: National Museum of Denmark).

Mortimer, C. (1988), 'Anglo-Saxon Copper Alloys from Lechlade, Gloucestershire', *Oxford Journal of Archaeology* 7, 227–33.

—— (1992), 'Patterns of Non-ferrous Metal Use during the Early Medieval Period', in *Medieval Europe 1992: A Conference on Medieval Archaeology in Europe, 21st–24th September 1992, at the University of York. Pre-printed Papers. vol. 3, Technology and Innovation* (York: Medieval Europe), 97–102.

—— Pollard, A. M., and Scull, C. (1986), 'XRF Analyses of Some Anglo-Saxon Copper Finds from Watchfield, Oxfordshire', *Journal of the Historical Metallurgy Society* 20 (1), 36–42.

Mortimer, R., Regan, R., and Lucy, S. (eds.) (2005), *The Saxon and Medieval Settlement at West Fen Road, Ely: The Ashwell Site* (Cambridge: Cambridge Archaeological Unit).

Muhl, A. (2006), 'Wikingerschmuck in der Altmark: Die Scheibenfibeln mit Borre-/Jellingestil-Dekor aus Dähre', *Jahresschrift für Mitteldeutsche Vorgeschichte* 90, 305–14.

Müller-Wille, M. (1977), 'Krieger und Reiter im Spiegel Früh- und Hochmittelalterlicher Funde Schleswig-Holsteins', *Offa* 34, 40–74.

——(1987), *Das Wikingerzeitliche Grüberfeld von Thumbly-Bienbek*, 2 vols (Neumünster: K Wachholtz).

——(ed.) (2004), *Zwischen Tier und Kreuz. Untersuchungen zur Wikingerzeitlichen Ornamentik im Ostseeraum* (Neumünster: Wachholtz).

Naylor, J. (2007), 'The Circulation of Early-Medieval European Coinage: A Case Study from Yorkshire, c. 650–867', *Medieval Archaeology* 51, 41–61.

——and Richards, J. D. (2005), 'Third-Party Data for First Class Research', *Archeologia e Calcolatori* 16, 83–91.

——Leahy, K., and Egan, G. (eds.) (2009), 'Medieval Britain and Ireland in 2008. Portable Antiquities Scheme Report', *Medieval Archaeology* 53, 327–46.

Nerman, B. (1969), *Die Vendelzeit Gotlands* (Stockholm: Almqvist and Wiksell).

Newman, J. (1993), *Three Antler Moulds from Ipswich*, The Finds Research Group AD 700–1700, Datasheet no. 17.

Nilsson, T. (1994), 'Stentinget—en Boplads med Handel og Håndværk fra Germanskjernalder og Vikingetid', *Vendsyssel Nu og Da* 14 (1991–3), 64–77.

Nørlund, P. (1948), *Trelleborg*, Nordiske Fortidsminder IV bd., I hefte (Copenhagen: Nordisk Forlag).

Oddy, W. A. (1983), 'Bronze Alloys in Dark Age Europe', in R. Bruce-Mitford, *The Sutton Hoo Ship Burial*, vol. 3, ii (London: British Museum Publications), 945–62.

Oldeberg, A. E. (1966), *Metallteknik under Vikingatid och Medeltid* (Stockholm: Seelig).

Ó Ríordáin, B. (1971), 'Excavations at High Street and Winetavern Street, Dublin', *Medieval Archaeology* 15, 73–85.

Owen, O. (2001), 'The Strange Beast that is the English Urnes Style', in Graham-Campbell et al. (eds.), *Vikings and the Danelaw*, 203–22.

Owen-Crocker, G. (2004), *Dress in Anglo-Saxon England* (Woodbridge: Boydell Press).

Paisley, F. (2004), 'Childhood and Race: Growing Up in the Empire', in P. Levine (ed.), *Gender and Empire*, 240–59.

Parsons, D. N. (2002), '*Anna, Dot, Thorir*…Counting Domesday Personal Names', *Nomina* 25, 29–52.

——(2006), 'Field-Name Statistics, Norfolk and the Danelaw', in P. Gammeltoft and B. Jørgensen (eds.), *Names Through the Looking-Glass* (Copenhagen: C. A. Reitzel), 165–88.

Paterson, C. (2001), 'Insular Belt-Fittings from Pagan Norse Graves in Scotland: A Reappraisal in the Light of Scientific and Stylistic Analysis', in M. Redknap et al. (eds.), *Pattern and Purpose*, 125–32.

——(2002), 'From Pendants to Brooches. The Exchange of Borre- and Jellinge-style Motifs across the North Sea', *Hikuin* 29, 267–76.

Paulsen, P. (1933), *Der Stand der Forschungüber die Kultur der Wikingerzeit* (Frankfurt: J. Baer).

Pedersen, A. (2001), 'Rovfugle eller Duer. Fugleformede Fibler fra den Tidlige Middelalder', *Aarbøger for Nordisk Oldkyndighed og Historie* (1999), 19–66.

——(2004), 'Anglo-Danish Contact across the North Sea in the Eleventh Century: A Survey of the Danish Archaeological Evidence', in J. Adams and K. Holman (eds.), *Scandinavia and Europe, 800–1350. Contact, Conflict, and Coexistence* (Turnhout: Brepols), 43–67.

Pestell, T. (2005), 'Using Material Culture to Define Holy Space: The Bromholm Project', in A. Spicer and S. Hamilton (eds.), *Defining the Holy: Sacred Space in Medieval and Early Modern Europe* (Aldershot: Ashgate), 161–86.

——and Ulmschneider, K. (eds.) (2003), *Markets in Early Medieval Europe: Trading and 'Productive' Sites, 650–850* (Macclesfield: Windgather).

Petersen, J. G. T. (1928), *Vikingetidens Smykker* (Stavanger: Dreyers Grafiske Anstalt).

——(1955), *Vikingetidens Smykker i Norge* (Stavanger: Stavanger Museum).

Portable Antiquities Scheme Annual Report 2004/5 (London: Department of Portable Antiquities and Treasure, British Museum).

Portable Antiquities Scheme Annual Report 2005/6 (London: Department of Portable Antiquities and Treasure, British Museum).

Portable Antiquities Scheme Annual Report 2007 (London: Department of Portable Antiquities and Treasure, British Museum).

Portable Antiquities Scheme Annual Report 2008 (London: Department of Portable Antiquities and Treasure, British Museum).

Portable Antiquities Scheme Annual Report 2009/10 (London: Department of Portable Antiquities and Treasure, British Museum).

Ramskou, T. (1955), 'Lindholm Høje. Second Preliminary Report for the Years 1954–5 on the Excavation of a Late Iron Age Cemetery and an Early Medieval Settlement', *Acta Archaeologica* XXVI, 177–85.

Reaney, P. H. (1935), *The Place-Names of Essex* (Cambridge: Cambridge University Press).

Redknap, M., Edwards, N., Youngs, S., Lane, A., and Knight, J. (eds.) (2001), *Pattern and Purpose in Insular Art: Proceedings of the Fourth International Conference on Insular Art: held at the National Museum & Gallery, Cardiff 3–6 September 1998* (Oxford: Oxbow Books).

Redmond, A. Z. (2007), *Viking Burial in the North of England: A Study Of Contact, Interaction and Reaction between Scandinavian Migrants with Resident Groups, and the Effect of Immigration on Aspects of Cultural Continuity*, BAR Brit. Series 429 (Oxford: Hedges).

Reynolds, A. (1994), 'A Late Anglo-Saxon Disc Brooch from Steyning, West Sussex', *Medieval Archaeology* 38, 169–71.

Richards, J. (2001), 'Finding the Vikings: The Search for Anglo-Scandinavian Rural Settlement in the Northern Danelaw', in Graham-Campbell et al. (eds.), *Vikings and the Danelaw*, 269–78.

——(2002), 'The Case of the Missing Vikings: Scandinavian Burial in the Danelaw', in S. Lucy and A. Reynolds (eds.), *Burial in Early Medieval England and Wales* (London: The Society for Medieval Archaeology), 156–70.

——(2003), 'The Anglian and Anglo-Scandinavian Sites at Cottam, East Yorkshire', in Pestell and Ulmschneider (eds.), *Markets in Early Medieval Europe*, 155–66.

——and Naylor, J. (2010), 'The Metal Detector and the Viking Age in England', in J. Sheehan and D. Ó. Corráin (eds.), *The Viking Age: Ireland and the West. Proceedings on the Fifteenth Viking Congress* (Dublin: Four Courts Press), 338–52.

——Naylor, J., and Holas-Clark, C. (2009), 'Anglo-Saxon Landscape and Economy: Using Portable Antiquities to Study Anglo-Saxon and Viking-Age England', *Internet Archaeology*, vol. 25.

Richardson, C. (1993), *The Borre Style in the British Isles: A Re-assessment*, unpublished M.Litt thesis, Newcastle University.

—— (1997), 'The Viking-Age Trefoil Mounts from Jarlshof—A Reppraisal in the Light of New Dscoveries', *Proceedings of the Society of Antiquaries of Scotland* 127, 649–57.

Riebau, M. H. (1999), 'Die Gleicharmigen Fibeln der Wikingerzeit', in G. Mangelsdorf (ed.), *Von der Steinzeit zum Mittelalter* (Frankfurt: Peter Lang), 23–119.

Rieck, F. R. (1982), 'Oldtid i Lange Baner', *Skalk* 1982 (3), 4–8.

Rippon, S. (2008), *Beyond the Medieval Village: the Diversification of Landscape Character in Southern Britain* (Oxford: Oxford University Press).

Roberts, B. K. and Wrathmwell, S. (2000), *An Atlas of Rural Settlement in England* (London: English Heritage).

Robinson, D. (2004), 'Chester's Northern Connections', *The Past Uncovered*, June 2004, 3.

Roesdahl, E. (1994), 'Dendrochronology and Viking Studies in Denmark, with a Note on the Beginning of the Viking Age', in B. Ambrosiani and H. Clarke (eds.), *Developments Around the Baltic and the North Sea in the Viking Age* (Stockholm: Produced by the Birka Project for Riksantikvarieämbetet and Statens Historiska Museet), 106–16.

—— (2007), 'Denmark-England in the Eleventh Century. The Growing Archaeological Evidence for Contacts across the North Sea', *Hikuin*, 7–31.

—— Graham-Campbell, J., Conner, P., and Peason, K. (eds.) (1981), *The Vikings in England and in their Danish Homeland* (London: Anglo-Danish Viking Project).

Rogerson, A. (2003), 'Six Middle Anglo-Saxon Sites in West Norfolk', in Pestell and Ulmschneider (eds.), *Markets in Early Medieval Europe,* 110–21.

—— and Ashley, S. (2008), 'A Selection of Finds from Norfolk Recorded between 2006 and 2008', *Norfolk Archaeology* 45, 428–42.

Rygh, O. (1885), *Norske Oldsager* (Christiania: Alb. Cammermeyer).

Sandred, K. I. (1979), 'Scandinavian Place-Names and Appellatives in Norfolk: A Study of the Medieval Field-Names of Flitcham', *Namn och Bygd* 67, 98–122.

—— (2001), 'East Anglian Place-Names: Sources of Lost Dialect', in J. Fisiak and P. Trudgill (eds.), *East Anglian English* (Woodbridge: D. S. Brewer), 39–61.

Sawyer, P. H. (1969), 'The Two Viking Ages of Britain: a Discussion', *Mediaeval Scandinavia* 2, 163–207.

Schulze-Dörrlamm, M. (1991), *Der Mainzer Schatz der Kaiserin Agnes aus dem Mittleren 11. Jahrhundert. Neue Untersuchungen zum Sogenannten 'Gisela-Schmuck'* (Sigmaringen: Thorbecke).

Shanks, M. and Tilley, C. (1992), *Re-constructing Archaeology: Theory and Practice* (London: Routledge).

Shetelig, H. (1920), *Osebergfundet. Bind III,* (Kristiania: Universitets Oldsaksamling).

—— (ed.) (1940–1954), *Viking Antiquities in Great Britain and Ireland,* 6 vols. (Oslo: H. Aschehoug).

Sidebottom, P. (2000), 'Viking-Age Stone Monuments and Social Identity in Derbyshire', in Hadley and Richards (eds.), *Cultures in Contact,* 213–35.

Sindbæk, S. (2003), 'An Object of Exchange. Brass Bars and the Routinzation of Viking-Age Long-Distance Exchange in the Baltic Area', *Offa* 58 (2001), 49–60.

Skaarup, J. (1976), *Stengade II. En Langelandsk Gravplads med Grave fra Romersk Jernalder og Vikingetid* (Rudkøbing: Langelands Museum).

Skibsted Klæsøe, I. (1999), 'Vikingetidens Kronologi—en Nybearbejding af det Arkæologiske Material', *Aarbøger for Nordisk Oldkyndighed og Historie* (1997), 89–142.

Skibsted Klæsøe, I. (2001), 'Trefligede Spænder fra Uppåkra', in B. Hårdh (ed.),*Uppåkra. Centrum och sammanhang*. Uppåkrastudier 3 (Stockholm: Almqvist and Wiskell International), 217–37.

Skovmand, R. (1942), 'De Danske Skattefund fra Vikingetiden og den Ældste Middelalder indtil omkring 1150', *Aarbøger for Nordisk Oldkyndighet og Historie* (1942), 1–245.

Smedley, N. and Owles, E. (1965), 'Some Anglo-Saxon "Animal" Brooches', *Proceedings of the Suffolk Institute of Archaeology* 30, Part II, 166–74.

Smith, J. (2000), 'Did Women Have a Transformation of the Roman World?', *Gender and History* 12(3), 552–71.

Smith, R. A. (1906), 'Anglo-Saxon Remains', in W. Page (ed.), *Victoria County History of the County of Somerset, Volume One* (London: A. Constable), 373–81.

Speed, G. and Walton Rogers, P. (2004), 'A Burial of a Viking Woman from Adwick-le-Street, South Yorkshire', *Medieval Archaeology* 48, 51–90.

Staecker, J. (2003), 'The Cross Goes North: Christian Symbols and Scandinavian Women', in M. O. H. Carver (ed.), *The Cross Goes North: Processes of Conversion in Northern Europe, AD 300–1300* (Woodbridge: York Medieval Press), 463–82.

Stalsberg, A. (1987), 'The Interpretation of Women's Objects of Scandinavian Origin from the Viking Period Found in Russia', in R. Bertelsen, A. Lillehammer, and J. R. Næss (eds.), *Were They All Men? An Examination of Sex Roles in Prehistoric Society. Acts from a Workshop held at Utstein Kloster, Rogaland, 2–4 November 1979* (Stavanger: Arkeologisk Museum i Stavange), 89–100.

Stamper, P. and Croft, R. A. (2000), *Wharram, A Study of Settlement on the Yorkshire Wolds* (York: University of York).

Stenberger, M. (1950), 'Erikstorpspännet och Hedeby', *Fornvännen* 45, 36–40.

Stocker, D. (2000), 'Monuments and Merchants: Irregularities in the Distribution of Stone Sculpture in Lincolnshire and Yorkshire in the Tenth Century', in Hadley and Richards (eds.), *Cultures in Contact,* 179–212.

Stummann Hansen, S. (1989), 'Toftanes—en Færøsk Landnamsgård fra 9.–10. Århundrede', *Hikuin* 15, 129–46.

Svanberg, F. (1998), 'Exclusive Jewellery, Borgeby and Western Scania c. AD 950–1050', *Fornvännen* 93, 113–23.

Symonds, L. A. (2003), *Landscape and Social Practice: the Production and Consumption of Pottery in 10th Century Lincolnshire,* BAR Brit. Series 345 (Oxford: Archaeopress).

Tegnér, M. (1999), 'Uppåkra under sen Vikingatid', in Hårdh (ed.), *Fynden i Centrum,* 225–42.

Thålin, H. (1984), 'Ringspangen', in Arwidsson (ed.), *Systematische Analysen,* 15–22.

Thomas, G. (2000a), *A Survey of Late Saxon and Viking-Age Strap-Ends from Britain,* unpublished PhD thesis, University of London.

——(2000b), 'Anglo-Scandinavian Metalwork from the Danelaw: Exploring Social and Cultural Interaction', in Hadley and Richards (eds.), *Cultures in Contact,* 237–55.

——(2006), 'Reflections on a "9th-century" Northumbrian Metalworking Tradition: A Silver Hoard from Poppleton, North Yorkshire', *Medieval Archaeology* 50, 143–64.

——(2007), 'The Missing Dimension: the Circulation and Production of Carolingian-Style Metalwork in Anglo-Saxon England', paper presented at the Portable Antiquities Scheme Conference, 17–18 April, 2007.

Thorén, P. (1994), *Grisskogen. En Vendel- och Vikingatida Gravfält I Ovansjösocken. Gästrikland,* Gästrikland: RAÄ- Rapport 33.

Thörle, S. (2001), *Gleicharmige Bügelfibeln des Frühen Mittelalters* (Bonn: Habelt).

Thrane, H. 1987, 'Das Gudme-Problem und die Gudme-Untersuchung, Fragen der Besiedlung in der Volkerwanderungs- und der Merowingerzeit auf Funen', *Frühmittelalterliche Studien* 21, 1–49.

Thunmark-Nylén, L. (1984), 'Ringnadeln', in Arwidsson (ed.), *Systematische Analysen*, 5–14.

Townend, M. (2002), *Language and History in Viking Age England. Linguistic Relations Between Speakers of Old Norse and Old English* (Turnhout: Brepols).

Trafford, S. (2000), 'Ethnicity, Migration Theory, and Historiography', in Hadley and Richards (eds.), *Cultures in Contact*, 17–39.

——(2007), 'Gender, Migration and Cultural Memory: Making Scandinavian Female Identity in the Danelaw', paper presented at the Viking Identities Network Conference: Gender, Material Culture and Identity in the Viking Diaspora, Nottingham, 30–31 March 2007.

Trotzig, G. (1991), *Vikingatida Gravkärl av Koppar och Kopparlegeringar från Birka och Gotland: Tillverkning, Användning och Sociala Förutsättninga* (Stockholm: Stockholm University Archaeological Research Laboratory).

Tweddle, D. (2004), 'Art in Pre-Conquest York', in R. A. Hall (ed.), *Aspects of Anglo-Scandinavian York* (York: Council for British Archaeology), 446–58.

Ulmschneider, K. (2000a), *Markets, Minsters, and Metal-Detectors: the Archaeology of Middle Saxon Lincolnshire and Hampshire Compared*, BAR Brit. Series 307 (Oxford: Archaeopress).

——(2000b), 'Settlement, Economy, and the "Productive" Site: Middle Anglo-Saxon Lincolnshire A.D. 650–780', *Medieval Archaeology* 44, 53–79.

Ulriksen, J. (2006), 'Vester-Egesborg—A Coastal Settlement from the Late Iron Age on Zealand', *Journal of Danish Archaeology* 14, 184–99.

Valante, M. A. (2008), *The Vikings in Ireland. Settlement, Trade and Urbanization* (Dublin: Four Courts Press).

Van de Noort, R. (2000), 'Where are Yorkshire's "Terps"? Wetland Exploitation in the Early Medieval Period', in H. Geake and J. Kenny (eds.), *Early Deira: Archaeological Studies of the East Riding in the Fourth to Ninth centuries AD* (Oxford: Oxbow), 121–31.

——and Davies, P. (1993), *Wetland Heritage: An Archaeological Assessment of the Humber Wetlands* (Kingston-upon-Hull: School of Geography and Earth Resources, University of Hull).

Van Houts, E. (1999), *Memory and Gender in Medieval Europe, 900–1200* (Basingstoke: Macmillan).

Wade, K. (1983), 'The Early Anglo-Saxon Period', in A. J. Lawson (ed.), *The Archaeology of Witton, near North Walsham*, East Anglian Archaeology Report 18 (Gressenhall: Norfolk Archaeological Unit), 50–69.

——(1993), 'The Urbanisation of East Anglia: the Ipswich Perspective', in J. Gardiner (ed.), *Flatlands and Wetlands: Current Themes in East Anglian Archaeology*, East Anglian Archaeology Report 50 (Norwich: Scole Archaeological Committee), 144–52.

Wallis, H. (2004), *Excavations at Mill Lane, Thetford, 1995*, East Anglian Archaeological Report 108 (Dereham: Norfolk Museums and Archaeology Service).

Walton Rogers, P. (2007), *Cloth and Clothing in Early Anglo-Saxon England AD 450–700* (York: Council for British Archaeology).

Wamers, E. (1985), *Insulärer Metallschmuck in Wikingerzeitlichen Gräbern Nordeuropas: Untersuchungen zur Skandinavischen Westexpansion* (Neumünster: K. Wachholtz).

——(1994), *Die Frühmittelalterlichen Lesefunde aus der Löhrstrasse (Baustelle Hilton II) in Mainz.* Mainzer Archäologische Schriften 1 (Mainz: Archäologische Denkmalpflege).

——(1998), 'Finds in Viking-Age Scandinavia and the State Formation of Norway', in H. B. Clarke, M. Ní Mhaonaigh, and R. Ó Floinn (eds.), *Ireland and Scandinavia in the Early Viking Age* (Dublin: Four Courts Press), 37–72.

——(2000), 'Karolingerzeit', in R. Müller (ed.), *Reallexikon der Germanischen Altertumskunde. Fibel und Fibeltracht* (Berlin: Walter de Gruyter), 176–92.

Weber, B. (1987), 'Vesle Hjerkinn—A Viking-Age Mountain Lodge? A Preliminary Report', in J. E. Knirk (ed.), *Proceedings of the 10th Viking Congress, Larkollen, Norway 1985. Universitets Oldsakamfing Skrifter* 9 (Oslo: Universitetets Oldsaksamling), 103–11.

Webster, L. E. and Backhouse, J. (eds.) (1991) *The Making of England: Anglo-Saxon Art and Culture AD 600–900* (London: British Museum Press for the Trustees of the British Museum and the British Library Board).

Wenham, L. P. (1987), *St. Mary Bishophill Junior and St. Mary Castlegate* (London: Council for British Archaeology for the York Archaeological Trust).

West, S. E. (1998), *A Corpus of Anglo-Saxon Material from Suffolk*, East Anglian Archaeology Report 84 (Ipswich: Suffolk County Council).

Westermann-Angerhausen, H. (2006), 'The Carolingian Objects', in S. H. Fuglesang and D. M. Wilson (eds.), 103–18.

Whitelock, D. (ed.) (1979), *English Historical Documents c.500–1042*, rev. edn. (London: Eyre Methuen).

Wiechmann, R. (1996), *Edelmetalldepots der Wikingerzeit in Schleswig-Holstein: vom 'Ringbrecher' zur Münzwirtschaft* (Neumünster: Wachholtz).

Wigren, S. (1981), 'Del av Fornlämning 106, Vikingatid, Grindtorp, Ö Rydssn. Uppland', *Gravfält och Boplatser från Järnålder samt Medeltida Verkstadsområde* (Stockholm: RAÄ- Rapport UV 26).

Williams, D. (1997), *Late Saxon Stirrup-Strap Mounts* (York: Council for British Archaeology).

Williams, G. (2007), 'Kingship, Christianity and Coinage: Monetary and Political Perspectives on Silver Economy in the Viking Age', in J. Graham-Campbell and G. Williams (eds.), *Silver Economy in the Viking Age* (Walnut Creek: Left Coast Press), 177–214.

——(2009), 'Viking Hoards of the Northern Danelaw from Cuerdale to the Vale of York', in Graham-Campbell and Philpott (eds), *The Huxley Hoard,* 73–83.

Williamson, T. 1993, *The Origins of Norfolk* (Manchester: Manchester University Press).

——(2003), *Shaping Medieval Landscapes: Settlement, Society, Enviroment* (Macclesfield: Windgather Press).

Wilson, D. M. (1956), 'A Bronze Mounting from Oxshott Wood, Surrey', *Antiquaries Journal* 37, 70–1.

——(1964), *Anglo-Saxon Ornamental Metalwork, 700–1100, in the British Museum* (London: Trustees of the British Museum).

——(1976), 'The Borre Style in the British Isles', in B. Vilhjálmsson et al. (eds.), *Minjar og Menntir* (Reykjavík: Bókaútgáfa Menningarsjóðs), 502–9.

——(1984), *Anglo-Saxon Art from the Seventh Century to the Norman Conquest* (London: Thames and Hudson).

——(1995), *Vikingatidens Konst* (Lund: Bokförlaget Signum).

——(2001), 'The Earliest Animal Styles of the Viking Age', in M. Müller-Wille and L. O. Larsson (eds.), *Tiere. Menschen. Götter. Wikingerzeitliche Kunststile und ihre neuzeitliche Rezeption* (Göttingen: Vandenhoeck and Ruprecht), 131–56.

——(2008a), *The Vikings in the Isle of Man* (Århus: Århus University Press).

——(2008b), 'The Development of Viking Art', in S. Brink (ed.), *The Viking World* (London, Routledge), 323–38.

——and O. Klindt-Jensen (1966), *Viking Art* (London: Allen & Unwin).

Wobst, M. (1977), 'Stylistic Behaviour and Information Exchange', in C. E. Cleland and J. B. Griffin (eds.), *For the Director: Research Essays in Honor of James B. Griffin* (Ann Arbor: Museum of Anthropology University of Michigan), 317–42.

——(1999), 'Style in Archaeology', in E. S. Chilton (ed.), *Material Meanings: Critical Approaches to the Interpretation of Material Culture* (Salt Lake City: University of Utah Press), 118–32.

Zachrisson, I. (1962), 'Smedsfyndet från Smiss', *TOR* 8, 201–28.

Index

Page numbers in *italics* denote figures, tables, and colour plates.